Place and Politics in Latin American Digital Culture

"*Place and Politics in Latin American Digital Culture* is bound to become a permanent reference not only in Latin American Studies but also among various disciplines in new media and the digital humanities. A much needed interdisciplinary contribution to the study of globalization in all its forms."

—*Eduardo Navas, Eugene Lang College,*
The New School for Liberal Arts, USA

This volume explores one of the central issues that has been debated in internet studies in recent years: locality, and the extent to which cultural production online can be embedded in a specific place. The particular focus of the book is on the practices of net artists in Latin America and on how their work interrogates some of the central place-based concerns of Latin(o) American identity through their on- and offline cultural practice.

Six particular works by artists of different countries in Latin America and within Latina/o communities in the US are studied in detail, with one each from Uruguay, Chile, Argentina, Colombia, the US–Mexico border and the US. Each chapter explores how each artist represents place in their works, and, in particular how traditional place-based affiliations, or notions of territorial identity, end up reproduced, reaffirmed, or even transformed online. At the same time, the book explores how these net.artists make use of new media technologies to express alternative viewpoints about the locations they represent, and use the internet as a space for the recuperation of cultural memory.

Claire Taylor is Professor of Hispanic Studies at the University of Liverpool, UK. Her research specialisms include Latin American digital culture, with a particular interest in hypermedia narrative, net art and experimental digital literature. Recent publications include *Latin American Identity in Online Cultural Production,* co-authored with Thea Pitman (Routledge, 2013); the edited volume *Identity, Nation, Discourse* (2009) and *Latin American Cyberliterature and Cyberculture,* co-edited with Thea Pitman (2007).

Routledge Studies in New Media and Cyberculture

Place and Politics in Latin American Digital Culture

Location and Latin American Net Art

Claire Taylor

Routledge
Taylor & Francis Group

NEW YORK AND LONDON

First published 2014
by Routledge
711 Third Avenue, New York, NY 10017

and by Routledge
2 Park Square, Milton Park, Abingdon, Oxon OX14 4RN

*Routledge is an imprint of the Taylor & Francis Group,
an informa business*

Library of Congress Cataloging-in-Publication Data

Taylor, Claire, 1972–
Place and politics in Latin American digital culture : location and
 Latin American net art / Claire Taylor.
 pages cm. — (Routledge studies in new media and cyberculture ; 20)
 1. Digital art—Latin America. 2. Art, Latin American—20th
century—20th century—Themes, motives. 3. Art, Latin American—
21st century—20th century—Themes, motives. 4. Art and the
Internet—Latin America. 5. Place (Philosophy) in art. 6. Identity
(Psychology) in art. I. Title.
 N7433.84.L29T39 2014
 776.098—dc23
 2013049854

ISBN: 978-0-415-73040-2 (hbk)
ISBN: 978-1-315-85023-8 (ebk)

Typeset in Sabon
by Apex CoVantage, LLC

This book is dedicated to Sue Wilson, for her courage, bravery and sheer determination.

Contents

Figures

Preface

NEGOTIATING NET ART COMMUNITIES IN LATIN AMERICA

I first became interested in Latin American net art in the mid-2000s when, in my early forays into online cultural production by Latin Americans, I came across several works whose formal aspects, creativity and aesthetic variety appealed to me. In particular, the role of Brian Mackern, who is analyzed in Chapter 4 of this book, was key in drawing my attention to the variety and vibrancy of net art as it is practised across Latin America and by Latina/o artists in the United States.

Over the course of the researching of this book, many of the artists have generously given up their time over the past five years to answer my questions, chat with me about their work, and share their thoughts about their works in progress. I have been fortunate enough to be able to participate in events with them, including the workshop on the topic of *Radiografía del Net.Art en Latinoamérica: Vitalidad Creativa en Riesgo de Extinción* [*Radiography of Net.Art in Latin America: Creative Vitality at Risk of Extinction*], co-organized by Ignacio Nieto and Marina Zerbarini in 2012 in Argentina—two artists who have contributed to the works studied in Chapters 2 and 3 of this book. Similarly, several of the artists have been kind enough to accept my invitations to participate in events in Liverpool, including a telepresence event in 2012, and a virtual exhibition and workshop held with the Foundation for Art and Creative Technology in 2013. This book, thus, is the result not only of my own research but also of the generosity of the artists in giving up their time and in helping direct my thoughts.

Of course, such an endeavour, in which I, as a UK-based researcher, am working on cultural products developed in a Latin(o) American context, is not without its own problems, particularly as regards my positionality and my relationship to the research field. I am acutely aware of the unequal power dynamics lying behind this enterprise: as an Anglophone writing about a continent with a long history of colonization, I cannot ignore the issues that arise resulting from my place of writing and my locatedness within the Anglophone academy. Scholars have frequently cautioned us regarding the

hierarchies and power relations at play when members of the Anglophone academy 'do' Latin Americanism. As early as the mid-1990s, Enrico M. Santí cautioned that 'Latinamericanism, like Orientalism, is never far from the collective notion that identifies Europe, and by extension the United States, as a superior culture in comparison with all other non-European peoples and cultures', and critiqued the practice of Latin Americanism since it assumes that '"Latin America" is there to be charted, deciphered, understood, remade, and ultimately controlled by Latinamericanists, that is, implicitly at least positionally superior Western Europeans who never lose the upper hand' (Santí, cited in Williams 1997: 14). Indeed, many scholars have argued that the very concept of Latin American studies is suspect, given that it is, in Daniel Mato's (2003: 793) words, 'epistemologically, ethically, and politically loaded with the history of the application of the US and Western European hegemonic concept of area studies to Latin America'.

These and many other scholars have indicated the need for careful negotiation when Anglophone scholars engage with cultural products, practices, discourses and theories stemming from Latin America. Yet, at the same time, it is imperative that Anglophone scholars do indeed pay attention to Latin America, and to the cultural production, practices, discourses and theories developed there; to ignore what takes place within Latin America and Latina/o communities within the United States would be to adopt a stance that would have its own hierarchies and blind spots. Rather, what is important is to be sensitive to cultural difference and, in particular, to be alert to the ways in which Latin(o) American cultural practice inflects differently theories and concepts stemming from Anglophone and European contexts. Here, I take my cue from Nelly Richard, whose thoughtful writings on the negotiations between metropolitan theories and peripheral contexts have been hugely influential in Latin American studies. Richard (1993: 453) reminded us that as with all cultural practice, theoretical reflection is a 'materially *situated* activity', and that it entails not only significations but values and powers, including the academic prestige of specialized knowledge, and the 'European and North American hegemony over international theory'. Yet rather than reject international theorization, Richard posits that the central question facing scholars on the periphery (in which she includes Latin America) is 'how are we to take advantage of theoretical-conceptual categories put into circulation by its networks of discourse without adhering to its hierarchizations of cultural power?'. Richard (1993: 458–59) then goes on to conclude that we can find the answers to this question in 'some of the theoretical-discursive operations orchestrated by the periphery not only to "construct its own phrases with a *received* vocabulary and syntax" but also to subvert the interpretations codified by the pacts of hegemonic reading, diverting them toward local resignifications'.

In this book I thus aim to follow the advice of Richard and to pay attention to the ways in which theories and practices are inflected differently. Moreover, I also take my cue from the artists themselves analyzed in this book,

who engage in a creative sharing of theory and practice across national borders. Many of the works themselves that are studied in this volume are the result of collaborative endeavours that span national boundaries. Instances of this transnational collaboration can be seen, for example, in the *Memoria histórica de la Alameda* project analyzed in Chapter 2 of this volume, which involved for the most part participants in Chile, but also included the British-born and Italy-based artist, David Boardman, as international facilitator. Similarly, in the case of the works analyzed in Chapter 3, whilst the constituent works themselves are all by Argentine artists, the interface was developed by the German multimedia artist Agricola de Cologne working in conjunction with Raquel Partnoy. More significantly, there are several works included in this volume whose very premise lies in the fact of the crossing of national boundaries, with the most notable being *Turista Fronterizo* and *Vagamundo*, analyzed in Chapters 6 and 7, in which the central themes and place-based tropes of the works are places lying across national borders. Indeed, collaborative work, one way or another, underpins all of the works in this volume, in which there is not the scenario of the lone artist producing his or her masterpiece, but the collaborative creation of content.

Perhaps even more significantly, the sharings, creative borrowings, re-articulations and creative mashups of theory across national and continental boundaries form one of the most vibrant ways in which Latin(o) American net art articulates itself. That is, what is exciting about the work of the artists included in this volume is less the way in which they slavishly 'apply' theory to their local context, but instead how they demonstrate that this same theory ends up being inflected differently, and, often, confronted with the limits of its own theorizations. For instance, the work of the Situationists is mentioned by several of the artists studied in this volume as informing their practice; this is the case with Mackern, Fusco and Domínguez, and the varied artists of the *Memoria histórica de la Alameda* project who all, in their different ways, mention Debord and the Situationists as reference points. Yet what is most interesting in their work is less the 'use' or 'application' of the Situationsts, than the rethinking of their terms and an illustration of how we can read the Situationists differently. As we shall see in the chapters that follow, in the case of Mackern, for instance, not only are the theories of the Situationists updated for the era of late capitalism, and, specifically, for post-crash Uruguay, but also, crucially, the viewer of Mackern's work is brought up against and the way in which certain aspects of Situationist thinking (such as that on the passions) have subsequently been co-opted into the dominant libidinal order of the city.

Indeed, it is this sense of theoretical and creative borrowings that lies at the heart of net art practice. As we shall see in the Introduction that follows, the practice of the creative, partial and knowing reworkings of media formats, genre, styles and theories is what informs tactical media. It is this sense of the tactical borrowings by Latin(o) Americans in their digital practice that contributes to the vibrancy, impact and oppositional stance of their works.

Acknowledgements

I have been fortunate to receive research funding which has enabled me to undertake the research for and writing of this book. First and foremost I acknowledge the support of the Arts and Humanities Research Council, who awarded me a Fellowship in 2012–13 on the topic of 'Latin American Cultural Production Online from 1990 to the Present'. The Fellowship provided for research leave and time to dedicate myself to the project, without which this book would not have been possible. In addition, I also received financial support for events and smaller projects that were instrumental in the early stages of the planning for and thinking through of this book: these include a Modern Humanities Research Association conference grant, a University of Liverpool Culture and Creativity Research Network grant, and a University of Liverpool International Collaboration Fund award.

Thanks are also due to the many colleagues and friends who have supported, inspired and advised me throughout the planning, research and writing of this volume. These friends and colleagues include Andrew Brown, Debra Castillo, Hilda Chacón, Kay Chadwick, Luis Correa Díaz, Diana Cullell, Charles Forsdick, Loss Pequeño Glazier, Chris Harris, Tori Holmes, Kirsty Hooper, Geoffrey Kantaris, Par Kumaraswami, Jane Lavery, Lyn Marven, Héctor Perea, Thea Pitman, Jaime Alejandro Rodríguez, Eve Rosenhaft, Lisa Shaw, Philip Swanson and Scott Weintraub. I am also very grateful to the students, academics and members of the public who formed the audiences at the various seminars and conferences at which I have given papers over the past five years on the topic; their comments and feedback on the papers have been immensely helpful. Likewise, I also thank the anonymous readers at Routledge for their thorough reading, their attention to detail and their detailed comments which have helped me in the shaping of the finalized volume.

I also owe a debt of gratitude to the artists whose work is analyzed in this volume, for their time and patience in answering my queries, for their sharing of their ideas with me, and for their generosity in allowing me to reproduce images of their work. Many of them have also been kind enough to participate in events I have organized, and for that I am very grateful. To David Boardman, Agricola de Cologne, Andamio Contiguo, Irene

Coremberg, Ricardo Domínguez, Coco Fusco, Brian Mackern, Ricardo Miranda Zúñiga, Diego Mometti, Martha Patricia Niño, Bárbara Palomino and Marina Zerbarini, I am immensely grateful.

Whilst none of the chapters of this book has been published previously, earlier versions of some sections have appeared in articles. Preliminary work on *Turista Fronterizo* analyzed in Chapter 6 first appeared as an article titled 'Monopolies and *Maquiladoras:* The Resistant Re-encoding of Gaming in Coco Fusco and Ricardo Domínguez's *Turista Fronterizo*', in the *Journal of Iberian and Latin American Research*, 18:2 (2012), 151–165. Early work on *Vagamundo* analyzed in Chapter 7 first appeared as an article titled 'Resistant Gaming and Resignifying the Border Online: Ricardo Miranda Zúñiga's *Vagamundo, A Migrant's Tale*' in the *Journal of Latin American Cultural Studies,* 20:3 (2011), 301–319.

Finally, I extend my thanks to my department at Liverpool: the Department of Cultures, Languages and Area Studies. The ongoing support of fantastic colleagues in the department has been essential in my research and writing of this volume.

Any errors in the volume are, of course, my own.

1 Re-articulating Place
The Resistant Use of Technologies and the Tactics of Re-territorialization in Latin(o) American Net Art

One of the most hotly debated issues in discussions about the internet in recent years has been the extent to which online content can be understood as rooted in a particular place. Given that much of the initial hype about the internet in the 1990s presented the internet as a globalized medium inhabited by placeless netizens, the question of locality—of the rootedness of online content in a particular geographic setting—has come under question in recent years. As user-generated content has grown exponentially, and as a wealth of applications now allow users to refer to their geographical location, add geo-coordinates to their photographs on online platforms, or link content to online maps, amongst many others, the internet is increasingly becoming linked to offline place. The internet nowadays, rather than being a (solely) globalized, placeless medium, in fact offers ways of allowing people to make important connections to, and re-affirm their affiliations to, their physical, offline location.

I engage with this dynamic throughout this book, in which I focus on a vibrant community of Latin(o) American artists to investigate how, in their online works, they engage in re-imaginings of and representations of offline place. Broadly speaking, each of the artists' oeuvres falls within the category known as 'net art', an amorphous category that takes its origins in a specific group of artists in Europe in the 1990s whose work was collectively known as 'net.art' and whose works were characterized by playing with internet protocols, by putting errors within the system to artistic use and by the revival of avant-gardist aims of breaking down the barriers between art and life.[1] Net art 'without the dot'—or 'net art beyond net.art', to use Bosma's (2011: 32) suggestive term—refers more broadly to the parallel and successive waves of new media art located elsewhere in the globe, and is a term employed by many of the artists whose work is included in this volume. I use the term 'net art' throughout this book, thus, both because it is a term with which several of the artists appearing in this volume have dialogued, and because of its suggestive terminology and historicity, recalling as it does the avant-gardist thrust of the earlier net.art practitioners, as well as referencing a rich heritage of pre-digital networked art, and offline networks. Indeed, my contention is that what I here term 'net art' is inextricably linked

to offline praxis both in its subject matter and in its enactment, and as this volume explores, it is often in the intricate negotiations between online features and offline participation that the resistant potential of the works is actualized. The Latin(o) American artists analyzed in this volume develop cultural formats that give rise to new forms of local and regional place-based affiliations, and they interrogate some of the central place-based concerns of Latin(o) American identity through their on- and offline cultural practice.

Six particular works by artists of different countries in Latin America and the US are studied in detail in this book, with one each from Chile, Argentina, Uruguay, Colombia, the US–Mexico border and the US. The works selected for study depict particular iconic locales in the Latin(o) American imaginary, and each chapter explores how traditional place-based affiliations, or notions of territorial identity, end up reproduced, reaffirmed, or even transformed online. These locales range from the Alameda in Santiago de Chile as the contested space of historic memory in Chile; the Plaza de Mayo and other key locations in Buenos Aires as embodying Argentine identity in both the dictatorial and the neoliberal era; the Rambla Sur and iconic monuments in Montevideo as a defining image of the Uruguayan project of modernity; the cartography of the Colombian terrain as a contested territory; the US–Mexico border as physical and conceptual space in which the workings of late capitalism make themselves manifest; and the streets and the border as the socio-economic space in which US foreign policy is played out. Here, the volume engages with recent research over the past decade that has found that place is not lacking on the internet; rather, it is transformed, given different meanings, or re-affirmed in a variety of contexts.

As I discuss in the following, if networked digital media offers the possibilities of rethinking place and territory, then Latin(o) American net artists make creative use of this possibility to engage in the interrogation of and the reshaping of some of the central place-based metaphors of what it means to be Latin(o) American in the contemporary world. The works by the artists analyzed in this volume involve rethinkings of conventional conceptualizations of territoriality, citizenship and local and global affiliations—many of which notions are central to conceptualizations of Latin(o) America itself as a region. These rethinkings, as I argue in the following, are enacted through a resistant reworking of technology, whereby technologies conventionally put to use by corporate powers, state institutions and transnational capital, amongst others, are used against the grain.

This book thus poses two overarching questions. First, it explores the role that the internet plays in allowing for the formulation of place-based affiliations, asking how Latin(o) American net artists make tactical use of the interplay between virtual and real space to construct new formulations of territorial identity and new cartographies of (urban) space. Second, the volume explores how Latin(o) American net artists appropriate alternative modes of expression and dissemination enabled by new media technologies in order to give voice to oppositional or resistant discourses. Building

on and dialoguing with recent debates on tactical media, as well as on the rich Latin(o) American–specific heritage of the resistant appropriation of hegemonic tools in a broader sense, the volume investigates how the artists' re-appropriations of globalizing technologies and post-digital fragments provide space for the expression of oppositional discourses and for the recuperation of cultural memory.

REPRESENTATIONS OF PLACE AND NET LOCALITIES

It has frequently been noted that early conceptualizations of the internet, and of what has been problematically termed 'cyberspace', tended to assume a utopian vision of a limitless, free-floating realm, divorced from offline place. One of the pioneering descriptions of the internet, John Perry Barlow's (1996: n.p.) oft-cited—and subsequently oft-critiqued— 'Declaration of the Independence of Cyberspace', posited cyberspace as a 'global social space', and is representative of early conceptualizations of the web which saw it as free from geographical fixities.[2] Contemporaneous with Barlow, although drawing on an earlier formulation first set down by Marshall McLuhan in 1964 in his *Understanding Media* regarding the speed-up of our contemporary electronic age and the 'instant implosion and an interfusion of space and functions' (McLuhan 2001: 101) is the commonly held perception of the internet as a 'global village'. As Nisha Shah (2008: 9) notes, the metaphor of the as 'global village' arising in the 1980s and 1990s understands the internet as 'emblematic of globalisation' and as involving a 'planetary system' transforming the world into a 'single, global space'. This promise of the internet as 'global village' thus conceives of the internet as an idealized zone of unfettered self-expression, disconnected from geographical place.[3] Similarly, the notion of the 'netizen' as no longer a citizen of a particular nation-state but as a 'citizen of the world thanks to the global connectivity that the Net makes possible' (Hauben and Hauben 1997: 3) conceived of the individuals who negotiate the internet as rootless, entirely detached from their physical location. Although predominantly used in the 1990s, the frequency with which terms such as 'the global village', 'globalized' or 'netizen' are still bandied about in the press when referring to the internet is an indication of just how deep-rooted this idea of the internet as placeless, globalized space has become.

Yet these and other terms are, as many scholars have noted, representative of the utopian discourses that have been built and peddled about the internet but that, in actuality, do not hold true. For these early conceptualizations of the internet as involving erasure of geographical place, although still weighing heavily in the popular imagination, have subsequently been nuanced by a more recent generation of scholars and practitioners who have argued instead that, whilst certain conventional understandings of

geography and place may be challenged online, this does not mean that place is erased altogether. First, many scholars have critiqued the implicitly utopianist assumption that the internet offers a placeless space. Dodge and Kitchen (2000), in their extended study on the spatialities and geometries of the internet, argue that new media technologies give rise to new spatialities, but that this does not mean the erasure of geography. Detailing a variety of features such as material concerns of access and infrastructure, government control and surveillance, and the geographies of exclusion whereby spatial inequalities are reproduced online, Dodge and Kitchen (2000: 17) caution against 'wholesale acceptance of the placelessness thesis'. Instead, they argue that, while there is little doubt that the internet does 'significantly disrupt the spatial logic of modernist societies' it does not render geography obsolete, and that 'geography continues to matter—as an organizing principle and as a constituent of social relations' (Dodge and Kitchen 2000: 14).

Others, meanwhile, have noted the prominence of place in the place-based metaphors and indeed the very protocols underpinning the internet. On a purely formal level, Kathleen K. Olson (2005: 10) has noted how the dominant metaphors used to describe the internet have tended to evoke a sense of place, such as 'visiting' a 'site' or 'entering' a chat 'room'. We thus, in other words, bring our spatial preconceptions with us when we engage with the internet. More recently, scholars such as Steinberg and McDowell (2007: 126) have detailed how the domain name structure reproduces the 'territorial divisions of the world', since it both codifies content along nation-state lines, and reproduces US hegemony. In a structural sense, then, the internet's very protocols are structured such that they replicate offline geographical boundaries and geopolitical power relations.

Moreover, beyond these features such as geographies of exclusion or the nation-state structures embedded within the protocols of the internet, recent empirical studies have demonstrated the constructive and creative uses of the internet to affirm place, frequently from a bottom-up approach. Many such studies have shown that geographical place is highly significant in online culture and in online interaction. From studies on the anti-globalization movement in Australia, to analyses of the uses of new media technologies by Salvadoran immigrants living in the US, research has shown that, rather than geographical place being erased when one is online, in fact online technologies allow for re-connections with physical place (see, for instance, Capling and Nossal 2001, and Benítez 2006). In these and in many other similar studies, place is found not to be lacking on the internet, but rather is transformed, given different meanings, or re-affirmed in a variety of contexts.

Indeed, with the advent of Web 2.0 technologies, platforms such as Twitter, Flickr and Facebook, amongst many others, allow for a variety of different forms of georeferencing that involve the overt embedding of internet content within geographical representations. With millions of users worldwide adding geo-coordinates to their photographs on Flickr, linking videos uploaded to YouTube to locations on Google maps, or using Foursquare on

their mobile phone to post their location at a venue, amongst many other examples, the internet is, arguably, providing tools that enable people to re-establish connections with their physical place. The potentials for Web 2.0 technologies to integrate cartographic geodata with geotagged hypermedia, and to represent, interlink with, and foster closer relationships to geographical place has given rise to what Gordon and de Souza e Silva (2011) have recently termed 'network locality' or 'net locality'. Defined as an 'emerging form of location awareness' (Gordon and de Souza e Silva 2011: 2), net locality refers to the various technologies by which the internet merges with physical place, and geography becomes the organizational structure of the internet. Involving different ways of knowing and experiencing place, for Gordon and de Souza e Silva (2011: 3), 'net locality renders geography more fluid, but never irrelevant'. Such a phenomenon is not, of course, inherently resistant or countercultural; many of the new ways of expressing one's net locality in Web 2.0 platforms play into the hands of large corporations and the increasingly lucrative practice of data mining.[4] Nevertheless, what the rise of geospatial web applications and net localities means is that users have an increasingly ability to engage with offline locations as they interact online.

If such, thus, is the context in which new technologies offer the potential to reaffirm connections to physical place, regarding Latin America more specifically, scholars in a variety of studies on Latin American internet use have demonstrated that notions of local, national or regional location do not disappear online but, instead, are reconfigured in new and often resistant ways. Paul Fallon (2007), for instance, has shown how border bloggers, such as those grouped together under the Tijuana Bloguita Front, are involved in the expression of new collective identities which, whilst crossing national borders, nevertheless make explicit references to location and geographical space. Many scholars researching the Zapatistas have highlighted how their use of internet technologies was both global and firmly rooted in place, leading to the 'creation of a 'network identity around issues of local and international import' (Russell 2005: 574). Lúcia Sá's (2007) work has revealed how marginalized urban youth in a poor neighbourhood of São Paulo use the internet to create their own 'cyberspace neighbourhood' (Sá 2007), whilst more recently, Tori Holmes's (2012: 268) research into online content creators in a favela in Río has shown how they employ a variety of practices create a 'territorial embeddedness of local content' through features such as 'textual and visual anchoring in place'. Similarly, my own research has indicated how notions of locality and place-based identifications adhere online in a variety of different contexts, ranging from blogging to participatory mapping (see Taylor and Pitman 2012; Taylor 2013).

This, then, is the context within which the works studied in this volume sit. In the chapters that follow, I argue that online interventions such as net art make productive use of a range of new media tools to engage in the re-signification of locality. The internet, as I argue in this volume, is at the same time territorially located, and goes beyond conventional territorial markers,

definitions and borders. New forms of negotiation between the local and the global and between the virtual and the real are constantly being elaborated in net art, which leads to new ways of forming and understanding local, regional, and transnational locatedness. As such, my study is a form of contestation to those such as Laura Baigorri (2006: 72) who have argued that '*Latin art* has no meaning in an environment conceived as the paradise of nowhere-land' (emphasis in the original). That is, I argue here and throughout the chapters in this volume that it does, indeed, make sense to talk of Latin(o) American net art. In other words, that place-based concerns, and place-based affiliations, do not disappear when cultural producers engage with online technologies. From the creative interplays between online gaming and offline citizen interaction, to the embedding of resistant montages within Google maps, the net artists studied in this volume create new ways of affirming place via online technologies.

BETWEEN ART AND (LOW) TECH: RESISTANT USES OF TECHNOLOGY AND TACTICAL MEDIA

If the issue of the locality of the internet as noted above is one of the key areas for debate in scholarly studies and cultural practice in recent years, no less important have been the debates about the very technology itself of the internet, and the control over its content, platforms and the data it holds. Indeed, these same issues of locality on the internet mentioned above often hinge on control of the internet—on whom, exactly, is attempting to 'set borders', or whether place is re-created on the internet in bottom-up practices on the one hand, or via top-down corporate practices on the other. Thus, the issue of the regimes of power underlying the phenomenon of networked localities, and more broadly, the internet and its associated technologies comes to the fore. Frequently, theoretical and empirical studies focusing on the internet and its relationship to place have linked this issue to questions of corporate control and global capitalism. Manuel Castells's hugely influential trilogy *The Information Age*, the first volume of which was published in 1996, described a new spatial logic in which what he terms the 'space of flows' is set in opposition to the 'space of places' (Castells 2010a). In Castells's formulation, the progressive waning of the importance of place as it gives way to the spaces of flows is inextricably linked to the rise of global capital. Charting the move from a liberal, statist model of capitalism, to the neoliberal, corporatist model of capitalism of our present era, Castells (2010a: 502) argues that contemporary society is structured around flows of information, capital and symbols and that networks are the 'appropriate instruments for a capitalist economy based on innovation, globalization and decentralized innovation'.

Similarly, Christian Fuchs's argument that information and communication technologies dissolve spatial and temporal distances is closely linked to

his investigations into the global interconnected flows of capital. For Fuchs (2008: 111), 'network organization is a characteristic of the post-Fordist global economy' in which 'fast global flows of increasingly "immaterial" speculative capital [. . .] are transmitted and manipulated digitally by making use of network technology'. Bringing together Castells's (2010a) formulation of the space of flows as noted earlier with Giddens's notion of 'disembedding' (Giddens 1990) and Harvey's concept of space-time compression (Harvey 1989)—all of which engage, in their different ways, with the new configurations of spatialities in the contemporary era—Fuchs (2008) argues that the emerging spatial form we live in is that of 'global network capitalism'. Global network capitalism, for Fuchs (2008: 113), consists of global technological systems and transnational institutions that enable 'global flows of capital, power and ideology that create and permanently re-create a new transnational regime of domination'.

In the works of these and other theorists, the changing role of place with the advent of digital technologies is thus closely linked to new regimes of accumulation, to rapid flows of global capital and to transnational network capitalism. It is, therefore, particularly crucial to interrogate the ways in which place and locality can be re-articulated online, and in whose interests this re-articulation is undertaken. As noted earlier, a variety of Web 2.0 technologies enable users to reconnect to their physical place, yet often this takes place within the boundaries of, and serving the interests of, the multinational corporations providing the platforms. But the articulation of networked localities can also be undertaken from alternative approaches, via attempts to create oppositional spaces in which offline locations can be rethought creatively and artistically. These are the articulations under focus in this volume, and the various net artists studied engage in the creation of alternative, temporary localities that, of necessity, not only dialogue with, but also potentially talk back to, the logic of late capitalism. They engage in a series of resistant re-territorializations, underpinned by a tactical use of (globalized, capitalist) technologies, whereby a variety of technologies or technologically enabled formats are used against the grain. Such an approach, I now argue, comes both from broader trends in resistant online culture, and from Latin(o) American specificities.

Regarding the first of these, from its outset, the internet has frequently been conceived of as a site of tensions between resistant, countercultural hacker movements, on one hand, and corporate interests, neo-imperialist impositions, state surveillance and transnational businesses practices, on the other. On one hand, as scholars have frequently reminded us, the internet has its origins in techno-military surveillance, and, even in more recent and varied non-military uses, the liberatory potentials of the internet may be swiftly recuperated by big businesses, corporate interests and state powers. First, the fact that the internet has its origins in the US defence department's ARPANET project means that the internet as medium is for many suspect, since its structures were first built to suit the needs of the military.[5] More

recently, concerns have been raised over corporate uses of the internet which fuel the profits of big business or result in increased surveillance and restrictions on civil liberties. Large media corporations nowadays own or control access to a vast amount of content online, whilst search engine giants such as Google structure the online navigation of their platforms in ways that reinforce their own dominance.[6] Even user-generated content, such as that on Facebook, in fact serves to further the profits of multibillion-dollar corporations: with the explosion of social media and Web 2.0 platforms, the data ever more frequently inserted into social media by users lends itself to data mining processes that are highly lucrative for new media giants. This process of data mining, involving the aggregation of data from user profiles which are then sold on to businesses, proves one of the most important sources of profit for many social media platforms.[7] What has been called the 'corporate colonization of the internet' (Dahlberg 2005: 95–96), thus, is a particular concern and, for many, represents the sinister take-over of the internet by large multinational corporations.

On the other hand, conceptualizations of a *resistant* online culture have been in existence from the early days of the internet, and range from the figure of the cyberpunk and its associated celebration of the hacker ethic, the potentialities offered by virtual communities, the F(L)OSS movement and notions of tactical media. Regarding the first of these, early utopian conceptualizations of the digital realm tended to borrow from the countercultural image of the cyberpunk, a figure coming from predominantly literary imaginings of a futuristic cyberspace, and coined by Bruce Bethke in his 1983 short story 'Cyberpunk', although best typified by William Gibson's fiction, particularly his 1984 novel, *Neuromancer.* As David Bell notes, many subcultural cybercommunities borrowed the aesthetic and philosophical underpinnings of cyberpunk, such as those associated with the cybermagazine *Mondo 2000* (Bell 2001: 176) and the figure of the cyberpunk—the techno-savvy 'console cowboy', who leaves behind his real body as he jacks into cyberspace—proved a particularly alluring figure in early online culture, although has subsequently come under critique, particularly regarding its implicit gender and racial encodings.[8] Virtual communities, meanwhile, have been championed by the likes of Howard Rheingold, particularly in his influential *The Virtual Community: Homesteading on the Electronic Frontier* (2000), which envisaged the potential of virtual communities to 'bring enormous leverage to ordinary citizens' and urged people to 'make sure this new sphere of vital human discourse remains open to the citizens of the planet before the political and economic big boys seize it, censor it, meter it and sell it back to us' (Rheingold 2000: xix). Scholar Fred Turner (2006: 142), commenting on the WELL (Whole Earth 'Lectronic Link) of which Rheingold was writing and which was one of the first virtual communities, notes how the WELL was inspired by 'notions of consciousness, community, and the socially transformative possibilities of technology associated with the counterculture', resulting in a 'countercultural ideal of a shared consciousness

in a new "virtual community"'. Even if virtual communities nowadays are far from countercultural—the most popular of virtual communities today, Facebook, being a multibillion-dollar business recently floated on the stock market—nevertheless, in the early years, discourses about virtual communities championed their utopian, countercultural potential.

More recently, illustrations of the resistant use of online technologies can be seen in the F(L)OSS (Free/Libre and Open-Source Software) movements, in which source codes are made freely available by download from the internet and individuals or groups can then adapt, improve and build on the code. For some, such as Kate Milberry and Steve Anderson (2009: 393, 396), F(L)OSS initiatives are a 'liberatory praxis', and should be viewed as 'both a mode of production and means for addressing and ameliorating social ills'. In addition to this, nuanced understandings of the subversive potentials of the internet can be found in the notion of tactical media, a term whose origins date back to the Next Five Minutes (N5M) groupings and conferences, of which the first was held in Amsterdam in 1993. Tactical media is characterized by, in the words of Raley (2009: 1), projects not 'oriented towards the grand sweeping revolutionary event' but instead a 'micropolitics of disruption, intervention and education'. As Geert Lovink (2002: 258), one of the forerunners in the conceptualization of tactical media, has expressed it, 'tactical media are forced to operate within the parameters of global capitalism, despite their radical agendas. Tactical media emerge out of the margins'. This umbrella term, referring to a variety of interventions which include attacks on websites, hactivism, and collaborative software, amongst many others, is one which in many ways approximates to the practice of the net artists analyzed in this volume.

It is within this heritage that the artists and their works analyzed in this volume must be located; sharing concerns with tactical media, although not exclusively defined by it, the works included in this volume carry a strong sense of the resistant potential of new media technologies, and the need for technologies to be (temporarily and tactically) used against the grain. Such conceptualizations of resistant uses of technology are clearly not exclusive to Latin America; the cyberpunk aesthetic and the *Wired* mentality are predominantly a US phenomenon; the forerunners in virtual communities were in the US, although subsequently virtual communities of different scales and focuses sprang up worldwide; developers of free- and open-source software are located predominantly in Europe, the US and Canada. Indeed, regarding net art more specifically, some of the leading examples of net art as countercultural or resistant practice can be found in US-based projects such as RTMark, EToy, the YesMen, or in the work of European artists such as 0100101110101101.ORG.[9] That said, it is worth noting that regarding the latter category of tactical media, some of the forerunners in this practice were indeed Latin(o) American artists and activists. The most high-profile were the Electronic Disturbance Theater (EDT) who, building on the Critical Art Ensemble's definitions of this practice as 'the right to protest in

cyberspace in the era of information capital' (Critical Art Ensemble, cited in Carroll 2003: 146), developed the notion of 'electronic civil disobedience' as a form of 'social embodiment that allows everyday communities online and off the possibility of creating a space for civil society that is not directly tied to the dominant digital modes available, that is "communication and documentation" or high-end code politics, as the only political options available to the non-specialist to connect with civil society in a state of contestation' (Domínguez 2008: 664). Active from the late 1990s onwards, EDT's actions included its controversial Floodnet programme, which was used in 1998 to create 'virtual sit-ins' of those deemed the oppressors of the Zapatistas, and its recent Transborder Immigrant Tool (2010), which uses GPS and geospatial information systems in a mobile phone app to aid undocumented migrants in finding sources of water when crossing the US–Mexico border.

Indeed, as I argue in this volume, a particular sense of the resistant use of technologies manifests itself Latin(o) American net art, given the rich heritage of the region in the articulation of resistant uses of metropolitan or hegemonic tools. Thus, the resistant appropriations of technology by Latin(o) American net artists not only dialogues with other movements of resistant uses of technology around the globe, but also continues the strong Latin(o) American tradition of the knowing appropriation of metropolitan tools. This sense of Latin(o) American identity as lying in the resistant re-appropriations of pre-existing discourses was of course most famously articulated by Roberto Fernández Retamar, whose 1971 essay 'Calibán: apuntes sobre la cultura de nuestra América' argued that the Latin American symbol *par excellence* should be Calibán. For, Fernández Retamar (1989: 14) argued,

> Prospero invaded the islands, killed our ancestors, enslaved Caliban, and taught him his language to make himself understood. What else could Caliban do but use that same language—today he has no other— to curse him, to wish that the 'red plague' would fall on him? I know no other metaphor more expressive of our cultural situation, our reality [. . .] What is our history, what is our culture, if not the history and culture of Caliban?

Calibán as the figure for Latin American identity located in the strategic exploitation and manipulation of the master's language is a trope which bears particular relevance to Latin(o) American net art practice.

Indeed, this notion of a tactical reuse of the master's tools is one which has frequently been re-articulated in a variety of contexts regarding Latin(o) American culture, ranging from Néstor García-Canclini's (1989) notion of hybrid cultures in which Latin American culture resides in the hybridization of existing modes and genres, to Jesús Martín-Barbero's (1989) influential notion of 'mediation' as the resistant ways in which Latin Americans appropriate media content, through to Gloria Anzaldúa's (1987) call for a 'new mestiza consciousness', to name but a few. In this sense, if Latin(o) American

culture and identity lies, according to many of its most prominent theorists, in the resistant reworking and re-articulation of existing discourses, tropes and genres, then Latin(o) American net art is a particularly privileged space for the enactment of such practices. The net artists studied in this volume re-appropriate globalizing technologies and post-digital fragments in order to question the sociopolitical effects of new media technologies, and provide space for the expression of oppositional discourses. These artists operate within and across a variety of commercial platforms and, I would argue, the avant-gardist thrust of much contemporary Latin(o) American net art lies not in its outright rejection of the system (whether the system be understood as the dominant socio-politico-economic system, or the information technology system/platform being used), but rather in its tactical reworkings of such systems.

THE COORDINATES OF LATIN(O) AMERICAN NET ART

If, thus, the issues of place, network localities and corporate control come to the fore when considering new media technologies, the vibrant and growing communities of net artists within a Latin(o) American context frequently engage with these problematics. As I argue in the following, geographical imagery, dialogues with place-based social movements and a tacking between online space and offline place are particularly prevalent in the work of Latin(o) American artists. One of the reasons for this lies in the fact that the particular locales depicted in their works are imbued with social memory and are often the site of long-running debates central to the national imaginary. Struggles over the meaning of these particular locales, such as the Plaza de Mayo in Argentina or the US–Mexico border, have been central to the recent history of each country and of the wider region as a whole. Indeed, it is precisely because these locations are so overdetermined, or their meanings are still being fought over, that they constantly resurface in a wide variety of genres. Literary, cinematic and artistic representations of each of the locales selected in this book have been constants over recent decades as each country or region attempts to make meaning from these locales or to negotiate the struggles over their meaning. It is thus no surprise that new media genres such as net art engage with these iconic locales, dialoguing as they do with other genres and movements whilst putting new media technologies to particular uses in the interrogation of these place-based concerns.

Thus, two striking features come to the fore when analyzing net art in a Latin(o) American context. First, common to many such works is the engagement with, and representation of, offline place. This is frequently accompanied by a striving to rework the conventional meanings of these places, and/or create (albeit temporarily) public spaces. Second, there is an engagement with dominant sociopolitical concerns, and an attempt to critique or offer alternatives to these. This is apparent in many net artists of the

region and is often enacted through a tactical, resistant use of (globalized) new media technologies. In particular, their works often share a concern for tracing the configurations of power under late capitalism, for the bringing to light of the structural inequalities of late capitalism and for examining the transformations of the nation state under global capital.

With these key features in mind—the potential for the reworking of place and the potential for the resistant reuse of technologies—I now plot out the specific place-based tropes of this volume. We start first with the Alameda, the central thoroughfare cutting through Santiago de Chile that houses many of the nation's prominent monuments, buildings and landmarks, and that functions as a repository for a resistant memory of the Pinochet dictatorship. We then proceed in Chapter 3 to Buenos Aires, particularly the Plaza de Mayo and the city's waterways, as emblematic of the Argentine nation in its coming to terms with the aftermath of the military dictatorship. Subsequently, we move to Montevideo, Uruguay's capital, in Chapter 4, with a particular focus on its prominent buildings and thoroughfares such as the Palacio Salvo and the Rambla, conventionally seen as defining images of the project of modernity, but which become, in the work of the artist in question, emblematic of the segmented spaces of neoliberal reforms. Chapter 5 then continues with this thread of the effects of neoliberalism, but now focuses on the particular locale of the Colombian terrain and on the vested interests stretching beyond the borders of the nation state. Chapter 6 then looks at a specific location that straddles two particular nation states: the US–Mexico border, exploring this as both physical space and conceptual space in which the politics of late capitalism are played out. Finally, Chapter 7 expands this notion of the border and links it with the streets of New York, understood both as location of a sizeable community of Mexican immigrants in the US, and as location of the Fourth World within the US.

The first work to be analyzed, in Chapter 2, is the 2005 project *Memoria histórica de la Alameda* [*Historical Memory of the Alameda*]. A collaborative project involving several of the leading new media artists in Chile, along with international participants, *Memoria histórica de la Alameda* combines the recuperation of historical memory with the creative use of online technologies and enactment in offline places. Set in the Avenida Libertador Bernardo O'Higgins—commonly known as La Alameda—this work encourages the re-encoding of the Alameda as the scene of different events of oppression and resistance. The chapter focuses in particular on the online interactive map of geo-referenced content developed by the project members, in which archival footage, interviews, still photographs and sound files are remixed and inserted into a map of the Alameda. The chapter analyzes first the visual presentation of the map, focusing on how features such as the limited palette, the use of jagged lines and the lack of peripheral cartographic features function deliberately to visualize the Alameda as a site of tension and conflict, and sets out this location as central in the Chilean national imaginary. Subsequently, the chapter focuses on the interactive features of the map,

investigating how key locations along the Alameda are selected and tagged, and how multiple levels of data are encoded within the map, linking memory directly to cartographic representations. Finally, the chapter moves onto a discussion of the collective creation of its contents, making reference to the site-specific interventions which accompanied the project and exploring how internet-based and place-based practice are brought together in the production of resistant memory.

Following on from this, Chapter 3 analyzes the works included in the *Women: Memory of Repression in Argentina* exhibition of 2003, curated by Raquel Partnoy. The exhibition brought together some of the most prominent new media artists in Argentina, including Anahí Cáceres, Irene Coremberg, Marina Zerbarini and the artistic duo Andamio Contiguo, as well as works by Partnoy herself and other members of her family. The chapter focuses both on the curatorial interface as a work of art in its own right and on the individual works within it, exploring how they engage in memory preservation and link memory to the recuperation of and re-signification of physical place. It examines first how the curatorial interface, created by the German multimedia artist Wilfried Agricola de Cologne in collaboration with Partnoy, engages in a complex interplay with computer coding, memory and physical space. Here, resistant or countercultural uses of technologies, implicit connections to the past, and a focus on physical space are brought together in a dynamic which aims to rethink the meaning of the Plaza de Mayo. Subsequently, the chapter focuses on several of the constituent works contained within the interface, analysing how the key sites of memory in Buenos Aires are reworked and exploring how the remixing and superimposition of text, images and sound attempt to re-signify physical place and give prominence to the subterranean, shadowy figures hidden under the city centre. The chapter concludes by arguing that the tactic of this interface, and that of the constituent works by Partnoy and other artists, is to imbue urban space with the memory of the *guerra sucia*, yet also dialogue, at times, with the neoliberal era of the present. In their differing ways, each piece establishes close links between personal resistance and physical place, locates the viewer in a cityscape and soundscape which resonates with the memory of the disappeared, and proposes strategies for the recovery of memory.

Chapter 4 then analyzes the work of the Uruguayan net artist Brian Mackern, who is one of the pioneering figures in net art in the region. As well as his individual works of art that explore the formal aspects of the internet and engage in new cartographic representations of his country and of the wider region of Latin America, Mackern was also instrumental in sculpting a Latin(o) American sense of net art community, particularly through his *Netart latino database* (1999–), which draws together the work of leading net artists in the region.[10] Concentrating in particular on Mackern's *34s56w.org*, the chapter explores his representation of Montevideo and its iconic monuments, buildings and thoroughfares. Reading through the Situationists' theories of psychogeography and the spectacle,

the chapter argues that *34s56w.org* engages in the production of emotional maps and a re-signification of the cityscape, in which features such as the insertion of links, the flows of symbols across the map and the inversion of the North–South axis all function to disrupt the norms of cartographical representation. The chapter analyzes how the deliberately difficult aesthetics in Mackern's work—combining jump cutting, speeded-up footage, grainy or low-lit images, dissonant sounds, and lack of dialogue or voiceover—create for a viewer/user a panorama in which he or she has to participate actively in order to create meaning. Here, the chapter argues, the non-linear, multi-sequential access to the constituent sound and image files of the works constitutes a digital *dérive*, enabling the user via digital technologies to enter and exit different points of the cityscape at will and encourages the viewer to look (temporarily) beyond the spectacle of the cityscape. The chapter ends by arguing that Mackern's works in *34s56w.org* challenge us to negotiate new soundscapes and landscapes in our revisiting of iconic sites in Montevideo, and permit us brief glimpses beneath the spectacle.

Following on from this, Chapter 5 focuses on the work of Colombian multimedia artist Martha Patricia Niño, in particular her *Demo Scape V 0.5* (2005), a web-based work combining a variety of interactive features including clickable maps, feeds from Google, forms, questionnaires, images and static text. The chapter analyzes how Niño's work represents the Colombian terrain as a contested space between conflicting forces, at the same time as overtly questioning new media technologies and their role both in policing the nation, and in facilitating conflicts spreading beyond the borders of the nation. The chapter explores how *Demo Scape V 0.5* functions as a critique of contemporary geopolitics in which, by the creative insertion of external links, Niño draws our attention to the control over new media technologies and to human rights issues in Colombia's contemporary socio-political conflicts. The chapter then analyzes Niño's visualization of data through maps, investigating how tactics such as the rotation of maps along different axes, the insertion of links traversing boundaries of the map, and the re-semanticization of conventional terms of cartography disrupt the north–south axis along which cartographical relations are normally drawn, and have political implications. The chapter concludes by highlighting how *Demo Scape v 0.5* offers a sustained critical approach to existing representations of the Colombian terrain, and attempts to make visible the complexities of the contemporary socio-political landscape of that country, as well as point towards the international dimensions of the conflict and, in particular, the vested interests of multinational corporations in the Colombian terrain.

Chapter 6 focuses on the collaborative work, *Turista Fronterizo* [*Border Tourist*] of 2005, by Cuban-American performance and multimedia artist Coco Fusco and media hactivist Ricardo Domínguez. One of the most vibrant of the net art communities with a rich heritage of tactical media interventions and high-profile festivals, net artists of the border region have frequently made use of new media technologies to explore the concerns of the

border and to investigate the ways in which new media technologies—often put to use to police these very borders—may be re-encoded in a resistant fashion. Drawing on this rich heritage, *Turista Fronterizo* brings together the concerns of the two artists: exploring border crossings as a daily reality and the resistant use of digital technologies to counteract dominant ideologies. The chapter starts by analysing how this work closely engages with the border as both material locality and as representative of particular (corporate) practices. Here, the chapter focuses in particular on the maquiladora, and argues that it functions as the central trope encoding the work, standing as a synecdoche for post-Fordist late capitalism. The chapter subsequently examines how *Turista Fronterizo*'s playing with both digital and pre-digital conceptualizations of recombinatory praxis is undertaken as a form of questioning of the status quo, encouraging the user to establish and critique the interconnections revealed between the various locations visited. At the same time, the chapter also analyzes how the socio-economic inequalities of the border are encoded into the structural inequalities of the ludology of this work, whereby the differing life opportunities experienced in real life by inhabitants of the border region are reproduced in the differing game outcomes available to each avatar. The chapter concludes by arguing that *Turista Fronterizo*'s engagement with both pre-digital gaming formats, such as Monopoly, *Turista Nacional,* and the broader tradition of resistant gaming as propounded by the surrealists, along with the recombinant possibilities offered by digital technologies, provides for an oppositional work of art. As ludic possibilities are re-encoded with sociopolitical commentary, and game-board locations are re-encoded with the corporate practices of late capitalism, *Turista Fronterizo* aims to critique the structural inequalities of the border economy, and force the user into an active, critical position.

Chapter 7 then moves on to an analysis of the work of the US-Nicaraguan multimedia artist Ricardo Miranda Zúñiga, who again has also been involved in some of the vibrant border festivals. The chapter focuses particularly on his *Vagamundo* (2002), a multimedia work including a computer game with associated web links, an introductory video montage, a physical installation and public participation in the streets of New York. Paying particular attention to the way in which this work engages with the trope of the border and the streets, and with the representation of Mexican immigrants in the US imaginary, the chapter traces how the mobilizations of place-based tropes online and the acting out of such tropes in real offline place, function to encourage the viewer-player to re-evaluate some of the established representations of Mexican immigrants in the US. The chapter focuses on the aesthetic production of space in the work, illustrating how the different levels of the game locate the avatar in the stratified socio-economic spaces of the streets of New York. At the same time, the chapter also explores how the paratextual information framing the game, the periodic insertion of statistics, the use of a real-life photographic avatar in the bonus level, and the insertion of links to non-governmental organizations (NGOs) external

to the game all function together to encourage the player/viewer to step back from the gameworld and grasp the complex socio-political reality behind it. The chapter subsequently traces the complex and constant negotiations between digital media and street performance that are enacted in *Vagamundo*. Drawing on Miranda Zúñiga's references to 'temporary public commons'—themselves reminiscent of current debates on the electronic commons—the chapter argues that the bringing together of on- and offline place is central to the very working of *Vagamundo*. The chapter concludes by arguing that *Vagamundo*'s mobilizations of place-based tropes online, and enactment of such tropes in offline place, function to critique border relations and programmes such as Operation Gatekeeper and to reveal the conditions of late capitalism under which the undocumented migrants live.

The chapters that follow this Introduction thus aim to provide a sustained analysis of these six particular case studies, and their creation of resistant re-territorializations online. As has been argued in this Introduction, the issues of place, new spatialities and networked localities are some of the central questions regarding the internet today. These issues are contested, particularly as regards ownership of or control over the creation of localities and the generation of location-based data on the internet. In light of the heated discussions regarding network capitalism as noted earlier, and in the context of the increasing employment of location-based technologies in social media, the issues of in whose interests, and according to whose terms, the new spatialities online are created is a moot one.

Latin American net art, I argue in this volume, is involved intimately in these discussions and struggles over place, in a two-fold fashion. First, Latin American net artists are attempting to wrest control over georeferencing, location-based data, and the creation of net localities from the hands of multinational corporations. Each of the examples studied in this volume attempts to create place not within the logic of corporate capitalism but as a form of resistant re-territorialization online, and many of them explicitly formulate their approach as countercultural or as informed by the practices of tactical media. Here, for instance, Mackern's expressed dialogue with the theories of Debord in the cartographies of his *34s56w.org* reveals how Mackern's work is conceived of as an attempt to unmask the spectacle of the city of late neoliberal capitalism. Similarly, Fusco and Domínguez's re-creation of the border zone as locality in their *Turista fronterizo* in a way that critiques the *maquiladora* economy forms an attempt to create a network locality in opposition to the logic of corporate capitalism.

Second, at the same time, Latin American net artists are attempting to wrest control of the meaning of the particular offline place itself from governments or officially sanctioned histories. So, for example, the streets of the US are re-signified in Miranda Zúñiga's *Vagamundo* to give meaning to this place within the experiences of Mexican immigrants and to plot out a non-nation-state identity. Or, in a Chilean context, the Alameda is re-signified in the collaborative work *Memoria histórica de la Alameda* where monuments

such as that to Jaime Guzmán are re-semanticized, as creative montages short-circuit the official meanings of monuments and monumentalization. It is thus the struggle over place—both online and offline—that characterizes the works studied in this volume. The control of net localities and the control of offline place come together in the practice of Latin(o) American net artists, as they engage with particular place-based concerns and attempt to create temporary, tactically resistant re-territorializations online.

NOTES

1. For a detailed analysis of the net.art movement and its historicity, see Gere (2006) and Bosma (2011).
2. For critiques of Barlow, see Brian Loader (1997: 3–6), who points out some of the blind spots of Barlow's proclamations regarding politics and language use, and Aimée Hope Morrison (2009), who critiques the depoliticization and self-congratulatory tone of Barlow's declaration.
3. Again, it is worth noting the critiques that have been made of this particular formulation; Dodge and Kitchen (2001: 33), for instance, note how the 'global village' envisioned is one of 'largely homogenized Western values and cultures of consumption', whilst Zembylas and Vrasidas (2005: 66) have argued that the 'global-village narrative is a modernist myth' and that 'by erasing cultural differences and national boundaries, [it] can be seen as a form of colonialism'.
4. Gordon and de Souza e Silva (2011: 137) have analyzed how private companies and government agencies collect location data to track major trends, and provide a detailed analysis of the ways in which Google, Loopt, Foursquare and other similar location-based services 'monetize' their services through location-based advertising.
5. For more on the military origins of the internet, see Tuomi (2002).
6. See, for instance, Dahlberg (2005) on the ways in which large media corporations manipulate access to content through online advertising, and control and ownership of search engines, online spaces, web content, and applications software.
7. See, for instance, Christian Fuchs's (2012) critique of the political economy of privacy on Facebook, in which capital accumulation is based on the commodification of users and the mining of their data.
8. Many scholars have criticized the implicit gender and racial politics of cyberpunk, which assumes the white male as the norm; see, for instance, Anne Balsamo (1996: 130–131), who denounces the 'gender conservatism' of cyberpunk writers, noting the 'sexualization of the female body' within the genre, and the fact that its 'cyberspace heroes are usually men, whose racial identity, although rarely described explicitly, is contextually white'. Balsamo then concludes that the cyberspace as envisaged in cyberpunk is 'another site for the technological and no less conventional inscription of the gendered, race-marked body'.
9. For more on RTMark and EToy, see Stallabrass (2003); for more on the Yes-Men and 0100101110101101.ORG, see Corby (2006).
10. For a detailed analysis of Mackern's *Netart latino database*, see chapter 1 of Taylor and Pitman (2012).

2 *Memoria Histórica de la Alameda*
The Mapping Out of Memory Battles in Chile

The first of the works to be analyzed in this book is *Memoria Histórica de la Alameda* [*Historical Memory of the Alameda*] (2005), a site-specific and participatory project dealing with Chilean memory centred on the Avenida Libertador Bernardo O'Higgins in Santiago de Chile. As analyzed in what follows, this work imbues this location with the memory struggles of post-dictatorship Chile, remixing archival footage, interviews, still photographs, moving images and sound files. By integrating multiple strategies—the reworking of pre-digital footage into Flash animations; the linking of high-tech georeferencing with low-tech, handwritten memories on the street—*Memoria histórica de la Alameda* brings together internet-based and place-based practice in the production of resistant memory, engaging with the ongoing memory struggles in Chile's recent history.

The locality on which this chapter focuses, the Avenida Libertador Bernardo O'Higgins, is a busy thoroughfare cutting across from West to East through the centre of Santiago de Chile. Commonly known as the Alameda, the street is more than seven kilometres long and is home to many of the city's prominent monuments and iconic buildings. These monuments, plazas and buildings, and those of the streets running perpendicular to the Alameda, commemorate major moments in the nation's history, particularly its military history, with statues in honour of military and political leaders such as José de San Martín, Manuel Bulnes Prieto and Bernardo O'Higgins, from whom the street draws its name. Thus, as with the central streets of many a capital city, it is a thoroughfare whose monuments narrate the history of the nation, in particular celebrating its military victories and the achievements of its founding fathers. The work in question in this chapter, *Memoria histórica de la Alameda*, focuses on this street but draws out one particular period in national history, and attempts to generate from the iconic locations along the Alameda the hidden memory of this period. The period in question is that of the 1973–90 military regime in Chile. Following a coup on 11 September 1973, in which Augusto Pinochet, along with three other generals, overthrew the elected government of Salvador Allende (1970–1973), Chile lived under a military dictatorship until the return to democracy in 1990. Repression under the dictatorship

was widespread, with illegal kidnappings, torture and murder being under-taken by the security forces, and with significant numbers of Chileans being forced into exile. Not only is the main focus of the work, the memory of the years of state terror under the military regime that ousted Allende's govern-ment, but also, crucially, this work engages with the immediate present time of its making, since through its style, content, and enactment in physical place, it engages the viewer with the politics of the present day. It is, thus, a work that situates itself firmly in the past *and* in the present of the early to mid-2000s in Chile, the latter a period that has been characterized by scholars as one of 'memory reckonings' in which the memory of the earlier dictatorship becomes central to national debates. As I argue, the power-ful force of *Memoria histórica de la Alameda* lies in its ability to juggle these two timeframes—that of the military dictatorship and of the period of memory reckonings of the early to mid-2000s—and to demonstrate how these memory reckonings are inextricably linked to representations and understandings of place.

Memoria histórica de la Alameda is a collaborative project designed by participants in the Taller de Estética para una Tecnología Suave [Workshop in Aesthetics for Soft Technology] in Chile in conjunction with the media arts collective, Netzfunk,[1] with the main authors credited as Iván Atencio Abarca, David Boardman, Pablo Cottet, Diego Mometti, Enrique Morales, Bárbara Palomino and Melissa Trojani. The project was first launched in 2005, with updates made to the ways users could access the site in 2010, although the content of the site remained the same.[2] It was first exhibited in conjunction with the Museo de Arte Contemporánea in Santiago de Chile in 2005, and has since been exhibited at the *Bienal de Video y Artes Mediales* in Santiago in November 2005; the *d/Art/2006 Festival* in Sydney, Austra-lia, in May 2006; the eighth *Salón de Arte Digital* in Havana, Cuba in June 2006; the *Homemade: Festival dell'Autoproduzione Multimediale Artistica* in Carrara, Italy in October 2006; and the *Centrale dell'Arte: Selfmade* in Cosenza, Italy in December 2006. *Memoria histórica de la Alameda* is at once internet based and site specific: the project displays multimedia content on an online map at the same time as allowing the map to be navigated in the physical locations themselves, based on a platform for georeferential localization named 'Cultural Luggage'.

Before users enter the work itself, a section of the website providing information about the project includes two short epigraphs that frame the project. Under the heading 'Alameda and the history', the two epigraphs represent opposing poles of Chile's political spectrum and provide the his-torical grounding for the project.[3] The first of these, an extract from former president Salvador Allende's last public address to the nation, reads

> *Go forward knowing that, sooner rather than later, the great avenues will open again and free men will walk through them to construct a better society.*

Taken from Allende's last recorded address to the nation at 9:10 a.m. on 11 September 1973 and transmitted via the pro–Unidad Popular station, Radio Magallanes, the extract selected is significant both for its political import and for its focus on civic spaces.[4] There is, in this extract, a close connection established between place and politics in Allende's metaphor of the great avenues where socio-political freedom is figured as spatial freedom. Thus, this extract sets the scene for an exploration of physical places as closely linked to socio-political issues, as well as establishing a metonymical link to the wider project itself via the term *avenues*; whilst in the plural and not identified in Allende's speech here, the extract nevertheless places the 'Alameda' of the title of this work in a specifically politicized context.

The second epigraph, by contrast, following directly after that taken from Allende's speech, comes from General Augusto Pinochet and is extracted from a speech given by the former dictator in 1995, some five years after the return to democracy. The extract reads

> *It is better to be silent and forget. This is what we should do. We have to forget. And this is not going to happen opening cases, sending people to jail. FOR-GET: this is the word, and in order to happen, both sides have to forget and keep working.*

Given by Pinochet two days after the 22nd anniversary of the coup, the speech from which this extract is taken came during a period of intensive debate within Chile about the investigation into human rights abuses by the military. In May 1995 the Supreme Court upheld prison sentences for General Manuel Contreras and Brigadier Pedro Espinoza, the former head of the DINA and the chief of operations of the DINA, respectively.[5] Contreras and Espinoza had been convicted in 1993 of the double murder of Orlando Letelier and Ronni Moffitt during the dictatorship. Their appeal in 1995 gave rise to mounting tension and protests, in what Stern has called a 'showdown' between the media, political elites, military leaders, and human rights organizations (Stern 2010: 150), with Pinochet's speech of September 1995 forming part of the ongoing response from leading military figures. This particular extract is significant, thus, in that it highlights a key moment in the memory battles of post-dictatorship Chile. Moreover, the key term evoked by Pinochet here—*forget*—marks out one side of the ongoing disputes in democratic Chile. Pinochet's exhortation to forget is an overt stance against the prosecution of military personnel for their roles in human rights abuses and, more than simply a comment on the individual case of these two figures, represents one of the sides in Chile's memory struggles. As Stern, in his in-depth studies on memory in post-Pinochet Chile has argued, amongst the various stances in the growing struggles over memory, those who supported the regime developed, even as early as the 1970s, a framework of 'memory as mindful forgetting', involving 'closing [. . .] the box on the times of "dirty" war and excess' (Stern 2010: 5), a framework which was then to continue into the democratic

era. Pinochet's words, then, represent this framework, and the broader issue of Chile's memory battles, beyond the specific case of these two individuals.

These two epigraphs, then, both provide a timeframe for *Memoria histórica*, setting it within the sociopolitical debates starting with Allende's Unidad Popular government and ending with present-day Chile, and raise, in particular, the thorny issue of memory struggles in Chile. As scholars have demonstrated, the transition to democracy at the end of the Pinochet regime was not a smooth one, with issues such as the ongoing relevance of the 1980 constitution, the impunity of the military, and the remit of the Comisión Nacional de Verdad y Reconciliación [National Truth and Reconciliation Commission], amongst many others, being issues of contention amongst the various facets of Chilean society. Ongoing memory struggles formed one of the principal areas of tension in the transition and beyond and, as Stern (2010: xxiii) has argued, memory projects became 'central to the logic by which people sought and won legitimacy' in the post-dictatorship era.

In this broader context of memory battles, the specific date of the making of *Memoria histórica de la Alameda* is a particularly crucial juncture in Chile's post-dictatorship era. The mid-2000s in Chile were a particularly potent time in the exploration of national memory, with the election of Ricardo Lagos to the presidency in 2000, and the 30th anniversary of the coup in 2003. In September 2003 the Lagos administration created a presidential commission to document a list of persons subjected to detainment and torture under the Pinochet regime, and to continue the work of the earlier commission set up under the Aylwin government.[6] This new commission, titled the Comisión Nacional sobre Prisión Política y Tortura [National Commission on Political Imprisonment and Torture], but commonly known as the Comisión Valech after the Chair of the Commission, Sergio Valech, concluded its work in late 2004, and Lagos presented the findings in a televised speech to the nation on 28 November 2004. The Commission found that, rather than an isolated practice, political imprisonment and torture constituted 'una política de Estado del régimen militar, definida e impulsada por las autoridades políticas de la época' ['a state policy of the military regime, defended and encouraged by the political authorities of the time'], that 94 per cent of the former political prisoners had reported being tortured, and documented more than 27,000 victims, a figure significantly higher than those documented by the earlier Rettig Commission (Comisión Nacional sobre Prisión Política y Tortura 2005: 335, 334, 306).[7] Commentators concur in the fact that the Valech Report was a turning point in Chile's memory struggles: for Jorge Larrain (2006: 330), writing on Chilean national identity, the Valech report represented a decisive moment in which the 'discursive silencing' of the experiences of mass torture, arbitrary detentions, rapes and other illegal practices was broken, and memory could be reconstructed. For Stern, the Valech report was one of the two developments in the mid-2000s which proved decisive in the final crumbling of the heroic memory of the Pinochet years.[8]

Memoria histórica de la Alameda thus focuses on historical memory and frames itself within the ongoing memory battles in democratic Chile. That said, as the citation of Allende's 'alamedas' makes clear, historical memory is as much about specific *places* as specific *dates*, and this notion of place as central to the recuperation of historical memory is key to this work. For *Memoria histórica* focuses on the politics of memorials and monuments, questioning the meaning of many of Santiago's central reference points. The focus in this work, thus, is on the value and the meaning of particular sites within the city, and once we enter the work, we (re-)encounter iconic sites in the city centre. *Memoria Histórica* works by questioning the established monumental value of particular iconic sites, as well as engaging in current debates about monumentalization of new and proposed monuments.

In this regard, *Memoria histórica* speaks to the politics of place, and engages with recent debates regarding Chile's memorialization. Looking specifically at the *sitios de memoria* established by the democratic government from the early 1990s, Meade (2001: 125) has argued that, since Chilean society at that time had not held those responsible accountable, the memory sites existed as 'monuments to the contradictions of Chilean society and to the fragility of its democracy'. More recently, Hite and Collins's (2009: 381, 383) research into memorialization and commemoration in democratic Chile has demonstrated that a 'vast and often conflicting array of civil society groups' are involved in demanding and negotiating memorialization, in which conflicts over memorialization projects arise and the 'tension between public and private is particularly strong'. Struggles over memorials and monuments—over historical memory as represented by place—are thus central to the memory struggles of democratic Chile, and the politics of memorials and memorialization are brought under scrutiny in *Memoria histórica*.

Indeed, this emphasis on memory as linked to place is, I argue, brought to the fore in the title, which brings together two key terms conventionally seen as antonymic: memory and history. Here, the title, advocating the creation of a 'memoria histórica' plays on the distinction famously summed up by Pierre Nora (1989: 8), in which history is the academic discipline, a 'representation of the past', whereas memory is in 'permanent evolution, open to the dialectic of remembering and forgetting'. 'Historical memory', bringing together these two terms, is an attempt to narrate an alternative history that brings to the fore hidden memories that are often disavowed by official versions of history, frequently with a socio-political aim, and has been summarized by Boyd (2008: 135) as 'a form of social memory in which a group constructs a selective representation of its own imagined past'. Indeed, the term *memoria histórica* has particular potency in Spanish, as the late 1990s and mid 2000s saw what we might term a 'historical-memory turn' in various countries of the Hispanic world. A particular case in point was Spain, whose 'history wars' in the 1990s were followed by intense struggles over memory in the 2000s that addressed how, as a democratic society, Spain should confront its history of repression under Franco and break the de

facto 'pact of silence' that had characterized the earlier transition to democracy. The term *memoria histórica* came to be widely used in Spain to refer to attempts to revise Spain's past and publically come to terms with Franco's legacy, and has become enshrined in official discourse, with the Spanish Congress declaring 2006 the 'Año de Memoria Histórica' ['Year of Historical Memory'] and the subsequent creation of the Centro Documental de la Memoria Histórica [Document Centre for Historical Memory] in 2007. The title of this work, then, sits within a broader trajectory of memory struggles and national soul-searching that were taking place within and beyond Chile in the early 2000s, and situates the work within a tradition of resistant retellings of national history. The proposal to construct a 'memoria histórica de la Alameda', then, would be an attempt to re-insert memory—subjective, personal and affective—into the official history of Chile as envisioned by its key monuments and locations along the Alameda. As we shall see, this subjective, collective memory is evoked in *Memoria histórica de la Alameda* by way of innovate aesthetic techniques, in which fragments, sound files and images are brought together in creative and evocative ways.

In this way, as can be discerned in the title of the work and the two epigraphs that frame it, *Memoria histórica de la Alameda* engages with the dialectic of remembering/forgetting, so frequently evoked in Chile's memory battles, and ties this dialectic closely to the politics of memorialisation. It questions established monumental values, at the same time as actively creating memory sites itself through its site-specific performance, as will be discussed. Its questioning of the established value of monumental or iconic sites is enacted through the re-valuing of memory, by inserting personal and collective memory into the history of the city via non-linear, fragmentary narratives. In this way, intimating that a *memoria histórica* cannot be succinctly captured by the strict linear rules governing official historical discourse, this work aims to function, in the words of one of its participants, via the 'dispersion of story-tellings' in which diverse elements provoke a 'rupture in our perception and revealed the intimate folds of things, a certain secret nexus between them, hidden behind our daily reality' (Palomino 2007: 168).

This creation of a non-linear, resistant, historical memory is evident from the outset as we access the work. The opening screen of the *Memoria Histórica de la Alameda* is notable in its sparse use of graphics and limited palette: the screen has a white background, with black font used for text, blue for hyperlinks, and with only one image in black (see Figure 2.1). The title of the work appears across the top in black font, and directly below this lies the sole image on this page: a thick black line running from left to right, with several other lines, of varying thicknesses, intersecting it at intervals. These thick, jagged black lines create the effect of barbed wire or a scar cutting across the screen; as we later find out, these jagged, intersecting lines in fact have a particular meaning related to the project, although at this initial stage of viewing, their immediate relevance is unclear. The image is

constantly reproduced over the various pages of the project and so takes on the role of the emblem of the project.

Below this, a short text provides a description of the project, highlighting its site-specific and participatory nature. Particular mention is made of the iconic value and social and political implications of the Alameda, and the description goes on to give details of the role of the Alameda in the Chilean national imaginary:

> Since its foundation, in the beginning of the nineteenth century, La Alameda has represented the quintessential public space, being from time to time a place for strolling, a scenario of urban riots and guerrilla, mass political manifestations, religious processions and sport parades until its current function as urban backbone for public transportation and trades. Accordingly, this boulevard is a source of a virtually infinite collection of personal and institutional memories. *Memoria histórica de la Alameda* aims at putting in short-circuit the Avenue's landscape with the events marking its history and at bringing to consciousness a remarkable memory in a nation where the scars of the history are still tangible.

Here, the focus on the Alameda as not only the central thoroughfare of the city but also, more importantly, as the space along which many of the defining events of the country's history have been played out sets out its value as a repository of memory. The emphasis, therefore, is on urban space not simply as a static exteriority, but as part of the historical memory of Chile as well. Here, the reference to 'personal and institutional memories' indicates the tensions between personal memory and official or institutional history and raises issues of memorialization. This tension is where *Memoria histórica* inserts itself, with the notion of 'short-circuit[ing]' indicating how the project aims to challenge or rethink certain conventional historical meanings as conveyed by the cityscape. In particular, *Memoria histórica*'s focus on monuments and iconic buildings attempts to disrupt some of the conventional meanings of memorialization. Cultural geographers have frequently argued that monuments stand as emblems of the power relations governing the city: in the words of Pile (1996: 213), reading through Lefebvre, 'monuments may embody and make visible power relations, but they do so in ways which also tend to mask and/or legitimate and/or naturalise those relationships'.[9] If monuments, thus, are the embodiment of these power relations, but at the same time attempt to naturalize them, then *Memoria histórica*'s aim of 'short-circuiting' attempts to unmask and resist some of the meanings of these monuments, encouraging us to 'short-circuit' their official meanings and de-naturalize them. Ending on the aim of bringing to consciousness the 'memory in a nation where the scars of the history are still tangible', the description brings together the key terms of memory, visibility and cityscape whilst also recalling the scar cutting across the screen conveyed by the image, pointing forward to how this work aims to give greater visibility to historical memory, both within the cityscape itself and in online space.

Clicking on the link 'Memories Map' then takes us to the main content of the work itself. The page which is loaded is the first time we get any contextualization of the opening image, as it reappears here, in the top left-hand corner of the screen, but this time over a background which makes its meaning clear (see Figure 2.2). The upper two-thirds of the screen are filled with a map in colour, taken from the Google Maps web-mapping application and following the standard Google Map format, with the main thoroughfares marked out in yellow and green, smaller streets in grey, street names and main points of interest indicated in white, and Metro stations in blue. The specific location of the map selected remains the same, however many times we access the site—the city centre area of Santiago—and the orientation of the Google map is according to the conventional North-South axis, with the Alameda cutting across from right to left. In sum, the Google map looks to follow a standard cartographic representation of the cityscape of Santiago.

However, on closer inspection, several elements of this page disrupt this standard cartographic representation and indicate that the mapping will be a resistant one, even before we access the embedded content itself. Firstly, as noted earlier, superimposed on top of Google map, in the upper left-hand portion of the map, is the same line drawing map we saw on the opening page. It is located within a light grey rectangle, with the map itself and the title ('Memoria histórica de la Alameda') rendered in black. The rectangle is superimposed such that the Google map beneath is still visible but is less clear, because it partially shades the Google content below. This superimposition immediately encourages us to establish connections between this image and the map below it, and the contours of the image take on meaning when we see it in this context. Viewing the image superimposed above the Google map, we understand that this jagged shape is in fact also a map, but unlike standard cartographical representation, it displays only the routes the project, and the participants in it have taken: there is no contextualization, no indication of other streets, no indication of where these lines are located spatially in reference to other landmarks. The image, thus, captures the urban performance map (more about this follows) but is deliberately disorientating due to its decontextualization, and to the fact that it is not to the same scale as the Google map and, hence, does not fit neatly onto the Google one. There is, thus, a sense of resistant mapping from start: resistant to official memory but also, implicitly, resistant to corporate control of mapping content, through the construction of a map which cannot be easily or wholly subsumed into Google's one-size-fits-all model.

This resistant mapping is then actualized in the interventions into the map which, in conjunction with the other features, indicate how the map has had alternative content embedded into it. These interventions take the form of 44 tags which are inserted into the map; the title of each tag appears when we move the mouse over it on the bottom right-hand edge of the map, covering the map, in black font within a white rectangle. All the tags are located on and around the Alameda—the rest of the Google map has no tagging—and

clusters form where several tags are close to each other, such as, for instance, leading north along Morandé Street from the Alemeda, where several tags are around the presidential palace, the Palacio de la Moneda and nearby monuments leading up to it, such as the Monument to Bulnes.

Clicking on each tab or button activates a pop-up window which opens over the map, in a small white screen, linked to the relevant location icon on the specific site on the map. Whilst the content is loading, the same screen appears within each window: an image of a head and shoulders outline of a person rendered in black, with the map image superimposed across the head in white. This time, the map image cuts across the head, from top to bottom, such that the image has been rotated 90 degrees to the right, with the main confluence of roads now at the top of the image. This image, appearing as it does every time we access any of the 44 tagged content files, constantly prefaces our access to the constituent files and provides a violent image of personhood being cut across by, or bound by, a jagged shape. Also, knowing as we do at this stage that the jagged shape represents the Alameda, this recurring image indicates how the Alameda, and the historical events associated with it, are imprinted across the memory and personhood of all Chileans.

At the same time as this image, on opening each tag, there is also a short, harsh sound—like an alarm sounding—when each video is opened, again creating the effect of unease and implying warning. Subsequently, whilst the file is playing, the tag casts a shadow over the cityscape that lies below it, creating a darker zone spreading out from the tag; again, this contributes to the sense of unease because it creates visually the effect of the shadowy memories contained within the tag lying over the cityscape.

The files that are contained within these tags are a mixture of different forms of content, including video files, sound files, still images in photomontages, and text, and draw on a combination of sources, both historical and contemporary, although each refers to a specific site—a particular location on or near the Alameda. Although some of the files relate to exclusively contemporary experiences in urban Santiago, the majority involve historical content in one form or another, with several invoking specific historical events, and making extensive use of existing archival materials. Some involve a relatively straightforward use of historical files, with little remixing, whilst others, however, are more creative and engage in much more experimental presentation, making extensive use of a variety of archival sources, remixings and montages to create innovative forms of narration. An example of this can be seen in Tag 10 on the map, titled 'Bombardeo de la Moneda' [Bombardment of the Moneda Palace] which opens a montage comprising still and moving images as well as sound. Here, the content starts with a still black-and-white photograph of Salvador Allende and his wife, Hortensia Bussi, on the balcony of the Palacio de la Moneda, waving. Although the photograph itself is still, the image contained within the video zooms in, ever closer, towards Allende's face and raised hand, in a slow zoom lasting

six seconds. This initial sequence has no sound, and the slow zoom inwards encourages a moment of reflection and a focus on Allende. Abruptly, the sequence then cuts to moving images, composed of archival footage that cross-cuts from images of the Hawker Hunter fighter jets of the Chilean Air Force flying through the air to images of the Moneda being bombarded, with smoke billowing from the windows and roof. Here, diegetic sound runs throughout the whole sequence and starts abruptly; the loud harsh sounds of fighter jet engines and explosions run as a sound bridge across the whole sequence, all the more startling after the contemplative silence of the opening images.

After 54 seconds, the moving footage ends, and the sequence cuts to still image, as, at the same time, the sound ends abruptly. The still image is a black-and-white photograph which initially is very unclear and indistinct, looking no more than a collection of pixels. As with the opening still image, a zoom is effected on this image, but this time progressively outwards rather than inwards. As the zoom progresses, the pixels start to coalesce and produce a recognizable image: at the end of the zoom, the image shows the exterior wall of the same part of the Moneda, but now with rubble in place of the balcony and the walls crumbling.

As a whole, this content file, lasting only slightly more than a minute and with no voice-over or dialogue, has told us a short narrative. The event referred to is, of course, the bombing of the presidential palace by the Chilean Air Force which started shortly after 11:55 on the morning of 11 September 1973. One of the decisive events of the coup d'état masterminded by the military junta, and following attacks on the Moneda by troops and tanks of the Army earlier that morning, the bombing of the Moneda was instrumental in bringing the coup to its completion and ended with the death of Allende and the downfall of his government. The moving images in the middle section of this montage, grainy and of poor quality, are thus iconic images of a defining moment in Chilean history. Famously used by Patricio Guzmán in the opening sequence to his documentary film trilogy, *La batalla de Chile* [*The Battle of Chile*] (1975–79), for which Guzmán and his film crew had reportedly captured live images from their television set, the images have subsequently become some of the most defining of Chile's twentieth-century history.[10]

This footage, thus, is particularly resonant in the Chilean national imaginary, and its creative insertion into the montage generates greater poignancy. The mirroring in the opening and closing still images, with the return to the same geographical location of the opening—the exterior facade of the Moneda—conveys the narrative trajectory, as we have progressed in time, although not in space. Here, the fact that the closing image now no longer contains human figures provides a visual metaphor for Allende's death, all the more powerful for the lack of sound in these opening and closing framing images. Similarly, the mirroring in terms of technique, in which the framing images are subject to a zoom—with the zooming in of the opening

shot being effected in reverse as we zoom out of the closing shot—again conveys narrative closure and finality. This creative montage, then, communicates its message through a close focus on physical place, using the facade of the Moneda to tell its story, whilst also bringing the human figure (and its absence) to the fore. The absence of Allende and Bussi's body in the closing frame stands for the individual story of the ousted president and his death, but also, resonating beyond this, stands for the disappeared: the victims of the dictatorship whose bodies, like those of Allende and Bussi here, were erased from view. This montage, thus, narrates a story which brings the work of historical memory to bear on this particular location whilst also provides a haunting metaphor for the fate of the disappeared across the nation.

A further example of a highly creative montage which again engages with an iconic location in Santiago and attempts to draw out the historical memory imbued in the site is that on tag 27 of the map, titled 'Estadio Nacional' ['National Stadium'], comprising a photomontage of nine still black-and-white photographs. The first photograph shows men in a crowd and zooms progressively inwards to focus on one man; although the image is too grainy to be distinguished clearly, the man is standing and has a large swathe of material wrapped around him, most probably the national flag. We then cut to a second still photograph, this time of another man who stands with arms outstretched; again, as with the first image, the image is grainy, and it is difficult to discern if his raised arms, in an awkward position, are the result of celebrating or suffering. The next image depicts the stadium, blurred and out of focus, with the profile of a riot helmet, most probably worn by a *carabinero* or member of the armed forces, to the right of the shot. Then we cut to a photograph of a footballer scoring a goal, unopposed; this is the now infamous image of Francisco Valdés, player for the Chilean national team, scoring the controversial winning goal in the 1973 match against the Soviet Union (more on this later). Subsequently, we cut to a colour photograph of the scoreboard showing the result of the match (Chile 1, Soviet Union 0), as a zoom is effected on the image, to focus on the words 'La juventud y el deporte unen hoy a Chile. Copa del Mundo FIFA 1974' ['Youth and sport unite Chile today. FIFA World Cup 1974'] running across the top of the scoreboard. Running across all of these photographs is an extended sound bridge, comprising shouts and chants which appear to be recorded at a football match.

Subsequently, the sound fades and we cut to a photograph of a group of men sitting in the stands, with several rows of empty seats behind them, as the image zooms in. The image that follows is almost a mirror image of this one; starting with a close-up and then zooming out, it depicts armed troops on the pitch in the foreground with men in the stands in the background, revealing many empty seats behind them as the image zooms out. We then cut to an image of men sitting in the stands, some of them raising their hands; here it is unclear if they are raising their hands to gesture in response

to action on the pitch, or if they have been required to raise their hands at gunpoint. Finally, the sequence ends on a photograph of a member of the armed forces holding a prisoner at gunpoint; the soldier stands to the right of the frame, whilst the prisoner, arms raised, kneels to the left. The image is backlit, rendering the figures silhouettes, and the sequence lingers on this image as we zoom slowly out, in a zoom lasting 12 seconds. Over this latter half of the content file, when the sixth image appears on the screen there is a moment of silence, and then from the seventh image onwards, we hear a short excerpt of the voice of an unidentified woman speaking, who criticizes the 'amnesia bastante fuerte' ['blatant amnesia'] displayed by those who appear to ignore what took place at the stadium in the past. As the woman's voice ends, halfway through the penultimate image, the sound then cuts to crowds chanting 'aquí se mató; aquí se torturó' ['people were murdered here; people were tortured here'].

Again, as with the previous content file, this file has, through its creative recombination of still images, zooms and sound files, told a narrative that captures multiple frames of historical reference and imbues this location with historical and political memory. Whilst all the images relate, in one way or another, to the stadium, there are in fact three distinct timeframes captured in the narrative.

The event immediately referred to in the earlier images of this sequence is the football match held on 21 November 1973 between Chile and the Soviet Union, in the second leg of the play-off for a place in the FIFA World Cup to be held in West Germany the following year. This match, scheduled to take place slightly more than two months after the coup and to be held in the very same stadium in which Chilean subjects had been illegally detained, tortured and killed, caused international controversy. Despite the notoriety of the venue and international protestations, the FIFA delegation sent in October 1973 to inspect the stadium approved its use as a venue for the match.[11] The Soviet Union then refused to play, with the Soviet Football Federation issuing a communiqué to the then FIFA president Sir Stanley Rous stating their team would not play 'at a stadium stained with the blood of Chilean patriots' (cited in Goldblatt 2007: 16). However, in a highly unusual turn of events, instead of the usual awarding of a 3–0 win conventionally employed as a default when one team forfeits the match, the Chilean authorities decided to play the match, resulting in a macabre farce in which the Chilean team lined up, stood for their national anthem and then dribbled the ball down the pitch, unopposed, to score in a goalmouth with no goalkeeper. Branded by Uruguayan writer Eduardo Galeano 'the most pathetic match in the history of football' (Galeano 2003: 142), the images depicted of this match, then, are far from what they seem at first sight. There is a deep irony in the moment of the photomontage depicting the shot going into the goalmouth from Francisco Valdés's foot: there is, in fact, no opposing team, and the winning goal is pure artifice. Moreover, the subsequent shot depicting the scoreboard holds a particular poignancy

as it zooms slowly inwards on the phrase 'La juventud y el deporte unen hoy a Chile' ('Youth and sport unite Chile today') running across the top of the board. Given that the stadium had recently been the site of anything but national unity, and that a high predominance of young people were amongst those detained and tortured, the slow zoom in on these words highlights the atrocities of what had happened at the stadium.[12] Hence, the football chants that run as a sound bridge over this early sequence of photographs start to ring hollow, a fact reinforced when the image of the scoreboard disappears and the football chants end abruptly, leaving only silence. The montage, thus, serves to unmask what has been described by Victoriano as a 'sports fiction' (cited in Medina-Sancho 2013: 165), in which the game was staged as diversionary propaganda for the military regime, and the atrocities of the regime were covered over.

Subsequently, the more politicized images in the latter half of the montage, starting with the photograph of men sitting in the stands, and ending with the backlit shot of the soldier holding a detainee at gunpoint, are a reference to the earlier events taking place in the stadium: the detention and torture of detainees in the early months of the coup. Named in the *Informe de la Comisión Nacional de Verdad y Reconciliación* as one of the two most notorious detention centres in the capital (Comisión Nacional de Verdad y Reconciliación 1991: 97)—the other being the Estadio de Chile—the stadium was, according to the report, turned into a detention centre between 12 and 13 September 1973 and housed many thousands of detainees.[13] According to the *Comisión Nacional de Verdad y Reconciliación,* there was significant evidence of torture and ill treatment of detainees at the stadium, including fake executions and other inhumane forms of treatment, whilst the International Committee of the Red Cross reported evidence of both physical and mental torture in many of the detainees. This latter sequence, then, provides specifically politicized images of the stadium, and encourages us to reread the images we have previously seen, whereby the images of the crowds, and the expressions on their faces, may be read, in hindsight, as torture rather than ecstasy.

The third timeframe, meanwhile, is that introduced by the sound bridges running over the latter sequence of the montage. Here, the sound is a contemporary recording rather than archival and consists, first, of the voice of a woman—unidentified in the montage, but clearly that of Nuria Núñez, member of the Agrupación de Ex Presos Políticos [Association of Ex-Political Prisoners]—and, second, of protest chants outside the stadium.[14] The chant—'aquí se mató; aquí se torturó' ['people were murdered here; people were tortured here']—is a contemporary recording of a protest, and the implied reference of the deictic *aquí* in the chants is, in this case, to the Estadio Nacional itself. The slogan was chanted by protesters during the presidential elections of January 2000, when the Estadio Nacional was used as a polling station, and who were both protesting against the use of such a highly charged venue, and attempting to bring to the fore the historical

memory of the site. As well as its use here, the slogan has been used in other locations, venues in contemporary Chile are targeted by protesters, with a view to exposing the past atrocities committed at particular sites.[15] This third timeframe is thus that of the present-day making of *Memoria histórica*, in which battles for the memory of particular locations in Chile were taking place, and so brings to the fore the need for the recuperation of historical memory in the present.

Indeed, the deliberate choice to narrate the events in the montage not following a standard chronological order, but rather looping back and forward through time—where we commence with the football match of November 1973, and then track back to the events of September 1973, and finally end on the present day—illustrates the need to uncover historical memory. The emphasis here is less on a standard historical chronology and more on the need to remember the past in the present, in this elliptical movement through time. Moreover, the implied references to present concerns or events are strengthened by the venue itself and its meaning in post-dictatorship Chile. The Estadio Nacional has become a symbolic site in Chile's national imaginary; used as venue for Aylwin's inaugural speech as president on 12 March 1990, the day after taking office, later declared a national monument in 2003 under the administration of Ricardo Lagos, and the subject of Carmen Luz Parot's 2001 documentary of the same name from which this montage borrows, the Estadio Nacional is an iconic venue frequently evoked in Chile's memory struggles.[16] In particular, the memory of Aylwin's speech there looms large over this montage, since the ceremony at the Estadio Nacional in 1990 made use of the same technologies (albeit a more modernized version of the same) that we see focused on in this photomontage: during the 1990 ceremony, the scoreboard above the podium was used to display the names of the thousands of detainees and *desaparecidos*. The image of the scoreboard that we see in this montage thus takes on a new meaning, beyond its strictly historical context; in this montage, the scoreboard for contemporary viewers will carry not only the memory of the match of 1973, but also the more recent memory of Aylwin's address of 1990. Hence, the montage is imbued with multiple timeframes, in a process of bringing memory to bear on the present.

If the preceding examples of content files are instances where past moments are reworked into a creative narrative with implicit reference to the present, and in which resistant memories are inserted into existing national monuments, other files undertake the reverse tactic and make explicit use of contemporary issues which turn out to have strong historical roots. An example of this dynamic can be seen in Tag 23, titled 'El memorial a Jaime Guzmán' ['Memorial to Jaime Guzmán'] which contains a photomontage composed of nine colour photographs.

The montage starts with a still photograph of Guzmán, on which a slow zoom is effected, beginning with a close-up of the face of Guzmán, and zooming out to eventually reveal the background, showing rows of books

on the bookshelf behind him. After 25 seconds, a second photograph fades in over the top of this one, depicting a row of figures sculpted in dark rock; although this is a still photograph, a pan from left to right is effected, giving the impression of movement along the line of figures. The subsequent image is edited in via a wipe from right to left, showing a close-up image of the same sculpture, which zooms in on two figures sculpted in white in the foreground; the take zooms in so close that, at the end of the zoom, the image is barely recognizable as it is reduced to a collection of pixels. The sequence then cuts to the next image, a photograph of the sculpture from behind, with the cityscape in background, and again a slow pan is effected, this time from left to right.

After this, the sequence cuts to a series of images showing the surrounding buildings: the first of these is a long shot of two apartment blocks with banners hanging from their windows, although the lettering on the banners is indistinct. Subsequently, we cut to three close-ups; the first of these shows a window with a banner making reference to the location itself (Plaza Baquedano)[17]; the second is a straight-on close-up of another window with its shutters open and a banner hanging from the window declaring 'no gracias' ['no thanks']. The final image is a low low-angle shot of the front of the building, with a long banner, stating 'no queremos' ['we don't want it'], stretched below several windows.

Over this photomontage there is a single sound file, consisting of a voice-over read by a male speaker, describing first the life of Guzmán, and noting that there is a proposal by 'un partido político' ['a political party']—unnamed in the voice-over, but referring to the Unión Demócrata Independiente (UDI) [Independent Democratic Union]—to construct a sculpture in his honour.[18] This short biography details Guzmán's role in opposing Allende and his Unidad Popular government in the early 1970s, his part in helping to destabilize Allende's government, his subsequent support of the Pinochet regime, and his role in drafting the 1980 constitution. Finally, the voice-over describes protests by local residents against the sculpture, noting how residents of the Turri buildings that look onto the square have collected more than 200 signatures to date against the proposals.

This content file thus overtly explores the conjunction between past and present events, and between place and politics. Jaime Guzmán (1946–91) was a lawyer and an academic who was highly influential in Chile's politics of the latter half of the twentieth century. During his years as a student, he founded the Movimiento Gremial Universitario [University Gremialist Movement], a conservative political movement known as the *gremialistas* and that subsequently became, in the words of Huneeus (2007: 226), the 'main civilian power group supporting the Pinochet regime'. After the coup, Guzmán became legal advisor to the Pinochet regime and was a leading member of the Comisión de Estudios de la Nueva Constitución [Evaluation Commission for the New Constitution] which drafted the new constitution in 1980, widely seen as legitimizing the Pinochet regime. Within the new

constitution, states of exception were codified, freedom of the press and association were restricted, the Consejo de Seguridad Nacional de Chile (COSENA) [National Security Council of Chile] was set up and leftist doctrines were criminalized. The constitution was extensively criticized, with the Inter-American Human Rights Commission declaring that it 'gravely injure[s] the international order in matters protecting human rights' (cited in Snyder 1995: 270). As Ensalaco (1994: 410) notes, 'in the widely shared view [. . .], the new Constitution established "a presidential political system, with restricted participation and exclusive representation, tutelary power of the armed forces, and the untouchability of institutions in order to assure the regime's permanent authoritarian character"'. Guzmán's role, then, was a highly controversial one, in that for many he was seen as legitimizing the military regime. Guzmán subsequently founded the UDI, a right-wing conservative party, in 1983 and was elected senator in 1989, a role in which he continued after the end of the Pinochet regime, until his assassination in 1991 by members of the armed faction of the leftist Frente Patriótico Manuel Rodríguez (FPMR) [Manuel Rodríguez Patriotic Front].[19]

If such is the focus of the early images in the first half of the photomontage, the images in the second half of the sequence are of the Edificios Turri, a group of three residential apartment blocks along the south side of the Plaza Baquedano (also known as Plaza Italia), designed in the 1920s by the architect Guillermo Schneider Vergara and commissioned by the businessman Enrique Turri, from whom the buildings take their name. Built in art-deco style, these iconic buildings were the location of protests from 2002 onwards by local residents against the proposal to site the memorial to Guzmán in the Plaza opposite their residences.[20] The decision to build the memorial and its location has been one of the ongoing controversies of post-dictatorship era, and has, arguably, become one of the key sites of memory struggles. First proposed in the early 1990s, and approved in 1993 by Law 19.205 under the Aylwin government, the memorial was originally to be located in the Plaza Italia, a location central to Santiago's sense of urban identity, and frequent venue for political marches and popular cultural events.[21] Given the significance of the Plaza Italia as a place for collective expression, the proposal to locate the sculpture in its environs was particularly problematic. The images of the latter half of the file demonstrate the popular protest against the use of the Plaza Italia in this way, and, indeed, the protests were eventually successful; although beyond the timeframe of *Memoria histórica de la Alameda*, and hence not referenced in the montage itself, the monument was in fact relocated to the wealthy neighbourhood of Las Condes and finally completed in 2008.[22]

The significance of Guzmán, then, and of the monument to be erected in his honour, brings together place and politics and raises questions of memory struggles and memorialization. Yet the montage in this tag deliberately works against the official meaning of the monument, imbuing it with a counter-discourse that encourages us to read the monument otherwise.

For the intended political meaning of the monument by its sponsors—in the words of the Corporación Pro-Memorial Jaime Guzmán, to 'mantener vivo el recuerdo de la obra, figura y personalidad del senador, destacando sus principales atributos como fue su amor a Dios y la patria' ['keep alive the memory of the senator's work, public figure and personality, highlighting his main attributes such as his love for God and for his country'] (Corporación Pro-Memorial Jaime Guzmán, n.d)—is challenged by this creative photomontage. The montage itself refuses to abide by the memorial value attributed to the sculpture by its creators and instead, through its editing techniques, provides a resistant re-reading of the statue. This rereading is evident in the way in which, in the montage, the statue ceases to represent humanity under the benevolent gaze of Guzmán—the original intention of the statue's creators—but instead takes on a more sinister meaning. This is established firstly by the image-to-sound editing in the montage, in which, crucially, it is at the point at which we hear from the voice-over about Guzmán's political endeavours, and his role in destabilizing the Allende government and subsequently supporting the Pinochet regime, that we start to see images of the sculpture. The editing, thus, encourages us to view the sculpture as representing the embodiment less of Guzmán's ideals, and more as the result of his political machinations. Second, the camera work in the montage also encourages us to read this monument in a resistant way. For the slow pans across the two opening and closing images of sculpture allow us to see the bodies as filing past, one after the other; we focus, thus, on the slow passage of dark, cowed figures across the screen, which, combined with the voice-over, encourages us to read them as the bodies of those suffering these abuses of the regime.[23] No longer representing humanity protected by Guzmán's benevolent gaze, the figures now take on the shape of those persecuted by the regime—a regime legitimized by Guzmán. Third, the fact that these images are first introduced by a fade rather than a straight cut creates the visual metaphor of Guzmán's life work as being haunted by these dark, initially shadowy figures; the bodies of the disappeared are rendered as what subtends his political philosophy. In sum, this creative montage has attempted to short-circuit the official meaning of the monument and encourage us to de-naturalize it, with the emotive images recalling the disappeared and providing a resistant, affective memory to challenge the official monumentalization.

If file 23 involved the exploration of the memory battles surrounding a contested monument, other files attempt to bring to prominence the memory of those who have no monuments erected to them. Such is the strategy of file 8, titled 'Bar Jaque Mate: asesinato Monica Briones' ['Jaque Mate Bar: murder of Monica Briones'], which deals with the murder of a young woman in July 1984 outside the Jaque Mate bar in central Santiago. The montage is composed of three still images, over which zooms and pans are effected, starting with a colour image of the exterior wall of the bar, zooming in first on the name of the bar and then the number of the street, locating us in a

particular place. The second image is a shot taken from inside the bar, looking through the window to the exterior, with large chess pieces framed by the window, from which the bar takes its name.[24] The final image shows a cement floor, with a partial print of a boot imprinted on it, on which a slow zoom is effected; eventually, as the zoom ends, we have zoomed in so close as to make the image unreadable, displaying merely a collection of pixels filling the screen.

The sound throughout this content file consists of a voice-over read by a female speaker, addressed in the second person singular. The use of this informal *tú* form of address throughout interpellates us into the narrative, and locates us in the bar, but this is far from the interpellations of the tourist guide format. The voice-over asks not to pay attention to touristic points of reference, but instead, to the walls and the fact that 'algo tras ellas se esconde' ['something is hidden behind them], and to the 'convulsión política trasladada de lo público a lo privado' ['political upheaval transferred from the public to the private realm']. An assault on the senses is undertaken, as we are commanded, at various junctures, to 'huele', 'mira', 'escucha' and 'siente' ['smell', 'look', 'hear', 'feel'], complemented by the images we see on screen. Reference to the dictatorship is made as we are told that those responsible for the murder simply disappear into the 'oscuridad macabra de la dictadura' ['macabre darkness of the dictatorship'], and at the end we are, implicitly, positioned as one of the passersby who saw the incident but did nothing to stop it, as we are commanded, 'sigue caminando; sólo son historias de otros' ['carry on walking: it's only someone else's story'].

The event referred to in this content file is the murder of Briones who, on the night in question, had been drinking with a friend in the bar, and was later found dead in the early hours of 9 July 1984 on the street outside the bar. Her murder was dismissed by the police as a 'crimen común' ['ordinary crime'] (Robles 2008: 24), and was never solved; the case was finally closed in 1995 with no one brought to trial for the crime. However, Briones's murder was seen by feminists at the time as a crime that was explicitly *lesbofóbico*, and gave rise to the creation of Chile's first lesbian feminist organization, the Colectiva Lésbica Feminista Ayuquelén, which played an important role in the late 1980s in denouncing violence against lesbian women during the dictatorship.[25]

This content file, thus, aims not only to narrate Briones's death but also, more fundamentally, to demonstrate how her death illustrates the patriarchal nature of the dictatorship. Even if her murder was not directly undertaken by the security forces—and the content file does not explicitly name the perpetrators of the crime—the montage sequence depicts Briones's death as emblematic of the patriarchal stance of the regime.[26] Those who do not comply with the patriarchal model of the regime are a target, and the perpetrators of homophobic violence can act with the complicity of the security forces and the justice system. Here, the combination of sound and images at the close of the sequence, as we witness the cement floor on which Briones

died being dissolved into a mass of indistinct pixels, represents as much her death as the cover-up and the failure to bring the perpetrators to justice.

In contrast to the file about Guzmán analyzed earlier, the sequence about Briones has no permanent monument to refer to but, more than a lament on the lack of monumentalization, the sequence aims at re-investing this particular site as a memorial to her. The constant commands throughout for us to pay attention to the building, to look, hear, feel and smell our surroundings, attempt to generate an affective response in the viewer and re-create memories rather than an official history. These commands—ones which we may hear as we access the content online or as we visit the bar in situ (which is discussed more in the following)—thus work towards the creation of an affective geography as we engage with the material, and encourage us to experience the Bar Jaque Mate as imbued with the memory of Briones.

This technique of employing the second person to interpellate the viewer-user into the critique is used in several other tags, with one other striking example being tag 34, entitled 'La ley de financiamiento' ['The finance law'], in which the events in question are contemporary rather than historical. This tag opens a montage containing eight still colour photographs over which zooms and pans are effected, starting firstly with an image of a protest banner initially in close up, and which zooms out to reveal a human figure being cut loose above the jaws of a monster titled 'privatización' ['privatization']. Subsequently, we cut to another protest banner, with this time a pan from left to right that lingers on a barcode. This is followed by another banner displaying text and then a photograph of a window, with a sign declaring 'se vende la educación' ['education for sale']. The sequence then cuts to a distance shot of the facade of the main building of the university, in which, in the foreground, the statue of Andrés Bello has its mouth bound with a scarf. The sequence then cuts to three images which are graphically matched: the first is a long shot of wall covered in small notes, with students standing in front of it, whilst the next two are close-ups of these notes. Running across the entire sequence is a voice-over by a female reader who addresses us in third person and discusses the state of higher education in Chile.

The events referred to in this montage are the student protests against Law 20,027 passed by Chilean Congress in 2005 which provided the legal framework for the creation of a student loan system that, although guaranteed by the state, would be financed by the private capital market. The students were protesting against what they saw as the increasing privatization and marketization of higher education in Chile, and the images on which the montage focuses, such as the bar code, present students as products within a marketplace. This content file thus has an explicitly contemporary focus but, in the context of the other files located near it, and in the light of *Memoria histórica de la Alameda* as a whole, encourages us to draw out continuities with earlier historical periods. The viewer of this montage cannot but recall the fact that the process of neoliberal reforms first started in Chile under Pinochet's dictatorship, reforms which, with

relation to education specifically, made Chile's higher education system one of the most privatized in the world. The juxtaposition of this file with the other ones taking a more historical focus thus encourages the viewer to trace connections between present concerns and past events, and reminds viewers that the neoliberal reforms first implemented in the Pinochet era have an enduring legacy.

Given the significance of the creative remixing of sound, image and text throughout *Memoria histórica* as noted previously, it is particularly noteworthy, then, that the last of the files numerically, number 44, is dedicated to one of the leading figures in Chilean musical history of the twentieth century, Violeta Parra. Taking as its title the title of one of Parra's songs—'Al centro de la injusticia' ['At the centre of injustice']—the contents of the file are relatively straightforward in terms of technique, although poignant in their simplicity. We see first the title giving the exact location across the top of the screen—'Galería las Delicias / Al medio de la Alameda de las Delicias'—whilst below this, the main screen displays a still black and white photograph of Parra, with the lyrics of the song superimposed over the top in red font, verse by verse. The sound file consists of a recording of the song, and the song chosen here is one of Parra's most overtly political, its lyrics in many ways providing a microcosm of the tactics employed by *Memoria histórica de la Alameda*.[27] The lyrics start by providing what appears to be a conventional eulogy of the national terrain, setting out Chile's national boundaries, yet by the second verse, it is precisely in the bucolic 'valles con sus verdores' ['green valleys'] where 'se multiplican los pobladores' ['slum-dwellers multiply']. Subsequently, the lyrics make a series of politically charged statements regarding those living in misery in *conventillos* [tenement houses], and the rich profiting from the poor, with the major national industries—agriculture and mining—singled out for the social-economic inequalities underpinning them. The song ends resoundingly on the lines: 'Al medio de Alameda de las Delicias / Chile limita al centro de la injusticia' ['In the middle of the Alameda de las Delicias / Chile borders on the centre of injustice'].

Here, the structural framing of the song—in which the same phrase is used to open and close the song—demonstrates the increasing politicization as the song progresses. Whereas at the start of the song, the phrase 'Chile limita . . .' ['Chile borders on . . .'] referred to Chile's geographical location (its limits with Peru), now, it is employed metaphorically to refer to Chile's socio-economic situation. It is also significant that the song ends on this specific location—the Alameda de las Delicias—which was the name given to the Alameda in the early nineteenth century when it was the venue along which the city's elites would stroll. Here, as the song ends, the relevance of the location given in the title bar to this content file becomes clear. Our location is recorded not as Avenida Libertador Bernardo O'Higgins, nor simply 'Alameda', as in other files in *Memoria histórica,* but as 'Galería las Delicias/ Al medio de la Alameda de las Delicias'. In no other content file of *Memoria*

histórica is the name of the Alameda given in this way. The culmination of the song, thus, is the Alameda itself, and this is where the song ends on its most damning statement, a statement which has strong political resonances.[28] We are, thus, clearly located in Parra's lyrics in this final content file of *Memoria histórica*, which ends on the symbolic location on which the entire project is based.

In these and many other examples, the content files of *Memoria histórica* thus engage in a creative recombinatory practice, mixing both across timeframes, in their uses of archival and contemporary content, and across media in their blends of sound files, text, still images and moving images. This recombination in the content files is then given a further impetus in the enactment of the work itself, since as well as the online map, the work also involves pedestrian participation on the streets of Chile, following the content files around the Alameda. During the month of July 2005 on the launch of the project, members of the public engaged with the project, carrying a backpack, portable computer, GPS receptor, headphones and handheld device, and navigated the content both virtually as they accessed the content files, and physically, as they visited the sites associated with each file. Citizen participation in the project was thus envisaged by the project members as an integral part of the work and as intricately linked to the issues of memory and remembering. In this, the backpack carried by each participant was conceived of as emblematic of the aims of *Memoria histórica de la Alameda*, and described in the words of one of the project leaders, Bárbara Palomino, as a 'backpack-bomb, of time, of history, of memory', whose charge 'expels consciousness, visions, contacts, friendships, emotions' (Palomino 2007: 169). This notion of the *backpack-bomb* refers to the historical charge that the backpack carries, and the way in which its contents bring to light the memory of the places visited, exploding official historical discourse. Moreover, the emphasis on 'visions, contacts, friendships, emotions' indicates the desire to create affective geographies and to attempt to establish emotional, subjective reactions to place.

This emphasis on the affective is particularly significant given the tacking back and forth between online and offline interventions within this work; as noted earlier, many of the content files within the work attempt to generate an affective response that would counteract the official discourse told by the monuments examined. The linking of affective response to physical place within the content files is thus given a greater impetus with the combination of online and site-specific interventions, since those users visiting the locations in situ are able to view the monuments in front of them, touch their very fabric, and so forth. For instance, with regard to file 8 as mentioned previously, those who participate in the urban intervention can actually enact the commands given in the content file to touch and smell in their interaction with the building.

In addition to this, on the night of the launch of the project, between 30 June and 1 July, a further participatory intervention, named 'Aquí me

acuerdo que . . .' ['Here I remember that . . .'] was carried out in the streets of Santiago. Participants in the project went along the Alameda sticking up posters which had the words 'Aquí me acuerdo que . . .' written across the top, with the logo of *Memoria histórica* (the head and shoulders profile, cut across with the map image), at the top left. Below this was a blank space in which members of the public could then record their own memories. According to the project leaders, this intervention meant that 'se tomó la calle por medio de una red oculta, para transformar la Alameda en un diario de su misma memoria en la que cada transeúnte fuese partícipe' ['the street was taken by a hidden network, in order to transform the Alameda into a journal of its own memory in which every passerby was a participant']. Here, the vocabulary of urban (guerrilla) resistance—*tomar la calle, red oculta*—is employed to indicate how this particular intervention, and the broader project of *Memoria histórica* itself, aims to (temporarily) take back urban space for resistant memories. The use of the low tech (handwritten posters) alongside the -high tech here functions as a further way in which the city can be inscribed otherwise, as passersby participate in the generation of memories on the cityscape.

Moreover, these various offline interventions then feedback into the web-based work itself, since photographs, a video montage and a GPS image of the route created by participants were subsequently uploaded to the website. Here, in a two-way process between online work and street intervention, content creation on the street then generates further pieces in the online content. With regard to the GPS image, the version uploaded to the website after the street intervention displays the routes taken by participants, marked out by a fine white line on a black background and clustered near red dots indicating the key locations, the image plots out an outline map. The map clearly speaks to the central map logo of the work as a whole, providing a visualization of actual participation on the ground. Similarly, regarding the images, we are able to view participants actually visiting the sites and photographs they themselves took as they did so; these photographs thus provide an additional level of commentary on the content of the embedded files as well since they demonstrate quite emphatically the revisiting of these historic sites in a contemporary intervention. The video montage, meanwhile, provides a further level of the remixing of content, since it consists of a creative mix of some 6 minutes of footage, combining footage of the participants as they move around the city, with excerpts from the original content files embedded within *Memoria histórica*. Here, therefore, the original content files—which were, of course, engaged in remixing existing photographs, sound files and moving images themselves—now become subject to a further remixing, and are invested with the meanings traced by the participants as they moved around the city.

Now, for instance, excerpts of voice-overs and sound from the original content files are mixed with diegetic sounds of the city as the participants move around it, producing a soundscape in which the sounds of historical

events are constantly intermingled with the sounds of the contemporary cityscape. The editing techniques contribute to this, whereby in several cases the sound from the original content file is matched with a sound recorded from the contemporary urban intervention. For example, a short extract starting at 4 minutes 31 seconds into the video montage is taken from content file 31, containing a recording of a telephone conversation on 11 September 1973 in which the state of emergency was declared; here, in the short extract chosen, we hear an unnamed voice asserting the need to 'aplicar la ley marcial' ['apply martial law']. The sound subsequently cuts to contemporary diegetic sound, but this cut is not marked overtly, and we hear firstly the loud noise of an engine roaring, and then an alarm sounding. While these sounds are actually from the contemporary footage—a motorbike starting up and what is most probably a car alarm sounding nearby—the seamless way in which they were joined with the previous sound extract, and the obviously equivalences—whereby we initially assume the alarm to be the *toque de queda* sounding—suggests connections between the past moments conveyed in the original content file and the present intervention.

Similarly, the juxtaposition throughout the video montage of sound from one source and images from another leads to a dynamic in which past and present are again creatively recombined. This technique is brought to the fore most overtly in the dramatic ending to the video montage that juxtaposes contemporary footage of one of the participants gazing at the Moneda, with the excerpts of historical sound contained in content file 10 of the Chilean air force bombing the building in 1973. Here, as in other moments of the montage, the historical weight of this particular location is brought to the fore, and its viewing in a contemporary context is overwritten by the significance of the events that took place here in the past. In this final part of the video montage, there is no contemporary diegetic sound to provide a respite from the archival sound that still imbues the location with meaning. In these and many other instances, thus, this video montage, more than being a simple recording of participants, gives a further impetus to *Memoria histórica* and its attempts to constantly bring to the fore the memory of historical events in the present reality. Indeed, the fact that excerpts from each of the original content files are short, and not numbered or titled, means that we constantly have to attempt to decipher where they have come from; this fact encourages us to continually check back against the content files, re-view them, and understand them anew in the light of the offline participants' trajectory through the city. In this feedback loop from offline to online we thus witness a further example of the ways in which *Memoria histórica* attempts to establish the interconnections between contemporary urban experience and the weight of the past: in the words of the project members, to establish a 'diachronic basis' in which memories and facts from the past are directly compared to contemporary conditions ('About', Memoria histórica 2005: n.p.).

As this chapter has argued, the *Memoria histórica de la Alameda* project makes creative use of a combination of internet-based and site-specific interventions which come together to produce a resistant, historical memory of the Alameda and the iconic locations it houses. Engaging with the politics of monuments and memorialization, *Memoria histórica de la Alameda* attempts to unmask or denaturalize some of the most prominent monuments in this central thoroughfare and, in so doing, question the values they represent in Chile's national imaginary. In line with the theories of Lefebvre and the Situationists—both acknowledged as influences by the project members—the work attempts to unmask the city, as the multiple recombinations of sources attempt to imbue the sites along the Alameda with collective memory and generate an emotional response. This unmasking of the Alameda's monuments is undertaken in order to engage in memory struggles and to produce historical memory. Aesthetically, *Memoria histórica de la Alameda* aims to produce memories of the Alameda that are not captured in linear narrative, but that are produced in resistance, via montages, recombinations of sounds and images and the productive bringing together of a variety of sources. In this way, this is a work which engages closely with Chile's ongoing memory struggles and aims to produce affective geographies for the participants who negotiate its urban spaces.

NOTES

1. Netzfunk was established in 2004, and describes itself as an 'open network of dispersed artists sharing in common a subversive idea of art, and the hate for the multifarious mafias of art, culture, economy, armies and politics' (Netzfunk 2010).
2. For an overview of the updating of the site, see the section of the website titled '2005–2010: Hacia dónda va MHA?'
3. The initial pages about the project are available in both English and Spanish; hence, I have cited here from the English for ease of reading. Once entering the main content files of the work, however, all the content is in Spanish; hence, I later cite in Spanish and provide English translations.
4. One of the junta's first acts early on the morning of the coup was to order pro-UP radio stations to cease transmissions or face aerial bombardment (Breshanan 2002: 163). Radio Magallanes was the only pro-UP station still transmitting by the time of Allende's final broadcast to the nation.
5. The Dirección de Inteligencia Nacional (DINA) was first established in November 1973 as a commission under the Pinochet regime and, in the following, year was formalized by Decree 521 on 14 June 1974. It was later replaced by the Central Nacional de Informaciones (CNI) in 1977. The DINA was responsible for coordinating the detention and torture of detainees; as the Informe de la Comisión Nacional de Verdad y Reconciliación notes, with the creation of the DINA, victims were selected by intelligence units and kept in secret detention centres where they were tortured (Comisión Nacional de Verdad y Reconciliación 1991: xvi).
6. The earlier commission, named the Comisión Nacional de Verdad y Reconciliación, was set up by Supreme Decree 355 on 25 April 1990 to investigate

the truth about serious violations of human rights committed between 11 September 1973 and 11 March 1990. After nine months of investigations, on 8 Feburary 1991 the commission submitted its report to the then president of Chile, Patricio Aylwin Azócar. The report is also known as the *Informe Rettig*, taking its name from the chairman of the commission, Raúl Rettig.

7. The Rettig Commision considered approximately 3,400 individual cases (Comisión Nacional de Verdad y Reconciliación, tomo 1, 2001: 7), of which they confirmed 2,115 cases of human rights violations leading to death or disappearance (Comisión Nacional de Verdad y Reconciliación, tomo 2 2001: 1311).

8. The other development identified by Stern as decisive in this regard was the revelations about Pinochet's corruption and money laundering.

9. Indeed, it is worth noting that the project members cite Lefebvre's *The Production of Space* (1991) as one of the inspirations for the making of *Memoria histórica de la Alameda*, highlighting Lefebvre's notion of a 'texture of space' as a main influence (cited in section '2005-2010: Where does MHA go to?' on the page 'About' of the website).

10. The three parts of Guzmán's trilogy comprise *La batalla de Chile: la insurrección de la burguesía* [*The Battle of Chile: Insurrection of the Bourgeoisie*] (1975), *La batalla de Chile: el golpe de estado* [*The Battle of Chile: the Coup d'Etat*] (1976) and *La batalla de Chile: el poder popular* [*The Battle of Chile: The Power of the People*] (1978). Guzmán also used the footage in his 1996 documentary film *La memoria obstinada* [*Obstinate Memory*], in which he returned to Chile after years of exile and interviewed people who had participated in the original trilogy; for some, this film constitutes the 'cuarta parte' ['fourth part'] of *La batalla de Chile* (Valenzuela 2005: 10). In an article about their project, the makers of *Memoria histórica de la Alameda* have highlighted the importance of Guzmán's film as the inspiration for their project (Boardman 2007: 89).

11. The decision of FIFA to go ahead with holding the game at the Estadio Nacional has been the subject of critique both by international bodies at the time, and scholars since; as Sugden and Tomlinson note, missives were received from several Eastern Bloc nations, Latin American nations and African nations protesting the decision (Sugden and Tomlinson 2007).

12. According to the *Informe de la Comisión sobre Prisión Política y Tortura*, the largest single age group of those detained by the regime were those classified as 'adulto joven' ['young adult'] (between 21 and 30 years old at the time of their detention), comprising 44.2 per cent of all detainees (Comisión sobre Prisión Política y Tortura 2005: 471).

13. Thousands of detainees were held at the Estadio Nacional, although exact figures for the total are hard to ascertain. The Red Cross reported that as early as 22 September there were 7,000 detainees held at the site (cited in Ensalaco 2000: 32); the following month, according to a secret report for the junta, a total of 7,612 prisoners were processed through the National Stadium between 11 September and 20 October (cited in Kornbluh 2003: 154). Read and Wyndham (2008: 82) give an estimate of more than 14,000 detainees taken to the National Stadium for interrogation, torture or execution between September and November 1973, although they do not cite the source of their statistics. Parot's film gives the figure of 12,000 detainees, although again does not cite the source of its statistics. The *Informe de la Comisión Nacional sobre Prisión Política y Tortura* (Comisión Nacional sobre Prisión Política y Tortura 2005: 366, 376) names the Estadio Nacional as the 'centro con el mayor número de detenidos' ['centre with the largest

number of detainees'] and states that its prisoners 'se contaban por miles, no por cientos' ['run into the thousands, not hundreds'], although does not give an exact figure.

14. Both of these recordings—Núñez's short statement and the protest chants— appear in Carmen Luz Parot's documentary film *Estadio Nacional* (2001).

15. Kelah Bott (2006: 1) also documented the use of the slogan during the presidential elections of 2006, when the Estadio Nacional was also used as a polling station. In addition to its use at the national stadium, the slogan was also used in protests held at other venues formerly used as detention and torture centres; Stefania Presutto (2008: 113) notes the use of the slogan 'aquí se torturó' in contemporary protests held every Thursday outside Londres 38, one of the most notorious of the DINA's torture and detention centres.

16. Parot's (2001) *Estadio Nacional* involved interviews with more than 30 witnesses of the atrocities of the National Stadium.

17. Plaza Baquedano was formerly known as Plaza Italia, and is still called by this name in some accounts.

18. The sculpture was sponsored jointly by the UDI (Unión Demócrata Independiente) and the Fundación Jaime Guzmán.

19. Formed during the 1980s as an armed wing of the then banned Communist Party of Chile, the FPMR was involved in several acts of opposition to the Pinochet regime, but after the transition to democracy split into two factions: a non-violent faction and a splinter group still undertaking armed resistance.

20. A detailed history of the protests can be seen in Renato Villegas's documentary film *La batalla de Plaza Italia* [*The Battle of Plaza Italia*] (2008).

21. Indeed, it is worth noting that content file 42 of *Memoria histórica*, titled 'Plaza Baquedano y manifestaciones populares' ['Plaza Baquedano and popular protests'], describes how the Plaza is often the venue for public protests and notes that one of the longest and most extensive was celebration of the triumph of the 'No' vote in the 1988 plebiscite.

22. Controversies arose over official recognition of the memorial, in particular the suitability—or not—of the Chilean president to attend memorial ceremonies there. At the monument's inauguration in 2008, then president Michelle Bachelet was reported in the press to have accepted an invitation to attend the ceremony, although in the event she declined to attend; her decision received a great deal of press attention from both left and right (see Waldmann Mitnick 2009: 226–27). The subsequent president, right-wing billionaire Sebastián Piñera, attended a service held at the memorial to commemorate Guzmán's death in April 2010.

23. Indeed, it is worth noting that Hite and Collins's research into the eventual location of the sculpture in Las Condes has illustrated that reactions to the sculpture do not always comply with its intended meaning. They note that, given that the image was not of Guzmán, but instead of a row of dark figures, 'ironically passers-by could be heard speculating that the row of figures represented the disappeared' (Hite and Collins 2009: 395).

24. The term *jaque mate* refers to the chess move 'check mate', although is also potentially a play on words, referring to the popular drink, *mate*.

25. For more on the foundation of Ayuquelén, see Robles (2008: 23–27).

26. Although the perpetrators of the crime were never identified, some link the crime directly or indirectly to the military regime. Pedro Lemebel's short chronicle about the death of Briones, 'Las Amazonas de la Colectiva Feminista Lesbica Ayuquelén', for instance, published in his collection *De perlas y cicatrices*, attributes the crime to the Chilean security forces, declaring that those responsible were 'esos monstruos, seguramente CNI' ['those monsters,

doubtless CNI'] (Lemebel 1998: 155). Cecilia Riquelme, one of the co-founders of the Colectiva Ayuquelen, asserts that Briones was murdered by an 'ex amigo detective' ['former friend of hers, a detective'] (cited in Robles 2008: 24).

27. The Fundación Violeta Parra (2008) lists 'Al centro de la injusticia' as one of the songs composed by Violeta Parra, although there is no recording of her singing it. This recording is most probably sung by her daughter, Isabel Parra.

28. The final words of the song, 'Chile limita al centro de la injusticia', still have strong resonances today; it is worth noting, for instance, that Ricardo Lagos employed this phrase as his slogan in his inaugural speech of his 1999 presidential election campaign, explicitly evoking Parra's song (Lagos 1999: 1–2).

3 Sites of Memory in *Women: Memory of Repression in Argentina*

Following from the previous chapter, whose focus was a work that explored historical memory in Chile, the present chapter now turns to an exhibition of works in Argentina in 2013 which, in their different ways, not only engage with the memory of a dictatorial past but also draw out connections to the inequalities of the neoliberal present. The exhibition in question is the *Women: Memory of Repression in Argentina* exhibition of 2003, curated by Raquel Partnoy, and whose online interface was created by the German multimedia artist Wilfried Agrícola de Cologne, in collaboration with Partnoy. The chapter focuses both on the curatorial interface as a work of art in its own right and on the constituent works within it, exploring how they engage in memory preservation and link memory to the recuperation of, and re-signification of physical place.

The key location under scrutiny in this chapter, and with which the curatorial interface, and the constituent works dialogue, is Argentina's capital city, Buenos Aires, and its principal sites of memory. These include the city's waterways, the Plaza de Mayo and the clandestine detention centres of the dictatorship, amongst other locales. These are high-profile locales within the city, and central both to Buenos Aires's sense of identity as a city and to struggles over the memory of Argentina's recent past. The waterways, most prominently the Río de la Plata, are not only central to Buenos Aires's identity as a port city built on immigration but also, as will be discussed in what follows, become representative of the abuses of military power, and were the location where many of the disappeared met their deaths. The Plaza de Mayo is the political centre of Buenos Aires, flanked by buildings housing the major offices of state, including the Casa Rosada presidential palace, the Ministry of the Economy and the National Security Service, as well as the Banco de la Nación Argentina [National Bank of Argentina] and the Metropolitan Cathedral. It has frequently been the venue for political protests, stretching back as far as the May Revolution of 1810 from which it takes its name and taking in mass rallies in support of Juan Domingo Perón in the 1940s, but is nowadays synonymous with one protest group in particular, which takes its name from the venue: the Madres de Plaza de Mayo protest group which was established in 1977, one year into the most brutal military

regime in Argentina's history. The detention centres, established early in the dictatorship and sites of systematic torture, abuse and killing of thousands of Argentineans, are prominent sites of memory in contemporary Argentina.

If these are some of the most prominent locales with which these works dialogue, the historical period informing all of them is that of the military dictatorship (1976–83). Following a coup on 24 March 1976 which deposed the then president Isabel Martínez de Perón, Argentina was ruled by a military junta until 1983. Under the regime, Congress was dissolved, various articles of the constitution were suspended, all supreme court judges were sacked and the rule of law was disregarded. The regime engaged in systemic human rights violations, with the establishment of hundreds of clandestine detention centres, and the abduction, torture and murder of thousands of persons, with most human rights organizations concurring in the figure of 30,000 disappeared persons.[1]

Hence, the 'repression' of the title of this exhibition refers most immediately to this period and, indeed, the memory of this period, and the primacy of Buenos Aires as the centre of political power yet also as the locus of memory and potential resistance are reflected in all the constituent works of the exhibition. At the same time, as we explore the works within this interface, we start to trace broader histories of repression, as the constituent pieces encourage us to establish connections between, for instance, the dictatorship and the later period of the 2001 economic crisis in Argentina, or, for instance, with earlier periods of repression. Thus, the work of the various artists included within the curatorial interface establishes a relational understanding of key memory sites, in which locations are interlinked with other locations and in which the timeframe of the repression is linked with prior and subsequent political eras. Here, the artists' tactics reflect recent scholarly observations on memory sites in Argentina and on how they function as relational places. Tufró and Sanjurjo (2010: 121) have argued that where the Plaza de Mayo and, more recently, the clandestine detention centres constitute the central places of the memory of the dictatorship, from the end of the 1990s, there has been a process of what they term 'descentralización de la memoria' ['the decentralization of memory'] that seeks to 'inscribir marcas de la memoria en espacios cotidianos a lo largo y a lo ancho de la Ciudad de Buenos Aires' ['inscribe the marks of memory in everyday places along the length and breadth of the city of Buenos Aires']. Such a process, Tufró and Sanjurjo argue, constitutes an attempt to capture the arbitrariness of violence which was a central element in the state policy of 'diseminar el terror en toda la sociedad' ['disseminating terror throughout society'] during the dictatorship. Thus, each memory site within Buenos Aires needs always to be considered as one memory place within a much wider urban fabric, across whose entirety the memory of the repression is to be constructed. Indeed, even in the case of those actions centred on one specific location, such as the Plaza de Mayo itself, recent scholarship has shown how these actions are in themselves scaled and relational. Bosco's research into the

activities of the Madres de Plaza de Mayo has emphasized the complexity of memorial landscapes, reminding us that places and landscapes should not be understood as bounded within a particular geographic territory, but rather seen as the 'nexus of networks of social relations' that occur at multiple spatial scales simultaneously. Bosco (2004: 385) then argues that the weekly collective rituals of the Madres 'condense in one place competing strategies that are otherwise enacted at different spatial scales', illustrating how competing scaled discourses about memory and commemoration become visible and experienced in particular places and times by different groups. The Plaza de Mayo, thus, being one of the key memory sites of the dictatorship, is at the same time relational, and no longer solely rooted in the plaza itself. So these works within *W:MoR* also create a relational understanding of memory sites with which they deal, linking them with multiple locations and multiple timeframes and, indeed, often foregrounding the subterranean or hidden elements of each location.

The *W:MoR* interface itself is a collaborative project, co-authored by the German multimedia artist Wilfried Agricola de Cologne in collaboration with Raquel Partnoy—an example, as with other pieces explored in this book, of creative dialogues between European and Latin American artists. Agricola de Cologne's work encompasses both internet art and online curatorial projects, with the majority of his pieces tending to engage in sociopolitical commentary, with some of these, such as his *]and_scape[* (2002) linking this commentary to physical space. His curatorial projects focus predominantly on the topic of memory, in particularly his ongoing *[R][R][F]* (Remembering-Repressing-Forgetting) online curatorial project (2003–). Raquel Partnoy, meanwhile, is a prominent Argentine artist, who has worked in the medium of painting for several decades before curating this project. The influence of Partnoy as curator is evident throughout the work, not only through the curatorial statement that introduces the exhibition but also because many of her own pieces form an integral part of the work, ranging from providing a visual backdrop to the work of others, through to being the focus in their own right, and, just as importantly, providing the personal family story that informs the exhibition as a whole. Prominent throughout Partnoy's oeuvre is a concern on the one hand for depicting the female body and gender-based discrimination, such as her *Women of the Tango* series exploring how tango lyrics depict the mistreatment of women, and, on the other, a desire to reflect the sociopolitical climate, particularly that of the dictatorial and post-dictatorial years in Argentina. Many of her paintings reflect her personal circumstances, particularly her Jewish heritage, and the abuses that her family suffered during the dictatorship when her daughter, Alicia Partnoy, was disappeared by the Argentine military in January 1977 and held first in a clandestine concentration camp and subsequently in prison until her release in 1979. These events profoundly marked the Partnoy family, and constantly resurface in their works, including the exhibition which is the subject of this chapter.

The online curatorial interface of *W:MoR* engages with this dynamic of memory work and of establishing a gendered resistance, yet also brings into play the role of technology and the primacy of place in establishing this resistance. The interface displays a complex interplay with computer coding, memory, and physical space, starting with a dark grey screen, over which a flashing cursor appears in the centre. Slowly, text in light purple Courier font appears across the screen, letter by letter, as the cursor moves across the screen, eventually spelling out the phrase 'running to Buenos Aires—>'. Immediately, the conceit here is a nod to early computing norms and early net.art, with a variety of features mimicking computer code and (now obsolete) technologies. The flashing cursor is common to the pre-visual, text-based terminals of the 1970s and 1980s, and the ponderous slowness with which the text appears on the screen again implies an older, slower era of computing. The use of Courier font, a monotype font which apes typewriter output, nods to pre-digital forms of communication as embodied by the typewriter, and at the same time, as the most commonly employed font in ASCII art, immediately recalls this early digital art form. As Liu (2004: 349), borrowing Lunenfeld's phrase, puts it, such ASCII characters are 'tinged by nostalgia' and create the impression of 'retro-styling' since they simulate early DOS-based computer screens.[2] Similarly, the insertion of what appear to be elements of computer code—the '-' and '>' symbols, with the latter commonly used in HTML tags—again recalls the techniques of prominent net.artists such as JODI, whilst the conceit of 'running' implies we are waiting for software to be run.

All these features combine to create a deliberately dated interface in which computer coding and the structural features of new media technologies are brought to the fore as artistic components. The opening screen thus immediately situates the exhibition in the context of the resistant reuse of low-tech, a conceit which informs the work of several other artists analyzed in this volume (see also Chapters 4, 5 and 6). At the same time, however, the use of these visual tricks situates the works within this exhibition in a concrete physical and historical context. The use of the mock computer code in the '—>' is a visual trick that aims not to replicate a real command but instead to create the image of an arrow across the screen, in ASCII art fashion. This, combined with the words *Buenos Aires*, creates the impression of movement towards a physical place, and emphasizes that the artwork we are about to enter will transport us to Buenos Aires. Moreover, the implied references to the 1970s and 1980s by the dated font, blinking cursor, and deliberate slowness of the mock 'software' we are about to run has a much more politicized meaning in the case of the exhibition we are about to view. Rather than pure retro styling, or a ludic, quasi-nostalgic reference to a prior era of computing, the historical referent of the technological forebears recalled by this interface is much more sinister: the 1970s and 1980s, in Argentina, are the time of military dictatorship and state oppression. The retro style here thus recalls not a utopian era of early computing and early hacker endeavours

but instead the period of the military dictatorship with which the content of the works dialogue. The interface thus combines here immediately for the viewer a resistant or countercultural use of technologies, an implicit connection to the past, and a focus on physical space, a dynamic which we see enacted in the interface and in the constituent works themselves.

Once this deliberately anachronistic message has finally appeared in its entirety, the title of the exhibition then fades in along the bottom of the screen in lower case, above and below which there is a line of '+' symbols; these symbols and the letters of the title keep floating up and down, constantly moving and changing places with one another. To the left of this title there is an icon which is to reappear at various points throughout this work: a line drawing of a white headscarf, shaped as if worn around a head and tied beneath the chin but with a black space where the head should be. The headscarf is a synecdoche for the Madres de Plaza de Mayo; first worn in 1977 when the first women met in the Plaza de Mayo to protest against the military dictatorship, the white headscarf has now become the most immediately recognizable symbol of the Madres. In the words of Marguerite Guzmán Bouvard (1994: 182), the white headscarf represents a 'symbol of love and unity' but also, as expressed by founder Hebe de Bonafini, as a symbol it 'continues to be the condemnation of torture, rape, assassination and theft in this country'.[3]

After the title and icon have faded in across the foot of the screen, the rest of the interface then fades in across the main body of the screen. We see first a background image that fills the screen: a black-and-white photograph of a city square in Buenos Aires with trees in the background, a group of onlookers standing in a semicircle and, in the foreground, a couple dancing, in a classic tango pose. The image is sufficiently generic—the depth of field is too shallow to make out the surrounding buildings—for this to be representative of the Buenos Aires cityscape as a whole. Superimposed across this monochrome background then appear three colour photographs and one video file that fade in, each of differing sizes. To the left of the screen, a large colour photograph, in landscape format, takes up a sizeable portion of the screen and depicts a demonstration by the Madres de Plaza de Mayo, showing a crowd of women with those at the front caught in *plan américain*; with their arms raised and mouths open as they shout a protest, they wear white headscarves and carry photographs of their disappeared around their necks. To the top right of the screen, a smaller photograph in close up showing head and shoulders only, depicts one particular member of the Madres; wearing white headscarf she is gesticulating, her finger pointing forward towards the camera in an accusatory fashion. Although the photograph is not captioned, the person depicted is unmistakably Hebe de Bonafini, one of the founders of the Asociación Madres de Plaza de Mayo and who continues to be its most prominent spokeswoman. To the extreme right of the screen is a large, portrait style photograph, this time showing one individual protester in full-body shot. She wears a black headscarf,

rather than white, and carries a photograph hung around her neck, show-ing three young people and the word *fusilados* [*shot*] at the bottom. Finally, in the centre of the screen there is a video file depicting a man and a woman dancing tango in an interior shot. As well as these images, running continu-ally over the interface is a sound file, repeated on a loop of a song in a slow rhythm akin to a bossa nova.

The curatorial interface thus provides us with an image of the city of Bue-nos Aires that is then challenged by the multiple layers of images and links that the interface provides. First, it establishes some of the conventional tourist images of Buenos Aires; the city square, framed by the trees in bloom, speaks to the romantic image of Buenos Aires as the 'Paris of the Ameri-cas', whilst the couple dancing tango represents the iconic national dance of Argentina, one which is frequently packaged as a smouldering dance of passion. Yet these images are then undercut by means of the resistant images and links which are embedded into this background. That various still pho-tographs of the Madres overlap this background image and partially obscure it means that the monumentality of the city square is overshadowed by the figures of the Madres, and implicitly, of the disappeared. The interface thus refuses to allow for the traditional monumentality of the plaza, and, through its multiple layering of images and hyperlinks, implies that embedded within the superficial beauty of the square is a complex sociopolitical history that we are encouraged to negotiate. The interface also, through intertextual ref-erence, hints at the gendered stance that the work will take, in the parallels that arise between the image of the tango and Partnoy's two previous series of paintings on the topic. The image of tango here thus, for those with a knowledge of Partnoy's oeuvre, hints that its conventional gender encoding will be challenged by this work.

From this challenging interface, we then gain access to the various sec-tions within the work. The photograph to the left, depicting the Madres in a street protest, brings up in the centre of the screen a pop-up box with a series of links to relevant information and sites; these range from entities that deal with the specifics of the Argentine dictatorship, such as the Madres de Plaza de Mayo, to other organizations that deal with more global issues of alternative media and social issues, such as *IndyMedia*. Along the bottom of the screen, below the title, are further named links, starting firstly with a brief Curatorial Statement, and then the main content links.

The first of the content links is named 'Testimonies', and clicking on this brings up a black pop-up window to the right of the screen containing five named links, each to various testimonies in different formats, some poetic, some narrative and some correspondence.[4] On clicking on each individual link, another pop-up window appears in the centre of the screen, loading an image to the top left, a short author biography below, and the testimonial text itself to the right of the screen, all superimposed across the Plaza de Mayo background. In these pieces, the interplay between text and image, and the relationship between both of these and the background behind

them, creates a dynamic that establishes close links between the cityspace, literary expression and resistance.

A particular example of this can be seen in the case of the poem 'The Hordes Came' by Etelvina Astrada (see Figure 3.1). Here, the thumbnail image accompanying the text shows graffiti dominated by three colours—black, white and red—and depicting three figures wearing military uniform, with red epaulettes, black-and-white caps, and black military jackets, but instead of faces, there are just three grimacing skulls. To the left of these three figures, the Argentinean flag can be seen fluttering in the breeze, but its traditional sky blue is now faded to grey. The style of the graffiti borrows much from Picasso's *Guernica* (1937) in its use of perspective, sharp, awkward angles, and limited palette to convey conveying a nightmarish scenario of state terror, whilst also, in putting the skull centre stage, nods to Mexican artist José Guadalupe Posada's famous series of engravings that employed the skull as a form of critique. Below the image, the title of the graffiti is given as 'Damned Military Junta', explicitly situating the graffiti within the context of the Argentine dictatorship. This image, in terms of both its content and style, thus conveys an impression of militaristic state terror.

Yet in addition to the style and content of the image, the genre itself also signifies in the context of the interface. The use here of graffiti as a genre specifically—in preference to, say, oil paintings or watercolours—lies in the significance of graffiti in relation to urban space. For graffiti is, of course, an art form enacted on the very fabric of the cityscape, and one whose style and content is frequently oppositional to the dominant urban order. In their work on place semiotics, Scollon and Scollon (2003: 146, 147) define graffiti as a 'transgressive sign' since it 'violates sensibilities and laws of emplacement'; thus, graffiti's location on the urban fabric is crucial, since it is precisely the violation of conventional laws of emplacement that help give graffiti its oppositional force. Indeed, a growing body of empirical research into graffiti in urban contexts in Latin America has demonstrated the ways in which graffiti art is closely linked to its locality and constitutes an attempt to resist the dominant inscription of the urban order.[5] The significance of this image, thus, lies not only in its style and content but also in its resistant emplacement; it is an alternative inscriptions of the urban fabric that challenges the tourist image of the Buenos Aires square and the tango dance that opened the work.

The foregrounding of this resistant genre then gives greater weight to the accompanying poem, as a creative dynamic is established between text, image, and curatorial backdrop. The author of the poem is the Argentine poet Etelvina Astrada (1930–99), who emigrated from Argentina to Spain in 1974 as a result of political oppression, her eldest son having been disappeared under the military dictatorship. Astrada published two collections of poems, *Autobiografía con gatillo* [*Autobiography at the Trigger*] (1980) and *La muerte arrebatada* [*Death on the Run*] (1981) as well as an edited anthology titled *Poesía política combativa argentina* [*Argentine Political*

Combative Poetry] (1978) in which she explicitly set out to provide a collection of critical voices on the Argentine dictatorship. The particular poem in question here—'The hordes came, in my country'—appeared in Alicia Partnoy's (1989) edited volume *You Can't Drown the Fire: Latin American Women Writing in Exile,* an anthology specifically focused on giving voice to women's writing in conditions of repression.

It is, thus, one of Astrada's most overtly political poems and makes direct reference to the machinery of state terror and the effect on the populace. Moreover, the imagery of Astrada's poem dialogues in productive ways with the image. The three figures of the graffiti, for instance, are associated with the fourth verse of the poem and its reference to 'Three polluted asses / and a single face truly sinister. / Three professional buzzards'. Here, the triad in Astrada's poem is mirrored in the graffiti's three figures, and both make reference to the three leaders of the first military junta: General Jorge Rafael Videla, general commander of the army; Admiral Emilio Massera, commander in chief of the navy; and Brigadier General Orlando Ramón Agosti, commander in chief of the air force. Similarly, Astrada's notion of the 'single face' is hauntingly mirrored in the graffiti which deliberately refuses to give individual faces to the military figures. Her listing of names in verse three, meanwhile—the roll call of the disappeared—finds its counterpart in the shadowy, barely visible faces across the foreground of the graffiti image, in which what appear to be posters depicting human faces jut across the chests of the three military figures. Finally, the still visible backdrop of Buenos Aires that permeates the whole of the screen—since the contours of the opening screen still remain visible behind the poem and the graffiti—grounds this work firmly in physical place. Similarly, Hebe de Bonafini's accusatory finger still points through the layers of images, meaning that the work of the Madres remains visible, and the Plaza de Mayo becomes a shadowy presence, always informing our reading of the poem. In this way, the curatorial interface is more than simply the reproduction of a poem on a web page; it is through its juxtaposition and its superimposition with other elements, and through the layering of various images related to the urban fabric of Buenos Aires, that the poem gains resonance and works in conjunction with the pictorial.

If the preceding is an example of a poetic work that has been reworked and juxtaposed with images to create a resistant whole that attempts to narrate a counter-discourse to the dominant urban order, other links mobilize factual as well as artistic images. Such is the case of Graciela Cabales's 'Black Eyes', in which the accompanying photograph that appears in the top left of the pop-up window depicts not a cultural-artistic expression, but instead captures a real-life moment of human figures engaging in their work. The photograph is in colour and was taken from a high angle; the viewer looks down on three figures are who crouching in a deep sandy pit. Wire lines mark out a rectangle in which the three figures are working and, in front of them, in the foreground, lie piles of human skeletons. The photograph thus

depicts the process of the excavation of human remains undertaken after the return to democracy, principally by the body EAAF (Equipo Argentino de Arqueología Forense), whose role was to uncover the bodies of those who were abducted, tortured and killed by the military regime, and who had been interred in mass graves marked only with the acronym 'NN' ('ningún nombre'), often at the edges of official cemeteries.[6] Although this photograph is undated and has no reference to a specific place, it is in fact an image of the EAAF team at work on the exhumation of bodies at the edge of the San Vicente cemetery in Córdoba, which started in 2002 and which found remains corresponding to 91 individual skeletons (EAAF Annual Report 2005: 61).[7] It is, thus, an image which will be particularly resonant at the time of the making this exhibition, with the excavation of San Vicente at the forefront of the minds of the Argentine people.

The text which lies to the right of this image is a short story by the scriptwriter and author Graciela Cabales. The story starts by narrating what appears to be an idyllic encounter in a café between the female narrator and an unnamed young man, as the narrator glances over to him, noting how his 'deep black eyes' move her. However, as we read farther, we realize that this is far from a romance blossoming between two strangers; an unease is established in the first paragraph with a reference to 'the memory of those other eyes' which goes unexplained, and we learn that the narrator has undertaken this same trip to the café several times with the purpose of spying on the young man. The narrator becomes increasingly anxious as the story progresses, as her hands begin to shake, and she runs through a series of potential strategies to approach this stranger. Halfway through the story, she imagines speaking to him, and plays out in her mind a future conversation with him; here, details such as the fact that she imagines herself scolding him for combing his hair in public hint at a parental relationship between the two, although this is counterbalanced by her musings on what sort of a family he comes from. Then, as the story comes to its climax and the young man stands, the narrator realizes that, after all, he is not the person she was looking for, and she decides not to speak to him. The final paragraph of the story then reveals to us the hidden relationship that the narrator was attempting to uncover:

> Tomorrow, perhaps, someone else will come and I will see if I can find in his eyes the black eyes of my own son. And his look, the one that pierced my heart the morning they came to take him away.

The close of the story, thus, makes clear that this has been not a tale of a thwarted romantic encounter in a café, but rather the ongoing tragedy of a woman who is still searching for her disappeared son.

Again, as with the Astrada poem, the force of the short story here gains from its juxtaposition with the images on the page. The photographic image of the exhumation of bodies at San Vicente gives additional meaning to the

story, since it depicts precisely this process—the identification of the disappeared, and the possibility of closure—that the female narrator, trapped in her never-ending cycle of visits to the same café, cannot have. The conjunction of text and image, with the one envisaging a reunion that is ultimately thwarted, and still trapped within a cycle of searching for the disappeared love one, and the other depicting identification and recovery of the body, but only as the remains of the dead, present different possibilities for the relatives of the disappeared, although neither, of course, result in the happy reunion. Moreover, as with the Astrada piece, the text and the image function in relation to the other features of this page, in particular the background. The way in which the photograph of the exhumations fades in, partially obscuring the Buenos Aires plaza beneath, intimates that it depicts what lies under the surface of Buenos Aires. Thus, a close relationship is established between the cityscape of Buenos Aires, and these cadavers as the subterranean figures haunting it; below the picture-postcard image of the city square, both figuratively and literally, lie these mass graves that illustrate in stark fashion the outcome for the disappeared son in Cabales's story.

In this section, therefore, we witness a creative recombination of texts and images that trace a resistant discourse on the Buenos Aires cityscape. In each case, as with that of the other three pages included in this section, this multimedia assemblage makes creative use of the possibilities of new media technologies, particularly in the interlinking and superimposition of texts and images, to generate the shadowy presence of the bodies of the disappeared haunting the cityscape of Buenos Aires.

If the preceding examples are cases in which print texts have been remobilized into the curatorial interface in order generate new, multimedia works of art, three other of the links from the curatorial homepage open up three works that were, conversely, designed digitally and for presentation on the web from their inception. This is the case of the three links in the main page labelled 'Marina Zerbarini', 'Andamio Contiguo' and 'Irene Coremberg', each of which opens up in a new window a work of art by each of these three artists.

The first of these opens a net art piece by Marina Zerbarini titled *Tejido de memoria* [*Memory Weave*], in which the memory of the dictatorship is closely interwoven with the injustices of the present, and in which the cityscape of Buenos Aires comes under close focus throughout (see Figure 3.2).[8] This is immediately evident from the main screen of the work whose background, however far we scroll to the left or to the right, remains the same: a black-and-white photographic image repeated several times in a mosaic format, depicting the interior of a building, with bare walls, concrete columns and high windows. Although not explicitly identified as such, the location in the photograph is the basement of the ESMA (Escuela Superior de Mecánica de la Armada) in Buenos Aires, one of the most notorious of the regime's torture centres where an estimated 5,000 people were detained, tortured and killed. We are, thus, firmly located within the Buenos Aires cityscape,

and one of the key memory sites which bears traces of the injustices of the past. The scrolling date located at the top right of the page then provides a further indication of the historical context in which this memory weaving works: starting at 1977, the date rapidly scrolls forward to the present day (2003), and then restarts at 1977. Of course, 1977 is one year after the installation of the dictatorship but also, more important in the context of this work, the year of the establishment of the *Madres de Plaza de Mayo* whilst 2003, as well as being the date of the work, is also the year in which then president Néstor Kirchner took the first steps towards the repealing of the *Ley de obediencia debida* and the *Ley de punto final*. The scrolling date thus carries significant meaning in terms of the bringing to justice the perpetrators of the crimes of the dictatorship, and captures, in shorthand form, the work of memory weaving—of tracing multiple connections between past and present—that is enacted by this work as a whole.[9]

The work itself comprises a myriad of named and unnamed links, many of which are hidden within the visuals and are constantly fluctuating, changing shape and morphing. This, coupled with the fact that the mouse cursor disappears at periodic intervals, deliberately frustrates any easy navigation of the work, forcing the viewer-user into an active role, and producing multiple, non-sequential narratives of memory. The content embedded within these links takes the form of video files, still photographs, texts, graphs, and user input, through whose interweaving an oppositional commentary on past and present Buenos Aires is created. There are frequent references— textual, visual, aural, statistical—to the city of Buenos Aires, as well as a repeated use of materials pertaining to the Madres de Plaza de Mayo in particular. Moreover, in addition to the use of historical sources (including, although not limited to, information from and about the Madres), there are also numerous statistics about contemporary poverty and inequality in Buenos Aires. The sources used in this work thus function to refocus the city and to contest the established meanings of the Buenos Aires cityscape from a dual perspective: from an engagement with historical sources which draw out the traumas of the dictatorship which still inhabit the modern city and from an engagement with contemporary sources which underscore the inequalities still plaguing twenty-first-century Buenos Aires.

The second of the links to online art works opens a piece titled *Nunca más* [*Never Again*] by the Argentine digital art duo Andamio Contiguo, comprising Norma Cabrera and Silvia Debona. Founded in 1992, Andamio Contiguo has a long history of collaborative theatre work prior to its collaboration in 2002 on the digital artwork included in this exhibition. The title of their work immediately situates it within the context of the disappeared and the attempt to document their lives, borrowing as it does the title from the famous report of the Comisión Nacional sobre la Desaparición de Personas.[10] The phrase *nunca más* is thus a highly charged term in Argentina, and, in the wake of the atrocities highlighted by the report that carried the same name, its use here cannot but recall the human rights abuses of the

dictatorial regime. On entering Andamio Contiguo's work we first encounter an introductory text that makes explicit reference to the disappeared, and to the 'deep black hole in the conscience and destiny of our country', and subsequently describes the work we are about to enter as a 'memory tool'. Following this, the work itself loads, starting with a black grainy screen, on which three rows of zeros, with five zeros in each row, appear across the central axis. After a short pause, the zeros start to be replaced by other numbers, as individual numbers start flicking forward quickly, whilst at the same time zeros flicker in and out briefly at random points around the screen, appearing for less than a second before they disappear again. At first sight, thus, *Nunca más* looks like a work that will play with computer coding, with flickering numbers taking centre stage.

However, the political significance of the numbers is made clear by a series of black and white photographs that appear at the left-hand side of the screen; taken in head and shoulders portrait, each photograph shows a different woman, whilst at the top right, the name of the woman appears. Just as the numbers never stay still and keep fluctuating, similarly, after only a few seconds, the photograph disappears, to be replaced by another one, with another name appearing in the top. The animation finally ends on a static screen bearing the statement 'Estos son los nombres de 145 mujeres desaparecidas en Argentina durante la última dictadura militar' ['These are the names of 145 women disappeared in Argentina during the last military dictatorship'] with below, a list of all the names.

In this work, Andamio Contiguo weave together computer coding, memory and gender, to produce a work of art that brings to the fore the historical memory of the suffering of women under the dictatorship. Again, as with the curatorial interface itself, Andamio Contiguo's piece re-semanticizes some of the key terms of computer coding, and the quasi-ludic redeployment of dated computer technologies. First, the term *herramienta de memoria* [*memory tool*] used to describe the work initially predisposes us to think we are opening a software tool that will manipulate or improve our computer's memory. However, as we engage with the work, we come to understand that the terms are re-semanticized: the 'memory' being mentioned here is not computer memory but human memory, the collective memory of the disappeared. Similarly, the rapidly scrolling numbers do not represent a computer programme being run, but the almost ungraspable numbers of victims and the ungraspable nature of the horror. The constantly flickering numbers, and the way in which zeros flicker across the screen at differing locations, is not a ludic play with codes but a comment on the sinister employment of state apparatus to track down and disappear purported subversives.

Second, the imagery within this piece, with its reliance on the same repeated photographic format—a grainy, high-contrast headshot– situates the work within the context of political protest, particularly that of the Madres de Plaza de Mayo. As has been frequently noted, the composition and style of this photographic format—black-and-white headshots,

usually in a straight-on frontal shot, and grainy due to multiple copying and enlarging—has become one of the most potent and easily recognizable symbols of the protest marches of the Madres de Plaza de Mayo. Moira O'Keeffe (2009) notes that the shared formal aspects makes this particular photographic format an identifiable category for the representation of the disappeared, and argues that their particular significance lies in the fact that, when the Madres de Plaza de Mayo first began to demand information about the whereabouts of their children, the regime responded that there was no evidence that these individuals existed nor had disappeared. The use of the official identity document photograph, then—in preference to, say, family photographs or holiday snaps—was a deliberate strategy of resistance by which the Madres proved that their children existed, and so functioned as a 'a prop of witnessing and of protest' (O'Keeffe 2009: 528). The use of the headshot within Andamio Contiguo's work thus immediately brings to mind the Madres' tactics, functioning as an image of resistance and of the refusal to forget. At the same time, however, O'Keeffe has argued that the format of the identity photograph as used by the Madres does not dwell on the individual. Noting how, in the identification photographs employed by the Madres, it is impossible to make out much facial detail, O'Keeffe (2009: 528) argues that 'the actual face of the missing individual is not the focus of interest here; it is the worth of the photograph as evidence of a life that provides the meaning in these gestures'. Indeed, this fact appears to be acted out in Andamio Contiguo's *Nunca más*, in which the fast scrolling forward of photographs never allows us to dwell on one particular individual for any length of time and in which the frequently poor quality of the reproduction of the photograph means that we cannot always discern the individual facial features clearly. This presentation of the images is then coupled with the scrolling numbers which continue this understanding of the value of the photographs: the numbers are in a sense a roll call, a list of persons to provide evidence of a life.

Finally, significant in Andamio Contiguo's piece is its deliberate gendered focus. Throughout the animation, the images display only female faces, and the text at the close specifically flags for us that these represent 145 women who were victims of the dictatorship. This focus on disappeared women is an attempt to bear witness to the estimated 30% of *desaparecidos* who were women (figure cited in the Comisión Nacional sobre la Desparición Personas [CONADEP] report). In so doing, Andamio Contiguo's piece resonates with the curatorial interface within which it sits, tracing connections between its own roll call of women victims and the broader networks of female solidarity and resistance established by the interface.

Finally, the third of these digital art works is Irene Coremberg's *Túneles de la memoria* [Memory Tunnels]. A brief gloss of the work appearing in the right-hand window again makes explicit reference to the disappeared, whilst the window opening up across the main screen of *W:MoR* displays, in saturated tones, a colour image, with bright green hues of water in the

background and a sepia photograph showing a head-and-shoulders portrait shot in the foreground. Again, as with Andamio Contiguo's piece mentioned earlier, the head-and-shoulders shot immediately recalls the photographs employed by the Madres in their protest marches, but here the facial features have been blanked out; although the hair, the ears and the outline of the chin are visible, the face has no eyes, mouth or nose. The way in which the work is initially displayed here, partially overlapping the city square of the W:MoR interface, again suggests conjunctions between the two locations. Indeed, as we discover on entering the work, the lurid green water is that of a tunnel, and its insertion here into the cityscape implies that running beneath the picture-postcard surface of the Buenos Aires cityscape is this tunnel carrying the memories of the disappeared.

Once entering the work itself, the animation starts with an image of high brown walls to either side of the screen with the same lurid greenish water at the bottom of screen. Continually over this first half of the animation, the same sound is repeated: that of dripping water, with a hollow ring to it. After approximately six seconds, the image suddenly zooms forwards, down the tunnel, with our perspective as if at waist height moving through the water. As we move forward, we see several photographs superimposed, floating on the water; in sepia and crumpled, each photograph shows the same male face in a head-and-shoulders shot, but progressively the facial features start to become erased. In the first, the photograph has the mouth erased; in the next, the mouth and eyes; and so forth until we reach a photograph that simply has a scrawl across it, reading 'no name'. Then, beyond and into the vanishing point, several blank photographs appear, floating in the water. Subsequently, the perspective alters and we move under water, and at this point, the sound changes to a harsh, buzzing noise as if emitted from a weapon or alarm. In front of us, eventually occupying all the screen, appears a composite image of dozens of passport-style photographs set into a montage, which rises from the bottom of the screen and in which the images are rendered in negative format. The images rise upward, above the water level and out of the top of the frame (see Figure 3.3).

This short animation, and the way in which it has been inserted into the curatorial interface, establish a strong connection between politics, memory, and the cityscape. The image of the tunnel in Coremberg's animation draws on another of the over-determined place-based tropes of the Argentine national imaginary: that of the river. The lurid, eerie waters with the hollow dripping sound bring to mind one of the military's favoured methods for the disposal of the bodies of the disappeared, namely, into the country's waterways, and often into the Río de la Plata itself. In the late 1970s at the height of the dictatorship, bodies began to wash up on the shores of the Río de la Plata, leading human rights groups, including the Madres, to suspect that the military regime was disposing of the bodies of the disappeared in this way. This was publicly confirmed after the end of the dictatorship in the high-profile revelations of retired Argentine naval officer Adolfo Scilingo

in 1995, who described the so-called *vuelos de la muerte* [death flights] in which the navy would take live prisoners, drug them and push them out of planes to their death. As a result, the banks of Río de la Plata have become another symbolic memory site in Argentina: as Tandeciarz (2007: 153) notes, the decision to build the Parque de la Memoria on the shore of the Río de la Plata was due, in part, to its proximity to the river where thousands met their death, whereas Payne (2008: 48) comments on the use of shore of the Río de la Plata as a symbolic site for the scattering of ashes of one of the founders of the Abuelas. The river is thus a highly charged location, and Coremberg's setting of her animation within a subterranean, watery tunnel encourages us to read the images within it as representing the disappeared. Indeed, Coremberg's tunnel resonates with the other location employed as backdrop by the interface, since it establishes a connection between the two locations—the city plaza and the waterways—suggesting that beneath the picture-postcard facade of the city lie the waterways that carry the bodies of the disappeared to the sea.

Within this evocative setting, and offset by the disturbing, non-diegetic sounds, the photograph takes centre stage as the principal motif that runs throughout the animation. In the first half of the animation, the photographs appear fleetingly in front of us, before sliding just out of our grasp, and in their depiction of the human face that is progressively robbed of its individual features, they provide an extended metaphor for the fate of the victims of the dictatorship who were 'disappeared' just as the facial features disappear. This visual metaphor for the disappearance of the individual and the lack of due process culminates in the fifth photograph, where even the outline of the face has disappeared, and the sheet of photographic paper bears only the words 'no name'. These words have a particular resonance in an Argentine context since the term *ningún nombre* [no name], 'NN' written as shorthand, was used by the military regime on the graves of the disappeared on the edges of official cemeteries as noted earlier and was allocated to the babies born to women in captivity who were subsequently given away.[11] 'No name' thus has an immediate political resonance and encourages us to read the progressive wearing away of identity in this sequence as representative of the experience of the disappeared.

This first half of the animation, then, conveys the process of the denial of identity by the regime and the erasure of body. If such is the impact of the photographic images in the first half, the second half turns this on its head and employs the photograph as a symbol of resistance and as bearing the traces of identity. In this second half, the mosaic composed of 35 individual photographs again borrows, as with Andamio Contiguo's piece mentioned previously, from the classic identification shot that immediately recalls the Madres' protests, but now these images are rendered as negative. The significance of the negative here is that it functions both as a ghostly trace of the human—the individual features are almost impossible to make out in this reverse image—but at the same time stands as an image of reproducibility

and the negation of erasure. Since multiple copies can be made from the negative, identity cannot be fully erased, for the photograph can be printed again and again, and so this image, despite its haunting, shadowy depictions of the human face, becomes an image of resistance as it rises slowly from the waters, bringing up from the depths the memory of these individuals.

These three works, in their different ways, thus engage in explicit commentary on the military regime and its aftermath, and, to varying degrees, establish connections between iconic locations they depict and the hidden memories of these locations. *Tejido de memoria* draws on visual, textual and aural material relating to the Plaza de Mayo and the Madres, yet also establishes relational sense of place, linking the Plaza and the protest to other zones and iconic locations within Buenos Aires. *Túneles de la memoria* establishes a close link between another key site of memory—the city's waterways—and the memories of the disappeared, creating an extended visual metaphor for the fate of the disappeared and the possible recuperation of their memory at the animation's close. *Nunca más*, although offering no overt depiction of the cityscape, nevertheless by its mobilization of the classic photo format used in the Plaza de Mayo protests, brings forth the photo as a 'prop of witnessing' and recalls its use in this iconic location. Although functioning as works in their own right, the insertion of these three pieces into the *W:MoR* interface establishes interconnections with the interface itself and between and among the various constituent works it comprises.

If the preceding are examples of the way in which the works of other writers and artists are creatively remixed into Partnoy's work, another substantial section of this work, titled *Family Portrait – Art, Memory, and Politics*, opens up a hypermedia project that remixes the works of Raquel Partnoy herself, including her paintings, essays and poetry, along with those of other members of her family: sections of prose and poetry by her daughter, Alicia Partnoy; poetry by her granddaughters Ruth, Eva and Anahí; and an extended essay by her husband, Salomón Partnoy. *Family Portrait* constitutes one of the most substantial sections of *WMoR*, containing 74 individual web pages that combine text, image, sound and animation. Again, as with the reworking of poetry, testimonials, narrative and correspondence by other authors as analyzed earlier, so, too, in *Family Portrait* the artistic value of the work lies in its creative recombination of existing works to explore personal stories, memory and sociopolitical context.

The initial screen of *Family Portrait* has a dark blue background, with an image showing a cityscape in high-angle shot taken at dusk of Bahía Blanca, the hometown of the Partnoy family in Argentina. Superimposed across this are three photographs depicting Raquel Partnoy to the centre, Alicia Partnoy to the right of the frame and Ruth Irupé Sanabria (Alicia Partnoy's daughter) to the left of the frame.

On clicking 'Enter', an initial screen of dark blue is loaded, over which a jagged red line, resembling a crack or barbed wire cutting across the screen from top to bottom, is superimposed. The line appears three times, each

section of it appearing jerkily, in jump-cut, whilst the accompanying noise is a harsh, metallic sound, possibly a rapid-fire weapon or a piece of electronic equipment. After the jagged line appears for the third and final time, it opens outwards, creating a jagged space in the centre of the screen into which a colour image appears. The image, although not credited here, is immediately recognizable as one of Raquel Partnoy's paintings: one of her works in the *Surviving Genocide* series, the painting depicts three human figures, two of whom are blindfolded with a third, to the left of the frame, with his face uncovered. Painted from the 1990s onwards, the *Surviving Genocide* series of paintings was conceived of by Partnoy as a way to bring together the history of Jewish peoples suffering under the genocide of Nazi Germany and those who suffered under Argentina's military dictatorship (Partnoy 2005a: 226). The image, thus, immediately has resonance with Partnoy's other artistic projects and, in particular, immediately sets this work within the timeframe of the military dictatorship.

Moreover, the associations of this particular image, in preference to any other from the *Surviving Genocide* series, lie in the resonances it already brings with it. The specific image here is a colour painting titled 'Con los ojos vendados' ['Blindfolded'], based on a black-and-white drawing that Raquel Partnoy drew to illustrate her daughter Alicia Partnoy's *The Little School: Tales of Disappearance and Survival in Argentina* (1986). This collection of tales narrates Alicia Partnoy's experiences when held in the notorious detention centre *La escuelita* [*The Little School*], from which the book takes its name, telling of her plight and that of several of her companions in the centre. Given that Alicia Partnoy's volume is one of the most famous testimonies of the Argentine dictatorship, the image used to accompany it, and which appears on the front cover of many editions of the book, is thus immediately recognizable. As Cooey (1994: 88) notes, in its original setting in *The Little School,* this image communicates the violence of the prisoners' situation, whilst also conveying 'the prisoners' resistance to victimization and to a fetishizing of their pain'. Indeed, it is worth noting that scholars such as Detwiler (2000: 65) have recently argued that this particular image—the blindfold—is the central trope of Alicia Partnoy's text: described again and again in the testimonies, represented in the accompanying artworks and alluded to via the pervasive use of synecdoche and metonymy throughout the narrative, the trope of the 'blind-folded eye-witness' structures the entirety of the text. Since this same screen loads when we access any of the sections within *Family Portrait*, this image similarly becomes the leitmotif or logo of the work, representing the tension between the necessity of the act of bearing witness, on one hand, and the bewildering sensory experiences of the disappeared, on the other.

From this highly charged image, we then access the main content pages of the work. Clicking on the subtitle that appears below the image—'Art, Memory and Politics 2'—loads another screen, depicting the same cityscape that we saw in the earlier screen, over which an image of a menorah fades in towards the bottom of the screen and the names of the three women in

blue font zoom forward over the centre of the screen. To the bottom right of the image, four further names appear, each preceded by a '+' sign: José, Salomon, Eva and Anahí. Again, as with other elements of this work, there is a close link established between the cityscape, the personal story (the names of the family members) and computer coding, in which the '+' symbol is used here not to represent the ubiquitous computer programming langue C++ but to create a family tree. Moreover, given that the '+' symbol is the same symbol employed in the opening screen to frame the words 'women and the memory of repression in argentina', a graphic matching is established with the home page, allying this opening page with the politically charged imagery of the home page.

The various sections within the work remix textual extracts, images, and sound files from the creative output of the various members of the Partnoy family. After a prologue consisting of segments of text taken from Raquel Partnoy's essay 'Surviving Genocide' (2005a), accompanied by sounds and images, the main sections of the work present artistic and literary representations of repression alongside factual and testimonial sources.[12] The section titled 'Main part' consists of sixteen individual lexia each of which are presented alongside a reproduction of a painting by Raquel Partnoy. The first three of the lexia are extracts taken from Raquel Partnoy's (2005b) biographical essay 'The Silent Witness', discussing her motivations behind her various series of paintings, and focusing particularly on her aim of preserving family memories in her paintings.[13] The following ten lexia are composed of extracts from the introduction to Alicia Partnoy's (1992) poetry collection *La venganza de la manzana*, all but one accompanied by a reproduction of one of Raquel Partnoy's paintings, and a sound file.[14] The extracts selected here focus on the attempt to bear witness: the lexia tell of the experiences of a female prisoner in the third person, in particular her striving to record her suffering in a notebook, the attempts by herself and other prisoners to convey their experiences, the possibility (or lack of) of poetic expression and the inadequacy of language to capture the horror of what they are experiencing. Again, the creative force of the individual lexia comes as much from the conjunction of the texts with images and sounds as from the textual extracts themselves. This is particularly evident in the first of these ten lexia, in which the textual extract, image, and sound file work together less in a smooth, transparent narrative than in a creative tension. Here, the textual extract begins with 'in a prison cell in South America, a woman is trying to remember every single poem she has ever written' and continues with a reference to the date and country. The extract ends by emphasizing the significance of the written word as a way of bearing witness:

> No longer blindfolded, she is now 'free' to read the hundreds of messages scratched into the walls with the bottom edges of toothpaste tubes. Most importantly, her captors have given her a precious pen and a brand new notebook.

This textual extract is accompanied by a sound file of a woman's voice, yet, crucially, the sound file does not actually correspond to the text; instead of hearing the text read out as we see the written words, we hear an entirely different reading. The sound file consists of a woman's voice—Raquel Partnoy—reading out one of Alicia Partnoy's (1992) poems from the same collection, titled 'Testimonio'. Here, again in contrast to the written text, the poem is read out in Spanish, and starts by declaring 'El micrófono / me hace una reverencia / de cablas enroscados' ['The microphone / bows to me / with its tangled cables']. Thus, whilst we read about the woman's experiences as a prisoner in the third person, simultaneously we hear a woman talking in the first person, describing how she gives testimony in a court of law. The combination of text and sound file here, thus, creates a double timeframe: that of the prison cell, when the suffering took place, and that of the court of law, when the suffering was later denounced. It also establishes a strong connection between bearing witness through poetry in the textual extract and bearing witness in the court of law in the sound file (which, in itself, is a voiced poem). At the same time, underneath this sound file, we can also hear a further sound file, that of the same musical theme in a minor key that played over the 'Prologue' section. The overall effect here is thus a deliberately disorientating scenario in which text and sound are mismatched, and we have to strive to make out the voices competing for attention. The lexia thus engages in an enactment of the experiences of the blindfolded eyewitness as she struggles to make sense of her experiences, and that of the families of the disappeared in their searching for the traces of their loved ones.

Added to this, the accompanying image then strengthens this sense of attempting to bear witness whilst also shedding light on the interpretation of this lexia as a whole, for the image reproduced here is the painting 'Con los ojos vendados', the same one that opened *Family Portrait* as a whole. As noted earlier, the blindfold was one of the central motifs of Alicia Partnoy's (1986) earlier collection of testimonial tales, *The Little School*. As Detwiler (2000: 62) has argued in the context of this earlier work, the overwhelming presence of the blindfold sets up a series of double articulations in which '(eye)witnesses undoubtedly manage to "see" the referent through a combination of sensory input from sources other than the visual mode' and are 'compelled by the presence of the blindfold to construct unity out of their hyper-fragmented environment'. This image of the blindfolded eyewitness is one which thus brings with it the necessity of drawing on multiple sensory sources in the attempt to bear witness. The painting, thus, provides us with the key to how the creative mixing of sound, text and image in this lexia is to be interpreted: it is only through our understanding of the text, sound files and images as competing voices for our attention, but which all must be taken into account, that we can start to build a composite understanding of the lexia. Like the blindfolded eyewitness, we, too, must constantly attempt to assimilate multiple textual, visual and sonic sources in our negotiation of this work.

This lexia and the others like it in this section thus creatively remix text, image and sound to create a composite work of art. Crucially, the tactics here, and in particular the first of the 'Alicia' lexia which forms an interpretative key, set out the *complexity* of bearing witness. That is, as our navigation of the lexia makes clear, the act of bearing witness is not straightforward, and as readers/viewers, our access to the experiences of those disappeared by the dictatorship is not straightforward.

The subsequent section, 'Argentina in Flames', makes use of two different genres of written text: it presents first fifteen lexia containing extracts from the essay 'Disasters of Neoliberalism' by Salomón Partnoy (2002), followed by five lexia containing extracts from a speech given by José Partnoy on the death of Felipe Glasman in 2002. The first of these source texts is an essay originally published in the left-wing journal *Covert Action Quarterly* in 2002, in which Salomón Partnoy criticizes the neoliberal policies of President Menem and his counterparts in other Latin American countries. The extracts presented in *Family Portrait* are a condensed version of the original, lengthier essay, and although some parts have been adapted and others cut, both the original essay and the extracts provide a blistering critique of neoliberalism, slating it as a political philosophy which, in the words of Partnoy involves national sovereignty being 'subjugated to the global capitalist system' (lexia 7). The extracts cover a wide range of historical reference points, from the Peronist era, the dictatorship, Menem's presidency (1989–99), and the la Rua presidency (1999–2001), although the majority of the lexia discuss the economic crisis of 2001, including reference to the default on the country's foreign debt, the *corralito*, the popular protests on the streets of Buenos Aires, and rising unemployment. Ten lexia are accompanied by photographs, most of which depict riots and demonstrations in Buenos Aires, in front of or inside major national landmarks such as the Banco de la Nación Argentina, and several depict the *cacerolazos* [pot-banging protests]. Throughout these lexia, the conjunction of the textual extracts with images establishes a strong sense of physical place, as the images locate the text spatially, and link protest to several key locations within Buenos Aires. Moreover, through a variety of strategies, parallels are drawn between the practices of neoliberalism and the earlier period of repression under the military dictatorship. This is effected via the organization of the material, which moves back and forth across time periods from the 2001 crisis to the earlier military regime, as well as through the striking visual parallels being drawn. Here, for instance, images of the riot police charging the protesters in 2001 (shown in lexia 2 and 4) bear a notable resemblance to images of repression by the armed forces on the streets in the military coup of 1976 and its aftermath. These visual parallels, which become evident as we weave our way through the lexia, encourage us to draw connections between the earlier period of repression and the present day, including de la Rúa's deployment of the federal police to put down protests in the Plaza de Mayo in the last few days of his presidency in December 2001, a fact explicitly mentioned in

lexia 13. As with Zerbarini's tactic in her *Tejido de memoria* mentioned previously, in which she intimated that the work of the Madres did not come to an end with the end of the dictatorship, here, the situating of these extracts within a broader trajectory of ongoing injustices in Argentina encourages us to continue to question the actions of the ruling class in Argentina and to interrogate, if no longer the overt violence of a military regime predicated on the torture and disappearance of purported subversives, then the structural violence of a neoliberal state.

This section is then followed by the 'Between Two Skies' section, which explicitly sets out to explore the conjunction of landscapes and humanscapes and includes creative pieces by five women of the family: Raquel, Alicia, Ruth, Anahí and Eva.[15] Of the fifteen lexia linked to Raquel, eight include a painting by her, accompanied by text, whilst seven present text only. The texts set out Raquel's motivations for her various series of paintings, starting with the significance of Bahía Blanca as a landscape and moving onto other landscapes and cityspaces within her work. All the lexia within this section are accompanied by the same sound file which runs over them: a version in minor key of the highly stylized and much replayed tango song 'Jealousy'.[16] The minor key and discordant tones establish a link with the discordant music that plays in other sections of the work whilst also, via the genre of tango in particular, making an intertextual reference to Raquel Partnoy's series of paintings based on the themes of that musical genre. Here, the fact that this highly famous song is here rendered in screeching tones, and with sparse orchestration, implies that, just as with Partnoy's paintings on tango, the musical genre is not to be taken at face value; rather, it should to be interrogated as to its implicit gender hierarchies. Like the picture-postcard image of the couple dancing tango that opened *W:MoR,* the song 'Jealousy' here hints at a facade that is to be dismantled in the course of our viewing of the work as a whole.

In particular, the third and fourth lexia of this section, titled 'Cityscapes 1' and 'Cityscapes 2', respectively, draw out the relationships between cityscapes and humanscapes in Partnoy's works, and, we may extrapolate, in the functioning of *Women: Memory of Repression* as a whole. In the first, Partnoy comments that 1976—the year of the military coup—was when human figures began to appear in the doorways, windows and skies of her paintings of cityscapes. Commenting on the indifference of the population to the atrocities that were happening around them, Partnoy personifies this attitude in the cityscape itself, arguing that 'my city, the cold Bahía Blanca, was silent', and flags up the institutions of the city—the army, the Catholic Church and the press—as complicit with this. In the second, Partnoy affirms the need for a 'human presence in my cityscapes' and describes how the series *The Inhabitants of Silence* was intended to tell the stories of the disappeared and how the series *The Dolls* was to narrate the experiences of those who, like Ruth, are left without parents. Accompanying these two texts are reproductions of her paintings, 'The Saltmarsh' and 'The Street of the Castle' (1978),

respectively. In both images, the windswept landscapes and the twisted, contorted lines of the buildings create a disorientating, unwelcoming environment whilst in the latter, the foregrounding of the doll, and the two shadowy human figures in the background create a visual impression of the destruction of family life in this hostile environment. Again, as with much of this work, the paintings speak for themselves but also resonate with the multiple lexia with which they are interlinked; here, the notion of human, personal tragedies being played out against a harsh, distorted cityscape resonates with the tales of human suffering told by Alicia's poetry in earlier sections of this work.

Four of these lexia also contain poetry by Raquel Partnoy herself, including, in the lexia titled 'Humanscapes 2', the poem 'Blindfolded'. A short explanation from Partnoy accompanies the poem, explaining that 'in both painting and poem, I not only tried to tear away the blindfolds from their eyes but also unveil/reveal the truths of such a mad time'.[17] Thus, again, in this section of the work, there is an obsessive return to this central motif or logo of the blindfold. In the poem itself, the image of the 'light-hand-mother / tearing away cloth / from oppressed eyes / walking mad, /roaming streets' of the second verse establishes an implicit link with the actions of the Madres de Plaza de Mayo, through the appellation of 'mad' given to the mother figure. The Madres were famously labelled by the military regime 'las locas de la Plaza de Mayo' ['the mad women of the Plaza de Mayo'], in an attempt to dismiss their high-profile protests in the political centre of Buenos Aires. As Guzmán (1994: 244) has observed, this appellation was intended to 'undermine their credibility in the public's eyes, and to keep them in their places—that is, marginal and invisible'. Yet the Madres subsequently took up that appellation as a term of resistance; it has often been mobilized in speeches by de Bonafini and others, and significantly, one of the publications of the Asociación Madres de Plaza de Mayo—the journal *Locas: Cultura y utopía* [*Mad Women: Culture and Utopia*], established in 2000—takes the term as its title. The act of 'tearing away cloth/from oppressed eyes' thus becomes one of collective action, through its association with the Madres. This association is then made even stronger in the second verse when we read of the 'light-mothers-hands, / holding signs / holding photos / of their children, / they who march / every Thursday / searching, reclaiming / and searching still'. Here, the actions of the light-mothers' hands are those of the Madres in their protest marches every Thursday in the Plaza de Mayo.

This particular lexia thus establishes a clear link between Partnoy's paintings and the actions of the Madres, and as a result, we are encouraged to reread this same image that we have seen elsewhere throughout this work. Here, and throughout this work, the blindfold becomes a kind of visual counterpart to the Madres' headscarf logo: where the Madres' headscarf was about visibility, about marking out the Madres as resisting the logic of the military regime, the blindfold is concerned with obscuring vision. This particular lexia thus puts these two prominent images into play with each

other, revealing that the hand grasping at the blindfold here, and attempting to tear it away, is an allegory for the Madres. It is only as we navigate through the multiple links of this work that we start to draw all these threads together, and the full meaning of the image logo becomes clear.

If this conjunction of image and poetry functions within one particular lexia, other conjunctions are deliberately drawn across several lexia. For instance, the second, fourteenth and fifteenth of these lexia are all interwoven with intertextual references, but it is only once we have navigated through all of these lexia that we come to realize their interrelatedness and construct a narrative that runs across multiple lexia. Lexia 2 comprises a reproduction of Partnoy's painting 'Clamour', accompanied by a biographical text detailing Partnoy's years in Bahía Blanca. Lexia 14 consists of two paragraphs of a short text describing the Argentine economic crash of 2001 and the ensuing social unrest, accompanied by a reproduction of Partnoy's painting 'Dreaming of Peace'. Lexia 15 has no image but is instead comprised of three columns of text, the first a short introductory paragraph and the next two being the verses of Partnoy's poem, 'Landscape'. The short paragraph informs us that the poem we read in this lexia and the painting 'Clamour' are companion works intended to demonstrate 'how impunity left free all the assassins responsible for the killing of people during the years of dictatorship' as well as to narrate how 'injustice, due to impunity, did not punish the corrupt governments who led to the disastrous economical situation that Argentina's population is currently enduring'. In this textual extract Partnoy is attempting to draw parallels between the actions of the military dictatorship and those of the democratic governments that followed them. Although not mentioned directly by name, we can assume that Parnoy is referencing the Menem and post-Menemista neoliberal reforms in the era running up to the 2001 crash.[18] This attempt to establish interconnections between the two historical periods is then mirrored in the technique of interconnecting different lexia, as we are now encouraged to weave a narrative that encompasses lexia 2 that displays the image, lexia 14 that sets out the factual data and lexia 15 where we have the poetic representation. If we track back and forth across these lexia, we notice that the imagery of the poem in 15 speaks to the images we have seen in the painting in 2. Its opening stanza, declaring that the 'the impunity of assassins darkens the sky' is complemented by the painting where the sky, far from a natural blue, ranges from dark black at its edges to an ochre at its centre. Similarly, the two human faces emerging from the clouds in the painting, with their skeletal features and mouths opened as if protesting or screaming, are mirrored by the third and fourth lines of the poem which declare that 'even in the shadows people scream out / they cry for their dead'. Perhaps even more importantly, some of the more allusive elements of the painting are drawn out when viewed in conjunction with the poem. For instance, in the painting we see a cityscape in which three large buildings, across the horizontal axis of the painting, are twisted and at angle, as if starting to fall, with

the largest of these buildings, to the left of the frame, recalling the iconic medieval building, the Leaning Tower of Pisa, in its multiple layers and its list. However, when reading this image alongside the second stanza of the poem—'Gray ghosts roam the landscape/ dressed up in the arrogance of their epaulets/ walk hand in hand/ with businessmen'—the medieval building is now re-interpreted as representing a contemporary crisis: it stands for the effects wreaked on the Argentine economy of the neoliberal reforms of the 1990s and 2000s. Thus, the conjunction of text and image has established a close connection between landscape, the actions of the military junta via the synecdoche of the epaulets and the neoliberal policies of the democratic governments as represented by the businesspeople. This connection then allows us to read the image of the buildings as depicting the skyscrapers of the central business district of Buenos Aires, representative of the neoliberal reforms and the subsequent crash. Indeed, the links between suffering during the dictatorship and suffering under neoliberalism are strengthened in the light of Salomon's essay which we accessed in an earlier section of the work; again, we create meaning across the various lexia, and our viewing of the painting and reading of the poem here will be influenced by our access to the essay earlier in the work.

In these ways, the curatorial interface of *W:MoR* and the constituent works it houses engage with the city of Buenos Aires and some of the central sites of memory within it. The works frequently display a relational understanding of place, first, through the ways in which the locale depicted becomes relational spatially, as it is linked across space to other locales of resistance, and second, through how the locale becomes relational temporally, since it is linked backwards and forwards in time to earlier and later periods of repression. Each of the works engages in a dialogue with past repression and an attempt to bring forth memories of the dictatorship, but, that said, each work does not follow the same strategy. Some, such as Coremberg's *Túneles de la memoria*, deal exclusively with the past and propose the recovery of memory; others, such as Zerbarini's *Tejido de memoria* or Agricola de Cologne and Partnoy's *Family Portrait*, combine this recuperation of past memories with an interrogation of present concerns. The varied works do engage with the memory of repression, but, as several of them demonstrate, this memory is ongoing, marrying the memory of dictatorial violence with the recent memory of structural violence. Here, Zerbarini's use of contemporary statistics demonstrating continuing inequalities and poverty within Buenos Aires, or the creative remixing of Salomón Partnoy's essay denouncing neoliberalism with images that recall an earlier period of dictatorial abuse maintain a delicate balance, not positing that the structural violence of neoliberalism is akin to torture, but, rather, demonstrating how structural violence must also be brought under scrutiny. It is this structural violence—the violence of the neoliberal model—that comes under question in the work to be analyzed in the next chapter, Brian Mackern's *34s56w.org*.

NOTES

1. The report of CONADEP (Comisión Nacional sobre la Desaparición de Personas) documented slightly fewer than 9,000 cases of disappeared persons, although the real figure is likely to be substantially higher. As noted in Brysk (1994: 683), CONADEP was only able to process less than half of the material it received during its nine-month tenure, added to which new reports of disappearances were still being submitted from rural areas as late as 1988, long after CONADEP had completed its report. Human rights organizations have set the figure at somewhere between 15,000 to 30,000 disappeared; the Asociación Madres de Plaza de Mayo sets the figure at more than 30,000 cases (Asociación Madres de Plaza de Mayo 2005), as does Amnesty International.
2. ASCII art started as a way of creating images before computers had graphical facilities, and involved producing on-screen drawings by forming shapes out of ASCII letters, numbers and symbols. Since Courier font is a monospace font, where all characters are identical in width, it was one of the preferred fonts in ASCII art, because the fixed size and shape of the character is important in the formation of the image. More recently, the works of JODI and Vuk Cosic have played with this early digital art form; see in particular Cosic's (1999) *ASCII History of Moving Images* and his *3D ASCII* project. Indeed, it is worth noting that contemporary ASCII artists stress the connections of this digital art form with a much longer history of pre-digital artistic and textual experimentations; see Cosic's references to Mallarmé, Apollinaire, Dada and OuLiPo as forerunners of ASCII art (Cosic 1999: 20).
3. The logo is employed extensively by the Asociación Madres de Plaza de Mayo in its website, its radio, its press releases, its Twitter account and its journal, *Ni un paso atrás* [*Not even one Step Backwards*], in which the *o* of *paso* is replaced by the headscarf logo.
4. These are, in order, the poem 'The Hordes Came' by Etelvina Estrada, the short story 'A Visit to my Mother' by Irene Martínez, the testimony 'Arriving at the Plaza' by Matilde Mellibovsky, the letter 'Dear Alicia' by Carmen Batsche and the short story 'Black Eyes' by Graciela Cabales.
5. Da Silva Iddings, McCafferty and Teixeira da Silva (2011: 13), in their research into graffiti literacies in the Vila Madalena neighbourhood of São Paulo, have argued for the 'ecosocial nature of graffiti' since it has become 'integrated into the environment, semiotically interacting with the space it occupies and the inhabitants', whilst Kane (2009: 9), in her research into stencil graffiti in Buenos Aires argues that it should be understood as an 'illegal, multi-vocal, visual urban discourse that alters the texture of street experience through inventive juxtaposition of mass-mediated and local imagery'.
6. The EAAF was first established in 1984 by request of CONADEP and the Madres in order to respond to the need to identify the disappeared, and has subsequently been involved in the excavation of mass graves around the country and, more recently, worldwide. For more on the activities of the EAAF worldwide, see Egaña et al. (2008).
7. The photograph is displayed on p.59 of the *EAAF Annual Report 2005* (EEAF 2005).
8. For a detailed analysis of Zerbarini's *Tejido de memoria*, see my chapter 'Reworking the Lettered City: The Resistant Re-territorialisation of Urban Place' in Taylor and Pitman (2012).
9. The *Ley de punto final* (Law 23,492) was passed in December 1986 to put an end to prosecution of those accused of violence during the dictatorship, whilst the *Ley de obediencia debida* (Law 23,521), passed in 1987, stated that neither officers nor subordinates could be legally punished for crimes committed

during the dictatorship since they were acting out of 'due obedience'. Kirchner took the first steps towards repealing both laws in 2003, leading to two years of legal debates, at the culmination of which, in 2005, the Argentine Supreme Court declared these amnesty laws unconstitutional, thus paving the way for future judicial proceedings. The repealing of these laws was largely seen as a victory for human rights, and led to the reopening of cases against the perpetrators of torture and other human rights abuses.

10. The report of CONADEP was titled *Nunca más: informe de la Comisión Nacional de la Desaparición de Personas* (1984).

11. An estimated 500 babies born to women who were held captive by the military regime were subsequently abducted and given away, often to military personnel or friends of military personnel; for more on this see Arditti (1999).

12. The full text of Partnoy's essay 'Surviving Genocide' is published in Ruggiero (2005: 209–23), although only certain extracts are reproduced in *W:MoR*.

13. The extracts used in the lexia are condensed versions of paragraphs taken from the essay 'The Silent Witness' (Partnoy, 2005b), drawn mostly from pages 29 and 31, and focusing on Partnoy's work depicting the *desaparecidos*; many of the other topics covered in the original essay, such as her work on tango, are not included in these lexia. Part of the second lexia is also included in the 'Curatorial statement' for *W:MoR*.

14. The fourth of these ten lexia has no accompanying image and is composed simply of two columns of text.

15. The fourth and fifth of these sections contain a short poem by Anahí, aged 8, and a poem by Eva, aged 13, although these two sections are not analyzed in this chapter.

16. 'Jealousy', or 'Jalousie Tango Tzigane' was composed by Danish composer Jacob Gade in 1925 and became a major hit; it has frequently been employed in cinema as the 'archetypal' tango song, the most famous of the cases including the Hollywood blockbuster *Death on the Nile* (dir. Guillermin 1978) and Almodóvar's *Átame!* (1990).

17. These poems are 'Blindfolded', 'Between Two Skies', 'The Beasts' and 'Landscape'.

18. Carlos Menem, president of Argentina from 1989–99, ushered in a raft of neoliberal reforms, including the privatization of state-run companies, the mass dismissal of thousands of state employees, the slashing of billions of dollars of government social spending and the opening of the Argentine economy to international markets.

4 Remapping Montevideo
Affective Cartographies and Post-Digital Remixes in Brian Mackern's *34s56w.org*

Whereas the previous chapter explored an exhibition and its constituent works that focused on a particular period of repression in the past, albeit then linking this past to present concerns, the present chapter turns to a collection of works that contrast the modernity of the early twentieth century with the failures of the post-crash neoliberal era of the twenty-first century. The collection in question is *34s56w.org* by the Uruguayan net artist and curator, Brian Mackern, comprising several pieces all focused on Montevideo. The chapter focuses on how the various works in this collection engage in the production of affective maps and a resignification of the cityscape.

The key location under consideration in this chapter, and the focal point of all of the works composing *34s56w.org*, is Montevideo, the capital city of Uruguay. Founded in 1724, Montevideo is located on the shores of the Río de la Plata and is central to discourses of Uruguayan identity. Particularly in the first half of the twentieth century, Uruguay's heyday, Montevideo was hailed as a port city, emblematic of Uruguay's status as a country built on immigration; as a country facing Europe, and hence open to European ideas, and as representative of Uruguay's status as the 'Switzerland of the Americas', or as a prosperous, modern European city within Latin America.[1] The specific buildings and venues represented in Mackern's works stem, for the most part, from this period of Montevideo's history and development: they are the iconic buildings and construction projects undertaken in the first half of the twentieth century and conceived of as emblematic of Montevideo's modernity and progress. These buildings and venues include, amongst others, the Palacio Salvo, constructed in the 1920s at the height of Uruguay's prosperity and viewed as the epitome of modernity; the port and buildings around it, evocative of the port city built on immigration and an export-led economy; and the Rambla, the coastal boulevard running along the shoreline of the Río de la Plata, and emblematic of the era of rapid development and modernization of Montevideo in the 1920s.

These locations, and others like them, are obsessively repeated in Mackern's work, and yet come under intense scrutiny, in which the discourses of modernity and progress are undercut by Mackern's challenging interfaces and disturbing visual-sonoral landscapes. Mackern's pieces in *34s56w*.

org acknowledge the historical import of these buildings and locations, but do so in order to point out the contemporary anxieties and problems of twenty-first-century Uruguay, particularly in the wake of the financial crisis that shook the country in 2002. Following the economic crash of neighbouring Argentina in late 2001, 2002 saw the collapse of the Uruguayan financial system, with the economy entering into severe recession, and the Uruguayan peso being devalued by 90% (figure cited in Pellegrino and Vigorito 2005: 63). Unemployment rose steeply, average household income fell almost 20% in real terms, poverty increased, and there was a significant rise of those making a living in the informal sector with, by 2005, informal workers representing nearly half of all workers in the private sector in Uruguay (Amarante and Espino, cited in Estrades and Terra 2011: 2). It is this socio-economic climate that informs the works within *34s56w.org*; as will be analyzed, Mackern's pieces often contrast the discourses of modernity embodied in Montevideo's architecture with a wider crumbling urban environment, and jarring, dissonant sounds and images that belie these discourses. *34s56w.org* thus engages in a sustained fashion with the urban environment of Montevideo, and, in particular, with the ways in which this city can be mapped, but does so through a dual timeframe, often focusing on buildings, construction projects and venues that reflect the utopian discourses of progress of the early twentieth century but in order to critique the structural inequalities brought about by twenty-first-century late capitalism.

As noted in the Introduction to this volume, Brian Mackern is one of the pioneers of net art in Uruguay and beyond. His earlier works tended to explore the formal aspects of the net and programming languages, such as his series of 'artef@ctos virtuales' that included his *JODI/web_o_matic [n]coder* which pays a tongue-in-cheek homage to the pioneers of net.art, whereby the user types in a 'source code' which is then converted into 'lenguaje JODI' (Mackern 2000), or his *Cort_azar*, in which a series of vowel sounds, as pronounced by the Argentina author Julio Cortázar, are remixed randomly on a series of loops, as allusion to the person who 'exploró las posibilidades de narrativas alternativas que ahora son posibles en internet' ['explored the possibilities for alternative narratives that are now possible on the internet'] (Mackern, n.d.).[2] More recently, Mackern has become interested in cartographic representation and localization, and his later works have all engaged with these concerns. His *latino netart database* (2000–05) is in some ways a transitional piece, combining his earlier interests in its play with ASCII art, with his more recent concerns in its engagement with mapping practices.[3] His *Temporal de Santa Rosa [Santa Rosa Storm]* (2010), meanwhile, involves several recordings of electrical interference caused by the storm of the same name in various radiofrequencies, and which are then remixed into a visual-sonic installation that engages with the storm's geographical location as it moves over South America.

The particular series of works under analysis in this chapter all appear as part of the umbrella collection, *34s56w.org*, which is both the name of the

collection, and the URL at which they are located. The somewhat cumbersome title—at first, perhaps, frustratingly difficult for the user to remember and type into the title bar—is a deliberate tactic of Mackern's, and one which mixes references to new media technologies with cartographical representations. We are faced with a title that appears to be, at first sight, a series of random characters, mixing both alphabetic characters with numerical characters in a decidedly non-user-friendly manner. The title/URL, then, at first appears to be an error in computer code, or at least, certainly, a nonintuitive URL. However, on closer inspection what appears to be mere random conjunctions of alphabetic and numerical characters turns out to have great significance in itself, since the characters are, in fact, the coordinates of Uruguay's capital city, Montevideo, in degrees of latitude and longitude: 34 degrees South, 56 degrees West. The title, thus, renders the location of Montevideo as mock computer code and points towards the bringing together of mapping practices and new media technologies that characterizes the works in this collection. At the same time, that this title mimics an error or, to use Mackern's words, displays an 'ausencia de referencias' ['absence of referents'],[4] indicates how the works within this collection will also play with the notion of the errors or failures generated by telecommunications.

Before entering the work itself, a brief explanation of the work can be accessed by clicking on the 'About' link located at the foot of the screen which brings up a small pop-up window containing brief information and keywords about the project. This consists of the title of the work, followed by a string of keywords, these being: 'fragmentation—discontinuity—collage—vectors—psicogeography [*sic*]—transparency—multilayerization—ambiguity—connection of the different—emotional maps—organization/desorganization [*sic*]—rupture of space/time relationships'. The text itself is then superimposed over a map showing the Montevideo bay area; the map is black with grey outlines and appears dated, showing mostly features of the landscape rather than roads with very little detail of infrastructure.

This brief, telegraphic introduction to the topic provides key words that, in their layout on the page, recall the keywords of search engines; separated by dashes, they appear to be successive attempts to classify or access the works we are about to view, rather than the conventional narrative introduction commonly used to describe an artist's work. The terms themselves all centre on mapping and visualization but point towards the disruption of or questioning of conventional mapping norms. Hence, we are introduced to the notion of multilayerization rather than transparency, to ambiguity rather than clarity, and to the simultaneous presence of the antonyms 'organization/desorganization' [*sic*], all of which trouble the conventions of mapping practice. In particular, the term 'psicogeography' [*sic*] indicates how this work will attempt to create an alternative mapping experience, and is, I argue, the interpretative key to this work. The term makes reference to 'psychogeography', the practice developed in the mid-twentieth century by the Situationists and first articulated by Guy Debord, in his 1955 essay

'Introduction to a Critique of Urban Geography'. For Debord (1995: 3), psychogeography was intended to refer to practices involving 'provisional terrains of observation, including the observation of certain processes of chance and predictability in the streets', and should aim to reveal 'the precise laws and specific effects of the geographical environment, consciously organized or not, on the emotions and behaviour of individuals'. Two years after the publication of Debord's essay, the Situationist Internationale was founded, bringing together four avant-garde groups that went on to publish twelve issues of their journal *Internationale Situationniste* until 1969.[5] A favoured technique of the Situationists in their psychogeographical research was the 'dérive', which aimed to make the participant aware of the states of mind associated with certain streets, buildings and zones within a city. The origins of many of the Situationist Internationale's theories can be found in Marxist thought, and their objectives involved resisting established meanings of urban space, particularly as these were regulated by capitalism. Since for the Situationists the alienation inherent in capitalism permeates all society, their strategies such as psychogeography and the *dérive* were intended to 'combat the alienating effects of the city's compartmentalization into zones that facilitated capitalist productivity' (Hancox 2012: 237). Key to this enterprise was the notion of the 'spectacle': for the Situationists, the spectacle referred to the fact that a new stage of capitalist development had begun in which the commodity form now predominated over lived experience and the 'commodity completes its colonization of social life' (Debord 1994: 29). Their psychogeographic strategies were thus aimed at unmasking the spectacle and revealing what lay beneath it. It is, thus, significant that Mackern has chosen to ally his works with the Situationists' counter-hegemonic tactics of psychogeography: we are, in this way, encouraged to approach the works within *34s56w.org* as attempting to re-signify urban space with a particular view to deconstructing the close links between urban structure and capitalism. Yet, as with Mackern's images of key buildings within Montevideo, his use of psychogeography and the *dérive* is now directed to unmasking not the spectacle of commodity capitalism, the reigning form of capitalism for Debord's era, but corporate capitalism of the twenty-first century.

The specific works in the collection *34s56w.org* are all taken from a wider body of work by Mackern that he has denominated his 'soundtoys'. Exhibited as part of the celebrations of the 2005 Día del Patrimonio [Heritage Day] in Uruguay—the annual celebrations of Uruguayan culture taking place in September–October each year, centred mostly around the capital city—the works selected were those making specific reference to Montevideo.[6] Highlighting the potentials of digital technologies to provide decentralized distribution, non-linearity and interactivity, Mackern (2006: n.p.) then defines his soundtoys as 'interfaces sonorovisuales reactivas / generativas / interactivas' ['reactive / generative / interactive sound-visual interfaces'] in which 'la navegación individual de cada usuario genera su propio entorno sonorovisual' ['each individual's navigation generates their own sound-visual

environment']. Mackern's soundtoys, then, aim to give emphasis to the user to remix and generate content, and involve the creation of an environment that is both visual and sonorous. In other words, Mackern's works strive to generate landscapes *and* soundscapes.

Such, thus, is the broader context in which the works in *34s56w.org* sit, combining the creative uses of digital technologies with the possibilities of generating new landscapes. When we access the interface itself, the opening screen of *34s56w.org* has a black background, with the majority of the screen occupied by a cartographic relief map, depicting the terrain and geographical features, and rendered in beige. The map shows Montevideo and the shores of the Río de la Plata, but it is rotated on its axis through 180 degrees, such that the Punta de Carretas (the southern-most tip of Montevideo, jutting out into the river mouth) is pointing upwards, towards the top of the frame, rather than downwards. On the top right-hand corner of the map lies the standard arrow commonly employed to indicate the orientation of a map, depicted in red font and pointing upwards, but this time indicating 's' rather than 'n'; the standard reference of the compass is thus also reversed. In this conceit, there are obvious intertextual references to Mackern's previous works, which themselves paid homage to iconic figures within Uruguayan thought. The immediate intertextual reference here is to Mackern's *netart latino database* (2000–05), which employed a limited series of characters to sketch out the contours of Latin American net art in the form of an inverted map of the continent. This format, as with the format of *34s56w.org*, was itself an obvious homage to Uruguayan artist Joaquín Torres García's iconic drawing *América invertida* [*Inverted America*] (1936), which reversed the conventional representation of the American continent, excluding the USA from the map and locating Chile and Argentina at the top. Torres García's image has been widely read as an attempt to counter US cultural imperialism, in its refusal of conventional cartographical orientation, and its attempt to question the primacy of 'the North'. The conceit of the flipping over of the map thus has an implicitly sociopolitical commentary to make, and, in a Uruguayan context, is immediately recognizable as a visual citation of Torres García, whose map is by now a ubiquitous image in Uruguayan popular culture, adorning everything from posters to T-shirts.

In Mackern's version, gridlines traverse the map, from top to bottom and from left to right, this time apparently following conventional norms of cartographical representation, yet over the top of these, further lines, at a variety of angles, traverse the map. Rendered in dotted lines, these links provide the access to the content of the site. The map itself is static, but waves of dots constantly flicker over it, starting from the tip of the peninsula, and then radiating out, like radio waves, with the centre of the waves starting out from Punta de Carretas. The form in which these waves are depicted—radio waves—is a nod to pre-digital forms of communication, a conceit common to Mackern's work, which frequently references dated or obsolete technologies as a resistant gesture.[7] The waves indicate flows of communication, and

as such imply that a resistant form of mapping is superimposed onto the conventional gridlines that we see underneath.

In summary, the conventions of mapping are undercut or rewritten in various ways in Mackern's interface: the insertion of links which bear no immediate relation to the relief-style mapping underneath, the flows of symbols across the map and the inversion of the north–south axis all function to disrupt the norms of cartographical representation. It is then via this disorientating interface that we access the works, by selecting links across the map, three of which are analyzed in this chapter.[8]

24HORAS

The first of the works to be analyzed in this chapter is *24horas*, whose title is located towards the bottom left of the screen, but whose line links to the top of the screen, pointing towards central Montevideo. The initial screen of *24horas* depicts a greyscale map of Montevideo, this time rendered along the conventional north–south axis, and offering a bird's-eye view of the city (see Figure 4.1). However, the features depicted on it are indistinct since from the resolution at which the map is rendered, we can only distinguish pixels: roads, buildings, features of interest and so forth are not distinguishable on this map, again an indication that the work we are entering is interested less in the depiction of accepted points of reference of the city than in providing an alternative type of mapping, as we shall see. Superimposed on top of the map are 24 boxes, in black with white font, each showing a different time of day on the 24-hour clock. Across the top of the screen are two buttons—'geo sound mixer' and 'map'—referring to the two main interactive features of this work.

Clicking on each particular time of day then opens new content in the main screen, as the map itself is replaced by new content. The content activated consists of video files, showing black-and-white images, predominantly of grainy quality, set on a loop. Frequently, the images are speeded up, and most files last only a few seconds before starting back on the loop again. Over the images is a sound bridge consisting of sounds of the city; these sounds are environmental rather than human and often appear to be the sounds of electronic equipment, transport or static interference. There is no voice-over or dialogue in any of the 24 video files we access, meaning that there is no explanatory description or guidance as to what we are witnessing, and we must work hard to decipher the content. Similarly, although each content file relates to a location on the map it often does so only obliquely, and the viewer has to establish the connection as he or she deciphers the files.

Spatially, the files are located at different spots around the city and, as we navigate them, the conjunction and juxtaposition of files, as we select different times at random, frequently highlights the contrasts between different city spaces, as well as encouraging us to uncover the particular drives and

impulses associated with the city spaces. Although varying in the specific images used, the contents of each of the files share broadly similar themes: there is a focus on urban infrastructure, travel, and communications, since several files depict either highways or traffic; several others depict buildings, in particular skyscrapers, whilst still others depict telecommunications, such as transmitter towers and satellite dishes. It is in our movement across time and space as we access the files—that is, as we access at random files in adjacent or distant locations, and in chronological or non-chronological order—that we start to trace a digital *dérive* around the city. Our access to the files, and the ways in which we can recombine their sequencing and their sound content, thus provide a form of resistant psychogeography, a type of online *dérive* because, in our negotiations of the cityscape, we are encouraged to challenge the immutability of the spectacle of the city.

If we decide our access to the files to be a chronological one, then, as we encounter the content within them, we witness a narrative of the city which is fragmented and attempts to challenge the spectacle of the city and the capitalist endeavour it represents. For instance, if we start accessing the content from the earliest part of the day through to dawn (files 1.00 to 5.00), we build a narrative of the city as it awakens. The first four of these files each depict either swift-moving lights or transport across the city and comprise very low-lit moving images. The first of these, file 1.00, shows very dark, grainy images, with flashing lights across the bottom half of the screen; possibly depicting cars or train carriages going past the viewer, the images appear to be speeded up and create the sensation of fast-moving transport across the dark cityscape. The accompanying sound is metallic and repetitive, possibly capturing the sound of a train going over tracks. Following on from this, file 2.00 continues with the very low lighting of file 1.00, and we witness indistinct neon-type lights constantly flickering over the centre of screen; there is no background visible to enable us to contextualize or make sense of these lights. Taken in conjunction with file 1.00 we might assume these lights to represent another mode of transport across the city, although they could, equally, be taken from billboards or street lighting. File 3.00 is, visually, very similar to file 2.00, depicting again multiple flashing and flickering lights, although this time now occupying all of the screen. Again indistinct, and with no background contextualization, the lights appear to dance across the screen, tracing patterns that almost create words across the black background of the night sky. Finally, file 4.00 is where the images start to become more distinct: although of grainy quality, the images are clearer than the previous three files, showing a road stretching out ahead of us, running towards a vanishing point in the centre of the screen. The sequence is shot from inside a car as it advances along the road, and road markings and street lights hurtle past us, as the image is speeded up. Resonating with the lights we saw in the earlier sequences, the lights in this sequence are now in context, revealing us to be speeding through a city that is about to wake up.

These four files, chronologically, have served as establishing shots of the city, following classic cinematic conventions by which establishing shots provide spatial exposition and 'set the scene' of the cityscape (Bordwell and Thompson 2010). In terms of content, the montages depict some of the commonplaces about city space: the bright lights of the urban environment; the modes of transport, the impression of the fast pace of city life conveyed by the speeded-up images and the constantly flickering lights. We might assume, then, from this opening sequence of files, that we are witnessing fairly traditional establishing shots of the city space as encapsulating modernity, technology and progress. The images allow themselves to be read as depicting the city as embodying the successes of modernity and the capitalist ideal; arguably, the city as spectacle in the Situationists' use of the term. Indeed, the predominance of bright, neon lights in these early files helps to cement this analogy; there is, quite literally, a constructed spectacle in the overly bright, dazzling neon lights in this establishing sequence.

For this reason, the file which follows—file 5.00—is particularly resonant after the images of travel, speed and spectacle that preceded it, and functions to undercut these conventional images of the city-as-modernity, to reveal the material conditions underneath the spectacle. This file consists of a very short sequence of highly grainy images, rendered so close up that the individual pixels are visible on the screen. The images depict what are most probably the shadows created by a person or object located outside of screen space, to the left of the screen. In contrast to the previous four files, which all depicted manmade objects of progress and modernity—cars, trains, neon lights, roadways—the image here is of human activity, with no discernible technology in sight. The images appear to depict the arms of a person, which enter the screen from the top right, and are opening and closing, as if picking up or sorting through something which lies towards the bottom of the screen, on the ground outside the screen space. In contrast to the opening four files, the images in this short montage are not noticeably speeded up, whilst the accompanying sound file is of a rustling noise, like bags being opened or paper being crumpled.

There is no further contextualization in file 5.00 to enable us to make sense of what we see on screen. But the three elements combined—the time (the early hours of the morning) the moving image (arms picking up or collecting something) and the sound (the rustling of bags/paper)—function together to suggest an image of urban rubbish pickers. Known as *clasificadores*, urban rubbish pickers make their living in Montevideo by gathering and sorting urban refuse from the city's metropolitan area and municipal refuse centres. Their existence on the streets of Montevideo has been documented since at least the 1950s, although there was a sharp rise in their numbers after the 2002 economic crash in Uruguay, with the UCRUS (Unión de Clasificadores de Residuos Sólidos) giving figures of close to 15,000 *clasificadores* in the city (cited in Moates 2010: 53).[9] The image in this file, thus, in sharp contrast to the previous four files, is of human subsistence on the streets of the city, scraping a precarious living from the detritus on the streets.

In these opening five files to *24 horas*, then, we are presented with a narrative that has firstly established, and then challenged, the spectacle of the cityspace of Montevideo. In sharp contrast to the opening four files which all conveyed an impression of the cityspace as highly technologized, fast paced and in which progress is paramount (both in terms of content, via the images of neon lights, technology and transport, and in terms of technique, via the speeded-up, ever-moving images), the fifth file undercuts these prior representations of urban modernity and achievement. Viewing these five files in sequence allows us to better understand, or rather seek to further decode, the images of the first four; given that in these first four images, the extreme low lighting did not allow us to discern anything in the background, now, with the dawn light of file 5.00 revealing the *clasificador*, we are encouraged to re-evaluate the earlier files. The *clasificador* may well have been hidden, thrown into shadow, by the neon lights—the spectacle—of these earlier images. The image of the *clasificador* thus subtends the city; underneath these initial four files, where the background was not visible and only the dazzling lights of the spectacle could be seen, lie the *clasificador* and the precarious economy he or she represents. By the time dawn arrives in the 5.00 file, the hidden economy that is disavowed by the neon lights, the transport networks and the fast pace of the earlier files is revealed. Thus, this sequence, with its implied reference to the *clasificadores* depicts the existence of Castells's Fourth World within the much-vaunted First World city of Montevideo, a city that has been described by Renfrew (2004: 16) as demonstrating the 'contradictory conditions of neoliberalism', in which its 'capacity to dazzle' is counterbalanced by the 'realities of its poverty'. These five opening files, then, present us with the 'capacity to dazzle', captured by the neon lights and fast-moving images, only to reveal the poverty subtending this. Thus, in our *dérive* through these files, we have been encouraged to discover what lies beneath the spectacle.

If such is the narrative told when viewing the first five files chronologically, other narratives are created when accessing files spatially rather than chronologically, if we choose to view files that cluster around particular locations. For instance, files 9.00, 10.00 and 17.00 are all located close by each other, towards the bottom half of the map, in an area stretching from the port, across the *ciudad vieja* and towards Punta Carretas. The northern-most of these, file 9.00, is located just inland from the port, and opens up a short video consisting of a greyscale, grainy image in which, at the extreme bottom of the screen, rooftops are just visible. Occupying the majority of the screen is an expanse of sky, with a tall, thin mast cutting across the centre of the screen from top to bottom, reaching up from the rooftop. Clouds move swiftly across the sky in the background, from right to left, and the sound accompanying this file is a hollow, echoing sound. Located close by, although slightly further to the south-west, file 10.00 contains two straight-on shots of the city, the first taken from street level and the second taken from a rooftop. The street-level image shows an intersection

in central Montevideo, with the bell tower of the neoclassical Metropolitan Cathedral in the background, and a telegraph post in the foreground. The rooftop image, by contrast, is dominated by a satellite dish which occupies most of the screen, although through its slats we can make out the same bell tower in the background to the right of the screen. The two images are edited together via jump cuts, with each image remaining on the screen for less than a second, rendering the viewing extremely disorientating and the images very difficult to discern clearly.

Close by these two files, although farther towards the east, file 17.00 comprises a montage of several shots which range from close-ups of buildings to panoramic shots of the city. Set on a fast-paced loop, these images comprise a close-up of a domed roof of a building; a low-angle shot with the edge of tall office block to the left of the screen, a farther office block at the back right of the screen and a more ornate tower in the centre back; a panoramic shot, looking down towards the port; another panoramic shot looking down towards the waterfront, this time with approximately half of the screen taken up with rooftops; and an extreme close-up of an exterior façade of a stone building, showing relief work cut into the stone. These various images, edited together, provide a dizzying depiction of urban space. The domed roof we see briefly in the first shot, the ornate tower in the second, and the extreme close-up of the façade in the fifth are clearly those of the Palacio Salvo, an Art Deco building located in the Plaza Independencia. The Palacio Salvo, built in the 1920s in the heyday of Uruguay's prosperity, is one of Montevideo's most iconic buildings; with 28 floors and standing 84 metres high, it was the tallest skyscraper in Latin America at the time of its building, and was viewed as the 'apoteosis [del] proceso modernizador' ['apotheosis of the modernizing process'] (Rocca 2000: 18). Highly controversial because of its overly ornate style and slated by Le Corbusier (Antelo 1992: 854), the Palacio Salvo was nevertheless admired and praised as symbolic of modernity by avant-garde and futurist poets of the twenties such as Alfredo Mario Ferreiro and Juvenal Ortiz Saralegui. The most famous of these tributes to the Palacio Salvo came in Ortiz Saralegui's poetry collection of the same name in which, for Ortiz Saralegui and others like him, the Palacio Salvo functioned as the 'símbolo inequívoco de la metrópoli' ['unequivocal symbol of the metropolis'], with Ortiz Saralegui's poems attempting an 'apropriación del espacio urbano modernizado' ['appropriation of modernized urban space'] (Antelo 1992: 855). Indeed, Aínsa (2005: 16) has argued that the highly original (and controversial) architecture of the Palacio Salvo has become an almost 'obligado referente poético' ['compulsory poetic reference'] in Uruguayan letters.

If such is the significance of the Palacio Salvo, the panoramic shots looking down to the mouth of the river and the port evoke, of course, another of the timeworn symbolic locations of Montevideo: the port city built on both immigration and an export-led economy (more on this below). This fast-paced montage sequence thus brings together iconic monuments and

locations of Montevideo's history, particularly of the early twentieth century when Uruguay was at the height of its prosperity. The speed with which the images flash past conveys the fast pace of urban modernity. Yet at the same time as showing their historical significance, these images also display the encroachment of modern technologies into these historic spaces: these images, as they swiftly flash past, antenna and satellite dishes are visible on the rooftops. The sequence as a whole, thus, presents urban structures as, nowadays, closely linked with telecommunications infrastructure.

These three files, located close by each other on the map, when viewed in sequence present images of the city which display its different historical layers: its foundations and continuing role as a port city in file 9.00, its colonial heritage as represented by the cathedral in file 10.00 and its early-twentieth-century prosperity in the Palacio Salvo in file 17.00. Running across all of these montages is also the theme of new media technologies, as a variety of telecommunications devices are shown to be inserted into this historic landscape. Viewing this files together, thus, creates the impression for the viewer/user of the layering of the cityscape, and of the close ways in which telecommunications technologies are now integrated into the fabric of the city. Here, the significance of the dizzying effect of the fast-paced editing, coupled with the dissonant sounds created by *interference with* rather than *communication by* electronic equipment creates an image less of the success of capitalist modernity than of unfulfilled modernity, or the cracks and gaps of late modernity. Mackern's dissonant soundscape–landscape thus flags the gaps in the spectacle that are opened up by the failure of telecommunications technologies, using them to open our eyes to the failings of the late capitalist model.

In these ways, through our journeys across the interactive map, we create narratives of the city as the different files come into conjunction and produce new stories. Yet in addition to this element of interactivity, there is also a further function by which we can remix the content of this work, facilitated by the 'geo_sound_mixer' located at the top of the screen. This function allows us to drag red symbols upwards along a vertical axis, and sideways along a horizontal axis, and position them on top of the images we are viewing. On so doing, different sound files are activated and superimposed on top of the existing sound file accompanying each montage. These sound files include a low rumbling like the noise made by an engine, a tinny alarm sounding, a sound like static, a noise like a thunderclap, a dog barking and a rustling noise. The sounds themselves were generated in the locations themselves and were captured via what Mackern has described as 'low tech field recordings'[10]—again, a deliberate use of low tech to create a counter-cultural soundscape of the city. Explaining in more depth the generation of these sounds, Mackern explains that the sounds were 'done on purpose, as an aesthetic statement but also cultural/political, as this work was made in the middle of a huge crisis we had in Rio de la Plata in 2002'.[11] In this way, Mackern's low-quality, jarring sounds of the urban soundscape intend to

provide a commentary on the sociopolitical conditions subtending the city. These are then inserted into the work in such a way that we are able to remix our own versions of the city sounds, interspersing and superimposing new sound files over the content we are viewing; we can choose to activate one or several of the sound files at once, and so create a cacophony of sound.

The geo_sound_mixer thus allows a further level of interactivity and creative remixing in this work and allows us to build our own narratives, mixing images and sounds to explore new psychogeographies beyond those captured by the existing files themselves. In this way, we can build an alternative narrative of Montevideo through our digital *dérive*, and reveal the contradictions beneath the spectacle. For instance, we might choose to view file 11.00 which comprises several low-angle shots of a tall office block, some of which focus on the facades of the building itself and others on the large sign at street level in front of these blocks, showing an 'E' with a line through it. The building is the Torre Ejecutiva, the postmodern office block standing on the edge of the Plaza Independencia, and home to the offices of the president of Uruguay; the sign in front of it which appears in several of the shots indicates that parking is prohibited (with the 'E' for 'estacionamiento' being struck through). On top of this file, we can build our own soundscapes: mixing with the sound file of stray dogs barking, for instance, may bring to mind an impression of an urban wasteland beyond the glittering windows of the tower and may point towards the increasing inequalities generated by the free-market policies of successive Uruguayan governments, including increasing labour informality, a widening earning gap and higher unemployment rates from the mid 1990s onwards. Conversely, we may choose to view file 19.00 depicting the Montevideo skyline, with buildings silhouetted, and looking down towards the port. Mixing these images with the sound file of alarm bells ringing may bring to mind the recent economic crisis and the fact that Uruguay became a country of *emigration* rather than *immigration*. Because of the economic crisis of the early 2000s, Uruguay suffered a major new wave of emigration (see Pellegrino and Vigorito 2005); mixing alarm bells with this location that previously stood as the success story of Montevideo's modernity as built on *immigration* thus re-semanticizes this time-worn spectacle. In these and many other recombinations as we access the work, we actively negotiate the files and uncover the meanings of cityscape via our online *dérive*, undoing the spectacle of the city as modernity and the success story of capitalism.

RAMBLA SUR

The next link upwards from *24 horas*—located farther towards the top of the page, but going south rather than north, in Mackern's inverted cartographical axis—is titled *Rambla Sur* and opens another interactive work combining images and sounds of the Montevideo cityscape. This time, the focus is

on the Rambla, the long avenue which runs along the shoreline of the Río de la Plata in Montevideo. Again, emblematic of the era of rapid development and modernization of Montevideo, the construction of the Rambla Sur was first established by a decree of October 1925, which provided a public loan towards the cost of construction, and created the Comisión Financiera de Rambla Sur to oversee the project. Based on plans by engineer Juan P. Fabini, work began in 1928, and the Rambla Sur was officially inaugurated on 31 December 1935, bringing about changes both to the urban space and to the social composition of the area. As noted in a recent retrospective on the project, the reasons for the construction of the Rambla Sur were both aesthetic and hygienic, and, as well as generating more space for the city, the construction of the Rambla Sur also had as one of its aims to 'erradicar definitivamente el barrio prostibulario, popularmente conocido como "El Bajo"' ['eradicate once and for all the red light district, popularly known as "El Bajo"' (CDF 2012: 2). Hailed as one of the most ambitious and transformative construction projects in Montevideo, the Rambla Sur involved the construction of the first 4 kilometres in a project linking the city to the sea, in which 18 hectares of land were reclaimed from the sea. The Rambla Sur has since become one of the prominent symbolic locations in Montevideo; as Luciano Álvarez and Christa Huber (2004) argue, 'la Rambla, largo balcón sobre el mar [es] su emblema urbano' ['the Rambla, the long balcony giving onto the sea, [is] this city's symbol'], whilst for Silva (2006: 47), the Rambla becomes the 'extensión moderna' ['modern extension'] of Montevideo, representing the 'cualidades positivas en el imaginario montevideano' ['positive qualities in the Montevidean imaginary'].

Indeed, Remedi's extended article on the symbolic function of the Rambla has argued that the Rambla stands as the ultimate signifier of Montevideo. For Remedi (2005: 135, 139–40), the Rambla represents Montevideo's own 'imageability' and is 'appropriated and used to substantiate and articulate many diverse and contradictory cultural discourses in circulation within the national culture'. As Remedi (2005: 140) notes, given that the Rambla was conceived and built in the early decades of the twentieth century, for many it stands as 'evidence of Uruguay's grandiose historical and cultural Past, "the good old days", when Montevideo saw itself as the Athens of the River Plate, the Switzerland of America—that is, a European city in south America'. Remedi then goes on to argue that the Rambla's significance also lies in its geographical location, and in the implications that this location has in the national imaginary. Here, Remedi (2005: 145) notes that, in nostalgic readings of the Rambla, it 'stands and represents our absolute south', and, as such is 'thought to be the site closest to Europe and the Civilized World', expressing the notion that 'Civilization came from the sea, brought by colonizers, immigrants and cosmopolitan travellers', and hence confirming La Rambla as 'source of and point of entry to Civilization'. This nostalgic and reductive reading of the Rambla is then troubled, Remedi notes, by its contemporary meanings, particularly in the light of the 2002 economic

crash. Here, Remedi (2005: 154) cautions, the Rambla serves to disavow the increasing socio-economic segregation of the city since

> while the crisis of 2002 rendered some structural problems and social conflicts more visible . . . la rambla does work as a facade and blocking screen that gives—and fixes—a powerful (yet untrue) image to the city, one that, therefore, impedes us from seeing what is behind the image, behind the screen, or at a distance. . . . Montevideo is increasingly segmented and segregated along class and sociocultural lines.

Interestingly, Remedi's terms here *(facade, screen, image)* resonate with the vocabulary of the Situationists and point towards the need to interrogate the Rambla as much for what it represents, as for what it attempts to hide or disavow.

In Mackern's *Rambla Sur*, the main screen depicts the sea front, with the silhouettes of the buildings around the bay in the background of the picture, and the waterfront in the foreground (see Figure 4.2). The image is based on a drawing of the Montevideo skyline taken from Uruguayan artist Juliana Rosales's project entitled *RT/OW (RoundTrip, OneWay)*, on which Mackern collaborated. The image is greyscale and is impressionistic rather than photographic: the contours of the bay, the buildings and other geographical features are rendered in jagged lines, waves and clusters of pixels. The overall effect created is similar to that of a woodcut, in which the images are rendered in crude lines, with contours and shapes created via the thickness or proximity of these lines. At the same time, these contours and lines appear to be generated via modern technologies, in their aping of sound waves or waves of data to create this woodcut-like image. There is, thus, as in many of Mackern's works, a deliberate play with low and high tech: whilst the image appears to be created from data drawn from high-tech sources, the resulting image itself appears decidedly low-tech. In effect, we see the use of high-tech to produce a low-resolution image.

The top two-thirds of the screen are taken up by this image, whilst the bottom third is comprised of a line graph, marked out in black jagged lines on a white background. The graph represents sound waves or data waves, with several horizontal lines marking out the range of the data, and a continuous line, moving upwards and downwards, marking out the frequencies at which the date is recorded. This is, thus, identifiably a graphical plotting of data of some format or other, although there are no labels nor key on the graph to enable us to decode it fully. That said, implied meaning is given to the graph by its positioning on the screen: the location of the graph directly below the image of the Montevideo coastline produces visual symmetries between the graph and the image above it. Seen below the city's skyline, the graph imitates a skyline, with its clusters of high frequencies mimicking the clusters of tall buildings jutting out into the sky. There is, thus, an immediate analogy drawn between the skyline and the graph, encouraging us to view

connections between the cityscape and the soundscape, connections which will be brought to the fore as we negotiate and activate this work.

Whilst these are the still images composing the main screen, there is also a continuous moving element in the shape of a black horizontal line that constantly runs from left to right over the image, whilst the title of the work, located in the top left-hand corner of the screen, periodically flashes on and off. There is also a rhythmic, static sound that runs continuously over the images, which appears to be the noise created by interference with digital devices; beyond this, no other sounds are heard over this initial home screen.

The interactive elements of this piece lie in the ability of the user to activate sound files embedded in the work. As we move our mouse over the graph in the bottom third of the screen, certain clusters in the graph light up in grey; clicking on the highlighted cluster then activates a dotted line from the graph to a location on the panorama above. The name of the location appears in a white box and opens a new sound file associated with each location. These locations are, from left to right, Viviendas Aduana, Palacio Salvo, Antena Canal 10, Palacio Municipal, Antena Canal 4, Playa Ramírez and Rueda Gigante.

Again, as with *24 horas*, the locations chosen are, in their various ways, iconic buildings or features within Montevideo that map out particular moments of its history and development. The Viviendas Aduana refers to the customs building situated on the Rambla 25 de Agosto, near the waterfront. Being the entry point to Montevideo for goods arriving from overseas, the Aduana building is thus symbolic both of Montevideo's prosperity of the early twentieth century and of the city's historic identity as a port city, built on the arrival of goods and peoples towards the end of the nineteenth century and in the first decades of the twentieth. Uruguay's economic boom of the late nineteenth century and early decades of the twentieth was due in large part to its strong export-led economy, in particularly during the Batllista years, in which the annual growth of gross domestic product was 5 per cent (Panizza 1997: 673) and Montevideo's population doubled (Acuña 2006: 239).[12]Montevideo's identity, then, as a city whose modernity was built on immigration and on the import and export of goods is encapsulated in this building, one of the earliest examples of art deco style in the city, and emblematic of the economic boom that offered Uruguay its high standards of living as the 'Switzerland of the Americas'.

The next building, the Palacio Salvo, as mentioned earlier, is symbolic of Montevideo's prosperity and modernity in the early twentieth century. The Palacio Municipal, following this, is the seat of the Intendencia de Montevideo, located in Avenida 18 de Julio. Originally designed by the architect Mauricio Cravotto in 1929, its construction began in 1935 and it was finally inaugurated in 1941. Moving eastwards across the image, next comes the Playa Ramírez, the beach running along the edge of the Rambla nestling in the curve of the bay, just west of the Parque Rodó. The origins of the Playa Ramírez date from the late nineteenth century, with the opening of the

tramway line Tranvía del Este and the installation of the first bathing huts in 1871 (da Cuhna 2002: 128). Its construction was part of a broader project of the joining the city to the coast, and the transformation of the coast into beaches and bathing resorts. Central to the transformation of Montevideo into a *ciudad balnearia* [seaside resort], the construction of the Playa Ramírez came in a period, according to Azcona, when the increasing division of the city into poorer west and wealthier east was cemented, with the industries in the west, and the beaches in the east; the Playa Ramírez, and others like it, attracted wealthy Montevideans as well as tourists from Buenos Aires, and was part of the increasing gentrification of the area (Azcona 2004: 63). The Playa Ramírez thus lies at a complex nexus in the history of Montevideo, involving part of the increasing movement to open the city to the sea; the regulation and regularization of leisure time; norms of hygiene and conduct of the time; and the increasing role tourism was to play in Montevideo's economy.

The Rueda Gigante [Big Wheel], meanwhile, is a reference to the fairground attraction situated in the Parque Rodó, one of the main parks in Montevideo, located just inland from the Playa Ramírez. Again part of the transformation of Montevideo in the late nineteenth and early twentieth centuries, the first fairground attraction on the site was the roller coaster inaugurated in 1889 and the site was transformed into the Parque Urbano in the early years of the twentieth century, eventually taking as its name the Parque Rodó in 1917 in honour of one of Uruguay's most prominent writers, José Enrique Rodó (1871–1917). The Rueda Gigante thus stands as another major symbol of tourism, leisure and modernity in early twentieth-century Montevideo, but also, due to its immediate association with Rodó, evokes one of the leading texts of Uruguayan and more broadly Latin American thought at the turn of the century. Rodó's most famous work, *Ariel* (1990), was an essay setting out a conflict between the materialism of the US and the wisdom and spirituality of Latin America, with Ariel standing as the symbol of Latin America. The Rueda Gigante, thus, stands as a symbol of this early-twentieth-century optimism about the leading role that Uruguay and Latin America more broadly were to play in the world order, as well as, of course, highlighting an uneasy conjunction of the material pleasures of fairground attractions and wealthy tourists, with Rodó's lofty, anti-materialist ideals.

Nestled amongst these highly visible and culturally charged locations—some of the principal sites on the tourist trail—are two which stand out as incongruous: the aerial transmitters of two prominent television stations. Canal 4 is a reference to Canal 4 Monte Carlo, the second oldest of Uruguay's television channels and whose transmitting aerial was formerly located at the top of the Palacio Salvo. Canal 10, meanwhile, is a reference to SAETA TV Canal 10, Uruguay's earliest television channel, operated by SAETA (Sociedad Anónima Emisora de Televisión y Anexos) and whose first broadcast went out in 1956. The aerial transmitter—also known as the Torre Saeta—is located on the roof of the SAETA building and, at 187 metres tall, is the second-tallest structure in Montevideo.

Mackern's points of reference in this sound-wave panorama, then, contain a mixture of historic buildings and modern telecommunications devices. In so doing, he invites the user to contemplate the conjunction of history with communications, and implies parallels between the sound waves registered on his graph, and the images of the city, parallels with are then strengthened when we access the work. The interactive element of the work comes in the ability of the user to activate sound files as he or she navigates the work. Clicking on each cluster in the graph in the bottom third of the screen activates a sound file associated with and generated by that location. Each of the sounds is electronic buzzing or hissing noises, mimicking the sounds of interference with electronic receiving or monitoring equipment. Indeed, the sounds themselves are generated from the interaction of the shapes of the buildings themselves with digital technologies. As Mackern explains,

> Los sonidos de Rambla Sur en realidad son los sonidos que produce el dibujado en un software de edición de audio. O sea el dibujo se convierte en una transposición directa al software de sonido, convirtiendo así el paisaje en una onda. Los sonidos individuales son los sonidos del dibujo de cada edificio como onda de sonido.[13]
>
> The sounds in *Rambla Sur* are really sounds that the drawing creates in an audio editing software. In other words, the drawing is converted by a direct transposition into the sound software, converting in this way the landscape into a wave. The individual sounds are the sounds of each building in the drawing as a sound wave.

In this way, the sounds in *Rambla Sur* are generated from the shapes of buildings themselves rendered as soundwaves, and hence the sounds produced are harsh, technologically generated buzzing or hissing noises. Thus, far from a coherent voice-over or dialogue, or even the decontextualized but nevertheless partially recognizable sounds of the city in *24horas* (such as the dog barking, for instance), the sounds in *Rambla Sur* are, more properly, post-digital sounds, that is, sounds created by the detritus or remnants of the digital. Mackern's tactic here continues a rich tradition in net art of the use of errors, flaws and rejects of the digital age: from JODI's use of status code errors in their works such as *http://404.jodi.org/* (1997), and even down to the quasi-mythical origins of the term *net.art* itself, net artists have often worked with the products of technical breakdowns to create works of art.[14]

In this panorama, I argue that the interpretative key is the Palacio Salvo. In some ways, Mackern's endeavour in this work to ally buildings with communication systems can be read as an actualization of Juvenal Ortiz Saralegui's poem as mentioned earlier. As Aínsa notes, in this poem Ortiz Saralegui's admiration for the Palacio Salvo is demonstrated not only in the poem itself but also on the book's cover, which depicts the outline of the building along with a large, illuminated sign on its facade. This sign is done in such a way that its 'destellos asimilan metafóricamente a un mensaje de

"radiotelefonía"' ['twinklings metaphorically look like a radio message'], with the words '¡están alerta/ están alerta/ los radio-escuchas de los horizontes' ['the radio-listeners of the horizons/ are alert/ are alert']. Continuing with this analogy, the book closes with the following: "Editorial Vanguardia Montevideo MCMXXVII Estación Palacio Salvo: ha terminado la transmisión" ['Vanguardia Publishers Montevideo MCMXXVII Palacio Salvo Station: transmission over']. Saralegui's futurist poem thus drew close parallels between poetry, telecommunications, and this iconic building, as, in the words of Aínsa (2005: 16), 'El Palacio Salvo se convierte en torre de transmisión de la obra' ['Palacio Salvo becomes the transmitter tower of the work'].

In this way, Ortiz Saralegui's poem celebrated the Palacio Salvo as symbolic of modernity not just for its architecture, but also as the transmitter of what was, at that time, the height of telecommunications technologies: radio transmission. Mackern's version clearly dialogues with this notion of the Palacio Salvo, and the other buildings identified in his work, as transmitters: they are, in a very real sense, the source of the sounds we hear in his soundscape. Thus, in almost an interactive version of Ortiz's poem, Mackern's *Rambla Sur* activates what Ortiz Saralegui, in a pre-digital age, attempted to achieve: to express through the written word the power of early telecommunications. Yet at the same time, Mackern's version is notably less celebratory than Ortiz Saralegui's. Whereas for Saralegui, the Palacio Salvo is celebrated as the site of communication and the source of modernity, in Mackern's version, it is the interferences, the static, the blips and bleeps—in short, the *failures* of communication—we hear. Mackern's work, then, is interested less in the buildings, tourist sites and transmitters for what they communicate, than for the creative and evocative sounds that their *failures of communication* produce. Hence, Mackern's tactic is to interrogate these iconic locations: by exploring the harsh, disparate sounds created by their shapes and contours, Mackern is implying that the values these buildings represent—the grand projects of modernity in Montevideo and Uruguay's expansion and modernization in the early twentieth century—have failed to live up to their claims.

GRAFFITI

The third of the pieces to be examined in this chapter, *Graffiti*, is located farther to the left of the screen in a link pointing upwards (in Mackern's reverse geography), towards the city centre. Set on a light grey background with darker grey gridlines, a map of Montevideo fills the screen, with the streets indicated in black, the main thoroughfares in red, and the coastline in blue. Again, as with *24horas* analyzed earlier, the detail of the map is deliberately missing: there are no street names, buildings or points of interest noted on the map to guide us in our reading of it. The only information we receive of

our location is found in a square in lighter grey towards the left of screen, which reads 'barrios cordón-palermo-parque rodó'. The reference here is to three neighbourhoods in Montevideo: Parque Rodó, the neighbourhood which takes its name from the iconic park mentioned earlier; Palermo, the neighbourhood just west of the Parque Rodó, bordering the seafront; and Cordón, the neighbourhood north of Palermo and Parque Rodó.

Across the bottom of the screen, a banner with red fill and black text reads, in capitals, 'TOPOGRAFÍA DE UN AMOR NO CORRESPON-DIDO' ['TOPOGRAPHY OF AN UNREQUITED LOVE']. Two winged angels, representing Cupid, appear on either side of the banner, their wings constantly fluttering but in an awkward, jagged way that makes it obvious that this is a still image that has been animated, rather than moving footage. The highly clichéd, overdetermined image of the cupid, and the deliberately awkward, artificial way in which it is animated put us on our guard, and warn us not to take the notion of 'amor no correspondido' ['unrequited love'] at face value. Indeed, as we negotiate the work, and undertake a *dérive* around its map, we become increasingly aware of the constructed status of the 'amor no correspondido' and are encouraged to deconstruct, rather than accept, it on its own terms.

Seven dots appear clustered around the south-west of the map and constantly flash from neon yellow to neon green. When we move our mouse over each dot, a green circle radiates out from each one, mimicking radio waves, or waves of data emanating from each particular spot. Clicking on each of these dots brings up a photograph that replaces the map and fills the main screen, showing graffiti in a particular location. As we make our way around this landscape, we trace our own digital *dérive* both through the pathways we create, and through our manipulation of elements within the image, as will be discussed.

For instance, clicking on the northern-most of these dots brings up a window titled 'Calle Santiago/Palacio Municipal'.[15] The location indicated here refers to the street, Calle Santiago de Chile, which runs from north to south along the eastern facade of the Palacio Municipal. The photograph shows the exterior of a building with dull grey walls and a window with bars towards the lower half of the screen. Graffiti, in thick black lines, is written over the wall above the window, in a mixture of upper and lower case. The first line of the graffiti reads '¿UN PAIS TRANQUILO Y' ['A PEACEFUL COUNTRY AND'], with the rest of this statement running off beyond the frame, into off-screen space. Below this, there is another line of graffiti that has been obscured and, below that, the word 'PUTASA' ['WHORE'].

Immediately noticeable is the fact that, across the middle line of graffiti, a thick black line has been digitally superimposed, blocking out the words beneath. However, by playing around with the work we discover that, by using our mouse and clicking and dragging, we are able to move this censor strip, and reveal what lies beneath: the name of the person about whom the final line of graffiti had been declaiming. It is thus significant that this image

shows initially a level of censorship—the personal name has been blocked out—but we are then able to reveal it, and moreover, temporarily re-position the thick black block elsewhere. We can move the censor strip and create new meanings; for instance, by blocking out 'TRANQUILO' ['PEACEFUL'] in the first line, we can make the graffiti read 'UN PAIS [. . .] PUTASA' ['A BITCH OF A COUNTRY], and so make the statement into one of critique of the nation and its government. We can, thus, not only follow the story told by the original graffiti as we trace paths through the city but also start to create our own resistant story as we recombine the lexia of the graffiti in new ways.

A further example can be seen in the dot located towards the south-west of the map, which brings up the file titled 'Calle Gonzalo Ramírez / Cementerio Central'. The photograph that appears in the screen is a mid-distance shot of an exterior wall which appears to be the boundary wall of the cemetery. A tree stands in foreground casting a long shadow which falls on the wall; the bare branches indicate that the image was taken in the winter months, as does the length of the shadow. The wall behind the tree is covered in a large number of graffiti, some of which are more leg-ible than others. The first line reads 'La muerte de' ['The death of'], with the rest of the writing obscured by the tree; below this, the next two words are obscured by the digitally superimposed censor strip, although the word that comes after—'puta' ['whore']—is still visible. Below this, a partial sec-tion of graffiti is visible, reading 'luchadores sociales' ['social fighters']. At the extreme left of the frame, the end of a statement that starts outside the frame is illegible, whist to the extreme right, a statement begins with 'hay desorden' ['there is disorder'].

In this file there is a sharp contrast between the beauty of the shot, with the visual symmetry created by the tree and its shadow, the two columns in the wall behind it, the bright blue of the sky visible in the top part of the frame and the blue-toned winter light which gives a lyrical quality to the image, and the contents of the graffiti. The shot is, in other words, beauti-fully staged, with the graffiti then taking centre stage in this shot. Yet, as with the other content files, here the graffiti is not only centre stage but also fragmented; the majority of the statements we cannot read in their entirety, either through part of the message being located in off-screen space, or through the message being weather-worn and eroded. We need to piece together meaning from the remaining scraps of messages available to us— *desorden, luchadores sociales, muerte* [disorder, social fighters, death]. From these, we are able to construct a variety of meanings, some of which may be oppositional; we may, for instance, envisage the word *muerte* as referring not to the conventional meaning of the cemetery, but as a statement wish-ing for revenge. Similarly, we may attempt to create a narrative involving *luchadores sociales* fighting against *desorden* or, conversely, being the per-petrators of that *desorden*. Again, our movement of the censor strip allows us to conceal or reveal different statements of the graffiti.

A further example of the ways in which we are encouraged to piece together scraps of meaning from the graffiti can be seen in the image located within the file named 'Gonzalo Ramírez y Ejido / Fábrica Strauch'. The photograph shows a dirty grey exterior wall, with a windowsill just visible to the top right of the frame. The wall is covered in several graffiti in different lettering: across the centre of the image, in upper-case lettering, is the statement 'STRAUCH: DEVUELVANLE EL TESORO A LOS MASSILOTTI' ['STRAUCH: GIVE BACK THE TREASURE TO THE MASSILOTTIS']. Below this, the censor strip partially covers a statement ending in 'TRAGA LECHE', and below that, in a different hand, are the letters 'MPLT'. In addition to this, there are various other fragments of graffiti, some more weather-worn than others, that can be glimpsed at the peripheries of the frame: a word starting 'na[. . .]' to the extreme right of the frame; a word ending in 'ato' to the extreme left of the frame; and a statement ending with 'puta' in which one of the words is obscured.

This image, perhaps more overtly than any of the others in this work, makes explicit reference to place in the graffiti. The exhortation running across the centre of the frame—'STRAUCH: DEVUELVANLE EL TESORO A LOS MASSILOTTI'—makes direct reference to the building on which it is written (the wall of the factory owned by the Strauch family), and refers to what has now become an urban myth in Uruguay. The 'Massilotti' refers to an ongoing controversy first started in 1950 with the arrival of the Italian Clara Claudia Masilotti in Uruguay; Masilotti brought with her a map belonging to her father, which purportedly showed the location of buried treasure within the grounds of the Cementerio Central, the main cemetery in Montevideo. Masilotti gained permission to dig up the cemetery, and the search continued throughout the 1950s, with a further attempt in the 1970s; the events generated great controversy, press speculation as to the origins of the treasure and conspiracy theories. One of these theories was that the treasure had been found and secreted away by the owners of a soap factory standing only a few metres opposite the Cementerio Central, beneath whose foundations lay a series of tunnels that linked with the Cememterio Central (Trochon 2008: 36). The graffiti, therefore, refers to this now common urban myth, and was, as Trochon has noted, a frequent slogan painted on the walls of Montevideo in the 1990s.

MPLT, meanwhile, refers to the Movimiento Por La Tierra, also known as the Movimiento por la Tierra y Contra La Pobreza. The MPLT was a platform established by Raúl Sendic of the MLN-Tupamaros (Movimiento de Liberación Nacional-Tupamaros), the prominent Communist urban guerrilla group that had emerged in the 1960s in Uruguay and remained active until the early years of the 1970s. After Sendic's release from prison at the fall of the military government in Uruguay in 1985, he declared in an open letter that he would no longer pursue his socialist goals by violent means but would 'work within the legal framework of democracy' (Waldmann 2011: 729), and envisaged the MPLT as a platform to build a wide, mass

movement to push for land reform (Garcé 2011: 123). This item of graffiti, therefore, references the ongoing struggles for agrarian reform and social justice within Uruguay.

These various short statements, or scraps of statements, then, work together to re-inscribe the fabric of the city in different, and sometimes conflicting ways. The overtly misogynist declarations of the author of the *amor no correspondido* contrast, for instance, with the politicized slogan in support of the MPLT. The former appears to be fully supportive of the dominant libidinal economy, in which women who do not respond in a fashion deemed adequate by men are objectified and judged as whores. The latter, by contrast, appears to be questioning of the status quo. Indeed, the fact that the graffiti supporting the MPLT is inscribed on the walls of the city itself points towards the inequalities of land distribution disavowed by the wealth of Montevideo and its gleaming buildings and monuments. Conversely, the graffiti relating to the Massiloti case refers more to urban myth and gossip than any politically charged impulse. Again, our movement of the censor strip around the screen allows us to create new narratives from this urban landscape; we may, for example, choose to place the censor strip over *MPLT*, and so create an image in which the demands for land reform are blacked out or neutralized in contemporary politics.

In this complex play between mapping, graffiti, urban space and censorship, we thus encounter two significant counter-narratives throughout *Graffiti*; first, the narrative told by graffiti itself, which transforms the official meaning of public buildings and monuments into a space for telling personal stories, and second, how, through this interactive work, we are able create new stories that adorn the walls of the city. Regarding the first of these—the status of graffiti as counter-discourse—Mackern's work celebrates to an extent the role of graffiti as non-official inscriptions on the walls of public buildings. Many of the locations in this work are prominent buildings in Montevideo—the Parque Hotel, symbolic of Montevideo's status as a *ciudad balnearia* and the opulence of its visitors, and the Cementerio Central and its celebration of the *heroes de la patria*[16]—but rather than seen in their official, monumental context in this work, they are inscribed alternatively. As noted in Chapter 3, graffiti serves as a popular urban form of dissent and, given that it has the potential to expand 'the visual horizons and cultural spaces of the city' (Kane 2009: 11), graffiti is a marking out of urban space by those who have no official role in communicating its discourse. Graffiti thus has the potential to uncover the spectacle of the city in its refusal to be bound by the official narratives told by monuments and buildings. That said, as we negotiate Mackern's work, we come to realize that this graffiti is not quite so oppositional, as will be discussed in the following.

Second, regarding the new stories or *dérives* that we create, the order in which we access the files, and the ways in which we manipulate the images we see, allow us to start to glimpse alternative messages within the cityscape. In particular, the device of the censor strip that appears in all of the content

files in this work implies the task of unmasking as central to our partici-
pation in this *dérive*; we are encouraged to move the censor strip, and so
attempt to unmask what lies beneath the spectacle. That said, whether what
is unmasked is ever fully oppositional is brought under question in Mack-
ern's work, which, as argued next, highlights how the story uncovered may
be just as much part of the dominant spectacle of the city.

As we thus progress through the other locations in this interactive map, we
come to recognize the same story of this personal, conflicted relationship—
or, to use Mackern's ironic term, this 'amor no correspondido'—as it is nar-
rated on the fabric of the city. The same name appears in every photographic
image we encounter, always obscured by the censor strip, and the same
terms—violent and misogynist vocabulary, with variations on 'puta' and
'putasa' used in every graffito—are always employed. There is, thus, a delib-
erate mismatch between what we read here and the romantic, centuries-long
literary trope of *amor no correspondido* of Mackern's subtitle. Having its
origins as far back at least as Virgil's *Eclogues*, the trope of the *amor no cor-
respondido* has a rich Hispanic tradition taking in Quevedo's poetry, Don
Quijote's unrequited love for Dulcinea in Cervantes's masterpiece, through
many nineteenth-century Latin American foundational novels, to the poetry
of the twentieth century, such as Neruda's *Veinte poemas de amor y una
canción desesperada*.[17] In contrast, then, to the elegance and lyricism of this
long-established literary trope, the *amor no correspondido* of this urban
graffiti is violent, coarse and abrupt. Moreover, it is told through fragments,
and we do not have access to the full story which can make this relationship
take on meaning. As we negotiate these content files, the literary trope is
revealed as having lost any transcendental meaning and is displayed as no
more than macho posturing.

Significantly, therefore, Mackern's tactic here is to question some of the
assumptions of the Situationists that inform his work. The notion of a '*topo-
grafía* de amor no correspondido' (my emphasis), allies the project with
the psychogeographic experiments of the Situationists, in particular their
attempts at mapping. It has immediate correspondences with the Situation-
ists' thinking, recalling Debord and Jorn's psychogeographic map of Paris,
the *Guide psychogéographique de Paris* [*Psychogeographic Guide to Paris*]
(1956), subtitled 'Discours sur les passions de l'amour' ['Discourse on the
Passions of Love']. For the Situationists, the *dérive* was a 'passional journey
out of the ordinary' (Debord 1995), in which 'unities of ambiance' could
be discovered as a way to 'establish a basis for reconstructing the city as a
terrain of passion' (Wood 2011: 187). In other words, passion and love, for
the Situationists, were counter to the dominant logic of the city, and so, by
tracing passion, they could establish counter discourses of the city. Mack-
ern's version, however, far from revealing unrestrained love as providing
one of the 'points of opposition to commodity exchange' as envisaged by
the Situationists (Plant 1991: 72), reveals instead that the passion displayed
in this *topografía de amor no correspondido* is part of the spectacle itself.

Running across all of the images is the same sound file; a mixture of sounds edited together, including a rustling noise, static sounds and dogs barking, set on a continuous loop. Again, as with Mackern's other works, there are no human voices to narrate the story or to help the reader/viewer to make sense of what he or she sees. The sounds themselves are retreated sounds gathered from the places in which the photographs themselves were taken.[18] This extended sound bridge, coupled with the images of walls with graffiti and violent vocabulary, combines to produce the sensation of an urban wasteland, far from the conventional meaning of these iconic buildings, and from the overdetermined images of Cupid.

In *Graffiti*, then, Mackern's tactic lies in the attempt to create new perspectives on urban space and, particularly, on the meanings of prominent monuments or locations within it. The conventional meaning of monuments—the luxury of the Parque Hotel, the authority of the Palacio Municipal—are contested by the graffiti which inscribes the personal (and, at times, the resistant) onto their fabric. Arguably, it is actually the peripheral graffiti (in other words, the graffiti on topics other than this 'amor no correspondido') that draws our attention; given the repetition of the same vocabulary across all seven sites, we become increasingly accustomed to the same terms ('puta', 'putasa') being employed over again, and so find more of interest in the peripheral graffiti. Moreover, the overtly misogynist terms of the 'amor no correspondido' indicate that this love story is part of the spectacle itself rather than an alternative, countercultural practice to counter the dominant logic of the city. The act of moving the censor strip to reveal what lies beneath may be, therefore, no more than a ruse; Mackern reveals that a *topografía de amor no correspondido* may not necessarily be as (utopianly) oppositional as the Situationists may have hoped and that an emotive mapping may be just as trapped in a dominant capitalist-patriarchal model that rules the city.

Finally, as the focus of attention, bringing to the fore the graffiti, rather than the stately, monumental works of architecture that lie beneath, gives value to this marginalized form of expression, often seen as vandalism or detritus in the cityscape. Here, significantly, the detritus of the city (graffiti) is turned into the work of art, just as the detritus of the digital age (the sounds created by interference and static, by the failures of communication) provides its soundtrack. Mackern thus invites us to consider how those elements shunned or disapproved of in urban space may be paralleled with those elements resulting from the failures of telecommunication: scraps of urban graffiti are read alongside scraps of the digital age.

These three works within *34s56w.org*, in their different ways, present some of the central concerns of Mackern's late oeuvre, with their focus on cartographies and on the negotiation of urban space. The deliberately difficult aesthetics—combining jump cutting, speeded-up footage, purposely grainy or low-lit images, dissonant sounds and lack of dialogue or voiceover—create for a viewer/user a panorama in which s/he has to participate actively in order to create meaning. The non-linear, potentially multi-sequential access

to the constituent sound and image files of the works forces us to undertake a digital *dérive*, as we use the tools of Mackern's various interfaces to enter and exit different points of the cityscape at will. The results of this *dérive*, as we access the challenging content of all three works, encourage us to start to look beyond the spectacle of the cityscape and to explore the hidden contradictions behind its principal buildings and monuments. Mackern's combination here of iconic buildings and locations that represented the discourse of Uruguayan modernity of the early twentieth century, with the jarring sounds and distorted images of failed communication, provide a commentary on late capitalism and the social exclusions it generates. That said, whilst Mackern directs our attention to counter-discourses of the city, or to its underside, he also cautions us that what may at first sight appear to be oppositional discourses may, in fact, turn out to be just as supportive of the status quo, as the images in *Graffiti* ultimately reveal. In this way, Mackern's works in *34s56w.org* challenge us to negotiate soundscapes and landscapes in our revisiting of iconic sites in Montevideo and to look beneath the spectacle.

NOTES

1. Described by Sondrol (1993: 236) as 'the ultimate foundational myth of Uruguayan exceptionalism', the conceptualization of Uruguay as the 'Suiza de América' conceived of Uruguay as a model country, because of its civilian rule, its democratic institutions and its financial stability during the early decades of the twentieth century.
2. Cortázar, particularly his 1963 novel, *Rayuela*, is frequently hailed as one of the precursors of hypertext fictions, or, in the words of Landow (1997: 38), a 'print proto-hypertext'. For more on Cortázar and his relationship to hypertext, see Landow (1997: 38, 56), Bolter (2001: 148), Douglas (2001: 38, 44, 56) and Gache (2006: 153).
3. For a detailed analysis of Mackern's *netart latino database*, see chapter 1 of Taylor and Pitman (2012).
4. Personal correspondence with the artist, November 2012.
5. The groups making up the Situationist International were the Lettrist International, the International Movement for an Imaginist Bauhaus, the COBRA movement and the London Psycho-Geographical Society. For more on the history of these groups and their coming together in the Situationist Internationale, see Barnard (2004: 104–05).
6. The majority of Mackern's *soundtoys*, including those not concerning Montevideo and so not included in *34s56w.org* are collected in the *Antología soundtoys [1996-2008]*.
7. The resistant use of low tech is a common conceit in many of Mackern's works, ranging from the deliberate aping of early ASCII art in his *netart latino database* (2000–05); the use of a continuous ream of now obsolete perforated fanfold paper, of the type used in dot matrix printers in the 1970s, in the companion volume to his database; and the use of green phosphor screen-display font, typical of the iconic IBM 5151 monochrome monitors of the 1980s, in his *JODI/web_o_matic [n]coder* (2000).
8. The full list of all the links within Mackern's interface is xtcs; mvd1942; graffiti; links; utc; 24horas; rambla sur; events. These include both the individual works themselves and links to further information about the project.

9. After a period of economic uncertainty from 1999 onwards, the Uruguayan economy experienced a full-blown crisis in 2002—or what De Brun and Licandro (2005: 2) call a 'triplet crisis', combining a currency crisis, a public debt crisis, and a panic in the banking sector.

10. Personal correspondence with the artist, November 2012.

11. Personal correspondence with the artist, November 2012.

12. José Batlle y Ordóñez was president of Uruguay for two terms (1903–07 and 1911–15), and presided over a booming economy and the modernization of the Uruguayan state. As Panizza (1997: 668) notes, there is general consensus amongst historians that Batlle was the 'founder of modern Uruguay'.

13. Personal correspondence with the artist, November 2012.

14. In one version of the origins of the term *net.art*, it purportedly stems from an e-mail message received by Vuk Cosic in 1995 in which, due to the incompatibility of the software, the majority of the text was rendered as incomprehensible ASCII code, with the exception of a short part reading ': [. . .] J8~g#l\;Net.Art{-^s1 [. . .]' (cited in Shulgin 1997: n.p.). In this version, the term itself arose from errors within digital technologies. However, this version has been questioned by Bosma, who argues that Shulgin invented this story about its true origin, in an attempt to 'mock the ongoing debates about what net.art was, who made it, and whether this practice really needed its own terms' and that the term was in fact coined by Berlin artist and Nettime founder Pit Schultz in 1995 (Bosma 2011: 148). Regardless of the exact origins of the term, certainly the creative use of errors generated by digital technologies has been a constant in net art practice.

15. The full list of locations from north to south, is Calle Santiago/Palacio Municipal, Esquina Ejido y Soriano, Esquina Durazno y Jackson, Gonzalo Ramírez y Ejido/Fábrica Strauch, Calle Gonzalo Ramírez/Cementerio Central, Esquina Gonzalo Ramírez y Minas/Edificio UTU, and Calle Lauro Muller/Parque Hotel.

16. The Parque Hotel was constructed in 1909 on the waterfront and was one of the preferred summer destinations for wealthy tourists in a show of social status (see da Cunha 2010: 83). The Cementerio Central, meanwhile, was first opened in 1835 and houses the graves of many celebrated figures in Uruguay's history, including writers Delimira Augustini and José Enrique Rodó and former presidents including José Batlle y Ordóñez and Luis Batlle Berres, amongst many others.

17. Virgil's second Eclogue told the tale of Corydon's unrequited love for Alexis; Garcilaso de la Vega's *Églogas*, borrowing from Virgil's tradition, also told of unrequited love, such as the first *égloga*, tells of Salicio's pain at being abandoned by the woman he loves. Don Quijote's unrequited love for Dulcinea was expressed in high-flown rhetoric, although, of course, in a mocking tone intended to debunk the norms of courtly love. In a nineteenth-century context, Doris Sommer's *Foundational Fictions: The National Romances of Latin America* charted how, in the major novels of the period, unrequited love formed a common plot device before the eventual resolution, since the 'unrequited passion of the love story produces a surplus of energy [. . .] that can hope to overcome the political interference between the lovers' (Sommer 1991: 48). Neruda's *Veinte poemas de amor y una canción desesperada* (1924) is one of his earliest and most famous poetry collections and addresses a lover who is often absent, distant or unreachable.

18. Personal correspondence with the artist, November 2012.

5 Questioning Democracy and Re-encoding the Map of Colombia

Martha Patricia Niño's *Demo Scape V 0.5*

Following on from the analysis of Mackern's commentaries on the spectacle of the city in late capitalism in Chapter 4, the present chapter now turns to the work of an artist who has explored the contemporary conditions of late capitalism as they spread across (and beyond the boundaries of) an entire terrain. The chapter focuses on the work of Colombian creative multimedia artist Martha Patricia Niño, in particular her 2005 piece *Demo Scape V 0.5*, and examines how her resistant maps redraw the geographical boundaries of the Colombian nation, indicating how flows of capital, peoples and conflicts traverse the borders of the state.

The key location under scrutiny in this chapter, and with which Niño's work constantly engages, is the Colombian terrain and the shape of the nation as represented in conventional cartography. More diffuse than the other locations analyzed in this book so far, Niño's Colombia is not represented by specific landmarks, monuments or buildings, but instead is represented by the contours and boundaries of the mapping of the nation: it is the map itself that for Niño is the central geographical representation of the nation. That is not to say that the map is devoid of any specificity; on the contrary, Niño's map, as we shall see in the chapter, is heavily imbued with the specifics of Colombia's sociopolitical landscape of the 1990s and 2000s. Indeed, as I argue in this chapter, it is this focus on the map rather than on any specific landmark, building or thoroughfare that conveys Niño's critique: it is precisely the diffuse nature of power that traverses the boundaries of the nation that forms the focus of Niño's critique. The key locale for Niño, thus, is the territorial boundaries of the nation that are at once specific to Colombia but which are, as we shall see, constantly traversed.

If such is the key geographical representation of Niño's work, the timeframe of her work is the period of the late 1990s and early-mid 2000s in Colombia. *Demo Scape V 0.5* explores the complex sociopolitical situation of this era, focusing in particular on issues such as military interventions into vast swathes of the Colombian national terrain, on US foreign policy in relation to Colombia, and on the vested interests of large multinational corporations in Colombia, particularly in the defence, mining, and petroleum sectors. Although including a range of references to Colombia's

sociopolitical situation of the 1990s and 2000s, Niño's work singles out for our attention one particular scheme that functions as an overriding structure defining the entire period: Plan Colombia, the multibillion-dollar package of US aid for Colombia which was initiated in 1999 and was approved by Congress in 2000.[1] First proposed under the government of Andrés Pastrana (1998–2002), Plan Colombia was continued under president Álvaro Uribe's two-term administration (2002–06 and 2006–10), the latter combining it with his own domestic policy of 'seguridad democrática' ['democratic security'] that stressed security as the over-riding issue, and which pushed for increasing militarization of the country. Plan Colombia focused on a supply-side approach to combating coca production in Colombia, and, given the complexities of the sociopolitical conflict within Colombia, and its strained relationship with the US, the plan has attracted criticism from NGOs, human rights associations, scholars and the public. It is this period of Colombia's recent history with which *Demo Scape V 0.5* dialogues and, as we navigate the work and explore its content in more depth, we are presented with a wealth of information about the complexities of Colombia's sociopolitical landscape and the ongoing inequalities in the country.

Niño is a Colombian creative multimedia artist and scholar whose works to date combine both web-based elements and site-specific installations. Her digital installations include works such as *Peligro biológico* [*Biological Threat*] (1999), in which a robot roams art galleries, criticizing works and harassing spectators and, more recently, her *Recorridos del cartucho* [*Travels Around El Cartucho*] (2003) involving interactive systems that provide narratives of the Santa Inés del Cartucho neighbourhood in Bogotá, historically one of the most troubled areas of Bogotá. *Hack-able Curator* (2007) is a ludic curating programme based on an algorithm that searches for images on Flickr and allows users to hack into the system using their mobile phones. *Relational Border Map* (2007) is a web-based work that imaginatively combines a series of terms that provide links to external sites and constantly trace and retrace new connections across the screen.[2] In all her works, whether involving a combination of web-based and installation art, or whether exclusively web based, there is a concern with using technologies to challenge artistic norms, such as in *Peligro biológico* or *Hack-able Curator*, or to narrate stories at the margins of the Colombian national imaginary, such as is the case with *Recorridos del Cartucho*. The particular work under analysis in this chapter, *Demo Scape V 0.5*, combines these two concerns, as it both interrogates the uses to which technology is put, and provides a sustained insight into the particularities of Colombia's conflicted sociopolitical landscape of the early to mid-2000s.

Demo Scape V 0.5 was developed during a residency at the Planetary Collegium, Plymouth, UK, in 2004 with financial assistance from UNESCO's International Fund for the Promotion of Culture. The work was subsequently included in the 'Muestra Monográfica de Media Art en Colombia' section of the *Simposio Arte & Media: Primer Encuentro Iberoamericano de*

Nuevas Tendencias en Arte y Tecnología, held in June 2005, and at *Memefest 05 – International Festival of Radical Communication*, the annual festival of 'socially responsive communication and art' organized by the Memefest Kolektiv, an international network of communication experts and media activists. The description of *Demo Scape V 0.5* by the author, as posted on the Memefest site, declares,

> Demo Scape V 0.5 is a parody of social software that attempts to accurately map a landscape of democratic activity by searching in Google. The work is a reflection about the way we build symbolic networks by receiving, distorting, transmitting, sharing and even ignoring information. It is a commentary about the immeasurability and mutability of concepts such as Democracy. (Memefest n.d.)

Niño's statement immediately alerts us to the parodic status of the work. Her mention of 'social software' (now more commonly known as 'social media') makes reference to the growth of a wide range of applications that emphasize the social nature of computer-mediated interaction and offer increasing possibilities for user-generated content, such as online forums, blogs, wikis, social networking sites and so forth.[3] That she specifically frames this within the mode of parody indicates to us her scepticism regarding the unthinking use of these tools. Indeed, her declaration that networks are built by 'receiving, distorting, transmitting [. . .] ignoring information' indicates how, in Niño's view, Web 2.0 and social media may lead not to the much-vaunted diffusion of information but, in fact, to its distortion.

The title of the work itself—*Demo Scape V 0.5*—is a neologism and plays simultaneously on political terminology, cartographic representations and new media technologies. The first half of the neologism is drawn from the term *democracy*, and, given the context of the work and its constant focus on Colombia, cannot but remind us of President Álvaro Uribe's much-proclaimed policy of 'seguridad democrática'. The first half of the title, then, makes explicit references to sociopolitical systems and, implicitly, to the specifics of Colombia's sociopolitical situation of the 2000s. The second half of the title refers first to cartographic representations, where the suffix — *scape*, derived from the term *landscape* (which itself derives from the Dutch term *landschap*), is now commonly appended to words to indicate 'view' or 'mapping' (in terms such as *seascape*, *cityscape*, *mindscape* and so forth). The 'scape' thus indicates visualization and mapping, a feature which we see coming to the fore in the work itself. At the same time, the term *scape* also, in the context of an internet-based work, clearly brings to mind to the early web browser, Netscape, first released by Netscape Communications Corporation in 1994, and popular throughout the mid-1990s. Netscape had lost its market share by the end of the decade, however, and indeed the demise of the Netscape browser was the crux of what have been called the Browser Wars and was at the centre of one of the most famous court

cases in the history of IT: the antitrust lawsuit brought against Microsoft in 1998.[4] Niño's use of *scape* therefore references IT technologies themselves and the battles for control of media access that are immediately raised by the spectre of Netscape. Niño's title thus brings together democracy, Colombia's sociopolitical situation of the 2000s, mapping, and new media technologies themselves. It is of no surprise, then, that these key terms invoked by her title—political regimes, a focus on Colombia, the visualization of data through maps and monopolistic and corporate practices in the use of new media technologies—are subjected to an extended critique throughout the work itself.

If such is the title of the work, on entering the homepage of *Demo Scape V 0.5* these principal concerns of Niño's come to the fore. The work opens on a home page characterized by a limited palette, with a black background and white lettering. The title of the work is given in upper-case letters in white graffiti spray-paint font, a font which is symbolic of graffiti and urban protest. It also, in the context of Niño's work with its constant self-reflexive references to new media technologies, serves as a visual metaphor for cyber-graffiti or digital graffiti, a practice involving hacking into a website's source code to change the homepage in order to leave a statement or slogan (Van Laer and Van Aelst 2010: 1160). The graffiti font, thus, with the connotations of counter-cultural resistance it brings with it, provides us with a further hint that the work we are about to enter will attempt to employ new media technologies with a critical edge.

Below the title, we are informed that what we are about to access is the 'alpha release' of the purported product. The term refers to the early stage of a software product known as 'alpha testing', normally involving the testing of an experimental version of the software by internal users, before passing to the next phase of 'beta testing' involving a limited number of external users. At the stage of the alpha version of a piece of software, typically the software is often unstable and can cause crashes or data loss. Yet there is, in fact, no such software, since, as we shall discover, Niño's work of art lies in the website itself, and the various sections within it that we navigate. The software itself never actually exists—Niño has not actually designed any software—but it is, rather, the multiple sections and interactive pages of *Demo Scape V 0.5* that constitute the actual work of art. Thus, here, as elsewhere in this work, there is the deliberate use of the terms of corporate computer software development, but in a tongue-in-cheek fashion in which the terms are re-semanticized. Rather than referring to the production of an actual software, Niño's use of the term *alpha* here hints that we are about to enter an experimental work in more than one sense. In other words, Niño's use of *alpha*, with all its connotations of experimental and unstable content, indicates how the work we are entering will engage in experimental new media practice for artistic purposes.

In addition to this blurb is also a mock company logo that appears in the top left-hand corner of the page, comprising white outline pyramids organized

into four columns and linked by a central axis. Below this, in the centre of the screen, lies the description of the purported (but ever absent) software. First, we are informed that, 'Demo Scape V 0.5 is a new development in social software designed for supporting, positioning, tracking, identifying, predicting, visualizing, intercepting, targeting, testing, morphing, policing and customizing democratic activity through new technologies'.[5] In this promise of a new social media software—Niño was writing during the start of the social networking boom, with the launch of Facebook in 2004 still fresh in people's minds—Niño apes much of the overblown rhetoric used to sell such media platforms to potential users, whilst also infiltrating this rhetoric with a critical edge. Rhetorically, the accretion of verbs becomes repetitious, promising ever more potential uses, and so at first sight appears to be a mere listing of multiple uses of the product. Yet of course, on closer inspection, the description contains a mix of standard marketing terms related to software (such as 'supporting', for instance) and more politicized ones ('intercepting'). The overall effect, then, is disturbing and double-edged, since the text appears to be intimating there is a need to 'police' or even 'intercept' democracy, thus implying that the software can be used to attack or prevent democracy. In sum, in this opening sentence, we are presented with a microcosm of the varied rhetorical strategies employed by *Demo Scape V 0.5* as a whole: the seemingly innocuous interspersed with the sinister; the aping of brand-speak combined with glimpses of the dangerously Orwellian scenario of the control of media, data and individuals.

Following on from this, the page then launches into a sales drive, lauding the qualities of the new software we are invited to purchase:

> This software can help us to comprehend and visualize some information through conventional maps and landscapes that link political maps with other kinds of information important for democratic analysis. You can even create your own democracy definition. The software is highly customizable so that it can be installed in different countries in different social conditions. It is currently under alpha release, and being tested only in third world countries, but it will soon be incorporated into the market. Please understand that not all the features are fully functioning yet.

In this chilling sales pitch, Niño draws on the boom in social media and the hype about its potential uses, particularly the liberatory claims regarding user-generated content, but then mixes this hype with sinister indications about the purported new software. We are promised, for instance, that the software is 'highly customizable'—a standard promise of much software sales pitches—but this is immediately undercut by what follows. Whereas, conventionally, software should be customizable according to different environments or operating systems—in other words, *virtual* environments— here it is customizable to different countries with their different social conditions—in other words, *concrete, sociopolitical* environments. Here,

thus, we have an indication that *Demo Scape V 0.5* will be using the norms of digital technologies against the grain, and will bring socio-political concerns to the fore. Similarly, the previous sentence which informs us that we can 'create your own democracy definition' puts us on our guard, and again encourages us to read between the lines of this purported product blurb. The disturbing possibility that democracy can be defined in accordance with particular interests—in the interests of a particular nation state, or a particular corporation, for instance—gives a sinister edge to the product description. Indeed, this notion of defining one's own democracy is enacted in another page of this work (see the following for further analysis).

The penultimate sentence, meanwhile, indicates how this work engages in a critique of contemporary geopolitics. The fact that it is 'being tested only in third world countries' again introduces a sinister note into this sales pitch and explicitly marks out the developing world as the testing bed for experimental, unstable versions of software. Here, the reference to the Third World refers firstly to the growing trend in IT outsourcing to countries of the global South, in particular India, from the late 1990s onwards. It thus speaks to the politics and economics of software development and the IT industry more broadly, where frequently, due to the desire to cut personnel costs, cheap labour in parts of the developing world is employed by software companies to develop and test initial (alpha) versions of software. The political implications of this—whereby cheap labour in the global South serves the needs of the First World and the profit margins of major multinational corporations—is explicitly highlighted by Niño's use of the highly charged term *third world* in this context. Niño is thus drawing our attention here to the material conditions of production of new media technologies and bringing to the fore the reliance on Third World labour frequently disavowed or glossed over by major multinationals providing services for 'First World' countries. In summary, this mock homepage sets out for us the central concerns of this work: the interrogation of the uses to which new media technologies are put, the uncovering of the workings of corporate capitalism, the resistant forms of mapping and the focus on sociopolitical conditions.

At the foot of this opening screen, we then have five terms in white font which link to the other main pages of the work, named 'Features', 'Definitions', 'Tests', 'Objects', and 'Maps'. The first of these, titled 'Features', loads a page setting out the purported features of this software. The left-hand side of this screen provides a list of the purported system requirements and features, although again, we see the socio-political commentary start to encroach on the standard terminology employed to market computer software to users. Here we are told that the 'system requirements' are as follows: 'Windows 2000 / Windows XP / Windows 98 / Mac OS X / Works better with: / Violent internal conflicts'. There is a deliberate jarring here, whereby the set of system requirements that would usually state that the software works better with a particular operating system and implicitly encourage us to use that system, are replaced instead by a reference to violent internal

conflicts. Resonating with the blurb on the homepage that promised us software customizable with different countries and their respective sociopolitical systems, this statement is an indication of the detailed sociopolitical information we will discover embedded in Niño's work. Below this, a list of key functions is given, employing a similar series of verbs as those used on the opening page, whilst a continuous text at the right-hand side of the screen explains the functions of this purported software.

These short sections of text, however, are peripheral, since the majority of the screen is taken up with a large image which fills the centre of the screen. Set at an oblique angle, slightly tilted to the left, this is a map of Colombia, marked out in green phosphor font. This font is one of Nino's preferred fonts, and appears in other of her works: visually striking against a black background, the font apes green phosphor screen-display font, a font typical of the iconic IBM 5151 monochrome monitors of the 1980s, and which has now become a visual metaphor for computer-generated code. Popularized in recent years in the *Matrix* film franchise (1999–2003) in the form of the 'digital rain' to represent the strings of data composing the matrix, green phosphor font is often used as a shorthand to discuss the implications of new media technologies and has been used widely in the work of net artists such as JODI and Brian Mackern, the latter also studied in this volume, to call attention to computer code and its uses.[6] This now deliberately dated font—since monochrome monitors, by the date of the making of *Demo Scape V 0.5*, were largely obsolete—thus both references early net art, and at the same time carries with it an implicit questioning of the uses of new media technologies due to its associations with the *Matrix* films. If, in the context of the *Matrix,* the green phosphor font of the digital rain represented the sinister control of alien forces behind the facade of reality, where the matrix was a computer-generated world built to keep human beings under control, it has been widely read as a critique of contemporary society. In this regard, James Rovira (2005: n.p.) has argued that the digital rain is in essence an analogy for the functioning of late capitalist societies:

> This is the Wachowski Brothers' commentary on late 20th century consumerist democracies and our participation in it: that we have been reduced to the status of drones feeding the system upon which we are dependent, and the system works hard to keep us from this knowledge.

This particular font then, brings into question the use of new media technologies, in particular questioning who has control over the data and what lies behind the surface of what we see. The green phosphor font thus stands for the system of global network capitalism: for the regimes of accumulation and regulation predicated on the control of flows of data. These central questions are brought to the fore in the content of *Demo Scape V 0.5* which encourages us, as we access its different pages, files and links, to interrogate power relations and global corporate capitalism as a system.

In addition to the font, which encourages us to read this map as engaging with the politics of new media technologies and the functioning of informational capitalism, the orientation and make-up of the map itself give further indications that the map will be a potentially resistant one. First, the fact that the map is set at an oblique angle indicates that Niño's map is not intended as a 'transparent' representation but as a device to question territorial boundaries and the politics of territorial control. That is, the fact that the map is not reproduced along the conventional north–south axis, but at a tilt, immediately flags up for the view familiar with the shape of the Colombian nation that something is amiss. Niño's representation of the map of Colombia here is intended to make us question the power relations inherent in the mapping process and will interrogate the political interests in mapping practices themselves. As has frequently been noted by geographers since Harley's work in the 1980s, which set out to explore cartography as a historically and politically specific practice, no map is ever neutral, since maps are plotted according to the dominant geopolitical interests of the time of their making. As Sletto (2009: 445) has recently summarized it,

> Maps are representational objects intimately implicated in projects of place making, and therefore they are tools of power. . . . Not only do they order the material world and make us visualize the *where,* but through their rhetorical power they also simultaneously obscure the *why.* Most maps—especially 'scientific' maps produced by regional, state, and global institutions and their agents—are mute about the social context and consequences of their own existence.

Sletto's words here, particularly regarding the role of maps in 'obscur[ing] the why' indicates how Niño's distorted map in this work must be read within the context of the power relations of mapping practices. Niño's refusal of the accepted conventions awakens us to these geopolitical interests: in this case, as we discover when we navigate and explore her map, these interests are those of multinational corporations and their incursions into Colombian terrain. This use of the oblique angle by Niño here is, as we discover, taken up again in other sections of the work (particularly the 'Maps' section, on which more below), and forms an attempt to reposition or rethink the conventional cartographical contours of the Colombian nation.

Second, a further transformation of mapping conventions comes in the detail of the map itself. For the space within the contours of the map is filled with green pyramids—the same shape as the mock company logo—with the contours themselves drawn in green. When the user moves the mouse over these pyramids, several constellations of them light up at once, representing the different *departamentos* [administrative districts] within Colombia, and the contours of that particular departamento appear, drawn out from the mass of pyramids. Again, this feature does not comply with standard norms of cartography, which would fill the spaces with either political data (main

towns and cities) or geographical data (principal rivers, mountain ranges and so forth). Instead, in Niño's map, the company logo literally occupies all of Colombia's national territory as charted on the map. The map's composition, not of features of the terrain but of the endlessly repeated corporate logo, thus functions as a visual metaphor for the encroachment of corporate power into national sovereignty.

Third, a further feature of Niño's map that resists mapping norms is the presence of links that lie both within and without the mapped area. As we move our mouse over these pyramids, URLs in white text appear which traverse the borders of the map. These links are to external sites containing information about Colombia, focusing particularly on issues relating to democracy, conflict and social justice within each particular *departamento*.[7] Here, the insertion of these liminal links that span the interior and exterior of the map is intended as a political commentary in itself. As will be discussed in more depth, Niño's map here suggests the vested interests that traverse Colombia's national borders. This fact of paratextual features that traverse the boundaries of the map is again an instance of the way in which Niño's map defies conventional mapping norms, and comes to have thematic significance, as will be explored later.

If such is the map interface itself, the links inserted within and across it bring into play the complex sociopolitical climate of Colombia of the 1990s and 2000s. The sites include NGOs, anti-war organizations, think tanks and conference reports and force the reader to engage with the complex debates about Colombia's national territory. To take one example, the two links which appear when moving the mouse over the Norte de Santander *departamento* link first to a page on *Why-war.com*, a student anti-war organization set up post-9/11 to promote peace and non-violence. The specific page selected from *Why-war* draws together a list of 51 articles that have been tagged with reference to Colombia. These include articles that specifically discuss aspects of Colombia's contemporary situation in detail, such as the Agence France-Presse article of 2002, 'Colombians Oppose US Request for Immunity From ICC', which details attempts by the US to request Colombia sign a waiver granting immunity for its troops before the International Criminal Court. Other articles, meanwhile, mention Colombia more briefly in relation to conflicts elsewhere in the globe, such as David S. Broder's article, 'Europe's Fury' for the *Washington Post* in 2002, which discussed worsening relations between the US and Europe, and which mentioned US troops in Colombia in passing. As we explore Niño's map and access these links we are, thus, encouraged to move beyond the map in more ways than one: to access information on a wealth of external sites; and to be attentive to the external interests influencing Colombia's complex sociopolitical situation.

The second of the links, meanwhile, loads a page on the Council on Foreign Relations (CFR) website, an organization established in 1921 with its headquarters in New York and Washington, D.C. Highly influential on US foreign policy, particularly during the Second World War and the first two

decades of the Cold War era when it was at the height of its power, the CFR has been the subject of critique from some parts for the excessive influence it exerts on US policy (see McMahon 1985: 445). The particular page of the CFR selected by Niño for our attention is a report based on a session held at the *Latin America: Sustaining Economic & Political Reform* conference in 2000, with the provocative title 'Colombia—A New Vietnam?' (Council on Foreign Relations: 2000). The implicit comparison drawn here is between contemporary US intervention in Colombia in the form of Plan Colombia, and its previously disastrous intervention during the Cold War era into the conflict in Vietnam from 1955–75, in which US involvement was envisaged as a way to prevent a communist takeover of South Vietnam as part of a wider strategy of containment.[8] The content of this particular link thus reflects official or quasi-official US government approaches to policy in Colombia. Indeed, a close inspection of the report reveals just how close the interests of the CFR and official government policy are: many of the speakers hold or have held roles in US or Colombian government agencies, including Ana María Salazar, who served at the Pentagon as Deputy Assistant Secretary of Defense for Drug Enforcement Policy and Support and who played a key role in the development of Plan Colombia, or Enrique Umaña-Valenzuela, who has held a variety of roles within the Colombian administration, including International Adviser to the Minister of Defence and later Vice Minister of Defence in Colombia. This link, therefore, provides us with what may broadly speaking be termed the official line on Plan Colombia, and the summary, given in the conference report, highlights how discussion centred on a variety of concerns including the danger of a 'regional spill-over effect' that could draw Panama, Venezuela and Ecuador into the fray. Again, the 'regional spill-over effect' recalls previous US arguments for intervention in Vietnam as part of a wider strategy of containment in Indochina.

Viewed together, these two links bombard the reader with a wealth of information about Colombia's current sociopolitical situation. Nino's deliberate pairing of *Why-war* with the CFR forces the user to bring together potentially conflicting viewpoints from the various articles consulted; the first brings together many articles openly hostile to US foreign policy; the second represents a limited range of views that, essentially, focus on how best to implement US foreign policy rather than challenge it. The effect of this is to make the viewer question in whose vested interests decisions about Colombia are made, and to understand how the situation within the borders of Colombia is inextricably linked to the actions of those external to its borders, particularly the US government and US global corporations. Thus, the conceit of the hyperlink traversing the map stands as a visual metaphor for the current state of Colombia's boundaries: it represents how the US government's decisions affect the Colombian nation, and the increasing incursion of US corporate interests into the Colombian terrain.

As we thus peruse these articles, despite the varied sources, we see a common thread emerging, which is mentioned directly or indirectly by almost

all the links and which stands as the epitome of this external intervention into the Colombian nation: Plan Colombia and its effects on the country and the wider region. As noted earlier, Plan Colombia, the multibillion-dollar package of US aid for Colombia, has focused on a supply-side approach to combating coca production in Colombia, running to a cost of more than five billion dollars by some estimates. The articles selected in Niño's chosen links highlight several of the key issues related to this controversial plan. Criticisms of the plan by NGOs, scholars and human rights activists have included the impact the scheme has had on the natural environment, the overly militaristic nature of the scheme and the detrimental effects on human rights. Regarding the natural environment, the large-scale fumigation (purportedly targeted on illegal coca crops) undertaken by private defence contractors working with the Colombian military under the auspices of Plan Colombia has brought about environmental havoc, causing illness amongst humans and animals, poisoning water sources, contributing to the displacement of rural peoples and killing legal alternative crops.[9] With regard to the militaristic aspects of the scheme, many scholars have criticized the excessive focus of Plan Colombia on bolstering the Colombian military, and noted that, although originally touted as a "Marshall Plan" for Colombia', the actual breakdown of the aid package was approximately 75 per cent for military and police assistance and only 25 per cent for economic and social development programmes (Elhawary 2010: 393). This excessive prioritization of military aspects has, in turn, led to criticisms of the human rights implications of the plan; given that Plan Colombia prioritized funding towards strengthening the Colombian military, several scholars and NGOs have highlighted the potential for the erosion of human rights and curtailment of civil liberties.[10]

The contents of these links in Norte de Santander, thus, bring up one of the most controversial schemes in the recent history of US–Colombia relations. As we pursue the various links and read the articles within them, our attention is drawn to the power relations that are mapped out, both by the content of what we read, and, significantly, by the technique by which Niño presents them. For, as we move our mouse over these links, the text of the links itself quite literally traverses the boundaries of the map. Rather than fitting within the contours of the Colombian nation, these links traverse it, lying partially within and partially beyond the map. Niño's resistant map thus visualizes how the boundaries of the nation are being traversed in contemporary global politics. Niño's traverse hyperlink is thus a commentary on late capitalist geopolitics as a whole—the increasing encroachment of global corporatism into the previously sovereign space of the nation state— and on Colombia in particular as a case in point—the incursion of US interests into Colombia, particularly to the advantage of US-based multinational defence contractors. Thus, the previous version of the modern nation state that ruled its sovereign territory has now been superseded by the late capitalist neoliberal state, in which US monies finance a scheme of militarization

within Colombia's borders and in which US-based private defence contractors reap the financial rewards.

Similarly, the other *departamentos* on the map bring up links to a variety of organizations that force the reader to take into account the political realities underlying the map, and the vested interests traversing it. These include, amongst others, the progressive monthly newspaper, *Change Links* (Chocó); the leftist periodical, *Colombia Journal*, which explicitly aims to promote 'political, social and economic justice in Colombia by creating a greater awareness and understanding of U.S. foreign policy' (Antioquia); and the anti-corporatist organization, *Pressure Point* (La Guajira). The content in these links highlights similar issues of national concern and, in the same way in which the Norte de Santander links highlighted US interventions in the shape of Plan Colombia, others, also, focus our attention on issues involving foreign incursions into Colombian national territory. In all cases, it is simultaneously the Colombian terrain *and* what lies beyond the boundaries of the Colombian terrain that Niño has chosen for her focus: that is, all the links selected deal as much with US foreign policy regarding Colombia, and multinational corporations' interests in Colombia, as with Colombia itself. These include, for instance, the link from Antioquia to a report by Anne Montgomery that discusses Plan Colombia as a scheme in which foreign corporations profit in Colombia at the expense of the local population. The report describes Plan Colombia as a way of 'ensuring access to resources', and argues that its purpose was to 'defend the operations of Occidental, BP-Amoco and Texas Petroleum, while securing access to potentially rich, but still unexplored, Colombian oil fields' (Montgomery 2001: n.p.). Here, thus, although the focus on the particular sector changes—in this case we read about the vested interests of oil giants rather than defence contractors—the overriding factor is the same: Plan Colombia, and its skewing towards the interests of multinational corporations, rather than those of the local population of Colombia. Other *departamentos*, meanwhile, cover different although related issues, such as La Guajira, which links to a statement from the PressurePoint protest group celebrating Global Justice Week in 2004. Here, after setting out their aim of countering 'abuses of unchecked corporate power and the corrosive influence on the democratic process', the statement goes on to give details of US mining companies and their interest in indigenous lands in Colombia. In all cases, whether mining corporations, global petroleum giants or defence contractors, the focus of the links selected by Niño is on the vested interests of corporate business in Colombia, constantly linking Colombia's national situation to global business interests.

All of the links in Niño's map, thus, involve explicitly linking the map to sociopolitical issues, and do so both to highlight issues relating to that particular region of the map and to indicate how those issues span well beyond the borders of the map. As we explore the map, we are confronted with a wealth of detailed statistics and reports that make visible for us the conflicts hidden within the contours of the Colombian map. At the same time, Niño's

map also works to draw our attention to spheres of influence that lie beyond its borders. The constant traversing of the borders of the nation in both technique and content thus serves to bring home to the reader the geopolitical interests that straddle Colombia's borders. Niño's tactic here thus works to re-semanticize the map and, indeed, re-semanticize the very notion of the (hyper)link itself: the link in Niño's map functions, quite literally, as a linking mechanism illustrating the hidden links between Colombian state policy and US (state or corporate) interests.

If these are the debates generated by our exploration of the various links as we trace a journey around the map, a further interactive element is available to the viewer by means of the search screen which is activated when clicking on each individual *departamento*. This loads a black search screen with a scroll bar to the right-hand side, and results are displayed across the middle of the screen. The search terms are preloaded from the map, such as, for instance 'Democracy Colombia Guajira', below which a large box loads with the search results. Here, Niño's strategy combines with the pre-loaded links already inserted into the map, as the search facility here allows for constantly updated information to be fed into the work. In this section of the work, then, Niño constantly draws out attention to what lies beneath or beyond the map, to the conflicts that are not rendered on conventional mappings of the nation and to the power relations that go beyond the boundaries of the map.

If the 'Features' part of the work has thus provided us with an in-depth view of the harsh realities of Colombia's political landscape, and the vested interests of global corporate giants, the next section of the work, 'Definitions', invites us to redefine existing notions of political systems. This section loads an interactive screen across which three statements appear in white text. Seven of the key terms within this statement are blank, and in their place appear either drop-down menus, from which the user select, or boxes in which the user must tick the appropriate option, along with a free text box at the end in which the user can insert his/her own terms. The preset text reads as follows:

> Derived from the two evocative [English/Greek] words 'demo' [the people/the population/experiment] and 'cracy' [power/authority/force/madness]
>
> It is a political system in which the supreme power resides in a body of [individuals / citizens / slaves / sheep] who can [elect / delegate / privilege] people to [represent / organize / silence / control / guide / disappoint / abuse / regulate / burden] them.

Coming after the 'Functions' section, which forced us to engage with the complex realities affecting democratic countries—for Colombia is, of course, a representative democracy, and in fact one of the longest-established democracies within Latin America—this section invites us now to reconsider

some of the notions we may have held about democratic rule. If the previous section had revealed to us in stark terms how the democratic rule of the nation state is, in fact, traversed by corporate interests, here we may well be inclined to revise commonplace notions about democracy. Indeed, given that President Álvaro Uribe's policy of increasing militarization was framed as 'seguridad democrática', we will be particularly aware, having perused the articles linked in the 'Functions' section, of the ways in which the term *democracy* can be moulded to particular political interests.

These three short statements and their various options allow the user to write his or her own definition of democracy, with the options offered ranging from the standard definitions to the deeply pessimistic. People within democracy can be figured, in the second statement, as citizens or slaves, an antonym which, of course, harks back to and questions the very establishment of democracy in classical antiquity. In Aristotle's classic definition of citizenship, slaves were one of the classes of humans excluded by definition from citizenship, thus not featuring in democracy at all.[11] Niño's juxtaposition of these two highly charged terms here thus encourages us to consider whether the subjects of democracy may be no freer than were Aristotle's slaves, as well as, of course, calling into question Athenian definitions of democracy where the ability of the citizen to participate in civic life was dependent on a non-citizen, slave class undertaking menial labour. Similarly, in the options Niño gives for us to define the elected body, the role of those elected can be either to represent or to abuse or silence the populace, again distorting the classical definitions of democracy.

Below this, the final line of this screen presents us with one short sentence and radio boxes that we can tick alongside each word choice: 'Democracy has to do with: Freedom / Culture / Technology / Market / Tourism / Information / Homogenization / Globalization / Other', with the final of these options allowing us to insert our own term of choice. In the final statement, as the list of terms progresses, we move from the definitions of democracy such as 'Freedom' that encapsulate the classical ideals of democracy, to terms such as 'Market', indicating the corporate interests of late capitalism. In this tactic, Niño is again encouraging us to consider whether classical definitions of democracy are now overtaken by corporate definitions; in other words, whether democracy, in the form of a population electing its representatives who sit on the governing body of the nation-state, can really function in our twenty-first-century era of late capitalism, where the untrammelled powers of global corporate giants traverse these same nation-states. Niño also links this questioning of democracy to new media technologies themselves, with terms such as 'Technology' and 'Information' flagging up to us the role that new media technologies have to play in modern democracies, yet this is not encoded as specifically positive nor negative. Defining democracy as 'information' could imply that new media technologies provide the public, in the form of citizen journalism, social media and so forth, with the tools with which to express themselves freely and democratically. Conversely, it

could imply that whoever has control over information in effect controls that democracy, and so points to the encroachment of corporate control into data on the internet.

When we have made our selection from the options Niño presents for us, clicking on 'create' generates the statement based on our selection. Thus, a user may choose to define democracy as a system in which power lies in a 'body of individuals who can elect people to represent them', and so set out a plea for the ideals of democratic representation. Conversely, the user may choose to express his or her disgruntlement with the system by declaring that the supreme power lies in a 'body of slaves who can elect people to abuse them', indicating his/her discontent with the functionings of democracy. Niño's tactic in this section of *Demo Scape V 0.5* thus involves permitting the user to question the existing political system although of course, only in a ludic or an ironic fashion. Yet, perhaps more important, what this section of *Demo Scape V 0.5* does is to highlight the gaps or inconsistencies in democratic rule. That this spoof software can enable us to rewrite our own definition of democracy, as we work our way through these options, necessarily raises the question of in whose interests are definitions of democracy written. We may, for instance, be inclined to view Uribe's campaign of 'seguridad democrática' in this light, as an Orwellian example of the redefining of democracy in terms of national security and increasing militarization of civilian life. Similarly, viewed in the light of the previous section that we have just navigated, and the details we have accessed via the interactive map, we may be encouraged to make connections with US interventions into the democratic process in Colombia, and so question to what extent the democratic process in Colombia is defined in US interests.

If the 'Definitions' screen allows the user a limited number of options as they peruse and click through the statements, the 'Tests' screen loads a much longer, interactive section in which the user must navigate and respond to 21 different questions. As with the 'Definitions' section, our navigation of the 'Tests' section is informed by the sociopolitical data we explored in the 'Features' section and, whilst this particular section is not specifically about Colombia, of necessity, we read its conflicts into the questions we are presented with. Ludic in format although also aping marketing strategies, this section of the work consists firstly of a short explanatory text, which sets out a spoof blurb of the potentials of the software:

> Our software can be used as a statistical tool to numerically and therefore democratically catalogue the population within your territory. The tools available for gathering information are surveys and tests which are very useful for on-line voting and cataloguing of individuals.

As with elsewhere in Niño's work, the Orwellian parallels in this short marketing ploy are deliberately drawn. The promise that this spoof software will provide the tools to catalogue the populace democratically, and allow

the profiles of individuals to be traced, creates an uneasy balance between the goals of democracy and surveillance. For how can democracy be enabled by this mock software tool, if it involves the tracking and surveillance of individuals? The Orwellian scenario of state surveillance and double-speak is brought up to date by Niño here; where, for Orwell, it was the totalitarian superstate of Oceania that subjected its populace to constant and invasive surveillance—reflective of the climate of the mid-twentieth century when statist capitalism was the overriding model—for Niño it is no longer *state* power but *corporate* power that encroaches upon the individual. Niño's references to surveillance here thus refer not to the surveillance of a state but to the capturing and mining of individual data for corporate interests. The process of 'cataloguing of individuals' refers nowadays to the common practice in contemporary informational capitalism of data mining and techno-surveillance, employed to serve the interests not of statist capitalism but of corporate capital. With the explosion of social media and Web 2.0 plat-forms, data mining and web surveillance are increasingly employed by new media giants as highly lucrative sources of revenue, a phenomenon that has led Christian Fuchs to describe a new political economy of privacy and data online, in which 'the users are sold as a commodity to advertisers' (Fuchs 2012: 144). For Niño, thus, this late capitalist model comes under scrutiny, and focusing on the corporate control of data, her mock marketing blurb highlights for us the contemporary flows of political power and capital.This fact, of course, should immediately put us on guard for we are, precisely, about to complete a (mock) consumer survey, and thus supply Niño's system with precisely the personal data she flags for our attention here.

Below this explanatory text, a short line in green neon font asks, 'Are you global? Find out your specific type', and to the right a small button titled 'sample' loads the first of a series of 21 question pages, soliciting data from the user. These pages all follow the same format: the fundamental question ('Are you global? Find out your specific type') appears at the top of each page; below this, the question number and question are given in white font; and below this again, the response options are given in white font, with radio buttons in neon green font alongside each. Selecting one of these but-tons automatically loads the next page with the following question.

As we work our way through the questions, shared themes emerge across them: five are about information technologies (questions 1, 11, 15 and 18), four revolve around global politics (questions 4, 5, 16 and 21) and two ask about financial details (questions 6 and 8). Some of the questions are fairly anodyne; we are eased into the survey by being asked to select our age range and gender (questions 1 and 2). Others, meanwhile, verge on the absurd, although they have implicitly political points to make. One case in point is question 3, which asks us to select which planet of the galaxy we live on—at first sight, a bizarre question—but then turns out to have a potentially political edge, given that one of the options we can select is Gaia. The reference here is to the Gaia hypothesis, first developed by Lovelock in

the 1970s and which proposes that the Earth is a complex, self-regulating system that can be thought of as a living organism. Gaia has been taken up by a variety of environmentalist groups, in particular certain brands of ecofeminism, as rejecting an anthropocentric attitude to our planet and as challenging monetary conceptualizations of the Earth as simply a collection of resources awaiting exploitation.[12] This option is, thus, a politicized and oppositional stance nestled amongst the other seemingly absurd responses we can give to this question. Similarly, question 9, asking us to select our profession, gives only four options from which to choose: 'humanist / salesperson / engineer / other'. Again, the initial absurdity of the tightly circumscribed range of options—where the only pre-programmed professions are humanist, salesperson, or engineer—appears at first glance to be a random selection of a small range of professions (if 'humanist' can, in any case, be called a profession). But on closer inspection, these three professions or roles relate to the key issues underpinning *Demo Scape V 0.5*: the first of these refers to humanism and ethics, and so the oppositional thread running through the work; the second refers to consumerism and a market-based approach to the world and its resources; and the third refers to the use of new media technologies. The three professions, thus, relate to the tensions underpinning *Demo Scape v 5.0*, and Niño's question here is, thus, inviting us to indicate where we locate our own stance in these tensions.

If these are apparently absurdist questions which turn out to have serious points to make, other questions engage in a very clear critique of the existing sociopolitical system, with several interrogating us about issues such as consumerism, human rights, and national security. This is the case, for instance, with question 12, which asks us to define human rights, for which we are then offered the following five options: 'A charitable institution / A utopia / A marketing ploy / Something worth fighting for / Something that can be exchanged for security'. The options Niño offers to us are deliberately thought-provoking both in their individual content and in their scope as a whole. In terms of individual content, the third option presents human rights as understood solely within the terms of consumerism. This option thus reads as a criticism of consumerism, but also, more profoundly, as an implicit critique of late capitalism as a system, which increasingly defines the individual in terms of market choices and lifestyle decisions, rather than in terms of fundamental human rights. Here, the market-run democracy, and its concomitant notion of the consumer-based civil sphere, is what comes under critique in Niño's tongue-in-cheek response, as it presents us with an implicit critique of market-based approaches which view human beings solely as consumers of goods, with rights being defined as the right to purchase goods. The fifth option, meanwhile, figuring human rights as a dispensable feature in exchange for security provides an implicit critique of regimes that quash human rights in the name of security. Whilst no named country is given, in the context of the work as a whole, we may be encouraged to recall some of the many links given in the 'Funciones' section of

this work that highlighted human rights abuses under the auspices of Plan Colombia and the plan's excessive focus on strengthening the military. If such is the effect on the reader in terms of the individual content of each response, the scope of the responses as a whole provides us with a further critique. For, in terms of scope, it is worth noting that of the five options we are offered, in no cases are we able to define 'human rights' as an actually existing entity. At best, human rights are something 'worth fighting for', but we are given no option within this satirical survey of actually affirming human rights as they currently exist.

Whereas questions such as question 12 invited us to consider the encroaching powers of late capitalism and global corporatism into human rights, other questions focus more closely on new media technologies and their effects, and link these to contemporary geopolitics. Question 15, for instance, asks us to define the 'digital divide', offering the following options: 'A virus that damages your hard drive / An advanced industry / An inevitable social problem / The gap left by a laser cutter'. The term we are invited to define—*digital divide*—was initially used in the 1990s to refer to disparities of internet access between rural and urban populations in the US and has more recently been used to refer to global inequalities in access, distribution and use of information and communication technologies. Given that it is, predominantly, the countries of the global South that suffer from weak infrastructure and poor connectivity, and whose citizens are located on the 'wrong side' of the digital divide, the digital divide is, at core, a geopolitical issue. Fuchs and Horak (2008: 14) have argued that, since most African countries lag so far behind they are in effect excluded from the information society, we should speak of a 'digital apartheid' that has 'real-world causes such as the unequal global distribution of resources', and which means that 'certain groups and regions of the world are systematically excluded from cyberspace and the benefits that it can create'. The digital divide, thus, is an inherently political issue, and forms one of the structural inequalities of informational capitalism.

Given that the digital divide is thus inextricably linked with global geopolitics, where inequalities of access are structured along the fault lines of global capitalism, this question is therefore not just about new media technologies per se, but forces us to make a statement about global inequalities. Crucially, though, this question, however we respond to it, is deliberately structured to allow us no space to contest this digital divide. Some of the responses, such as the first and the fourth, are deliberately absurd, demonstrating a lack of engagement with global inequalities. The only 'correct' answer, however, is deeply pessimistic, since it identifies correctly what the term means, only to declare such global inequalities 'inevitable'. Here, it is significant that if we discard these absurd definitions, we are left with no option to combat the digital divide. We thus have to opt between selecting absurd and incorrect answers (such as declaring the digital divide to be a virus on one's hard drive), and so ignoring the issue completely, or, if

we accept that the digital divide is a social problem, we can only flag it as 'inevitable'.

In these and other similar questions in this parodic survey, we are forced to consider the relationships between politics, technology, and globalization. When we complete the last question (question 21), a final page displays the results according to the responses given by the user, and the user is ranked according to the following categories: 'Global intimidator / global dreamer / global lamb / global citizen / not global / global consultant'. The scores in each of these categories are indicated above each term, based on our responses, whilst another button above these scores, labelled 'statistics', loads a new screen showing statistics generated from the responses by other visitors to the site to date, against which we can compare our responses with the general trends in users of the site to date. At the outset of this mock survey we were alerted to the sinister possibilities of corporate control of data and personal profiles. Here, by the time we reach the end of the survey, we have, obediently, generated just that information about our individual profiles. This trick of Niño's, in which at the end of this section we find our data mined and aggregated with that of other users of the survey, is intended to alert us to the dangers and to question the now ubiquitous practices of data mining by media giants.

Finally, the last of the sections of *Demo Scape V 0.5* is titled 'Maps' and loads a page, again with a black background, with short paragraphs of explanatory text in white font. Behind this text, in watermark fashion, we can discern the outline of Colombia. The text informs us that

> Demo Scape V 0.5 can be used with third party plug ins that let you monitor and record specific elements that are related with democratic factors.
>
> Activities like migration and displacement can now be integrated into the landscape thanks to this amazing social software.

Again, as with other sections of this work, Niño's text merges marketing-speak associated with computer technologies, with politicized terminology referring to socio-political situations. In computing terms, the verb *integrate* would normally refer to *system* integration, meaning the bringing together of different computing systems and software applications into a functioning whole. In Niño's version, this 'integration' is now taken beyond the realm of the computing system in itself and is made to refer to the issues of migration and displacement: in other words, how human populations are affected by conflict and, specifically, by the issues we explored in the earlier 'Features' section.

A green button located to the bottom right of this text is titled 'terms' and opens up another page, containing a long list of Terms and Conditions. Within these Terms and Conditions are parts that ape the language of corporate-speak, with particular attention given to the limitation of the

company's liability. Other parts, meanwhile, are more overtly parodic, such as the claim nestling within the seemingly straightforward list of liabilities that the Terms and Conditions accept no liability for the Terms and Conditions themselves containing errors. This byzantine strategy points up the fact we are not to take these Terms and Conditions at face value. Similarly, the paragraph setting out the limitations of the warranty ends by stating that the Terms and Conditions do not guarantee that the implementation of *Demo Scape V 0.5* will not infringe 'third party patents, copyright, registered trademarks, privacy or other human rights'. Again, it is only the eagle-eyed user here, who has trawled through the Terms and Conditions rather than blindly clicking 'accept' without scrutinizing them, who will notice the incongruence: whereas the limitation of a warranty should normally end on any possible impact on the rights of the *consumer*, here, we end on something much more fundamental: any detriment to *human* rights. Here, Niño's near-perfect aping of corporate speak aims to draw attention, once again, to the way in which corporate incursions into individuals lives may have repercussions for human rights, and, given the content we have viewed on other sections of the work, we may be inclined to draw parallels between the contracts of private defence contractors in Colombia and their human rights records.

Below this text, to the bottom right-hand side, there is a button marked out in neon green and marked 'accept' in white font. Once we have duly clicked on 'Accept', a page loads showing a map of Colombia, again set at an oblique angle. This time, the contours of the map are traced in white outlines, with the boundaries of each *departamento* clearly marked out and with dozens of dots, in the same green phosphor font used elsewhere in this work, that constantly quiver and move around the map. Again, the rotation of the country disrupts the north–south axis along which cartographical relations are normally drawn, and has political implications, as noted earlier. Niño's distortion here implies an attempt to disrupt cartographical hierarchies and, in particular, the location of the global South in relation to other countries of the world. Niño's off-kilter map attempts to visualize the power relations that have been obscured in conventional mapping practices. In so doing, she shares impulses with other mapping projects that have explicitly set out to address North–South inequalities, the most famous of which being Arno Peters's revised world map which attempted to counter what Peters saw as the 'Europe-centred character' of the Mercator projection whereby, by 'placing the equator deep in the southern half of the map, two-thirds of the available map surface were available to represent the northern half of the globe while the southern hemisphere had to be content with only one third' (Peters, cited in Müller 2010: 722). In a more specifically Latin American context, Niño's image of course dialogues implicitly with Torres García's iconic drawing just as Mackern's work did. Yet Niño's distortion also has crucial differences to Torres García's endeavour, since Torres García stated that his aims in his inverted map were to 'turn the map upside down'. Torres

García, in other words, flipped the map on its head; albeit reversing the terms, Torres García's map nevertheless maintained the north–south axis as the ultimate signifier in mapping practice. Niño's impulse, however, is rather different. Niño's map, rather than turn the cartography on its head, attempts to skew the notion of the north–south axis. In Nino's new version, it is the fact of there being a central north–south axis that is the problem; her map attempts to map out global relations that do not comply with a world view mapped out along north–south lines, and to resist dominance of the global South by the corporations of the global North.

If such is the orientation of the map, its internal features and paratextual details highlight for us just how these global politics make themselves manifest in the Colombian national terrain. To the left of the map, rather than a conventional explanatory, we instead are provided with two sets of statistics: the first indicating the internally displaced population and the second indicating this figure as a percentage of the displaced population worldwide. The figures that accompany these texts are not static, but instead constantly fluctuating, giving the impression of real-time data feeding into the statistics of the map. In the light of these statistics, we are then encouraged to read the map; whilst not specifically stated, presumably the quivering and constantly mobile dots on the map represent the flows of displaced peoples to and from the hot spots in the country. It is worthy of note that neither the fluctuating statistics nor the dots themselves remain still long enough for us to read them clearly; the figures constantly fluctuate so quickly that we cannot discern a concrete figure at any one point in time, with the percentage of the total population of displaced peoples worldwide fluctuating somewhere between 12 and 13 per cent. Here, the effect created by these statistics which never remain still is that the immensity of the situation is difficult to grasp, and the population is constantly under threat of a shifting, never-ending process of forced internal migration.

The dots, meanwhile, never settle, and traverse Colombia's terrain, tracing routes in particular from some of Colombia's most troubled rural regions to its increasingly populous urban centres. The dots thus trace out the routes of internally displaced peoples which, as statistics have shown, involve for the vast majority the movement of rural poor displaced from the countryside by violence to urban or peri-urban centres.[13] Other dots, meanwhile, go beyond the borders of the map, across the 640-kilometre-long border that Colombia shares with Ecuador (although, again, this country is not explicitly marked out as such on the map), and represent those who are forced into exile to escape the violence of the country, with Ecuador being one of the main destinations of Colombia's refugees.[14] Amongst these dozens of moving dots, three remain fixed, located in Cundinamarca and close to it; although not labelled, these dots presumably represent Bogotá, one of the main destinations for displaced peoples within Colombia.[15]

This politicization of the map is also indicated in a deliberate re-semanticization of the terms of cartographical representation, as below the

map itself, the words 'Demo Scape 0.5 / Political Map' appear. Here, Niño is re-semanticizing the cartographical term; conventionally, a 'political map' refers to a map marking out nation-state or administrative boundaries (as contrasted to a 'physical map' which marks out physical features such as rivers, mountain ranges, and so forth). Yet, of course, Niño's map is not a 'political map' in the conventional sense of the term; we do not see, on this map, the names of capital cities of the departments, for instance, nor any other of the key data normally associated with political maps. Instead, what the map actually represents are real-life political conflicts. In other words, this 'political map' actually maps out the *effects of politics* on the national terrain and on the populace. Visually, the map in this section recalls the map we saw earlier in the 'Features' section of this work, hence we are encouraged to read this later map as depicting the effects of the former. Moreover, this requires us to make further connections with the overall work itself, since this is not a map setting out democratic events (as promised by the software blurb), but showing displaced populations. We therefore, need to make the link between democracy (or lack thereof), and internal displacements, by drawing together the data we discovered in earlier sections of the work about Colombia's conflicted contemporary situation, about Plan Colombia and about vested corporate interests in the country, with this disturbing map of the effects on the civilian population.

This map, thus, displays the one of the most prominent issues in Colombia's contemporary conflict: the massive forced internal displacement that has been generated by the decades-long conflict and that escalated in the 2000s. Colombia is the country with the largest population of internally displaced peoples in Latin America, and the second-largest population of internally displaced peoples worldwide, second only to Sudan (Carrillo 2009: 527). At the time of making of *Demo Scape V 0.5*, in the early 2000s, there were almost three million internally displaced peoples (Villaveces-Izquierdo 2004), although that figure has since risen again, with current statistics estimating approximately four million, close to 10 per cent of the country's population.[16] As well as the violence from which they are fleeing, internally displaced peoples in Colombia are subsequently faced with extremely precarious living conditions in the city of their destination: according to a 1996 report by the Comité Consultativo para los Derechos Humanos y los Desplazados (CODHES), 86 per cent of internally displaced peoples were living in areas defined as 'urban misery belts' (CODHES, cited in Villaveces-Izquierdo 2004), whilst an ICRC/World Food Programme report in 2007 calculated that 99 per cent of people displaced from rural areas to urban areas are living in poverty and 85 per cent in extreme poverty (ICRC/World Food Programme, cited in Carrillo 2009: 534).

It is significant that much scholarly research on forced internal migration in Colombia has highlighted the lack of visibility that these peoples have within national debates and Colombian state policy. Tate (2009: 59) has argued that since most Colombians fleeing violence and instability

do not move to refugee camps, but instead resettle informally in shanty towns within Colombia, this creates 'one of the world's largest—but largely invisible—internally displaced population'. Meanwhile, Villaveces Izquierdo has argued that the 'official narrative' told by the Colombian state works to obscure the realities of internally displaced peoples, since 'the lack of census variables that capture the dynamics and impact of such dramatic demographic flux has produced a statistical conundrum that hides the crisis from policymaking spheres as well as from political debates, creating an 'official invisibility' (Villaveces Izquierdo 2004). Niño's map here thus functions to make visible the narrative of these displaced peoples and, due to graphic matchings with the 'Features' section, indicates that this map makes visible the invisible effect of Plan Colombia.

Internal displacement, then, is an inherently political issue in Colombia: directly linked to the country's sociopolitical situation, and yet often sidelined in official government policy, internally displaced peoples are the enduring result of the decades-long conflict within Colombia, and exacerbated by Plan Colombia and Uribe's policy of *seguridad democrática*, yet lack visibility within national debates. Niño's speaking back to mapping practices in this work thus has direct relevance to the specifics of Colombia's contemporary sociopolitical situation. Her revision of mapping norms—the setting of the map at an oblique angle that refuses the primacy of the north–south axis, the re-semanticization of cartographical terms, the lack of explanatory key and the fast-moving data—all function to contest conventional mapping functions, but also, specifically, to contest the (lack of) representation of IDPs in Colombian national debates. If, as Sletto's comments cited above note, maps serve to *obscure*, then Niño's deliberately unconventional map attempts to *make visible*: to make visible on the map of the nation the hidden histories of forced internal displacements.

Niño's *Demo Scape v 0.5*, then, presents us with a sustained critical approach to existing representations of the Colombian terrain and attempts, via a series of alternative mapping projects, to make visible the complexities of the contemporary sociopolitical landscape of that country. The repeated use of maps throughout the work highlights a preoccupation with the representation of the national terrain, and the role of displaced peoples within it. At the same, time, Niño's technique of employing links and symbols that traverse the boundaries of the maps point towards the international dimensions of the conflict and, in particular, the role of the US in shaping Colombia's national policies, and the vested interests of multinational corporations in the Colombian terrain.

In terms of its approach, *Demo Scape V 0.5* employs a rich mix of rhetorical strategies, combining parody, the deadpan aping of corporate-speak, hyperbole and the bathetic. At times engaging in serious debate and bringing to light hidden structural inequalities (such as the multiple linked articles about Colombia's current socio-political situation), at others reducing serious issues to the banal (such as the mock products on sale), and at yet other

times inserting sociopolitical commentary into seemingly innocuous questions (such as the mock customer survey), *Demo Scape V 0.5* constantly keeps the viewer/user off guard, never sure of how to interpret what comes next, and never certain whether to take what he or she reads at face value. In its combination of these approaches, *Demo Scape V 0.5* attempts to force the user-viewer not only to take on an awareness of the complexities of Colombia's contemporary conflict, and the devastating effects on its people, but also, and perhaps more important, to awaken the viewer to the functionings of late capitalism as a system and to how these effects are one example of the structural inequalities at late capitalism's heart.

NOTES

1. In a 2008 article, Dion and Russeler (2008: 400) estimated that the US had provided more significantly than 4 billion dollars under the auspices of Plan Colombia, whilst in 2009 Tate (2009: 54) gave the figure of more than 5.4 billion US dollars.
2. For a detailed analysis of *Relational Border Map*, see Taylor and Pitman (2012), chapter 4, 'Civilisation and Barbarism: New Frontiers and Barbarous Borders Online'.
3. The two terms—*social software* and *social media*—are often used interchangeably, although the latter is more commonly used in US and UK publications, whilst the former is more common in Northern European publications in languages other than English.
4. In this lawsuit, the US Department of Justice accused Microsoft of abusing its power in its struggle against Netscape, due to its bundling of its own Internet Explorer browser with the Windows Operating System, behaviour deemed monopolistic. For more on the anti-trust trial, see Spinello (2003); for more on the broader context of the Browser Wars, see Chiaravutthi (2006).
5. The entire content of *Demo Scape V 0.5* is available in English and Spanish. I have here cited from the English version for ease of reading.
6. Indeed, one of JODI's early net.art works of 1997 was titled *Digital Rain* (www.jodi.org/beta/rain/digi.html), and played with the concept of strings of data on screen generating raindrops, although in this case using blue rather than green phosphor font.
7. Not all of the *departamentos* generate links, since some of them remain empty as we pass our mouse over them. The ones that do activate links are, from north to south, La Guajira, Norte de Santander, Antioquia, Boyacá, Casanare, Chocó, Guaviare and Amazonas.
8. It is worth noting, of course, that Vietnam was a debacle not only for the US administration at the time, but also for the CFR more specifically, whose influence began to wane during the divisive Vietnam years (Schulzinger 1984).
9. See, for instance, Erler (2008) and Dion and Russler (2008).
10. Elhawary (2010: 395) argues that the prioritization of security has eroded civilian protection and the defence of human rights, citing as examples the rebranding of the conflict as a 'legitimate fight against terrorism', the state of unrest declared by Uribe in 2002, the increasing restrictions on civil liberties, and Uribe's 2003 attack on human rights organisations for being 'defenders of terrorism'. This leads Elhawary (2010: 389) to conclude that Plan Colombia, whilst seeking to enhance security, in actual fact has 'prioritised the security

of the state and its allies to the detriment of the protection of the civilian population', a fact which represents 'a violation of the fundamental rights of the civilian population'.

11. In book 3, chapter 1, of *Politics*, Aristotle (1996) defined the category of citizen in opposition to several other categories of non-citizen, including, as well as slaves, foreigners, children and the elderly.

12. For a detailed account of the tensions between Gaia theory and anthropocentrism, see Donahue (2010); for a discussion of the links between Gaia theory and ecofeminism, see Anderlini-D'Onofrio (2004).

13. In a 2000 article, Muggah (2000: 205–06) estimated that approximately 80 to 90 per cent of the internally displaced peoples in Colombia living in urban or peri-urban settlements were *campesinos* or rural smallholders from *departamentos* with the lowest per capita income indicators.

14. Since the mid-1990s, tens of thousands of Colombians have fled illegally across the borders to the neighbouring countries of Ecuador, Panama and Venezuela. Statistics cited in Riaño Alcalá (2008: 5) give approximately 260,000 Colombians living in refuge-like situations in neighbouring countries such as Ecuador and beyond. Formal applications for refugee status by Colombians in Ecuador totalled 27,851 between 2000 and September 2004 (figures cited in Moreano Urigüen 2005), although actual figures (that is, the many who did not apply for official status) are much higher.

15. Bogotá is the city with the largest displaced population in the country, followed by Santa Marta and Medellín; see the table in Carrillo (2009: 532), for the full list of Colombian cities with internally displaced persons populations.

16. According to statistics from Acción Social, cited in María Aysa-Lastra (2010: 279), by December 2009 there were 3.3 million internally displaced peoples in Colombia showing on the official internally displaced persons registration system. Ana María Ibáñez and Andrés Moya (2010), meanwhile, note Acción Social's estimates of forced displacement in Colombia affecting more than 4.5 million people by August 2009. That said, these figures may well be an underestimate; Ibáñez and Moya (2010: 660n2) note that there are two main sources of statistics—Acción Social, the Colombian state institution in charge of internally displaced persons, and CODHES, a human rights organization—and that 'Acción Social seems to underestimate the number of IDP's in Colombia while CODHES overestimates it', due to differences in the definition of a displaced household and the systems employed to collect the data. The total number of displaced peoples could therefore be even higher.

6 Monopolies and Maquiladoras
The Resistant Re-encoding of Gaming in Coco Fusco and Ricardo Domínguez's *Turista Fronterizo*

Picking up on the threads of the corporate powers that reach across national boundaries that we saw in the previous chapter, this chapter now focuses on a work whose particular concern and place-based trope is that of a specific border between two nations. The chapter focuses on the collaborative work *Turista Fronterizo* [*Border Tourist*] of 2005, by Coco Fusco and Ricardo Domínguez, and analyzes how this work closely engages with the border as both material locality and as representative of particular (corporate) practices.

As has been frequently noted, the border is a central trope in Chicana/o self-conceptualization. Conceived of both as a material place and a conceptual space, the two-thousand mile-long border between Mexico and the US functions, in the words of Arturo J. Aldama and Naomi H. Quiñones, as a 'geopolitical and geocultural space' whose multidimensional nature fosters 'unique forms of Chicana and Chicano cultural productions and informs complex cultural frameworks' (Aldama and Quiñones 2002: 1). Drawing on the historical origins of the border in the US–Mexican War of 1846–48, and on the contemporary material concerns of life on/crossing the border in the twentieth and twenty-first centuries, Chicana/o and Latina/o artists, theorists and scholars have worked extensively with the notion of the border as representative of not just the lived experience but also the psychological make-up of Chicana/o and Latina/o communities. The historicity of the border has constantly been evoked by successive generations of Mexican Americans and Chicana/o activists in their attempts to express their identity and fight for their rights; as early as the 1900s, struggles over the meaning of the border have been a constant in Mexican-American thought, commencing with the first waves of Mexican immigrants (García 1985). Subsequently, the concept of the border was famously mobilized by the Chicano Civil Rights Movement with the resurrection of the notion of Aztlán, the mythical homeland of the Aztecs. At the Denver conference in 1969, the publication of the *Plan espiritual de Aztlán* [*Spiritual Plan of Aztlán*] set down an outright rejection of the 'capricious frontiers' (*Plan espiritual* 1989: 1) that cut across the spiritual homeland, and laid claim to these lands as both ancient homeland, and as 'a mission and a state of mind' (Alurista 1991: 222).

More recently, the border has been analyzed as the geopolitical space in which US domestic and foreign policy is played out and in which the logic of corporate capitalism makes itself manifest. Writing in the early 2000s, José David Saldívar (2002: 262–63), borrowing Nancy Fraser's terminology, proposed viewing the US–Mexico border as a 'juridical-administrative-theraputic state apparatus' that disempowers migrant border crossers from the south into the north, and critiqued the 'military-like machine of low-intensity conflict' constructed along the border. Similarly, a wealth of detailed studies into the maquiladora economy of the border regions has illustrated how the practices of the maquiladoras [assembly plants] represent the continuation of historic systems of domination in the contemporary era of corporate capitalism. Studies such as those by Swanger (2002) have traced a trajectory from previous regimes of capital accumulation that drove indigenous tribes off their lands to the contemporary regime of transnational capital embodied in the maquiladora economy, whilst Lugo (2008) has compared the social and human consequences of global industrial capitalism as represented by the maquiladora economy to the early imperial conquest of Mexico's northern frontier in the sixteenth and early seventeenth centuries. The border thus is exemplary of both the state-sponsored militarization of the border region, and of the logic of late, corporate capitalism.

At the same time, for many contemporary Chicana/o artists and writers, the border is also a potentially creative zone, a fluid space where identities can be negotiated and power relations can be reworked. The works of Mexican/Chicano performance artist Guillermo Gómez-Peña, whether artistic, performative or theoretical, frequently engage with the metaphor of the border, and highlight its creative potential; in his 1993 text, 'The Border is . . . (A Manifesto)' Gómez-Peña (2002: 754) proclaims the potentialities of the border for offering, amongst others, opportunities for 'experimenting with the fringes between art and society', for creating 'hybrid art forms', for practising 'creative appropriation, expropriation, and subversion of dominant cultural forms' and for drawing up a 'new cartography'. Gloria Anzaldúa (1987: iii), meanwhile, famously conceived of the border as an 'herida abierta' ['open wound'], but one that brought with it 'compensations [. . .] and certain joys' due to the possibilities for 'keeping intact one's shifting and multiple identity'. In the projects of these and many other border artists—of which more below—the border is envisaged as a potentially creative zone, straddling two nation-states and ambivalently located within the logic of corporate capital and yet offering potential possibilities to speak out against, or at the very least reveal the contradictions of, its logic.

The border, then, is both metaphorical *and* resolutely material, and, as such, remains a central and yet highly ambivalent place-based trope in Chicana/o aesthetics. On one hand, the border represents the new spatialities in which US domestic and foreign policy, and corporate capitalism are played out: the increasing militarization of the border, the neocolonial conditions of production in the maquiladoras, and the role of the US in

classifying and policing racial others. On the other, the border represents a potentially positive zone: an aesthetics of resistance, a zone which traverses and challenges the boundaries of the nation-state, and the discursive site of production of a 'new mestiza consciousness' (Anzaldúa 1987: 77–98).

The work under analysis in this chapter is jointly authored by Coco Fusco and Ricardo Domínguez. Fusco is a Cuban-American performance and multimedia artist whose work is frequently characterized by the inter-rogation of racial stereotypes and the critique of (neo)colonial attitudes. Amongst her most famous works to date include her highly controversial collaborative performance with Guillermo Gómez-Peña, *Two Undiscovered Americans Visit the West* (1992–1994), which, in the words of Diana Taylor (1998: 163, 164), critiques the 'colonialist gesture of producing the savage body' and confronts the viewer with the 'violent history of representation and exhibition of non-Western human beings'. More recent works, such as the video *Operation Antropos* and the performance *A Room of One's Own*, present spectacles of the subjection of modern subjects post-9/11, and have been described as 'counterperformances' that are 'responses to the Bush administration's performance of power' (J. E. Muñoz 2008: 137). The shared focus in many of her performances, as in her print publications such as *English is Broken Here* (1995) and her collected essays in *The Bodies that Were not Ours* (2002), is on the representations of otherness, the classifica-tion of troubling bodies, and the treatment of (formerly) colonized peoples.

Coco Fusco's collaborator on *Turista Fronterizo*, Ricardo Domínguez, is a well-known media hactivist and co-founder of the cyberactivist group Electronic Disturbance Theatre (EDT). Domínguez describes the work of the EDT as involving new media technologies in a resistant fashion, in such a way as to 'negate the dominant ideologies that surround this tech-nology's politics, distribution, and "commodification"' (in interview with Fusco 2003: 153). Early projects included virtual sit-ins in solidarity with the Zapatistas, flooding servers by using the FloodNet tool developed by the group, as well as promoting electronic civil disobedience more broadly. More recently and controversially, Domínguez's tactical media project the *Transborder Immigrant Tool* (2009), is a mobile telephone tool developed using GPS to aid illegal immigrants crossing the US–Mexico border in find-ing water supplies. This project, representative of, in Domínguez's own words, a 'shift from tactical media to tactical biopolitics' (Cárdenas et al., 2009: 2) led to a substantial backlash against Rodríguez, as well as counter-campaigns in support of him.[1] As can be seen from this brief summary, Rodríguez's work is characterized by an overt concern for the structural inequalities facing Mexicans and undocumented immigrants, coupled with a tactics of using digital technologies against the grain.

This work on which they both collaborated, *Turista Fronterizo*, draws together the concerns of the two artists: an insistence on the links between online space and sociopolitical issues, or, in the words of Coco Fusco (2003: 151), the stress on how 'the Internet is a dramatic scenario that can facilitate

social and political engagement with issues in the offline world', the use of technologies against the grain (where, for instance, GPS technologies often put to use to track undocumented migrants are instead harnessed to aiding these same migrants to circumvent the systems of border control) and the exploration of border crossings as a daily reality. Yet at the same time as its place within the two respective artists' oeuvres, *Turista Fronterizo* must also be understood as part of a broader trajectory of creative interventionist work in the border region. Ranging from early collectives, such as the highly influential Border Art Workshop/Taller de Arte Fronterizo (BAW/TAF) founded in 1984, through to later collaborations that were more explicitly informed by notions of tactical digital media, such as the *Borderhack* festivals first initiated in 2000 by Fran Ilich, the US–Mexico borderlands have been the site of a rich and vibrant variety of cultural-activist interventions.[2] In these workshops and festivals, as with many others taking place in the border region, artists make use of new media technologies to explore the concerns of the border and to investigate the ways in which new media technologies— often put to use to police these very borders—may be re-encoded in a resistant fashion. Indeed, *Turista Fronterizo* itself was specifically conceived of as part of a wider collective project: it was developed by Fusco and Domínguez, along with Ivan Orkeny and Miklos Szurdy in the production and design team, as part of the *Tijuana Calling* online art exhibition of 2005, in which works made by artists living on both sides of the border were exhibited as one of the 'Scenarios' of the *inSite_05* festival.[3] First held in 1992, the *inSite* festival in 2005 involved a series of works under the umbrella 'Interventions', comprising projects that took place at a physical site, and 'Scenarios', comprising projects that employed the internet to create a space connected to the physical region of San Diego/Tijuana. According to curator Mark Tribe, the various projects comprising *Tijuana Calling* aimed to 'make use of the Internet to explore various features of the Tijuana/San Diego border region' (Tribe 2008: n.p). In particular, Tribe (2008: n.p.) highlights the main goal of *Tijuana Calling* as being to

> support projects that have the potential to reach beyond the art world and into an online equivalent of what has been called the public sphere. If the public sphere is a place where politics happens, then I am looking for projects that transform this sphere, if only temporarily.

Here, Tribe's comments on the 'public sphere' have echoes with the stances of many of the artists discussed in this volume, such as Miranda Zúñiga's statements on the 'temporary public commons' (see Chapter 7). Focusing on the need for art works to reach beyond the conventional confines of the art world, Tribe highlights the potential that online interaction offers to transform the public sphere. In this sense, and as is the case with many of the other works studied in this volume, *Turista Fronterizo* and the other pieces in *Tijuana Calling* aim to make tactical use of online space and

digital interactivity in order to force the viewer/player/user into an active, critical role and to think through the sociopolitical concerns of the border. Moreover, regarding the broader context of *inSite,* as Klein (2007: 34) notes, many of the Interventions—that is, the offline projects in physical place— were designed to 'highlight the inequities of trade, labor, and production, the result of post-global economics and the outsourcing of manufacturing goods to developing countries'. In this way, as will be argued, *Turista fronterizo* dialogues with the concerns of many of the place-based interventions of the festival, and engages, in its online representation, with the material concerns of the border economy.

If this is the context in which *Turista fronterizo* was developed, the authors themselves give further insights into the creative process in a short 'Proposal Text' describing the work, where they set out their aim as to re-create the experience of 'daily life bicultural negotiation in San Diego/Tijuana' (Fusco and Domínguez 2006: n.p.). Briefly acknowledging their debt to the Sur-realists and the Situationists who envisioned group game playing as a mode of exploration and creativity, Fusco and Domínguez make an explicit com-parison with Debord's *The Game of War* which 'foregrounds the structural connections between games, welfare and art', and their own work. This notion of foregrounding structural connections is, as will be seen, central to the functioning of *Turista Fronterizo.* Moreover, I would argue, beyond this structural similarity, *Turista Fronterizo* shares a series of profound simi-larities with certain impetuses of the Surrealists, particularly regarding the juxtaposition and recombination of sources as a method to reveal hidden meanings. As scholars have noted, for the Surrealists, game playing was one of the favoured techniques for getting beyond the confines of the rational mind, with André Breton's *Le cadavre exquis*, in which collections of words or images are collectively assembled to create new and often shocking mean-ings, being the most famous and much-imitated example (Breton 1975). As Elza Adamowicz (1998: 55) has put it, for the Surrealists, games were of particular interest since they 'deliberately break with the normal flow of dis-course which threatens to release clichés and automatisms of speech, by pro-ducing singular analogies and unprecedented associations'. Here, in *Turista Fronterizo*, we see a similar bringing together of many and varied items— corporate logos, photographs of workers' protests, short texts, images of avatars and so forth—which, as discussed later, function in a similar way, to shed light on the hidden meanings and to illuminate the profound connec-tions between the various elements. This sense of the exploration of 'unprec-edented associations'—or, as I would put it, '*disavowed* associations'—is, moreover, constantly re-enacted in the multiple replayings in the hands of the user. That is, the quasi-aleatory[4] recombinations of locations, images and texts is determined by the roll of the die, and differs each time the game is played. In so doing, they reveal the practices that corporate giants and multinationals disavow, namely, their reliance on cheap labour south of the border, exploitative working conditions, the flouting of labour laws,

environmental hazards and so forth. In this sense, the recombinations of a variety of source materials, coupled with their constant and shifting recombinations during game play itself, bring to light the disavowed associations between corporate practices, material inequalities, and border life.

Indeed, it is worth noting that this sense of the aleatory recombinations of texts and images can also be traced in many of the theoretical writings on hypertext and, more broadly, digital media. George P. Landow (1997: 179, 201), for instance, whose seminal work first published in 1991, *Hypertext*, provided one of the earliest theorizations of hypertext as a medium, emphasized the potential it holds for creating 'combinatorial fiction' and employed the image of the collage—itself, of course, one of the favoured techniques of the Surrealists—arguing that 'collage patchwork appears in the different link structures [. . .] that characterize each section of the web'. Similarly, Jay David Bolter's (2009: 51) assertions, again originally published in 1991, regarding 'hypermediated styles' which have their 'roots in collage and photomontage' argued for an understanding of hypertext as a combinatory practice. More contemporary theorists, such as Stefan Sonvilla-Weiss, have similarly signalled the recombinatory potential as central to contemporary digital practice; for Sonvilla-Weiss (2010: 9), the current revolution brought about by Web 2.0 lies in the resulting 'mashup culture', in which 'mashups follow a logic that is additive or accumulative in that they combine and collect material and immaterial goods and aggregate them into either manifested design objects or open-ended re-combinatory and interactive information sources on the Web'. Each of these theorists in their different ways emphasize how digital media offers the potential to recombine content—whether text, images, videos or sound files—in new and productive ways, a concept which proves illuminating when considering Fusco and Domínguez's practice in *Turista Fronterizo*.

In this way, I would argue, *Turista Fronterizo* draws on dual inspirations in its recombinatory praxis: both the Surrealists' proclamations regarding the radical potential of gaming, and the theorizations of scholars of hypertext and digital media which stress the notions of recombinations as central to their praxis. In this sense, *Turista Fronterizo* actualizes, *to an extent*, some of the radical edge of the Surrealists' proclamations, via the potentialities offered by digital technologies. That is, some of the ludic possibilities foreseen by the Surrealists, but which were, by necessity, hampered by the limitations of print technologies of the time, are now able to be actualized by algorithms and by the possibilities of embedding multiple media files within one interface. At the same time, however, as my analysis of Fusco and Domínguez's work shows, this does not mean that digital technologies per se are by definition emancipatory, or that *Turista Fronterizo* enacts a fully aleatory, radically utopian praxis. Rather, in the same way as many scholars have reminded us that there is nothing inherently oppositional or revolutionary in hyperlinking, hypertext or any other digital technology per se,[5] so too, Fusco and Domínguez's work negotiates the possibilities offered

by digital media, producing a resistant game but which, at the same time, points to the limitations of the system.

If such are the inspirations for the formal aspects of *Turista Fronterizo*, in terms of content Fusco and Domínguez make explicit reference to the importance of the border as the material and conceptual space in which their game is located. Thus *Turista Fronterizo* attempts to make use of the game format in order to create (alternative) cartographies, as Fusco and Domínguez (2006: n.p.) state their motive as

> To create a game that allows people from many walks of life and from many different places to 'take a trip' through the border zone by playing our game, and to step into the roles of others around them who they might see regularly but never speak to.

This notion of 'tak[ing] a trip', with all its connotations of the re-creation of physical place and also of the experience of travel, is one which is central to the ludology of *Turista Fronterizo*. That is, *Turista Fronterizo* not only names and reworks physical places in the San Diego–Tijuana border region, but also conjures up the lifestyles and practices that such places represent, as analyzed in the following.

As well as the setting for the game in terms of its content, the material place of the border is also integral to enactment of the game. As Rita Raley (2009: 54–56), in her brief overview of *Turista Fronterizo* notes, as well as the online work, Domínguez also constructed a '1970s-style Pac Man gamebox' for the project and installed it at the Zapatista headquarters in Tijuana. This online game thus has a concrete physical presence offline, a feature notable in other works studied in this volume. In *Turista Fronterizo*'s offline presence, two features come to the fore: firstly, the technology chosen and secondly, the location. Regarding the former, the popular arcade game Pac Man was first released in the US in 1980 and involved players guiding the eponymous character through a maze, eating 'pac dots' and avoiding enemies lurking in the maze. Its controls clunky by modern standards, and its avatar consisting simply of a circle with some pixels missing to indicate an open mouth, Pac Man is iconic of an earlier era of gaming technologies. Domínguez's deliberate use of out-of-date technologies in his employment of the Pac Man game box here resonates with the resistant use of low tech that characterizes the work many Latin(o) American net artists, and dialogues with many of the other artists analyzed in this volume.[6] Here, as noted elsewhere in this volume, the mobilization of obsolete technologies is a deliberately resistant gesture, a refusal of the latest high tech in favour of the use of low tech in a countercultural fashion.

Second, the location of the game box in the EZLN (Ejército Zapatista de Liberación Nacional [Zapatista Army of National Liberation]) headquarters links this game closely to the materialities of the border and to the struggles over meaning that continue to be fought over this iconic locale.

As Raley (2009: 54) notes, the computer that housed the game also formed part of the media lab, thus 'coordinating [. . .] the material and "virtual" aspects of *Turista fronterizo*' (Raley 2009: 54). In this sense, *Turista Fronterizo* must be understood as invoking the border as both material place and conceptual space, and in which gameplay undertaken by players online of necessity dialogues with, and is informed by, the offline location of its housing in Tijuana. The specific setting of the Zapatista headquarters in Tijuana imbues the game with the spirit of digital Zapatismo, of the practices of 'ripping into the electronic fabric' as a form of 'network_art_activism' (Domínguez 2008: 670). Moreover, the game's location on the Mexican side of the border rather than on the US side would seem to indicate an attempt to re-signify the border from the South, as well as linking the work materially and conceptually with digital Zapatismo and the practices of the resistant use of new media technologies for political protest.

In addition to its physical location in Tijuana, *Turista Fronterizo* is also accessible online, currently hosted at *The Thing.net,* a venue dedicated to 'developing, presenting and distributing innovative forms of on-line activism, media art and cultural criticism concerned with exploring the possibilities of electronic networks' (The Thing.net, n.d.). Again, the online location situates this work within a wider context of countercultural uses of new media technologies. From this online location, once we enter the work the issues of border practices, surveillance and policing come to the fore. This is established even before entering the game proper via the 'start page', consisting of a still image showing, in cartoon collage fashion, a long queue of cars and border patrol agents in the bottom half of the screen, and a myriad of closed-circuit television (CCTV) cameras in the top half (see Figure 6.1). Cutting across this screen horizontally in green font are the words 'Turista Fronterizo'. The only interactive element in this start screen is the 'enter/entrar' link, which is located in the largest and most visually prominent CCTV screen, situated centrally in the top half of the frame and coloured red. Again, as with other works analyzed in this volume, this paratextual information is crucial in locating us in the game world since immediately the practices and politics of border crossings are evoked. Moreover, the embedding of the 'enter/entrar' link within the image of the CCTV screen means that, from the outset, we are being implicated in the policing of the border: our entry point to the game is through the very technology (the CCTV screen) used to police the border. The ambiguity of the term here, where 'enter/entrar' could refer to entering the US/Mexico (real-life world) or entering the game (virtual world) makes this both a diegetic and an extra-diegetic command and immediately locates us as player in the politics of the border.

Clicking on the 'enter/entrar' CCTV screen then leads us to the initial selection page, where, prior to playing the game, we must select our avatar. Here we are presented with an opening screen with a black background and the subtitle of the game in white font: 'Un viaje virtual por la frontera san diegueña y tijuanense / A virtual journal through the San Diego-Tijuana

borderlands'. The graphics making up the background are sparse and the majority of the screen space is black, with one single feature cutting across it diagonally, from bottom left to upper right: a drawing of a fence with concrete posts, wires, brown panels and weeds growing at its base. Superimposed on this background are the images of the four avatars we may select to play the game. It is significant that, as we scroll down to see the full selection of avatars, the background image remains static; the border fence remains central, cutting across the screen and splitting it into two, however far up or down we scroll. In this sense, and like the tactics used by *Vagamundo* in its opening sequence (see Chapter 7 of this volume), the dynamics of this opening screen immediately convey to the player the sense of the border as all-pervasive and highlight its permanent presence both as concrete entity and as representative of the logic of the neoliberal border economy.

The avatars which appear on this background are shown as greyscale drawings, in passport-style format, with the head and shoulders framed within a small rectangular area—a nod, of course, to the border control and document checks through which each must pass in this border world. Moving the cursor over a particular avatar turns the image into colour and brings up alongside it a full-length image of each avatar, along with the character statistics of each. Clicking on a particular avatar then assigns that avatar to the player and automatically loads the game.

Once entering the game proper, visually and structurally the game recalls the classic boardgame format established by Monopoly, and clearly dialogues with this. There are ten squares across each side, and players have to move in a clockwise fashion around them by clicking an image of a die, and then moving their avatar the required number of spaces along the board. Landing on a particular square produces a particular outcome for each player, which is conveyed in the centre of the board via a short montage of images and an accompanying text. The instructions given in each text result in the player gaining or losing money, which they then must do by clicking on the button which is preset and marked 'recibe'['receive'] or 'pagar' ['pay'] depending on the particular circumstances.

The locations on the board make an ironic nod to the original version of Monopoly in their reference to physical localities and properties, but are here specifically encoded in the sociocultural concerns of the border, both in their reference to material localities and to conceptual concerns or corporate practices. Many of the squares give real-life venues as their locations—much in the vein of the original Monopoly—but this time using venues on the San Diego–Tijuana border. Moreover, these locations are, quite literally, located in the border of the game board itself, since they run around the edges of the board, and in this way the ludological and narrative features of the game are tightly knit. Here, the border/edges of the Monopoly game which were a purely ludological feature in its original incarnation, are now imbued with narrative and semantic value, representing the geographical border of the US–Mexico frontier, as well as the border practices inhabiting it, as will be

discussed below. In this sense, we can clearly see Fusco and Domínguez's (2006: n.p.) stated aim of creating a board game that presents a 'refracted mirror of the sociocultural space of the US-Mexico border'. The socio-cultural space is clearly represented by the place names and real-life venues, but, as will be analyzed, the notion of refraction—as a partially distorted but still recognizable image—is enacted in the critical way in which these places and venues are re-encoded.

Moreover, this refraction is also evident in the way in which the original Monopoly format is transposed onto a bilingual and bicultural space. As Fusco and Domínguez note in their 'Proposal Text' for *Turista Fronterizo*, this game dialogues not only with Monopoly, but also with the Mexican variant, which Fusco and Domínguez denominate 'Turismo', but is in fact called *Turista Nacional*. Published in Mexico from the 1960s onwards by Birján, *Turista Nacional* was a Mexican product, but which clearly copied the gameboard format of Monopoly, having the same layout and follow-ing similar rules of gameplay. That said, *Turista Nacional* positioned itself as distinct from Monopoly in its focus on a Mexican locale and its at least superficial resistance to the notions of monopoly capitalism encapsulated by the US game by refusing to use the term in its title.[7] In this sense, the Monopoly format is already hybridized by its infusion with its Mexican counterpart, and indeed the title of the work itself makes this clear, with the reference to 'turista' clearly recalling the Mexican board game. What is new, of course, is that in Fusco and Domínguez's version this is now encoded as turismo *fronterizo*; whereas the standard format and ideology of the Mexi-can boardgame was to reinforce national values and to promote national sites of interest, here, the game is located specifically in the border zone, that is, on the problematic and permeable edges of the nation-state. Whereas *Turista Nacional* represented the era of the nation-state, *Turista Fronterizo*, as we shall see, represents the era of global corporatism and the transna-tional economy. In this way, both the original gameboard formats—that of Monopoly and that of *Turista Nacional*—are othered, as the gameplay of *Turista Fronterizo* engages with the practices of the US–Mexico border.

One further significant refraction of the original comes in *Turista Fronter-izo*'s reworking of the original boardgame format since the entities selected for inclusion are not classified in terms of property valuation as in the origi-nal *Monopoly* whose gameplay rested on real estate and tangible values. In *Turista Fronterizo*, no actual numerical value is shown on each square; instead, it is the intrinsic corporate and legalistic practices which each entity represents that have an impact on the avatar and cause him or her to lose or gain money and thus affect his or her life chances. In this respect, *Turista Fronterizo*'s gameplay represents the shift in economic practices and global politics from the mid twentieth century of the original Monopoly to the twenty-first. If the property values of the original Monopoly stood for Ford-ist capitalism of the early twentieth century, here in *Turista Fronterizo*, the fact that the squares display the intrinsic and yet frequently disavowed

practices of corporate giants indicates the shift to post-Fordist, corporatist late capitalism of the twenty-first century.[8] *Turista Fronterizo*, in effect, updates Monopoly for the era of corporate capital and the regimes of accumulation based on the transnational border economy. In other words, that the squares no longer carry numerical values (representing commodity capitalism), indicates the shift to corporatist transnational capitalism.

At the same time, as Castells, Fuchs and others have reminded us, such purportedly global corporate capitalism is by no means globally equal. As Castells (2010b: 73) argues, the process of capitalist restructuring under the new dominant logic of the space of flows induces an 'extremely uneven geography of social/territorial exclusion and inclusion, which disables large segments of people while linking up trans-territorially, through information technology, whatever and whoever may offer value in the global networks accumulating wealth, information and power'. After a detailed study of vast disparities in income distribution in countries in Africa, Latin America and the US, Castells (2010b: 169) proposes that what we are witnessing in the era of late capitalism is the emergence of the 'Fourth World':

> At this turn of the millennium, what used to be called the Second World (the statist universe) has disintegrated . . . At the same time, the Third World has disappeared as a relevant entity, emptied of its geopolitical meaning . . . Yet, the First World has not become the all-embracing universe of neo-liberal mythology. Because a new world, the Fourth World, has emerged, made up of multiple black holes of social exclusion throughout the planet.

This Fourth World, for Castells, encompasses large areas of the planet such as sub-Saharan Africa but also, crucially, is present 'in every country, and every city, in this new geography of social exclusion' (Castells 2010b: 73). The Fourth World, thus, is the product of the structural inequalities of late capitalism, and its black holes of social exclusion—or what Christian Fuchs has called 'segmented spaces' (Fuchs 2008: 94)—reflect these inequalities. As will be discussed in the following analysis, *Turista Fronterizo* uncovers these segmented spaces, bringing to light the material conditions of production so frequently disavowed by corporatist transnational capitalism, and in so doing establishing firm links between the material conditions of production on the US–Mexico border, and the space of flows of transnational corporate capitalism.

Regarding the specific locations selected for inclusion in *Turista fronterizo*, some of the squares represent concrete entities with physical locations in San Diego or Tijuana, such as the Qualcomm Stadium, home to the San Diego Chargers football team, or the Basurero de Tecate [Tecate Rubbish Dump] in Tijuana, whilst others represent more broadly the agencies enforcing border policy and politics. Here, if the properties of the original Monopoly equate to the physical locations of *Turista Fronterizo*, then the

utilities and stations of Monopoly equate to the series of enforcement agencies that police the border in *Turista Fronterizo*. These include the Gobernación [Interior Ministry], the DEA (US Drug Enforcement Agency), the San Ysidoro Border Checkpoint,[9] the Border Patrol, the Mexican Consulate, the US Consulate and the Policía Judicial [Federal Police],[10] as well as two generic agencies labelled 'La carcel' ['jail'] and 'Campo Base Detention Center', a fictitious name which represents the policing and politics of the US–Mexico border.

Of the real-life locations or companies, it is significant that, in the context of this updated Monopoly for the twenty-first century, the entities selected provide a commentary and a critique of the socio-political concerns of the border, as much as offering a map of the border zone. Significantly, many of company names which appear in these squares are those of large corporate giants who own or run—often in controversial circumstances—maquiladoras south of the border. Entities located on these squares include Mabamex, an acronym derived from Mattel de Baja Mexico, the manufacturing facility of Mattel in Mexico; Medtronic, the large medical technology company which also has a maquiladora in Tijuana; Hyundai, which runs its Han Young de Mexico maquiladora in Tijuana; and technology giant Kyocera Wireless, which has a maquiladora in Tijuana. The maquiladora is, of course, one of the most iconic and yet most controversial images of border life of the late twentieth and twenty-first century. Famously responsible for hazardous industrial waste pollution in the region (Williams 1996; Kopinak 2002), serious breaches of health and safety procedures (Bacon 2001) and the flouting of labour laws (Cooney 2001; Williams 2003), maquiladoras are, at the same time, touted by neoliberals as the answer to Mexico's economic woes in the wake of the 1994 peso crisis, and as providing much needed skills for the local population. Moreover, for many scholars, the maquiladora functions as a synecdoche for post-Fordist capitalism as a superstructure; in the words of Michael Stone and Gabriella Winkler (1997: xiii), writing in their foreword to Norma Iglesias Prieto's now classic study *Beautiful Flowers of the Maquiladora,* maquiladoras are the 'prototype for [. . .] the corporate shift from Fordism to a global regime of flexible accumulation'. In a similar vein, Joe Bandy (2000: 236) has argued that the US–Mexico border is the site of 'neoliberal experimentation' and maintains that this has only been possible through the establishment of maquiladoras which function as a 'laboratory' for neoliberal development. In this sense, the maquiladora as an icon functions to embed this game within the context of late capitalist practices. Highly controversial and ambivalent entities, maquiladoras therefore represent not only the physicality of the US–Mexico borderlands but also the neoliberal practices and inequalities which structure border life.

Indeed, it is worth noting that the companies explicitly named in *Turista Fronterizo* have been the subject of recent controversies over their production practices and compliance with the law with regard to their maquiladoras south of the border. The most prominent of these is the two-year dispute

in which Hyundai's Han Young de Mexico *maquiladora* was involved. One of the most high-profile and controversial labour disputes of the entire history of the maquiladora sector, this two-year conflict (1997–98) was based around the workers' struggle to establish an independent labour union and protests against the ownership due about its failure to comply with Mexican labour law and health and safety regulations (Williams 2003). The Han Young dispute has been seen by scholars such as Bacon as exemplifying the way in which 'neoliberal policies, designed to foster foreign investment, have undermined the laws that have historically protected workers, farmers, and the poor' (Bacon 2004: 13); it is, therefore, no surprise that Fusco and Domínguez have chosen Hyundai as one of their locations in *Turista Fronterizo* and that this square, when activated in the gameplay, makes reference to industrial disputes (see the following for more on this). Similarly, the other corporations named in the game have been the subject of controversy, such as Kyocera Wireless, located towards the top right of the board, who sacked of a third of its San Diego workforce in 2005 in order to shift manufacturing to its Tijuana maquiladora with the aim of cutting costs. The Californian waste transportation and disposal company Alco Pacific, meanwhile, located towards the bottom left of the board, was the subject of prosecution by the Los Angeles District Attorney and by Mexican authorities in 1992 over the hazardous emissions of its processing plant in El Florido and the dumping of toxic by-products in the neighbouring semi-rural community.[11] More than just physical locations, then, these squares represent corporate practices and the workings of transnational capitalism.

In contrast to the locations which references maquiladoras and thus to the logic of corporate capital, some of the squares, although fewer in number, represent (partial) pockets of resistance to the neoliberal model. One such square is named 'Maclovio Rojas', referring to a small *colonia* on the outskirts of Tijuana, named after Maclovio Rojas, a Mixteco leader who had been fatally struck by a car in the San Quintin Valley in 1987. One of the centres of maquiladora activism, land struggle and protests against multinationals such as Hyundai and others, Maclovio Rojas is, in the words of Téllez (2006: 225), a 'powerful example of resistance to global capitalism', and thus stands as an image of struggles against the powers of the transnational corporations named in other squares on the game board. Similarly, another square is named 'CITTAC', the acronym of the Centro de Información para Trabajadoras y Trabajadores, Asociación Civil [Workers' Information Centre], a human and labour rights organization based in Baja California which defends the rights of maquiladora workers and campaigns for improved working conditions. Another square, named the 'Kumiai Lands' refers to the Kumeyaay native American peoples who reside in the greater San Diego and northern Baja California region, and for whom the US–Mexico border cuts through their historical territories. This square thus arguably represents a form of resistance to the nation state, given that their lands lie on both sides of the border, and offer a differing take on trans-border life, one which is not

driven by the exigencies of neoliberal policy, but by an ancient connection to the land. Finally, the Colectivo Chilpancingo refers to the Colectivo Chilpancingo Pro Justicia Ambiental [Chilpancingo Collective for Environmental Justice], a community action team based in the *colonia* Chilpancingo in Tijuana, and focused on social justice, health and the environment. The Colectivo Chilpancingo has been a high-profile player in the resistance towards the practices of some of the worst-performing maqualidora owners, with one of their most successful campaigns being that of the comprehensive clean up of the contaminated Metales y Derivados site, a plant owned by the US-based New Frontier Trading Organization, in 2004.[12]

Still others, meanwhile, represent the disavowed underside of the maquiladora economy, such as the square named Basurero de Tecate, one of the main rubbish dumps in Tijuana. Highly controversial and subject to periodic closures due to contamination and a spate of illnesses afflicting nearby residents, the Basurero de Tecate often housed waste from the nearby maquiladoras. The Basurero de Tecate, located as it is on the board only a few squares from Medronic and Sempra Chevrón, thus stands for those processes disavowed by corporate giants and their effects on the local population. A further square, meanwhile, named 'AFO' stands for the Arellano Felix Organization, otherwise known as the Tijuana cartel, and again represents the underside of the cross-border economy: the illegal trafficking of drugs. Here, the flagging up of the AFO as a major player in this *turismo fronterizo* highlights the violence and illegal activities taking place on and across the border, and indicates that the AFO is a major force in the border economy in the same way that the other, 'legitimate' corporations in the game are. In this tactic, the inclusion of the AFO alongside other businesses—it appears on the board sandwiched between the SD Convention Center and the Castillo del Mar Hotel—implies equivalence, suggesting that we should also question the values of the other corporations in the same way we would do those of the AFO. That is, we are invited to question the actions of corporate giants, in their trafficking of goods, people and waste across the border, in the same way as we would question the practices of the AFO.

In addition to the squares denoting location, *Turista Fronterizo* also has eight action squares. Whereas Monopoly had 'Community Chest' and 'Chance' cards, the eight squares in *Turista Fronterizo* are split between four which carry 'Dreams' cards and four which carry 'Nightmares'; landing on one of these squares brings up either a positive opportunity or a negative outcome for the player, respectively. Fusco and Domínguez's choice of terms to replace Monopoly's original ones is of course highly loaded, given that the game world is that of the borderlands. If many poor Mexicans find themselves forced to cross the border in order to survive economically and provide for their families, then *Turista Fronterizo*'s terms engage with and critique the oft-cited notion of the American Dream.[13] Indeed, it is particularly significant that Fusco and Domínguez present us with a stark polarization between Dreams and Nightmares: the Nightmares cards, which bring

up negative consequences for the player, are the dark side of the 'American Dream'. The dark side of the American Dream is thus the Mexican Nightmare, whereby the nightmarish outcomes thrown up by these cards inevitably point to the underside of the US economy, as well as highlighting the structural inequalities of border life, as will be analyzed.

The cartography of *Turista Fronterizo* thus presents us with various actors in the cross-border sociopolitical landscape, including legitimate and illegitimate businesses, official agencies and authorities, and grass-roots movements for resistance. *Turista Fronterizo*'s cartography thus speaks to the politics and complexities of the border economy; to the fact that the US neoliberal economy is dependent on the cheap sources of labour crossing its borders every year, yet commits vast sums of its budget to policing those very borders; and to the fact that the maquiladora industry is central to the wealth of global corporate giants, yet has its disavowed dark side in the destruction it wreaks on the Mexican natural environment, and on the health and rights of its Mexican employees.

If this is the layout of the board and its sociocultural cartography, in addition to this, as with other works analyzed in this volume (see Chapter 7), avatars within the game are crucial in locating the player within this cartography and positioning him or her in the gameworld. In *Turista Fronterizo*, the user is presented with a choice of avatar, but each of the avatars turns out to be an ironic stereotype of those working in and across the trans-border economy, with two coming from the Mexican side and two from the US side. A short gloss on each avatar in the selection page is provided, with a list of the key features detailing name, age, profession and mode of transport. Of those on the Mexican side who are attempting to cross to the US, the first, named *La todóloga* [The Do-everything], is 23 years of age, travels by *combi* [minibus] and her profession is described as 'lo que encuentre' ['whatever she can find']. *La todóloga* represents the typical working-class Mexican employed in casual labour, and her experiences when playing the game, as will be discussed, mirror the experiences of undocumented border-crossers to the US. The other Mexican avatar, meanwhile, is *El Junior*, 25 years of age, drives a Mercedes G500, and whose profession is described as 'huevón' ['lazy sod']. This avatar represents the Mexican upper classes, whose border crossing is for pleasure and tourism and who has a vastly different experience of border crossing from *La todologa*. These two avatars thus represent opposing scales in the enormity of Mexico's uneven wealth distribution, inequalities which are born out in the gameplay itself, as will be analyzed.[14]

Coming from the US side, the first border-crossing avatar is *El gringo poderoso* [The powerful Yankee], aged 47, who drives a Lexus Sedan and whose occupation is described somewhat euphemistically as 'Binational Businessman'. This avatar represents the powerful business class located in the US, yet whose business is dependent precisely on the supply of cheap labour afforded by the border zone. Finally, the second avatar from the US side of the border is the *Gringa activista* [Yankee activist], aged 30, who

drives a Volkswagen 'bug', and whose occupation is 'Anthropology Student'. This avatar is representative of the benevolent (although potentially self-deluding) US, left-leaning middle class.

Once the avatar is selected and gameplay begins, the hidden and disavowed underside of corporate border practices is revealed as the avatar lands on particular squares. As the die is rolled, our avatar moves around the board, and the random combination of locations in this border cartography encourages the player to understand the 'new metaphorical and narrative associations' that are plotted out, to borrow Adamowicz's (1998: 57) term. Within these multiple recombinations, we may, for instance, first land on Mabamex, and then on the next roll of the die subsequently land on El Basurero de Tecate; here, this connection established in the moment of gameplay forces us to consider these two entities—a US corporate giant and one of the major locations of environmental pollution in northern Mexico—not as separate features but as intricately interconnected. Or we may, for instance, land on CITTAC, and subsequently land on Mabamex, thus being encouraged to draw connections between the abuses of labour law highlighted by CITTAC and practices on the ground in the Mabamex maquiladora. In this way, in the practice of gameplay, the player is constantly brought up against new connections which force the hidden and disavowed practices of corporate giants to be brought to light.

Moreover, this strategy of bringing to light the hidden practices of corporatism and the inequalities of border life is further brought home by the multimedia features which come into play at the moment an avatar lands on each location. As we move our avatar to a new square, a short animation, still image or video, accompanied by a short text, appears in the centre of the board, informing us of the consequences of landing on that particular square. These short pieces comment on the sociopolitical realities associated with each particular location and frequently make reference to real-life controversies, disputes and human rights abuses that have taken place within the border region. When playing as *La todóloga*, for instance, if we land on 'NSK Security', a black-and-white photograph appears in the centre of the board, depicting women participating in a protest and holding placards declaring 'cuidado con las reformas del artículo 123' ['careful with the article 123 reforms']. A short text then appears, informing us 'Te hecharon porque exigiste que se respetaran las leyes laborales mexicanas. Gasta $50 en una consulta con un abogado' ['You got sacked because you demanded that Mexican labour laws were followed. Spend $50 on a consultation with a lawyer']. The reference here is to article 123 of the Mexican constitution, which sets forth a variety of stipulations, including length of working day, minimum working age and rest periods, amongst others. This outcome is a thus a reference to the flouting of labour laws which has characterized the operations of some maquiladoras in the region. In a similar way, when playing as the *Gringa activista*, if we land on CITTAC, a photomontage of four colour photographs appears in the centre of the board, showing workers

dressed in blue. The montage ends with the final photograph showing a Taco Bell doorway, with workers protesting outside carrying handwritten banners in Spanish and English which declare, 'yo no quiero Taco Bell' ['I don't want Taco Bell'], 'Taco Hell', fair wage' and 'one penny more', accompanied by an image of tomatoes. A text below in white font appears, instructing us: 'Attend workers' meeting in San Diego to plan a protest against Taco Bell. Spend $200 on sandwich signs'. Here, the reference is to the high-profile protests from 2002–05, in which a boycott of Taco Bell, under the slogan, *Yo No Quiero Taco Bell,* was organized to protest over the living and working conditions of the agricultural workers who pick tomatoes for that company.[15]

Thus, our landing on squares at random opens up, in each case, a socio-political commentary on the issues associated with each location. That said, as indicated briefly earlier, the recombinatory processes of this resistant game are only quasi-aleatory. In fact, although the rolls of the die and the subsequent combination of locations landed on are random, what is not randomized is the content, since the content does not appear independently and randomly across the range of the four avatars. Thus, almost paradoxically, we are in fact playing a game which is at once aleatory and yet predetermined. The first of these predeterminations comes in the form of the structural inequalities attached to each avatar from the outset of the game. Depending on the avatar selected, the 'starting account balance'—the available money we have for living on the border, and which, in effect, determines how long and how successfully we may play the game—differs. This ranges from a starting balance of $300,000 for the *El gringo poderoso*, to a significantly lower figure of $1,000 for *La todóloga*, meaning that from the very outset of the game, ludological possibilities are predetermined by socio-economic factors. In this way, the structural inequalities of border life are made into structural inequalities in the ludology of *Turista Fronterizo* itself; again, there is a clear sense in which ludology and narratology are tightly knit in this work.

Moreover, this structural inequality persists throughout the game, since each avatar has a different trajectory encoded within the game. Depending on the avatar we select at the start of the 'game', we are given starkly different scenarios, even when landing on the same squares. In effect, four 'narratives' are embedded into one game and the dice are, both literally and metaphorically, loaded. When comparing, for instance, the two avatars from the Mexican side of the border, *El junior* and *La todóloga*, who represent opposite ends of the scale in Mexico's uneven wealth distribution, we can see stark differences in their experiences and narrative as they progress through the game. If we have selected *El junior* as our avatar, our experiences as we land on different locations around the board/border are of hedonistic pleasure and excessive consumption. For instance, when landing on the square denoting the Castillo del Mar Hotel as *El junior*, our avatar's experiences are of a pleasurable vacation. The centre of the board displays a colour

photograph of an idyllic hotel overlooking rocks and a blue sea. An image of a birthday cake zooms in from the upper right of the frame, with the words 'happy 20th journey' iced around it, whilst the text 'Tijuana México' in multicoloured font appears from the right. Below this, the text informs us: 'pasa tu cumpleaños allí con tu novia. Gasta $500' ['spend your birthday there with your girlfriend. Spend $500].

By contrast, if we have selected *La todóloga*, our experiences as we play are of poverty, exploitation, and job insecurity. When *La todóloga* lands on the same square, a photograph of the same hotel appears in the centre of the gameboard, but with different images superimposed above it. Here, we see a line drawing of two cooking pots which appear over the bottom half of the photograph, and a short text appears in a banner to the right of the frame, informing us that 'Buscan ayuda en la cocina. Recibe $10' ['They are looking for kitchen staff. Receive $10']. These outcomes immediately alert us to the fact that the gameplay in *Turista Fronterizo* is unequal: the structural inequalities of the logic of corporate capital are reproduced in the structural inequalities in the game, where *El junior* has the purchasing power to be a client of the hotel, whilst *La todóloga* merely one of the temporary staff in this urban informal economy. These and other similar examples of patent socio-economic differences within the game lead us to question the structural inequalities of the border economy, and bring to light the existence of the Fourth World. In the segmented spaces of the border region, those like *La todóloga* working in the urban informal economy inhabit the Fourth World. Existing within the same geographical space as the First World inhabitant *El junior*, they represent, nevertheless, the existence of the Fourth World conterminously with the First, and reveal how the rise of global corporate capitalism is inextricably linked to the rise of the Fourth World.

Similarly, when landing on the Basurero de Tecate, the outcomes for these two avatars are starkly different and again representative of their socioeconomic status. When *La todóloga* lands on this square (see Figure 6.2), a still colour photograph of a hospital bed fills the centre of the board, and a short text in white font appears in the bottom third of the frame, informing us that 'Tu sobrino vive cerca del basurero y descubrió que tiene cancer de los pulmones. Gasta $100 para ayudarle con sus gastos médicos' ['Your nephew lives near the rubbish dump and finds out that he has lung cancer. Spend $100 helping him with medical costs']. Here, the option at the bottom left of the play board is already set to 'pagar' ['pay'], and in order to continue in the game we must press it, and so lose $100 from our total, before we can carry on to the next location. However, when *El junior* lands on this same square, a panoramic photograph of a seaside resort showing a small group of buildings around an idyllic bay appears. Over this photograph, images of grey plumes of smoke drift in from the left of the screen and eventually obscure the view of the sea. A short text appears below this photograph, informing us that 'la pinche peste del basurero está llegando hasta la playa privada donde llevas a tus amantes. Ve a la gobernación y habla con un

primo tuyo que trabaja allá para que investiguen a los dueños' ['the bloody awful smell from the rubbish dump is reaching the private beach where you take your lovers. Go to the Interior Ministry and speak to a cousin of yours who works there so that the owners can be investigated']. Again, the differing outcomes on the squares represent the marked inequalities of border life; the environmental pollution posed by the *basurero de Tecate* is merely an inconvenience disturbing the holiday of the upper-middle classes, as represented by *El junior*; for *La todóloga*, meanwhile, the pollution is the cause of life-threatening diseases and further poverty. Again, the gameplay of *Turista fronterizo* reveals to us the segmented spaces in which the inhabitants of the Fourth World life alongside those of the First.

Indeed, it is worth noting that these inequalities and differing life chances between *El junior* and *La todóloga* are even built into the 'Nightmares' and 'Dreams' cards of the game. Whereas for *El Junior*, his worst nightmares consist of being mistaken for the hired help employed to wash dishes at the *Tapenade* restaurant, or suffering from a painful hangover after partying too much on New Year's Eve, for *La todóloga*, her nightmare is that she is kidnapped by the DEA, interrogated for two days and has to spend all her money on a lawyer, thus effectively ending the game for this avatar.

Even starker examples of these structural inequalities can be found when comparing avatars from opposing sides of the border. The differing experiences making up the narrative of *La todóloga* and *El gringo poderoso* are particularly revealing regarding the structural inequalities of border life and of the ludological structure of *Turista Fronterizo*. For example, notable differences in outcome appear when these avatars land on the 'Hyundai' square. When *La todóloga* lands here, a black-and-white photograph of striking workers, carrying placards stating 'No más corrupción de la autoridad laboral' ['no more corruption of workers' authority'], appears in the centre of the board. Below this appears the text which denotes the outcome for the avatar: 'Tu novio fue golpeado durante la huelga. Gasta $50 en medicinas' ['Your boyfriend was beaten up during the strike. Spend $50 on medicines'], after which the player must click on the 'pagar' icon, and loses that sum of money from his or her total. Here, the photographic image makes reference to the long-standing industrial dispute over Hyundai's working practices, as mentioned earlier. Crucially, for *La todóloga,* the result of this is negative; as a poor working class Mexican, she is on the losing side of the industrial dispute, and in the game world, as in real life, finds that she is further forced into poverty as a result. In this respect, *La todóloga*'s game board experiences are representative of the poor Mexican working class who are a particular target of exploitation by maquiladora giants, a fact which is further confirmed by the html encoding within the work. Crucially, the URL changes according to avatar, and when playing as *La todóloga*, the specific URL is www.thing.net/~cocofusco/Maq/boardMaq.html. Here, the denomination of *La todóloga*'s gameplay as 'Maq' makes implicit reference to the maquiladora within its encoding, and as such is a nod to the likes of early

browser art undertaken by JODI and others where paratextual features such as title bars and source code formed a prominent part of the work of art itself. Here, reading between the lines/codes of the game, we are encouraged to see *La todóloga* as representative of maquiladora workers as a class, as the new subaltern class alienated by corporate capitalism and precariously scraping a living in the urban informal economy.

For *El gringo poderoso*, meanwhile, the outcome is rather different. If we have selected him as our avatar, we are presented with a different image and a different outcome when landing on the very same square. In this instance, landing on 'Hyundai' brings up a colour photograph of two workers with hard hats, standing feet apart, with sign stating 'no pasar. Policía' ['Police. Do not cross'] in the foreground of the photograph. Over the top third of this photograph, text in white font appears informing us: 'provide scabs during autoworker strike. Receive $1000'. These evident differences make clear that the different avatars, with their different socio-economic backgrounds, are on opposing sides in the dispute, and make overt reference to the flouting of labour laws common to the practice of many maquiladoras. More importantly, the different outcomes also reveal how the system of late capitalism as represented by the border space and the maquiladora economy is self-perpetuating, in that the dispute reinforces the poverty in which *La todóloga* finds herself, whilst *El gringo poderoso* profits further. In this sense, the gameplay reveals not only the structural inequalities but also the way in which the system—the system of the game just as the late capitalist system—benefits those who are already in positions of socio-economic power.

For the *Gringa activista*, meanwhile, border life represents a constant struggle to promote human rights, publicize the malpractices of corporate giants and support protest groups. In this regard, when comparing the outcomes available to this avatar with those of *El gringo poderoso*, we can appreciate how *Turista Fronterizo* provides a commentary on the workings of transnational businesses and their practices in the region. For instance, when the *Gringa activista* lands on 'Plásticos ACM', a colour photograph of a man in a lab coat holding up petri dish appears. A brightly-coloured scan of a lung zooms in from top right over the photograph, and a short text appears below: 'Film interview with UCSD medical researcher about the links between exposure to molten plastics and lung disease'. By contrast, when *El gringo poderoso* lands on this square, a colour photograph of an outdoor press conference fills the centre of the board, across which dollar bills subsequently zoom in, superimposed over the photograph and framing it from both sides. The text which accompanies this montage reads 'hold press conference to emphatically deny that workers' exposure to molten plastics is harmful. Spend $500 on the consultant who provides false data'. The company referred to here, Plásticos ACM, has a maquiladora in Tijuana and is a member of the Power-Sonic group of companies with their group corporate headquarters in San Diego. Here, the multimedia components brought up by this location provide contrasting versions of the business

practices of this corporation, although both, in their different ways, draw our attention to malpractices on the border. Both outcomes place media and representation at the forefront of each avatar's strategy: to publicize and bring to light malpractices in the case of the *Gringa activista* and to distort and cover up malpractices in the case of the *El gringo poderoso*. Thus, the outcomes presented to these two avatars, focusing on the revelation/hiding of corporate practices, present to us the same issue, but from opposing poles, and again encourage us to view the corporations named in *Turista Fronterizo* in a critical light.

Finally, a comparative analysis of the outcomes of all the avatars when landing on the 'US Consulate' square is particularly revealing, given this entity's status as one of the central agencies controlling border crossings, and arguably thus one of the central axes of the game. The *Gringa activista*, *El junior* and *La todóloga* all share the same background image which appears in the centre of the board when landing on this location, but the accompanying texts and superimposed images differ greatly, pointing out the differences in socio-economic circumstances of these avatars. When playing as *El junior*, a cartoon image spins into the frame from the upper right, showing a group of Mexicans walking up to the US Consulate in Mexico, with a thought bubble saying 'non-citizen entry'. The avatar of *El junior*, clearly cut and pasted, since the colours and visual style do not match the cartoon underneath, appears in the doorway, leaving the consulate, with a visa in his hand. Below this, a text informs us: 'Renova tu visa fronterizo. Gasta $100' ['Renew your border visa. Spend $100']. For the *Gringa activista*, meanwhile, landing on the US Consulate brings up the same cartoon of Mexicans approaching the US Consulate, but with a different text underneath in white font: 'Report stolen passport and other ID's. Pay $250 for temporary documents'. Finally, for *La todóloga*, landing on this square again brings up the same cartoon, but with a different text, this time instructing us: 'intenta conseguir una visa fronteriza. Gasta $50' ['try to get a border visa. Spend $50'].

A variety of features of the cartoon in this montage immediately alerts us to a previous era of cross-border relations. The muted colours, as well as the clothing and hairstyles of the characters, all locate this cartoon in the 1950s, and its particular content—Mexicans approaching the US Consulate—clearly recalls the leaflets advertising the *bracero* programme of 1942–62, representing a previous generation of pre–North American Free Trade Agreement (NAFTA) border relations. In these three cases, the original image of the *bracero*-era cartoon is inflected differently in this post-NAFTA, neoliberal form of transborder relations that *Turista Fronterizo* represents, whilst at the same time encouraging us to see links between the former programme and present-day socio-economic relations. The *bracero* programme has been harshly criticized by Chicano scholars, with Justin Ankers Chacón calling the programme 'a twentieth century caste system' that 'created a throwaway workforce' and was a 'throw-back to a bonded labor system', arguing that it represented a 'concerted effort by agribusiness to further restructure

the social relations of agricultural capitalism' (Davis and Ankers Chacón 2006:139–140).[16] If this is the reality encoding the original *bracero*-style cartoon, here, the remixed version created by Fusco and Domínguez re-encodes the original, whereby what is now being explored is the restructuring of social relations under transnational post-Fordist capitalism. Again, thus, Fusco and Domínguez are remobilizing outdated formats, updating the concerns expressed by the earlier *bracero*-era cartoon for the twenty-first century of corporate capitalism and NAFTA-era neoliberal restructurings.[17]

Fusco and Domínguez's updating of the *bracero*-era cartoon lies in its re-semanticization for twenty-first-century capitalism, in which it is the maquiladora economy, and the concerns of transnational corporations, that generate the flows of people across the border. Moreover, if, as Valdes and others have argued, NAFTA resulted in the creation of 'a newly dispossessed class of agricultural workers, many of whom were compelled to migrate to the United States' (Valdes 1995: 128), then the NAFTA-era border relations as enacted in *Turista Fronterizo* are directly connected to the issues of agribusiness which were represented by the previous *bracero* programme. This dispossessed class of former agricultural workers now makes up the workforce in the urban informal economy of the borderlands. Thus Fusco and Domínguez's remixing of the *bracero*-era cartoon is a form of updating the concerns displayed in the original cartoon—concerns which were, of course, those of the era of the original Monopoly and its embodiment of Fordist capitalism—for the twentieth-century neoliberal context.

If such are the connotations underpinning the three different outcomes for these avatars, it is striking therefore that for the fourth avatar, the *El gringo poderoso*, this specific image is notably absent. For *El gringo poderoso*, this same location brings up a short animated video in the centre of the board, showing a black-and-white block graphic of the US flag in which a door opens, a figure of a man walks in, the door closes around him, and the door then disappears. The accompanying text instructs us: 'Attend reception for bi-national businessmen. Spend $500 on a new tuxedo'. The visual metaphor here is clear, namely, that the US remains an open door for powerful businesses as represented by *El gringo poderoso*, but that it is firmly shut for others. In the course of gameplay, we become aware of the contrast with the iconography of the other three avatars; here, we may extrapolate that regulations such as the *bracero* programme and NAFTA are disavowed structures which in actuality underpin his wealth and power as a business man, and thus of the corporate practices he represents.

In these and many other instances of game play, *Turista Fronterizo* aims to interrogate the socio-economic inequalities structuring border life, and encourage the user to establish and critique the interconnections revealed between the various locations. The overdetermined trope of the border is constantly evoked and revisioned throughout the work, and the practices of major multinationals operating on the border are brought under sustained scrutiny to reveal the structural inequalities of the logic of corporate

capital. Perhaps even more effective than the Surrealists' entirely random-ized games, the use of digital media in this work to randomize the outcomes but to nevertheless ensure that outcomes are pre-programmed according to each particular avatar, means that the structural inequalities of border life are brought to the fore. By bringing together pre-digital gaming formats with the recombinant possibilities offered by digital technologies, Fusco and Domínguez update the Fordist capitalist values of Monopoly for twenty-first-century corporate capitalism. The border, with the maquiladora stand-ing as a synecdoche for the post-Fordist capitalism that rules border life and creates the segmented spaces of the Fourth World, is laid bare in all its complexities in *Turista Fronterizo* and the experiences of the avatars force the user to interrogate the inequalities created by this system.

NOTES

1. The University of California at San Diego threatened to revoke Dominguez's tenure as a result of him developing his tool, and Domínguez was reviled on national television, such as the on Fox News Channel. For more on the response to the *Transborder Immigrant Tool*, see Goldstein (2010) and Dit-tmar and Entin (2010).
2. For more on the BAW/TAF, see Herschberger (2006).
3. A total of five works were included in *Tijuana Calling*, the other four being Anne-Marie Schleiner and Luis Hernandez's *Corridos*, Ricardo Miranda Zúñiga's *Dentimundo*, Angel Nevarez and Alex Rivera's *LowDrone*, and Fran Ilich's *Cybercholos*.
4. I am here qualifying the term *aleatory* since, as will be analyzed later in this chapter, the purportedly random experiences thrown up by the roll of the dice in fact turn out to be predetermined by socio-economic factors; hence, the recombinatory process of *Turista Fronterizo* is only quasi- or partially aleatory.
5. I am here referring to what Aarseth and others have warned against as 'techno-logical determinism', in which an empty 'rhetoric of novelty, differentiation and freedom' is frequently employed to characterize new media (Aarseth 1997: 14).
6. See also the works by Partnoy, Mackern and Niño, analyzed in Chapters 3, 4 and 5 of this volume, which each involve, in different ways, the invocation of dated or obsolete technologies as a resistant gesture.
7. *Turista Nacional,* whilst on the surface refusing Monopoly as an ideology in its title, is nevertheless focused on capitalist accumulation, given that the game play is based on investment in Mexico's principal tourist sites.
8. Although Monopoly, one of the most popular board games worldwide and which has sold millions of copies to date, in its contemporary format repre-sents the workings of modern Fordist capitalism with the winner the one who monopolizes the market and bankrupts his or her opponents, it is worth not-ing that the original game format on which it was based, The Landlord Game, was intended to be educational and warn its players *against* the pitfalls of capitalism. For more on this, and the development of the modern Monopoly game, see Orbanes (2006).
9. The San Ysidoro border checkpoint is located in southern San Diego and is the largest border-crossing point in world, with an estimated 50 million people crossing it each year.

10. The Policía Judicial Federal was the official name of the Mexican federal police force, although its name was changed in 2002 to the Agencia Federal de Investigación.
11. See Cass (1996) for more on this and other similar instances of hazardous waste dumping in Mexico.
12. See Carruthers (2008) for a detailed analysis of the environmental justice campaign to clear up Metales y Derivados and the role that the Colectivo Chilpancingo played in this.
13. It is worth noting the plethora of scholarly studies on Mexican immigration which invoke (and subsequently critique) the American Dream as one of the primary motivators in the flow of Mexicans from their own country to the US; see, as a representative sample, Livingston and Kahn (2002), Alba (2006) or McConnell and Marcelli (2007).
14. It is worth noting, of course, that Mexico's uneven wealth distribution increased as a result of the strong programme of neoliberal reforms from the 1980s onwards; see Li (2000: 277).
15. For more on the Taco Bell protests, see Drainville (2008).
16. See also Ronald Mize and Alicia Swords (2011) for more on the treatment of Mexican immigrants under US policy, ranging from the *bracero* programme to NAFTA.
17. It is worth noting that some scholars have pointed out continuities between the earlier *bracero* programme and NAFTA; see, for instance, Dennis N. Valdes (1995: 121) who draws out similarities in the ways in which both programmes involve changes in legal status.

7 Re-signifying the Border and the Streets in Ricardo Miranda Zúñiga's *Vagamundo: A Migrant's Tale*

This chapter follows on from, yet also extends the reach of, the analysis in the previous chapter, in which the US–Mexico border was the central place-based trope. The present chapter analyzes the work of the US–Nicaraguan multimedia artist, Ricardo Miranda Zúñiga, paying particular attention to the way in which his works engage with the trope of the border, of the streets and, associated with this, the representation of Mexican immigrants in the US imaginary.[1] Here, *Vagamundo* is read as depicting a shift from physical borders to conceptual borders which move with the Mexican immigrant, and where the interplay between real and virtual space, and between physical borders and psychological ones, is constantly traversed in complex and challenging ways. The chapter illustrates how Miranda Zúñiga's constant negotiation between digital media and offline localities aims to shock the viewer-player out of complacency and encourage him or her to question the sociopolitical structures underpinning the game world.

The central place-based tropes under analysis in this chapter thus continue with the main trope of the previous chapter in the work of Fusco and Domínguez, yet also link it to other key locales. Where, in Chapter 6, the border formed the structuring location of the entire gameworld, here in Miranda Zúñiga's work it is both the border and the streets of New York which form the central locations. As noted in the preceding chapter, the border is a central trope in Chicana/o and, more broadly, Latina/o self-conceptualization, conceived of as simultaneously a real and a conceptual space. However, whereas for Fusco and Domínguez the border region represented the entirety of the game world, for Miranda Zúñiga, as explored in this chapter, the border serves as an overarching framework, framing the starting and ending points of the work, but giving way to the space of the streets in the main body of the work itself. Thus, following on from Chapter 6, this chapter argues that the border and, subsequently, the streets/barrio in Miranda Zúñiga's works are the spaces in which the politics of US neoliberalism are played out.

In this analysis of the border and the streets, I draw on two important theorizations: first, Aldama's assertions regarding the elasticity of the border and, second, on the prominence of the streets in Chicano and Latino

self-identification.[2] Regarding the first of these, in his 2002 work, Aldama (2002: 15) set down a series of propositions regarding the border, the fourth of which declares that:

> Once crossed, the border is infinitely elastic and can serve as a barrier and zone of violence for the Mexican or Latino/a who is confronted by racialist and gendered obstacles—material and discursive—anywhere s/he goes in the United States. This means that the immigrant continually faces crossing the border even if s/he is in Chicago (or wherever in the United States)—a continual shifting from margin to margin'.

Aldama's notion of the elasticity of the border provides a useful approach to *Vagamundo* and the two iconic loci it manipulates. In essence, *Vagamundo*'s narrative reveals that, even when immigrants move from the framing location of the border to the streets for the majority of the gameplay, the mentality and politics of the border still continue, even if the border itself is not physically present. As will be analyzed, the framing paratexts of the game remain with the player/avatar when he or she subsequently moves beyond the border to New York, and the aesthetic production of space in the street scenes serves to reinforce the oppression and circumscription represented by the border in the frame.

Second, the space of the streets, one of the central tropes of certain brands of Chicano/a self-identification, is here brought to the fore and interrogated in the light of social inequalities and injustices. As early as Corky Gonzalez's *I am Joaquín* (1967), and subsequently consolidated in cinematic form in films such as Luis Valdez's iconic *Zoot Suit* (1981), the Chicano street gang, the *pachuco* figure and the streets of the *barrio* [neighbourhood] have frequently been conceptualized as central to the construction of an urban, male, Chicano identity.[3] What Raúl Villa (2000) has termed the 'barrio-logos' reveals a particular conceptualization of Chicano identity as intricately linked with the socio-economic space of the streets. Here in *Vagamundo*, the streets, and the three different neighbourhoods making up the locale of the three different levels of the game, engage with the dynamics of the barrio, but are encoded as a problematic space; whilst inevitably calling to mind the space of the streets as central to the construction of a (countercultural) Chicano urban identity, *Vagamundo*'s street space is more properly representative of discrimination, injustice and the locale where the rules of the system—the system of late capitalism—are played out. In this way, the production of space in this work, whether the space of the border in the framing material, or the spaces of the streets in the bulk of the gameplay, serves to interrogate some of the central socio-economic inequalities facing Mexican immigrants in contemporary US society.

If these are the two specific locales, the specific timeframe of the work is the late 1990s and early 2000s, with one particular referent—the long-running Operation Gatekeeper programme—functioning as principal sociopolitical

concern informing the work. Operation Gatekeeper was a programme of intense enhanced border enforcement, and was set up in 1994 by the Clinton administration, with the aim of reducing undocumented migration across the Mexico–US border into San Diego. The scheme involved the doubling in numbers of Border Patrol agents, the establishment of permanent highway checkpoints, the erection of 27 miles of reinforced fencing, along with motion sensors and thermal imaging devices, and the strengthening of ports of entry with computer-based identification systems. Yet Operation Gatekeeper did not put an end to undocumented migration to the US: instead, as several scholarly reports and studies undertaken by NGOs have documented, the effect of Operation Gatekeeper was to push migrants away from the city of San Diego and into the harsher, more dangerous terrain of the desert of Imperial County and the mountains east of San Diego County, where increasing numbers met their death from exposure to the harsh weather. Statistics demonstrate a rising death toll across the period in which Operation Gatekeeper was implemented: from 87 deaths at the southwest border in 1996, the total had risen to 499 by the year 2000 (Cornelius 2001: 669). Operation Gatekeeper, thus, as the framing device of Miranda Zúñiga's game, stands for the new era of US-Mexico relations of the 1990s and 2000s, but also, more broadly for the workings of late capitalism that propel immigrants north of the border.

Vagamundo is the work of one of the most prolific New York–based Latino artists, Ricardo Miranda Zúñiga. Miranda Zúñiga produces art works which involve innovative combinations of digital media, web art, computer-generated art, performance art and installations. Using a variety of digital technologies, whilst also drawing on pre-digital artworks such as comic strips and classical art, Miranda Zúñiga creates art works that involve both online interaction and public participation in the streets. These works, combining computer games, artistic representation, installation art and public participation, constantly have as their driving force the questioning of sociocultural norms, the critique of contemporary inequalities, and an attempt to de-doxify commonplaces and stereotypes.

Amongst his most high-profile works of the 2000s are *Carreta Nagua, siglo 21* [*Nagua Cart, 21st Century*] (2007), an art work commissioned for the second *Transitio_MX* Festival Internacional de Artes Electrónicas y Video in Mexico City, involving a rickshaw which is pedalled through the Alameda Central park in Mexico City, in which the public are invited to sit and watch a nine-minute animation. The movie, made by Miranda Zúñiga and in Spanish, recycles two key elements of Latin American popular culture; first, the Nicaraguan folk tale, *Carreta Nagua*, which describes a haunted cart pulled by death, and, second, the Mexican comic superhero figure El Chapulín Colorado, who appears alongside the Japanese alien superhero Ultraman in the animation. Including figures named 'Labor' and 'Capital' who flit across the screen as El Chapulín Colorado and Ultraman engage in debate, the animation highlights the plight of immigrants to the

US, and the injustices of the capitalist system. *Dentimundo* [*Dentiworld*] of 2005, meanwhile, was created as part of *InSite05*—the same festival at which Fusco and Domínguez's *Turista Fronterizo* of the previous chapter was exhibited—and describes itself as a 'multimedia documentary of [the] micro-economy between the U.S. and Mexico that investigates border dentistry' (Miranda Zúñiga 2005). Opening with an avatar promising us a 'cybernetic tour of the Mexican border' where our 'dreams may be realized for a small fee', *Dentimundo* provides a scathing attack on US health insurance and health tourism. *NEXUM ATM* (2003) is an interactive video sculpture in the form of an ATM, digital videos and an accompanying website, which aims to explore the history of US interventionism into other, smaller countries, taking the Bush administration as its particular focus. The work involves multiple strategies of resistance, including public participation as the members of the public access the ATM, the remixing of digital images for oppositional purposes in the form of the digital videos, and web activism, as the sites to which users are directed include a variety of civil activism websites and petitions. *Votemos.us ¡México decide!* [*Let'svote.us Mexico Decides!*] (2007–08) is a Spanish-language portal focused on the 2008 US presidential elections which, basing its argument on the constant circulation of people, products and capital between Mexico and the US, invites Mexicans to login and vote on the site for the US president. *Milagro de Chile* [*The Miracle of Chile*] (2010) interrogates Milton Friedman's famous assertions regarding the 'economic miracle' of Chile as representing the purported success of the neoliberal, free-market model.[4] Through a combination of workshops, an interactive game in the form of a virtual labyrinth, posters on public transport and street interaction involving portable electronic devices combined with public participation on the streets of Santiago, *Milagro de Chile* critiques Friedman's statement and contests the purported success of the neoliberal model. Finally, Miranda Zúñiga's latest work, *a geography of being: una geografía de ser* (2012), is an interactive installation combining wooden sculptures with animated displays and a video game and focuses on the issue of undocumented young immigrants in the US.

As can be seen from this brief summary of his works to date, Miranda Zúñiga's praxis frequently involves the reworking of existing images and popular discourses via digital technologies, and their subsequent combination with public participation in order to critique socio-political inequalities and to interrogate prevailing socio-cultural norms. As Miranda Zúñiga (n.d.) himself has put it,

> I approach art as a social practice that seeks to establish dialogue in public spaces (both physical and virtual) to broaden the work of art beyond what I may privately conceive. I view the street as an incredibly rich arena for interactive works that employ illustration, animation, sound and interactivity to draw an audience and ideally initiate a fruitful discussion.

The emphasis here on public spaces as being both physical *and* virtual points to the ways in which Miranda Zúñiga's praxis involves tactical use of the interplay between virtual and real spaces to contest established meanings of place, to construct new formulations of territorial identity, and to force a re-thinking of conventional conceptualizations of public space.

The particular work under consideration in this chapter, *Vagamundo: A Migrant's Tale* (2002), provides a striking example of these notions, inter-weaving real and virtual space, and challenging some of the commonplace assumptions regarding Mexican immigrants in the US imaginary. Like most of Miranda Zúñiga's pieces, *Vagamundo* is a multimedia work, including a computer game with associated web links, an introductory digital montage sequence, a physical installation and public participation in the streets of New York. *Vagamundo* thus involves constant negotiation between digital media and street performance, between new media technologies and enact-ment in real offline places. The interaction of all these elements, in which the conventional scope of the video game is challenged both in its content and in its presentation, as discussed later, can be understood in terms of recent trends in what has been variously termed alternative gaming, political game art or experimental game projects.[5] Such alternative gaming is often con-ceived of in opposition to, or as a critical development of, the commercial entertainment games industry. Critics of the billion-dollar global computer games industry have argued how its logic tends to reinforce capitalist values; Patrick Crogan (2007: 87, 92), for instance, reminds us that the computer game industry has its origins in the 'past of computer simulation, a past dominated by military technoscientific developments' which imbues com-puter games with a 'technocultural history'. Some, such as Stephen Kline, Nick Dyer-Witheford and Greig de Peuter (2003: 62), have even gone so far as to suggest that computer gaming could be seen to be the '"ideal com-modity" of post-Fordist, postmodern promotional capitalism. Kline et al. (2003: 5) argue that the computer game business 'powerfully demonstrates the increasingly intensive advertising, promotional and surveillance strate-gies practiced by post-Fordist marketers in an era of niche markets' and that therefore this industry 'displays the global logic of an increasingly transna-tional capitalism whose production capacities and market strategies are now incessantly calculated and recalculated on a planetary basis'.

If, then, the gaming industry in its conventional configuration, and the video game as its artefact, represent post-Fordist technocapitalism, as a counter to this status quo, gaming projects have emerged which attempt to resist such encodings. In this context, what we may term 'alternative gam-ing' can be seen as response to these conditions. Reviewing the growth in alternative computer games and interactive computer art, Tiffany Holmes (2003: 46) notes that 'the immense success of the gaming companies, now a global phenomenon, has inspired droves of artists to create new works that appropriate a game-like format to explore new structures for narrative and cultural critique'. Holmes then coins the term 'art games' to describe 'an

interactive work, usually humorous, by a visual artist that does one or more of the following: challenges cultural stereotypes, offers meaningful social or historical critique or tells a story in a novel manner' (Holmes 2003: 46). Such a description appears particularly fitting with regard to Miranda Zúñiga's work which, as will be explored, is constantly concerned with the reworking of cultural stereotypes, and the deliberate shocking of the player out of the game world. This is not to say, of course, that commercial gaming environments do not leave room for resistant gaming and reinterpretation by their users; as Dyer-Witherford and de Peuter (2009: 193) themselves have noted, gamers 'sometimes resist the dominant messages' encoded within games and manage to produce 'alternative expressions' from within. Rather, that what we see in *Vagamundo*, as will be discussed, is a much more overt tactic of actively directing the player towards resistant interpretations. That is, as will be discussed, the work as a whole sets up a series of interrogatives around the game environment, actively encouraging a resistant reading in which the user is compelled to critique the sociopolitical context in which the gameplay is set.

Indeed, this notion of alternative or resistant gaming can be seen to be reflected obliquely in Miranda Zúñiga's (n.d.) 'Artist Statement', where he declares that his work 'seeks to invert common tools of social control to create dialogue, exchange critical perspectives, generate questions and ideally inspire subjective action'. What Miranda Zúñiga refers here to as 'common tools of social control' may be understood as new media technologies themselves, for Miranda Zúñiga's work explores the extent to which technologies that may conventionally be used in the service of US neo-imperialism, capitalist accumulation or consumer culture may be recuperated for oppositional purposes. In this sense, Miranda Zúñiga's work, as exemplified by *Vagamundo* for the purposes of this chapter, functions as a form of resistant gaming in which new media technologies, all the while carrying traces of their original encoding, are re-signified for oppositional purposes.

This sense of the re-signification of original encodings is encapsulated in the title itself, which is, of course, a neologism, highlighting from the outset the fact that this work recombines and re-signifies pre-existing meanings. The neologism of *Vagamundo*'s title, combining the term 'vagabundo' ['vagabond'] with 'mundo' ['world'] illustrates how this work speaks to the politics of immigration. The first term is emotionally charged and value-laden, whilst the second refers to global politics. Regarding the first of these, the notion of the *vagabundo*—the vagrant, the undocumented migrant living on the streets—is revisited in Miranda Zúñiga's work, particularly through the figure of Cantinflas who appears as avatar in the work (on which more follows). In the case of the second, the term *mundo* refers, on one hand, to the notion of the game world—that is, the virtual environment we are about to enter—but, on the other hand, to the notion of national territories, borders and global politics. In combining these two terms, the title indicates how the work recycles and contests some of the conventional representations

of the Mexican immigrant as a *vagabundo*, whilst embedding this into a discourse on national territories, borders and global politics of immigration and inequality (*mundo*). Thus, *Vagamundo* signals itself as a critique of the US worldview which inscribes the cartography of 'the Mexican immigrant' and forces Mexican immigrants to self-imagine as other, as a problematic, unruly *vagabundo* other who must assimilate to US norms. The neologism 'vagamundo', thus provides a critique of this world and, as we see in the work itself, encourages us to deconstruct the easy assumptions that lie behind such a worldview.

If such is the importance of the title in preparing us for the interrogation of commonplaces and contemporary geopolitics that awaits us when we enter the work, other paratextual elements of *Vagamundo* also alert us to its status as questioning global politics and US foreign policy. As with many other computer games, Miranda Zúñiga's *Vagamundo* is framed by its paratexts, in this case, an introductory montage that prefaces the game itself. Here, when we open the work, an introductory montage loads, a common trick in commercial computer games to set the scene, present the avatar-character, and draw the viewer-player into the game world. Yet Miranda Zúñiga's version works to draw on the format of this common paratextual device, but with an opposing aim. All the while setting the scene, this introductory montage encourages us not to immerse ourselves in the gameplay (as the commercial computer game paratext would have it), but instead, to criticize the game world, and gain an awareness of its contradictions and the gaps in its internal logic before we play. The montage opens firstly on a photograph of a corrugated iron fence. The photograph is taken in close-up but is slightly out of focus, and, although in colour, grey tones predominate, since there are no other colours visible. The image shows several layers of barriers; in the immediate foreground, we see iron railings; directly behind them, the corrugated iron fence; and farther behind still and into the background, a perimeter fence, which appears to be concrete with barbed wire. The effect of this stark image is to confirm for us that there is no other landscape visible; here, literally, everything is reduced to the border, indicating its omnipresence as a trope and as a daily reality for the many hundreds of thousands of Mexican and Central-American immigrants who attempt to cross it each year.[6] At the same time, this opening image, with its recursive layering of borders, serves also as an image of digital networks, where the layers superimpose and criss-cross each other; it thus functions also as a meta-discursive image, standing for digital media itself, and offering an implied critique of the technologization of the border from the outset.

This photographic image is set against a wallpaper which consists of the US dollar sign repeated in small-scale font. This repetitive background, in which the dollar sign stands as a synecdoche for capitalism as a system and US neo-imperialism, reflects both the motivations for the border crossers, and also very system itself that condemns them. The dollar is representative of the perceived opportunities for increased wealth offered by

the American Dream, and yet the neo-imperialist conditions of production which exploit undocumented immigrants. In this way, from the very outset, Miranda Zúñiga's imagery dialogues with the problematic encoding of the border, and encourages us to explore the subsequent game in terms of the economic plight of the immigrant characters within it. Running across this first part of the montage is a harsh, metallic echoing sound: although there is no voice-over explanation to give meaning to the sound, its conjunction with the images here conveys a sense of enclosure within a harsh, restricting environment.

Superimposed on this image, a pair of statements then appear which frame the game we are about to play in sociopolitical terms. The statements are excerpts from a quotation, given first in English and then in Spanish, which states that 'crossing the border illegally should not be a death sentence; more than one migrant a day dies at the border/ cruzar la frontera ilegalmente no debería ser una sentencia de muerte; más de un migrante por día muere en la frontera.' The first part of the quotation, although not attributed here, is an oft-quoted response by civil rights groups to the US Border Patrol's Operation Gatekeeper implemented along the California–Mexico border. As noted earlier, although the purported aim was to prevent undocumented border crossings, Operation Gatekeeper had the effect not of stopping migrants, but of pushing them towards other, more dangerous areas of the US–Mexico border, such as the desert, mountain ranges and irrigation canals. As a result, as a variety of studies have shown, death rates soared, since border cross-ers were far more likely to die in these circumstances (Cornelius 2001: 669; Meneses 2003; Hinkes 2008: 16). The slogan quoted here thus reflects these statistics, arguing that the US Border Patrol's strategy forced undocumented immigrants into more dangerous terrain, increasing the likelihood of immigrants dying in the process. This quotation, therefore, is emblematic of the protests undertaken by the California Rural Legal Assistance Foundation, the American Civil Liberties Union and others against Operation Gatekeeper. It encodes the image of the border which starts the montage within the politics of US border policy of the late 1990s and the early 2000s.

Moreover, we should also note the significance of technological advances in the functioning of Operation Gatekeeper, a fact which resonates with Miranda Zúñiga's statements about the resistant reuse of digital technologies. As scholars have noted, Operation Gatekeeper's functioning was due not only to the construction of reinforced fences and increases in border patrol personnel but also to the increased use of surveillance technologies, including infrared night scopes, motion detecting sensors, remote video surveillance systems and a computerized system of biometric scanning (Cornelius 2001: 663). In this way, the increasing technologization of the border zone is implicit in Miranda Zúñiga's references to Operation Gatekeeper. His praxis, as analyzed in the following, is one in which digital and gaming technologies—imbued with the traces of their techno-military past as noted earlier—are put to resistant use against the grain. Indeed, if surveillance is

integral to the very genesis of digital technologies and the internet itself, with the internet having its origins in the US defence department's ARPA-NET project, then *Vagamundo* simultaneously engages with those technologies, and attempts to encode them in a resistant fashion. It also, of course, implicates us as viewer-player—for we are about to play a digital game and enter a world of digital simulation—and forms one further tactic of Miranda Zúñiga's in shocking us out of the game world.

Following this screen, a block graph then appears, again superimposed over the same background image. Carrying the title 'Total border deaths', the graph runs forward from 1995, the first full year of the implementation of Operation Gatekeeper, and the total jumps higher and higher, up to 2001 which displays 134 deaths. The block representing these statistics is red, and a figure, with a skull and crossbones superimposed on its chest, stands on top of the block. The sound over this part of the montage is now an intermittent buzzing sound, whose rhythm initially matches the jumping statistics, and so, like much of Miranda Zúñiga's work, is doubly encoded: the buzzing represents the jumping counter of the computer game, but also the electronic surveillance of the border. The way in which this information is represented, then, is both deathly and ludic, with the jumping graphics like a score reaching higher and higher, and indicates how Miranda Zúñiga's work will provide a disturbing revision of the ludic tendencies of conventional computer games. The 'quantifiable outcome' so central to the ludology of computer games (Zimmerman 2004: 161) is here refigured in terms of real deaths. This re-semanticization of computer game norms suggests that Operation Gatekeeper 'plays' with human life, whilst also preparing us for the sociopolitical questioning of the game we are about to enter.

Following this, there is a sudden change in sound of the montage, as a fast-paced techno-music starts, and accompanying this, the words 'But, you've made it across the border' appear over the top half of the screen and, below them, in large, 3-D shadow font, the instructions: 'And now you can play the American Dream'. These words position us as the undocumented migrant having crossed the border and indicate our entry to the game world proper. Yet they also put us on our guard, as with many of the other deliberate tactics of Miranda Zúñiga's: the reference to what we are about to play as the 'American Dream' immediately highlights that the game will deal with socio-economic realities, rather than being set in a ludic, fabricated gameworld.

This material, which we might classify under Gray's (2010: 25) terminology of 'media paratexts' in the sense of their being texts 'on the threshold' of other texts, functions in a similar way to the short introductory videos which are frequently used to introduce contemporary computer games and which, in the words of Mark Finn (2000: n.p.), function to 'discursively position the player within the narrative, providing them with information about the subject positions they are permitted to assume'. If, as Finn has argued, these computer game paratexts are primarily concerned with this

'discursive positioning' of the player, here, in Miranda Zúñiga's version, our discursive positioning is deliberately ambiguous. For *Vagamundo*'s introductory montage positions us both within the narrative as player (signalled by the second-person address) and, simultaneously, outside the narrative from a critical standpoint (implied in the statistics and quotations which encourage us to critique the narrative world in which our avatar will find himself).

After this introductory montage, we then enter the video game proper. The sequence cuts to a black screen in which our avatar appears, presented in the centre of the frame, with his name given at the top: 'Cantinflas' (more on this follows). Subsequently, the game commands are set out for us, and we finally cut fleetingly to a black screen with a line drawing occupying most of the screen space. The drawing, in white, depicts a perimeter fence cutting across from right to left, with a lorry to the left of the image. The perimeter fence is topped with barbed wire and, in its central panel, a drawing is discernible: although faint and showing little detail, the drawing is an outline map of the US. Below this, a quote from Claudia Smith of the California Rural Legal Assistance Foundation is given in yellow font, stating 'June 2002 was the deadliest month so far at the border. At least 70 migrants died'. Again, the fact of this screen coming directly after the game commands and the presentation of our avatar means that we are being encouraged to critique the game world we are entering rather than to immerse ourselves unquestioningly in it.

After this, a new screen loads depicting a colour photograph of a street and shop fronts, with a liquor store occupying the centre of the frame. Superimposed over the photograph, words appear in the same 3-D shadow font, giving us our precise location at the intersection of 145th Street and Broadway—namely, the district of Harlem, infamous for being one of the most troubled neighbourhoods of New York and of having some of the highest rates of poverty, unemployment and poor health in the city (see McCord and Freeman 1990; Newman 1996; Geronimus et al. 2006). The use of this particular font—a font which is dramatic and aggrandizing—is deliberate here. Miranda Zúñiga is contrasting the font—also used in the paratextual video to introduce us to the game world of the American Dream—with the location. The font, traditionally employed as an upbeat, 'bright lights' font to advertise the latest Broadway shows is undercut by the streets themselves. The ironic undercutting of this typeface, conventionally used to advertise Broadway shows, by its linking to the real-life streets of a particular intersection of Broadway, serves as another example of the ways in which Miranda Zúñiga uses digital technologies against the grain, selecting particular digital features (in this case, the iconic font), in order to critique the sociopolitical inequalities undercutting them.

Below these words, instructions to the player subsequently appear across the bottom half of the screen: 'You've made it to New York City', and 'You've got to avoid the liquor bottles in order to get a job'. The game starts, and the

backdrop changes to a computer-generated image of the same street, with the principal shop in the background, a liquor store, advertising vodka for $8.99 and other such promotions (see Figure 7.1). Our avatar stands slightly left of the centre of the screen, and green bottles then move rapidly across the screen from left to right, spinning as they move. The bottles appear at different heights across the screen, and we have to use the arrow keys and space bar to jump, duck or somersault to ensure that our avatar avoids them. Each time we fail to do so, our avatar takes a hit, and a red line graph running across the top of the screen decreases in size.

Our relationship with the avatar, and the manoeuvres which he and we are forced to perform, are central to the critique that *Vagamundo* levels against US immigration policy and the US mind-set. Regarding avatars, Marie-Laure Ryan (2006: 108) has noted the importance of the player's identification with the avatar in interactive narratology, since users 'project themselves as members of the virtual world by identifying with an avatar'. If an avatar, thus, functions as the way in which we are interpellated into the game, here the externally focalized avatar Miranda Zúñiga has created for us, and with which we are encouraged to identify—a Mexican immigrant—makes an ironic commentary on the stereotypes of the Mexican immigrant in the US mind set.[7] Miranda Zúñiga's choice of character in this first stage of the game, where we are specifically interpellated as 'Cantinflas', brings to bear a whole history of cultural references about Mexican (im)migration. Cantinflas is the stage name of the popular Mexican actor from the golden age of Mexican cinema, Mario Moreno Reyes, who played a series of stock Mexican characters in comedy films and was frequently the butt of jokes. The character as which he appears here and for which he is most famous is that of the *pelado*, representative of the urban underclass formed of rural migrants who moved to the city in the early decades of the twentieth century. Poor, shabbily dressed, and bewildered in the big city, the *pelado* was 'by definition, uprooted from the certainties of village life and thrust into the vagaries of the city' (Pilcher 2001: 58). Cantinflas in his representation of the *pelado* thus represents the shift from rural to urban society in Mexico of the first half of the twentieth century. Miranda Zúñiga then updates this in *Vagamundo*, making Cantinflas stand for the migration of Mexicans, post-NAFTA, to the US in the early twenty-first century and the shift to a transnational economy. Our avatar thus carries with him this cultural heritage, and encourages us to consider a parallel uprooting associated with twenty first century Mexican immigrants to the US, the critique now being directed not at the Fordist capitalism of Mexico's shift to an urban economy but at the late capitalism of the transnational economy.

Moreover, Cantinflas and the *pelado* figure he represented played a particular role in illustrating and yet critiquing the socio-economic conditions which had brought about his existence. Whereas, in the case of the original Cantinflas, the *pelado*'s 'nonsense language eloquently expressed the contradictions of modernity' (Pilcher 2001: p.xxii), here it is the nonsense of our

avatar's movements that make a mockery of US policy. The ridiculousness of the manoeuvres we are expected to perform, as we are forced to jump, duck, or summersault to avoid the liquor bottles, makes it clear that our avatar is not performing the conventional actions of an immigrant in New York. Rather, the actions of ducking and avoiding the bottles serve as visual metaphors for, and critiques of, the harshness of life for immigrants in late modernity. It is the social stereotype, rather than the physical bottles themselves, that we are attempting to avoid. Indeed, the deliberate jerkiness of the controls, and the limited ways that our avatar can move across the screen, means that the odds are stacked against us as we play, and we are likely to fail. If we are unsuccessful in our attempts to avoid the bottles, our avatar eventually collapses and a US Immigration official walks in from the left of the screen. The official drags our avatar by the heels, throws him off-screen, and the words 'And stay out!' appear in a speech bubble. The act of throwing our avatar, and us, off the screen—beyond the screen space and out of the game world—reflects both our losing the game in the classic codes of ludology as well as the experience of the Mexican immigrant in being ejected from the US.

If successful, however, in avoiding the bottles and surviving on the streets, we progress to the next level, and a new scenario loads. Here, our avatar morphs into another version of the stereotyped Mexican immigrant. Whereas, on the first level, the avatar is dressed in shabby brown trousers which are frayed and full of holes, is wearing a cap pushed back with his hair sprouting out and has his hands in his pockets, in the second level, the avatar stands slightly taller, although still leaning back, wears a baseball cap on back to front and has a loose T-shirt over baggy trousers. This attire, more representative of the Chicano street figure, represents partial assimilation, and on-screen titles inform us that we are now one of the 'Day Laborers available at "Slave Market"' in Brooklyn. Instructions in yellow font then direct us: 'Congratulations! You've got a job as a grocery bagger. Fight the stereotype monster and move onto a better job'.

The backdrop to our avatar, the street corner, is initially shown, as in the first level, via a colour photographic image, depicting a street corner with a grocery store in the centre of the shot, its goods displayed along the street front. This image is subsequently replaced with a computer-generated image of the same street, rendered in block shapes and bright colours and over which a repeated techno beat plays. Our avatar is, again, located towards the left of the centre of the screen, with the blue and white attire of the avatar standing out against the greens of the shop front and the greys of the pavement. Notably, and as with the first level, our avatar is unable to move beyond this backdrop; moving the cursors allows the avatar to move short distances from left to right across the screen, but he can never move beyond it, because the backdrop remains static throughout the gameplay. Miranda Zúñiga's trick here thus indicates how the avatar remains trapped within this socio-economic space. As we use the cursors and space bar to duck and

punch the monster, the notion of avoiding stereotypes which was encoded metaphorically in level 1 now becomes concretized in the shape of the 'stereotype monster', rendered through an animalistic cipher in the form of a huge, human-sized cockroach. Every time we take a hit from the stereotype monster, the words 'English only!' appear in a star, revealing how one of the central prejudices that Mexican immigrants have to fight against is the language barrier, as well as focusing our attention on language policy in the US. If we suffer too many punches, we lose and the owner of the store appears in the window, shouting to us in a speech bubble, 'You fired'. It is notable here that the store owner speaks in broken English, implying that he too is a recent immigrant to the US and pointing to one of the central concerns of this ironic game: the (dangers of) conformity and perpetuating the system.

If successful, level three sees our avatar morph once again, as we now stand tall, wearing a shirt and smart dark trousers, but with a telltale square of material folded over our arm, indicating we have now made it as waiter. On-screen instructions inform us: 'Congratulations! You've learned English and are now a waiter! Keep your guests happy and earn tips. Earn $180 and you've beaten the game'. As the instructions appear, the location for this level also appears on the screen, again in the same 3-D shadow font, informing us that we are in Upper East Side, one of the most affluent districts of New York. Our avatar appears in the foreground; behind him we see the front of a restaurant, with tables set out on the pavement, and a blue canopy and railings setting the customers apart from the implied off-screen traffic, and, crucially, apart from any close contact with our avatar himself. In other words, the aesthetic representation of space here makes clear that, even when located in the same frame, the socioeconomic barriers which separate the poor Mexican immigrant from the affluent US upper classes are still firmly in place; the railings, running as they do across the central horizontal plane of the screen, cut across the composition of the frame and mark out socio-economic divisions.

As with the work of Fusco and Domínguez analyzed in Chapter 6, Miranda Zúñiga's representation of the streets and manipulation of screen space here can be understood through recent theorizations on the presence of the Third World in the First World in late capitalist society, as articulated through Castells's notion of the 'Fourth World'. Castells's notion of the new geographies of social exclusion generated by global corporatism and late capitalism finds itself reflected in Miranda Zúñiga's game world. Here, in *Vagamundo*, the aesthetic composition of screen space serves to illustrate these internal stratifications, depicting Fourth World attempts at survival within a resolutely First World, upper economic class milieu. Thus, the representation of the streets here, far from a quasi-utopian locale of Chicano resistance, is the space in which the structural inequalities of late capitalism are played out.

In order to navigate around this stratified space, we have to use the cursors to move our avatar from left to right across the foreground of the

screen, and collect tips from customers with the space bar. The owner of the restaurant emerges periodically from the restaurant door to shout at us to 'Get those orders out', and our avatar has a short timeframe in which to work. The desperate attempt to accumulate tips, as the dollar bills appear on the screen only fleetingly before disappearing once more, again provides a comment on the precariousness of immigrant occupations, as it is virtually impossible to collect enough dollars in the time allotted. Given the limited controls and the jerkiness with which we move our avatar, we cannot move around this segmented space with sufficient ease to reap the benefits. Notably here, the socio-economic factors which were rendered in earlier levels of the game through metaphors or ciphers (beer bottles or cockroaches), are here laid bare in their actuality: that is, the dollar bills that appear on screen represent the late capitalist society which depends on and exploits undocumented immigrants. If we are unable to amass the required amount—a virtual impossibility except for the most dexterous of players—we lose, our avatar bows his head and sinks downwards, through the pavement and out of the game world.

Again, the use of the avatar in these levels is crucial in decoding Miranda Zúñiga's message. As the user progresses up through the various levels of the game, the avatar becomes increasingly assimilated and acculturated: clothes become more Americanized, employment becomes more regular, and the backdrop against which the avatar moves becomes more prosperous. Miranda Zúñiga's game thus clearly provides an ironic commentary on the pressures that Mexican immigrants face to assimilate and acculturate. Indeed, it is worth noting that on the summary page which prefaces the game (www.ambriente.com/cart/about.html) the image conveying the three main avatars deliberately visually mimics the iconic image 'The Road to Homo Sapiens' (1965), known popularly as 'March of Progress'. Described by evolutionary biologist Steven Jay Gould as 'the one picture immediately grasped by all' (Gould 1989: 31), 'The Road to Homo Sapiens' was drawn by the natural history painter Rudolph Zallinger to accompany anthropologist F. Clark Howell's 1965 book, *Early Man,* and has since become one of the most widely recognized scientific images worldwide, as well as, of course, generating hundreds of imitations and parodies. Despite not being the direct intention of either the author or the illustrator, the image has been widely read as a depiction of human evolution as a linear progression. Frommherz (2013: 151) has detailed the visual abstractions at work in Zallinger's image, including the arrangement of the humanoid figures according to the visual convention in left-to-right reading cultures, in which directionality towards right implies forward movement; the depiction of the figures in a march, an action of 'decisive forward motion', and so symbolizing humanity's will to evolve; and the gradual increase in body height and erectness of posture in the figures, which creates a rising silhouette line that 'visually suggests advancement'. It is notable, thus, that Miranda Zúñiga's summary page on which the three avatars are depicted together deliberately

mimics the dynamics of Zallinger's drawing, and employs the same visual abstractions: in Miranda Zúñiga's version the three avatars are presented in a horizontal line such that we 'read' them left to right; the second and third avatars are captured in mid-step, in the process of walking across the screen, hence conveying direction; and the increasingly upright stature of the avatars creates a curve across the screen implying advancement. Hence, Miranda Zúñiga is deliberately drawing parallels with this most iconic of images, although, at the same time, encouraging us not to identify with it, but to question it. Given both that the original image has been critiqued as conveying a false impression about the nature of human evolution as 'progress through successive stages towards a future goal' (Shelley 2001: 85), and that it has been widely copied and parodied—in its use in anything from cigarette advertisements to rock band album covers and episodes of the cartoon show *The Simpsons*—the image can no longer be taken at face value.

Miranda Zúñiga's image thus works to encourage us to question the notions of necessary progress, movement and improvement that were implicit in Zallinger's visual strategies, and imbues them, of course, with a particular sociopolitical specificity: the pressures of acculturation for Mexican immigrants to the US. Acculturation, a bone of contention in Latina/o and Chicana/o studies, and one which in Latina/o and Chicana/o contexts is often associated with 'Anglo-conformity' (Keefe and Padilla 1987: 15), proves particularly important when considering the user's relationship to the avatar and narrative progression. Progression is central to computer gaming and to the user's relationship with their avatar; as Julian Kücklich (2003: n.p.) has explained it, it is 'the player's desire to become the model player of the game that enables him or her to identify with the avatar, and thus to interact with the gameworld and make progress in the game'. If there is, therefore, a tight nexus uniting player, avatar and narrative/ludic progression,[8] the progressive change in the avatar of *Vagamundo* explores the implication that success is only obtainable through assimilation. The value-laden term *model player* employed by Kücklich can be paired with the notion of the 'model citizen': the 'model players/model citizens' are those who assimilate in order to progress in the game and, ultimately, win it. Miranda Zúñiga's praxis, in which such notions of assimilation, game progression and model players are brought under increasing scrutiny by the critical discourses which frame the game and by the sociopolitical comments which intersperse it, serves to undercut these notions. *Vagamundo*, thus, comments on and critiques this notion of assimilation as a necessary process to which Mexican immigrants must submit themselves, as well as also critiquing the structures of progression which encode computer games.

Beyond these three official levels of the game, if the player is successful in completing the third level, he or she is then offered access to the 'Extra level', which is in effect a bonus level of the game. The avatar now successfully assimilated into US society, the player is offered the choice of discriminating against new immigrants or helping them. If the player selects the option

to discriminate, he or she is awarded this extra level in the game and takes on as an avatar a US Border Patrol guard who has to shoot immigrants attempting to cross the border. If the player selects the second option, he or she is directed towards a list of activist information and NGOs dedicated to new immigrants. It is crucial, of course, that access to the bonus level of the game—conventionally used in video game design to reward the player and provide him/her with 'unlockables' that will encourage him/her to play again (Rogers 2010: 71)—is awarded to those who choose to discriminate; that is, to those who perpetuate the system against which their avatar has previously been fighting. In this way, Miranda Zúñiga has again woven a tight thread between his game world and outer social reality: if the purpose of an unlockable is to encourage us to play again and thus perpetuate the gameworld, here, this is allied with playing along with, and perpetuating, the sociopolitical system. There is thus a clear statement made about those who refuse to break the rules of the gameworld/worldview, namely, that their stance involves perpetuating the system.

Indeed, it is notable that this sense of perpetuating the system is reinforced by the visuals making up this unlockable bonus level. The omnipresent image of the border which opened the paratextual introductory video now re-emerges in the bonus level of the game, as the player now finds their avatar at the border, this time policing it from the other side. This level starts first with a black screen over which a white line drawing of a helicopter hovers in the centre, below which instructions in yellow lettering command us to 'protect our borders!'. This screen is then replaced with one depicting the border zone in full colour, and running across all of this level is a sound sequence composed of screams, the noise of helicopter blades slashing through the air and police sirens, all merged together into a sound collage set on a continuous loop. A grey perimeter fence runs across the top half of the screen towards the vanishing point in the top left, and an expanse of dusty ground occupies the bottom half, whose shading indicates the presence of off-screen search lights. Now in vivid green, the hovering helicopter re-appears, located towards the left of the perimeter fence and standing as a synecdoche for the hi-tech militarized surveillance of the border. Our avatar stands in the foreground in the bottom left corner of the screen, as our target—the illegal immigrant, in the shape of a cut-out photograph—moves across from right to left alongside the fence. The cursors and space bar are now used not to move our avatar around the screen as in the previous levels, but instead to move a sight line around the screen, and to shoot. Tellingly, the figures moving across the screen representing the border crossers are all an animation of the same image: a photograph of a real person. For the first time within the levels of the game itself, the figure on screen is represented not as a cartoon character a la Cantinflas, but as a human being, in a photograph which looks suspiciously like Miranda Zúñiga himself. The shock effect of the insertion of a real-life image in this bonus level is to make the viewer-player step back and refuse to shoot and to jolt him or her out of

the game world. Indeed, it is interesting to note that, should we choose, we can in fact decide to aim our gunshots elsewhere, including at the map of the US imprinted onto the wall. Visually, thus, we have come full circle and find ourselves still locked within the game/system: we are back where we started, in the game world equivalent of the introductory paratext. This, coupled with the real-life image of the immigrant in this final level should set off warning bells for the player if he or she has selected this level: we have, literally, not gone anywhere and have ended up back at the start.

If this is the option open to the player who wishes not to challenge the system (whether the system of the game world, or the sociopolitical system), the second option, by contrast, means that the player, instead of remaining within the confines of the game narrative, opens out the game world to wider social reality, and is encouraged to engage in real-life activism. Here, the user is directed towards two print texts—Nancy Foner's (2001) edited volume *New Immigrants in New York* and Mike Davis's (2001) *Magical Urbanism: Latinos Reinvent the U.S. City*—as well as being provided with links to the projects of two leading civil rights organizations involved in protesting border policy, those of the California Rural Legal Assistance Foundation and the Asociación Tepeyac. The first of these, Foner's edited volume, is an academic study of immigration in New York exploring a variety of immigrant communities, including not only Hispanic immigrants but also covering Chinese, Korean, Jewish and Jamaican immigrant communities, amongst others. The second, by one of the leading scholars on Latina/o and Chicana/o communities, explores the 'ethnic transformation of the urban landscape' by Latina/o and other communities, as well as decrying the 'invisibility of Latinos' (Davis 2001: 9) and mapping out the coordinates of the 'latino metropolis' (Davis 2001: 49). Both of these print texts thus highlight the transformation of the streets and of urban space by Latinos and others, and so engage with the representation of the streets in the game narrative. Whereas in the game world our avatar was trapped within his respective sociopolitical space in the varying levels of the game, these books provide a more nuanced, in-depth exploration of the realities of life for immigrant communities in the US and provide the reader with a wealth of statistics behind the flat, one-dimensional space of the game world.

The two civil rights bodies, meanwhile, represent the start and end points of the game narrative, with the former focusing on economic justice and human rights on behalf of the rural poor and new immigrants in California, and the latter promoting the rights of Latino immigrants in New York. The first of these, the California Rural Legal Assistance Foundation (CRLAF), has been one of the most vocal opponents of Operation Gatekeeper and was the co-author, along with the American Civil Liberties Union (ACLU), of the 2001 complaint submitted to the Inter-American Commission on Human Rights that widely condemned the scheme. The complaint submitted by the ACLU and the CRLAF charged that the US government was responsible for violating Article 1 of the American Declaration of the

Rights and Duties of Man by deliberately channelling migrants eastward out of the San Diego region of California and into the more hostile terrain of the Tecate mountains and the Imperial County desert. In their complaint, ACLU and the CRLAF contended that the US government implemented Operation Gatekeeper in a way that knowingly led to the deaths of immigrants, arguing that 'the facts show that Operation Gatekeeper was designed to place migrants in mortal danger in order to deter their entry into the United States' (ACLU and CRLAF, cited in Nevins 2003: 176). The CRLAF was thus one of the most high-profile opponents of Operation Gatekeeper at the time of the making of *Vagaumdo*, and this link therefore draws the player out of the game world, and into the arena of human rights activism. Indeed, it is also worth noting that the CRLAF is the acknowledged source of the quote given in the opening screen in the first level of *Vagamundo*, and the unacknowledged source of the initial quote given in the introductory paratext. In both these cases, thus, the CRLAF is tightly linked with the opening stages of the game, as with the border politics of the bonus level at the game's close, and stands to encourage us to question, rather than play along with, the rules of the game world.

The Asociación Tepeyac, meanwhile, is a network of NGOs with a particular focus on promoting the wellbeing and human rights of undocumented migrants in New York. Established in 1997, in a period in which New York saw a notable increase in the numbers of Mexican immigrants, the Asociación Tepeyac focuses in particular on recently arrived immigrants, their vulnerable position in the work place and in the problems they encounter neighbourhoods in which they live. As well as informing immigrants about their labour rights and the social services they can access, the association also aims to be an 'un espacio de encuentro para que los mexicanos pudieran identificarse como parte de una comunidad y reconstruir su sentido de pertenencia' ['meeting place where Mexicans can identify as part of a community and reconstruct their sense of belonging'] (Rivera-Sánchez 2004: 460). This particular link, thus, directs us towards the work of the Asociación Tepeyac and of the various NGOs with which it works in their attempts to transform the lives of Mexican immigrants on the streets, thus encouraging us to interrogate the setting of the three levels of the main gameplay of the work.

These four sources selected thus dialogue with the paratextual information provided in the opening montage, with the statistics interspersed throughout the game and with the further paratextual information on the website hosting the game.[9] Here, the boundaries of the computer game are opened, and the user is encouraged to break beyond the confines of the gaming world with its circular logic and reinforcement of the system, to enter into real-life activism. In this option, the mechanics of the game, with all the implications of assimilation and conformity the game progression throws up, are challenged by the user. Instead, it is the latent potential, interspersed throughout the game in the form of the periodical use of

statistics and commentaries on the current plight of Mexican immigrants in the US, that is actualized by the user as s/he transcends the game world and moves into activism.

This sense of the necessity of opening out the game world, and of challenging the accepted boundaries/borders of the system, is further developed by the pedestrian interaction which is an integral part of this work. In addition to the introductory montage and the video game, one further and highly important interactive feature of *Vagamundo* was its showcasing and enactment in public spaces. Miranda Zúñiga took the artwork into the streets of New York, in particular in Brooklyn and Manhattan, in order to generate public participation.[10] Conceived of as a 'mobile public art project' (Miranda Zúñiga 2002: n.p.), the battery-powered game was taken into the streets in a pushcart with a monitor, computer and joystick, and pedestrians were invited to play the game (see Figure 7.2). Here, the enactment of the work on the streets of New York- the same streets of the game world—provides a way of encouraging the player-spectator to engage with the socio-political environment in which s/he lives. Indeed, in this enactment on the streets, Miranda Zúñiga is, in effect, returning to the material space of the streets which formed the first step in the creation of the work: Miranda Zúñiga has commented that the starting point in his creation of *Vagamundo* was 'informed by interviews that I conducted with new immigrants from Latin America residing in Manhattan and Brooklyn' (Rider 2002: n.p.). If these interviews provided the initial source experiences for *Vagamundo*, then the enactment of the work back on the streets of New York serves to further this connection between physical place and the virtual gameplay.

Moreover, this sense of the reworking of place is furthered by the materialities of the installation itself. The significance of a home-made push cart as the vehicle for the artwork reflects the reality of many undocumented immigrants who are forced to make a living in the grey economy in the US, selling home-produced food on the streets.[11] The cart is, in other words, the vehicle through which many undocumented migrants survive in the grey economy on the streets of New York and many other cities in the US. Miranda Zúñiga's choice of this vehicle is thus deliberate, and he has highlighted the significance of the cart in *Vagamundo* as representative of Mexican and other Latin American immigrants who work in the 'alternative economy' and which he sees as an example of the 'Third World tactics of survival . . . within the US' (Rider 2002: n.p.). Miranda Zúñiga's comments here clearly engage with global politics and the social stratification inherent to late capitalism. His notion of 'Third World tactics of survival' recalls Castells's (2010b) arguments regarding the Fourth World, and the fact that global informational capitalism simultaneously generates and is dependent on pockets of exclusion. Miranda Zúniga's *Vagamundo*, in its contrasting of the digital technology of the game with the decidedly low-tech, recycled and reclaimed materials of the pushcart, lays bare the workings of Castells's

model. The materiality of Miranda Zúñiga's *Vagamundo*, then—its enactment on the segmented spaces of New York's streets and its presentation in the makeshift handcart so often used by the inhabitants of this Fourth World—thus works to bring the viewer-participant face-to-face with the realities of the workings of late capitalism. In other words, the creative combination of elements—the critical digital game project, the enactment on the streets, and material form in which it is presented—lay bare the structural inequalities of late capitalism.

Of course, it is significant that in Castells's (2010b: 379) formulation, this new geography of social exclusion is inseparable from what he terms '*informational* capitalism' (my emphasis), in other words, a capitalism predicated on the high-speed flows of information facilitated (at least in part) by new media technologies. The Fourth World is, thus, the result of the structural transformations occasioned by what Castells terms 'global network capitalism', and lies at the nexus of informational capitalism, poverty and social exclusion. Miranda Zúñiga's work, combining digital technologies with street participation, makes a particularly apt use of multiple media to interrogate this nexus. That is, it is precisely here, in the interlinking of digital computer games with pedestrian participation, of informational technologies with Fourth World survival on the streets, where late (informational) capitalism resides.

Miranda Zúñiga's praxis, thus, attempts to provide a critique of and a form of contestation to this nexus. Sharing concerns with several other of the works analyzed in this volume, *Vagamundo*, through its critical reuse of computer technologies (technologies which underpin both late capitalism *and* the policing of undocumented immigrants), aims to re-utilize these tools against the grain, in a tactical and temporary moment of resistance. Moreover, by making the streets an integral part of the work of art itself, *Vagamundo* lays bare the very materiality underpinning late capitalism. In this way, if it is on the streets where the residual effects and necessary conditions of global network capitalism are experienced, then *Vagamundo*'s combination of high and low tech speaks to and critiques these conditions, both in its content and its materiality.

In addition to the installation of the artwork within the street vendor's cart, the subsequent pedestrian interaction provides a further, highly significant strand in Miranda Zúñiga's practice of exploring the sociopolitical concerns of Mexican immigrants in the US. Since public interaction with the artwork was not contained within institutional spaces such as galleries or museums, but instead undertaken within the streets, *Vagamundo* forces the public to engage in a re-thinking of their own status on the streets. In a similar way to the enactments of *Memoria histórica de la Alameda* on the streets of Santiago de Chile analyzed in Chapter 2, which encouraged pedestrians to re-evaluate the monuments, buildings and landmarks they encountered, so, too, does *Vagamundo* attempt to engage the participant with the urban space in which they find themselves. Although not relying

on a set of specific markers and tags as *Memoria histórica de la Alameda* did, *Vagamundo*'s reference to the city space is nonetheless clear: the game the participants are invited to play positions their avatar within the very same streets in which they find themselves, since the launch of the work and many of its subsequent showcasings took place in New York, location of the streets represented in *Vagamundo*. As such, the participants are encouraged to re-evaluate the cityspace, experiencing it from the point of view of the marginalized through the avatar they assume, but also, more importantly, to re-evaluate the city space as the space in which the logic of late capitalism is played out. This pedestrian participation means that members of the public become protagonists in the art work itself, with the viewer implicated in the construction of *Vagamundo* in multiple ways: in a very physical sense the viewer engages with the work of art, touching the keyboard, leaning on the cart for support and so forth, whilst also, in a more virtual but equally important sense, manipulating the avatar and furthering the avatar's narrative on screen.

At the same time, the use of public participation in *Vagamundo* can also be read in the light of Miranda Zúñiga's stated aim of creating a commons. In a recent interview, Miranda Zúñiga described *Vagamundo* as a 'mobile public art project designed for on the street interaction to create temporary public commons' (Rider 2002: n.p.). Here, Miranda Zúñiga's notion of a 'temporary public commons' brings together the concepts of on- and offline place, a conjunction which is central to the very workings of his art; that is, the interplay between real and conceptual borders in the content of *Vagamundo* is paralleled in the interplay between on- and offline space in the enactment of *Vagamundo*. Regarding, first, the offline implications of the term, the notion of the 'public commons' in an offline context is frequently associated with issues regarding land ownership, and the concept stems from collective land uses of pre-capitalist societies. This sense of collective ownership of land and of resources has been remobilized in recent decades by many activists—in particular those of anti-globalization movements—and scholars who advocate a revival of the notion of the 'commons' in order to counter prevailing capitalist appropriations of land, wealth and resources.[12] If this material concept of the 'commons' is what is mobilized in an offline context, online debates, in many ways building on these same notions, have argued for the creation of a 'digital commons' or 'creative commons' in which developments such as open-source software can potentially provide for a 'cornucopia of the commons' (Bricklin 2001: 51), and thus resist the 'cyber-spatial land grab' (Coleman and Dyer-Witherford 2007: 935) of global media giants and state corporatism. Thus, the notion set forth by Miranda Zúñiga here—that of creating a 'temporary public commons' through his artworks—brings into play both real and virtual space and, crucially, calls up debates on ownership, location and belonging, all of which concepts are central to the themes of *Vagamundo*.

Pedestrian interaction, therefore, for Miranda Zúñiga draws on a dual impetus: it draws on existing practices from performance and installation art which aim to reclaim public spaces, and second, it engages with contemporary debates about the public (electronic) commons. In so doing, Miranda Zúñiga brings the experiences of his avatar in the virtual space of computer games into the real physical place of the streets and embeds his narrative of the border and of the streets within wider debates about public commons. In this regard, Miranda Zúñiga's aesthetic praxis can be understood to make creative use of new media technologies in order to produce a rethinking of place-based policies and politics.

The various strands of the work—the introductory paratextual montage, the computer game, the links to activist sites, the mobile cart and the pedestrian participation—function together to challenge the boundaries of artistic genres, and, in so doing, to challenging some of the central structural features of conventional computer games, and some of the principal assumptions regarding Mexican immigrants in the US. Returning to Aldama's assertions on which this chapter opens, the notion of the 'elasticity of the border' is demonstrated by Miranda Zúñiga's work, as the dominant, greyscale image of the perimeter fence in the introductory video permeates the game and frames it, reappearing at the work's close in the bonus level. We can, therefore, read the experiences of our avatar on the New York streets of the game narrative as one example of the 'multiple vectors of forced liminalities produced by the U.S.-Mexico border' (Aldama 2002: 11).

In summary, Miranda Zúñiga's praxis in *Vagamundo*, in which real experiences of immigrants on the streets, based on interviews, are then filtered through the digital computer game, subsequently brought back out onto the streets through the installation of the ice-cream cart, and finally enacted via pedestrian participation, reveals a 'tacking back and forth' across virtual and real space of the sort that Arturo Escobar has called for (Escobar 1999: 32). This tacking back and forth chimes with *Vagamundo*'s dual aim of (temporarily) claiming back public place, and of forcing a rethinking of the conceptual spaces of the border and of the streets. By combining resistant remixings of digital and pre-digital sources with pedestrian interaction in offline place, Miranda Zúñiga examines and critiques the trope of the border, the streets, and the representation of Mexican immigrants in the US imaginary. More specifically, his work also critiques the new era of border relations encapsulated in Operation Gatekeeper, and the conditions of late capitalism under which the undocumented migrants live. As we learn as we play the game and progress through its levels, the segmented spaces of the New York streets are where the Fourth World is located, and where the politics of neoliberalism are played out. Our avatar, trapped in the successive socio-economic spaces of each level of the game represents for us in stark terms the workings of this system. The deliberate tensions established by Miranda Zúñiga throughout the work between the two-dimensional world of the gameplay and the complex sociopolitical

reality beyond it—through the interspersed statistics, through the shock effect of the human target in the bonus level, through the links to NGOs, and through the enactment on the streets—encourage us to break out beyond the game. *Vagamundo* thus ultimately encourages the player-user to refuse to play along with the game, and instead to challenge the laws of the game world/system.

NOTES

1. Although Miranda Zúñiga is not Mexican himself, his work *Vagamundo* represents specifically Mexican immigration in the narrative of the game itself, as will be discussed later.
2. I am purposely choosing to give the term in its masculine form rather than in the preferred 'Chicana/o' formulation, given that, as will be discussed below, this is a particular gendered conceptualization of Chicano identity.
3. It is worth noting the gendered critiques of this conceptualization of Chicano identity; see, for instance, Alica Gaspar de Alba's (2003: xix) edited volume *Velvet Barrios*, which analyzes the 'ethnic performance of maleness and femaleness' associated with the *barrio*.
4. Writing in a 1982 column in *Newsweek*, Friedman described Chile under Pinochet as an 'economic miracle', and the phrase 'the miracle of Chile' has since come to represent the neoliberal, free-market model. Such a notion has, in recent years, been widely critiqued; see, for instance, Peter Winn's (2004) *Victims of the Chilean Miracle*.
5. Laeticia Wilson (2006: 269) uses the term *political game-art* to describe games in which the political content works to 'morph the play-space into a think-space'; Patrick Crogan (2007: 88) uses the term *experimental game projects* to describe works which involve a 'critical interrogation of gaming culture'; Jahn-Sudmann (2008: 9), meanwhile, lists the terms 'Games with an Agenda', 'Serious Games', 'Persuasive Games', or 'Social Change Games' to describe the types of games which 'are explicitly arranged as a critical, interceding practice in order to call attention to social problems in the "real world"'.
6. Estimated undocumented entries into the US in the mid-early 2000s were calculated at over 500,000 entries (2005 figures), with a further 1,139,282 being apprehended at the border (United States Government Accountability Office 2006: 42).
7. I am here referring to the fact that our relationship to the avatar in *Vagamundo* is one of third-person or external focalization, since we see both the virtual world and the body of our avatar. See Ryan (2006: 240n9) for more on this.
8. I am here employing both terms (narrative/ludic) in conjunction to signal that I view narratology and ludology as closely intertwined rather than mutually exclusive systems. If narratology was initially opposed to ludology in earlier computer game debates, more recent scholarship has argued that computer gaming must be understood through a conjunction of the two (see, for instance, Brand and Knight 2003). Given that, as James Ash and Lesley Anne Gallacher (2011: 354) put it, 'when playing a game many users experience the game as a story with a narrative as well as a complex rule-based system', earlier debates surrounding narratology and ludology are thus 'based on something of a false dichotomy'. I share this view and indeed, as can be seen from the analysis in this instance, I argue that progression is both ludic (propelling the game forward) *and* narrative (furthering the life story of our avatar).

9. I am here referring to the information available at www.ambriente.com/cart/index.html, which, in addition to providing a preamble to the work and reviews of it, includes newspaper reports on deaths on the border.
10. Miranda Zúñiga took the art project to the *Kitchen's Annual Neighborhood Fair*, Manhattan in September of 2002, as well as presenting it at various art festivals and conferences.
11. For more on Mexican immigrants and street vending, see Zlolniski (1994, 2006) and Bhimji (2010).
12. See, for instance, David Bollier (2003: 8) who argues the case for 'reclaiming the commons' as a strategic move to 'identify and describe the common values that lie beyond the market place', as well as protests by a variety of anti-globalization groups to 'reclaim the commons'.

8 Struggles over Place
Latin(o) American Net Art as Resistant Praxis

As this volume has shown, the wide variety of work by Latin American practitioners online who work within the broad boundaries of net art shares certain concerns, even if the formal, generic and technical aspects vary widely. Common to all the works studies in this volume is a concern for the prominent sociopolitical concerns of the particular country in question and the regimes of power at work, whether these be the continuing tensions overhanging from a previous era, such as the periods of dictatorship in Argentina and Chile, or the contemporary conflicts generated by neoliberalism. Regarding the first of these, issues of the historical significance of the particular locale come to the fore in *Memoria histórica de la Alameda* and the constituent works of the *W:MoR* exhibition, in which these various pieces attempt to imbue iconic locales in the national imaginary with the memory of earlier periods of repression. In the case of both these works, explicit references to earlier periods of dictatorial rule are constantly linked to the present, with the works illustrating not just how historical memory must be preserved but also, more profoundly, how some of the tensions and polarizations of the dictatorial era still remain to be resolved in the present. Others, such as Mackern's *34s56w.org*, oscillate between the contemporary references to Montevideo's urban fabric and telecommunications systems, and the images of Uruguay's past in the heyday of its modernity, in order to interrogate and look beneath the veneer of the contemporary spectacle. Indeed, even those works which deal most overtly with contemporary issues, such as *Turista fronterizo* and its interrogation of neoliberal border politics of the 2000s, in fact embed their critique within a wider historical framework, such as, for instance, the evocation of the *bracero* programme as an earlier counterpart to the contemporary post-NAFTA border relations.

With regard to the latter, what is particularly noticeable across all the works is an interrogation of the workings of late capitalism, whether these workings are contrasted to earlier periods of dictatorial power as in *Memoria histórica de la Alameda* and *W:MoR* or form the central focus of the critique as in *Vagamundo* or *Demo Scape V 0.5*. Across these works, several central concerns regarding late capitalism emerge: the new configurations of power under late capitalism, the structural inequalities of late capitalism

and the waning of the nation state in the face of the increasing powers of transnational corporate capital.

Regarding the first of these, the new configurations of power under late capitalism form one of the concerns frequently articulated by the artists studied in this volume. Many of their works explore the workings of post-Fordist late capitalism, particularly as this relates to Latin America, and they engage with specific moments of their nation's history where these workings are played out. Even in the case of those works engaging explicitly with the past, as is the case with *Memoria histórica de la Alameda* and *W:MoR*, the past is then linked to the neoliberal present, as is the case of the tags relating to present-day protests in the former, and the lexia relating to the *corralito*, the *cacerolazos* and the street protests of the period of the economic crash in Argentina in the latter. The period from the 1980s onwards saw the rise of neoliberal regimes across Latin America, predicated on structural adjustment, export-led growth, privatization of previously nationalized industries, deregulation and the privileging of market-led solutions over state intervention. What Gareth Williams has called Latin America's 'continued and often violent insertion into late capitalism and its increasingly global networks of communication' (Williams 2002: 1) forms one of the shared concerns across many of the artists studied in this volume, as they analyze and critique the shift in economic practices and global politics from Fordist capitalism of the early twentieth century to post-Fordist, corporatist late capitalism of the twenty-first century. Thus, whether suggesting interconnections between earlier forms of state-sponsored violence and the structural violence of neoliberalism as in the case of the *W:MoR* works in Chapter 3, or juxtaposing the iconic buildings of modernity and commodity capitalism with scenarios of corporate capitalism as in the case of Mackern's pieces in Chapter 4, the artists studied in this volume engage in a sustained critique of the new configurations of power under late capitalism.

Regarding the second of these, the structural inequalities of late capitalism form another of the central concerns of the artists studied in this volume. Their works frequently critique the structural violence of the neoliberal state, and place the social exclusions generated by late capitalism under sustained scrutiny. What Žižek (2009: 12) has termed the 'systemic violence' that is inherent in the social conditions of global capitalism, and which involves the '"automatic" creation of excluded and dispensable individuals, from the homeless to the unemployed' often comes under focus in their works. Thus, from a consideration of the streets of New York as the space in which the structural inequalities of late capitalism are played out, in the case of Miranda Zúñiga in Chapter 6, to the existence of the Fourth World in contemporary Montevideo in Mackern's works in Chapter 4, the artists explore the spatial geographies of global capitalism, and the uneven territories of exclusion that are generated.

Third, the waning of the powers of the nation state, or the transformation of the nation state in the face of the increasing powers of transnational

corporate capital are central concerns for many of the artists studied in this volume. In a Latin American context, scholars have frequently observed how the modern nation-state is losing its legitimacy—a legitimacy that was already partial and never fully achieved—in the face of global corporatism. This does not mean that issues of national identity are meaningless; as Williams (2002: 2) has observed, the emergence of the neoliberal order and the profound social and economic transformations brought about 'does not signify the final demise of the nation but, rather, its profound and far-reaching re-definition and restructuration in the face of increasingly transnational realities'. The diffuse nature of power that traverses the boundaries of the nation, the increasing encroachment of global corporatism into the previously sovereign space of the nation state and the movement from the model of the modern nation state that ruled its sovereign territory to the late capitalist neoliberal state are all questions analyzed by the artists studied in this volume. Thus issues such as how, under the structures of neoliberalism, national sovereignty is being subjugated to the global capitalist system is a shared theme across several of the works analysed in this volume, whether this be the regimes of accumulation based on the transnational border economy as in the case of Fusco and Domínguez in Chapter 6, or in the incursion of corporate capital into the national terrain as in the case of Niño in Chapter 5.

Thus, in arguably all of the works studied in this volume, to a greater or lesser extent, the effects of late capitalism are played out and critiqued by the practitioners in their depiction of net localities; from the attempt to allow the viewer/user to glimpse beneath the spectacle of capitalism in Montevideo in Mackern's work, through the linking of earlier periods of oppression to the contemporary policies of neoliberalism in *W:MoR*, to Fusco and Domínguez's critique of the border zone as representative of the workings of global corporate capital, each of the works in this volume is informed by an attempt to resist the colonization of the locale by the logic of late capital.

That said, whilst the works in this volume often share concerns, the aesthetics and tactics of these varied artists cannot be reduced to one singular model and indeed, as has frequently been discussed by scholars in new media arts, there is no one singular aesthetic or practice that now defines the shape of net art. Instead, as I have attempted to demonstrate throughout the preceding chapters, the works analysed make use of a variety of different genres and generic conventions, as well as tactical re-uses of a variety of commercial platforms. Indeed, it is precisely in this variety of approaches, and in the knowing, tactical re-appropriation of digital tools and platforms that Latin(o) American net art finds its countercultural thrust. As the chapters in this volume have demonstrated, whilst shared tactics are notable across many of the works analyzed in this volume, significant differences are prominent when comparing aesthetics. One of the most obvious of these differences lies in features such as (narrative) structure, characterization (or lack of) and format, in which distinctions between high and low art come into play.

These differences are immediately obvious when comparing, for instance, the deliberately difficult, high-art aesthetics of Mackern's challenging, disorientating works in *34s56w.org* as analysed in Chapter 2, with, for instance, the deliberate aping of popular cultural forms in Miranda Zúñiga's *Vagamundo* as analyzed in Chapter 7. Mackern's rejection of any overt narrative progression, his use of post-digital sound in preference to explanatory voice-over, his employment of jump cuts, speeded-up footage and deliberately grainy images, all contrast to Miranda Zúñiga's adoption of a highly accessible format that follows a narrative-ludological progression, is based around a unified central character, and provides us with instructions as we enter each level of the work.

Yet, what is notable in the case of all the works analyzed in this volume is less a slavish adherence to a particular module of high or low art, but rather a creative borrowing, a cannibalistic approach to existing genres and, accompanying this, a creative mash-up of high and low art in most of the works studied in this volume. Thus, Ricardo Miranda Zúñiga does not adhere slavishly to the conventions of the computer game narrative in his *Vagamundo*, but intersperses the gaming scenes with links, statistics and sociopolitical commentary that jolt the reader out of any easy identification with the game world. Similarly, videos following classical Hollywood narrative format *sit alongside* photomontages employing jump cutting, discontinuity editing and dissonant sound in *Memoria histórica* as analyzed in Chapter 3 of this volume; this work as a whole is not characterized by one, single aesthetic but brings together a variety of formats that span high and low art. Or, to take another example, fluctuating images, flickering codes and non-linear structures abound in the *W:MoR* interface as analyzed in Chapter 4, along with lexia employing straightforward narrative progression; again, the creative force of this interface and the constituent works it houses lies more in its bringing together a variety of aesthetic formats rather than a slavish adherence to any one format. Even in those works analyzed in this volume whose aesthetics are the most challenging and would appear to be the most firmly situated within the realm of high art, such as Mackern's *34s56w.org*, popular cultural formats such as graffiti form an integral part of the work. The works analysed in this volume, thus, do not rely on one mode as privileged but, instead, employ a creative and tactical borrowing from multiple modes and genres. The work of Latin American net artists thus lies on a spectrum; there is no longer (if ever there was) a purely oppositional space, or one purely oppositional genre or mode in which net art can engage in resistant practice. Rather, it is the creative borrowing—the mash-ups and the re-mixings—that provide net art with its oppositional force, and ally it with movements such as that of tactical media, which envisions a partial, tactical borrowing of particular media formats in a temporarily resistant gesture.

These creative reworkings of genres, codes and forms are enacted, as this volume has shown, with particular attention to the politics and representations of place. Each of the works studied in the preceding chapters engage, in

their different ways, in a re-signification of offline place, making tactical use of the interplay between on- and offline in order to encourage rethinkings of offline place. In so doing, they engage with the issues of place, new spatialities and networked localities—some of the central questions regarding the internet today. These issues are contested, particularly regarding ownership of or control over the creation of localities and the generation of location-based data on the internet, and place becomes the central node in which struggles for control are enacted. Latin American net art, as I have argued throughout this volume, is involved intimately in the discussions and struggles over place that have been at the forefront of debates in internet studies in recent years. The reason for this is two-fold, relating, first, to place as it is conceived on online and, second, to the specifics of place in Latin America and to the struggles over the meaning of place in the region.

These locations, whose meaning, memory and memorialisation are still being fought over, formed the basis of this book and each of the works examined within it. Thus, the *Memoria histórica de la Alameda* project brought together internet-based and site-specific interventions to produce a resistant, historical memory of the Alameda and the iconic locations it houses, and so engage closely with Chile's ongoing memory struggles. *W:MoR*, both the interface itself and the constituent works it housed, engaged in memory preservation and linked memory to the recuperation and re-signification of physical place, whilst also demonstrating that memory is ongoing, marrying the memory of dictatorial violence with the recent memory of structural violence. Mackern's alternative cartographies of Montevideo, in their challenging, multisequential structure, encouraged us to look beneath the spectacle of the cityscape and to explore the hidden contradictions behind its principal buildings and monuments that would conventionally convey the discourse of Uruguayan modernity. Niño's *Demo Scape V 0.5* presented us with a sustained critical approach to existing representations of the Colombian terrain, and attempted, via a series of alternative mapping projects, to make visible the effects of that country's sustained conflicts and the transnational corporate interests encroaching on its terrain. Fusco and Domínguez's *Turista Fronterizo* constantly evoked the overdetermined trope of the border to highlight the practices of major multinationals operating in the region and to critique the structural inequalities of the logic of corporate capital. Miranda Zúñiga's *Vagamundo* mixed real experiences of immigrants on the streets, an online computer game, installation and pedestrian participation, as a form of (temporarily) claiming back public place, and of critiquing the US's Operation Gatekeeper and the presence of the Fourth World on the streets of the US.

In all of these instances, net localities come to the fore, and there is both a focus on the specifics of each particular locale, with, at the same time, shared place-based features coming to the fore, and shared imagery or tropes coming under focus. For instance, in the work of several practitioners, a critical re-examination of cartographies is enacted, such as in Mackern's inversion

of mapping norms in *34s56w.org*, *Memoria histórica de la Alamedas*'s jagged performance map, or Niño's skewed cartographical axes and hyperlinks in *Demo Scape V 0.5*. In other works, shared imagery can be seen in the images of iconic buildings and monuments, such as the Plaza de Mayo in *W:MoR*, or the Rambla, the Palacio Salvo, and the other buildings of Uruguay's modernity in Mackern's *34s56w.org*. In still others, it is the human figures and avatars associated with each location, such as in *Turista Fronterizo* and *Vagamundo*, that come to the fore. In all of these cases, the interrogation of the locale is, simultaneously, an interrogation of the regimes of power that control the meaning of that locale. It is thus the struggle over place—both online and offline—that characterizes the works studied in this volume. The control of net localities and the control of offline place come together in the practice of Latin(o) American net artists, as they engage with particular place-based concerns and attempt to create temporary, tactically resistant re-territorializations online.

References

Aarseth, Espen J. 1997. *Cybertext: Perspectives on Ergodic Literature* (Baltimore: Johns Hopkins University Press).

Acuña, Carlos. 2006. 'Regulación del desarrollo urbano y formas de producción de la ciudad. Caso Montevideo', in Lucía Álvarez, Carlos San Juan and Cristina Sánchez Mejorada, eds., *Democracia y exclusión: caminos encontrados en la Ciudad de México* (Mexico D.F.: Universidad Nacional Autónoma de Mexico), pp. 229–252.

Adamowicz, Elza. 1998. *Surrealist Collage in Text and Image: Dissecting the Exquisite Corpse* (Cambridge: CUP).

Agence France Press. 2002. 'Colombians Oppose US Request for Immunity From ICC', *Why-war.com*, August. http://why-war.com/news/2002/08/20/colombia. html. Accessed 6 June 2013.

Agricola de Cologne, Wilfried. 2002. *]and_scape[*, www.nmartproject.net/agricola/ mpc/volume3/and_scapes_x.html. Accessed 28 June 2013.

———. 2003-. *[R][R][F]* (Remembering-Repressing-Forgetting), http://rrf200x.new mediafest.org/blog/. Accessed 28 June 2013.

Agricola de Cologne, Wilfried, in collaboration with Raquel Partnoy, 2003. *Women: Memory of Repression in Argentina*, http://argentina.engad.org/tango1.html. Accessed 1 February 2013.

Aínsa, Fernando. 2005. 'Una "jirafa de cemento armado" a orillas del "río como mar": la invención literaria de Montevideo' in Teresa Orecchia Havas, ed., *Memoria(s) de la ciudad en el mundo hispánico y luso-brasilero* (Berlin: Peter Lang), pp. 3–31.

Alba, Richard. 2006. 'Mexican Americans and the American Dream', *Perspectives on Politics*, 4:1, 289–296.

Aldama, Arturo J. 2002. 'Millennial Anxieties: Borders, Violence, and the Struggle for Chicana and Chicano Subjectivity' in Arturo J. Aldama and Naomi H. Quiñones, eds., *Decolonial Voices: Chicana and Chicano Cultural Studies in the 21st Century* (Bloomington: Indiana University Press), pp. 11–29.

Aldama, Arturo J. and Naomi H. Quiñones. 2002. '¡Peligro! Subversive Subjects: Chicana and Chicano Cultural Studies in the 21st Century' in Arturo J. Aldama and Naomi H. Quiñones, eds., *Decolonial Voices: Chicana and Chicano Cultural Studies in the 21st Century* (Bloomington: Indiana University Press), pp. 1–7.

Alurista, 1991. 'Myth, Identity and Struggle in Three Chicano Novels: Aztlán. . . Anaya, Méndez and Acosta', in Rudolfo A. Anaya and Francisco Lomeli, eds. *Aztlán: Essays on the Chicano Homeland* (Albuquerque: University of New Mexico Press), pp. 219–229.

Álvarez, Luciano and Christa Huber. 2004. *Montevideo imaginado* (Bogotá: Convenio Andrés Bello).

Anderlini-D'Onofrio, Serena. 2004. 'The Gaia Hypothesis and Ecofeminism: Culture, Reason, and Symbiosis', *DisClosure*, 13, 65–94.

Antelo, Raúl. 1992. 'Veredas de enfrente: martinfierrismo, ultraísmo, modernismo', *Revista Iberoamericana*, 160–161, 853–876.

Anzaldúa, Gloria. 1987. *Borderlands/La frontera: The New Mestiza* (San Francisco: Aunt Lute Books).

Aristotle. 1996. *The Politics and the Constitution of Athens* (Cambridge: CUP)

Ash, James and Lesley Anne Gallacher. 2011. 'Cultural Geography and Videogames', *Geography Compass*, 5–6, 351–368.

Asociación Madres de Plaza de Mayo. 2005. *Memoria fértil: la dictadura, la impunidad y la compleja trama de complicidades 1976–2005* (Buenos Aires: Asociación Madres de Plaza de Mayo)

Astrada, Etelvina, ed. 1978. *Poesía política y combativa argentina* (Guernica: Zero).

———. 1980. *Autobiografía con gatillo* (Madrid: Ayuso).

———. 1981. *Muerte arrebatada* (Barcelona: Ambito Literario).

Atencio Abarca, Ivan, David Boardman, Pablo Cottet, Diego Mometti, Enrique Morales, Barbara Palomino and Melissa Trojani. 2005. *Memoria histórica de la Alameda*, http://memorialameda.tinktank.it/. Accessed 25 May 2013.

Aysa-Lastra, María. 2011. 'Integration of Internally Displaced Persons in Urban Labour Markets: A Case Study of the IDP Population in Soacha, Colombia', *Journal of Refugee Studies*, 24: 2, 277–303.

Azcona, Emilio Luque. 2004. 'Los imaginarios de Montevideo a través de sus tarjetas postales (1890–1930)', *Contrastes: Revista de Historia*, 13, 57–75.

Bacon, David. 2001. 'Health, Safety, and Workers' Rights in the Maquiladoras', *Journal of Public Health Policy*, 22:3, 338–348.

———. 2004. *The Children of NAFTA: Labor Wars on the U.S.-Mexico Border* (Berkeley: University of California Press).

Balsamo, Anne. 1996. *Technologies of the Gendered Body: Reading Cyborg Women* (Durham: Duke University Press, 1996).

Bandy, Joe. 2000. 'Bordering the Future: Resisting Neoliberalism in the Borderlands', *Critical Sociology*, 26:3, 232–267.

Barlow, John Perry (1996), 'A Declaration of the Independence of Cyberspace', https://projects.eff.org/~barlow/Declaration-Final.html. Accessed 1 August 2010.

Barnard, Adam. 2004. 'The Legacy of the Situationist International: The Production of Situations of Creative Resistance', *Capital and Class*, 28, 103–124.

Bell, David. 2001. *An Introduction to Cybercultures* (London: Routledge).

Benítez, José Luis. 2006. 'Transnational Dimensions of the Digital Divide Among Salvadoran Immigrants in the Washington DC Metropolitan Area', *Global Networks*, 6:2, 181–199.

Bhimji, Fazila. 2010. 'Struggles, Urban Citizenship, and Belonging: The Experience of Undocumented Street Vendors and Food Truck Owners in Los Angeles', *Urban Anthropology*, 39:4, 455–492.

Boardman, David. 2007. 'Hacking in Santiago', in Troyano, ed., *Instalando: Arte y Cultural Digital* (Santiago: Ediciones Lom), pp. 164–165.

Bollier, David. 2003. *Silent Theft: The Private Plunder of our Common Wealth* (New York: Routledge).

Bolter, Jay David. 2001. *Writing Space: Computers, Hypertext, and the Remediation of Print* (New York: Routledge), 2nd edition.

Bordwell, David and Kristin Thompson. 2010. *Film Art: An Introduction* (New York: McGraw-Hill).

Bosco, Fernando J. 2004. 'Human Rights Politics and Scaled Performances of Memory: Conflicts among the *Madres de Plaza de Mayo* in Argentina', *Social & Cultural Geography*, 5:3, 381–402.

Bosma, Josephine. 2011. *Nettitudes: Let's Talk Net Art* (Amsterdam: NAi Publishers).

Bott, Kelah. 2006. 'Aquí se mató, aquí se torturó: Chile Struggles to Shed its Painful Past', *Fault Lines: Newspaper of the SF Bay Area Independent Media Center,* 2:3, 1.

Boyd, Carolyn P. 2008. 'The Politics of History and Memory in Democratic Spain', *The Annals of the American Academy of Political and Social Science*, 617, 133–148.

Brand, Jeffrey E. and Scott J. Knight. 2005. 'The Narrative and Ludic Nexus in Computer Games: Diverse Worlds II', *Proceedings of DiGRA 2005 Conference: Changing Views – Worlds in Play*, www.digra.org/dl/db/06278.57359.pdf. Accessed 7 January 2011.

Bresnahan, Rosalind. 2002. 'Radio and the Democratic Movement in Chile 1973–1990: Independent and Grass Roots Voices', *Journal of Radio Studies*, 9:1, 161–181.

Breton, André. 1975. *Le Cadavre exquis: son exaltation* (Milan: Galleria Schwarz).

Bricklin, Dan. 2001. 'The Cornucopia of the Commons' in Andy Oram, ed., *Peer-to-Peer: Harnessing the Power of Disruptive Technologies* (Sebastopol, CA: O'Reilly), pp. 59–63.

Broder, David S. 2002. 'Europe's Fury', *The Washington Post*, March 27.

Brysk, Alison. 1994. 'The Politics of Measurement: The Contested Count of the Disappeared in Argentina', *Human Rights Quarterly*, 16:4, 676–692.

Capling, Ann and Kim Richard Nossal. 2001. 'Death of Distance or Tyranny of Distance? The Internet, Deterritorialization, and the Anti-globalization Movement in Australia', *The Pacific Review*, 14:3 443–465.

Cárdenas, Micha, Amy Sara Carroll, Ricardo Domínguez and Brett Stalbaum. 2009. 'The Transborder Immigrant Tool: Violence, Solidarity and Hope in Post-NAFTA Circuits of Bodies Electr(on)/ic', *Proceedings of the MobileHCI Conference 2009*, www.uni-siegen.de/locatingmedia/workshops/mobilehci/cardenas_the_transborder_immigrant_tool.pdf. Accessed 18 February 2011.

Carrillo, Angela Consuelo. 2009. 'Internal Displacement in Colombia: Humanitarian, Economic and Social Consequences in Urban Settings and Current Challenges', *International Review of the Red Cross*, 91, 527–546.

Carroll, Amy. 2003. 'Incumbent upon Recombinant Hope: EDT's Strike a Site, Strike a Pose', *The Drama Review*, 47:2, 145–150.

Carruthers, David. 2008. 'Where Local Meets Global: Environmental Justice on the US-Mexico Border', in David Carruthers, ed., *Environmental Justice in Latin America: Problems, Promise and Practices* (Cambridge, MA: MIT Press), pp. 137–160.

Cass, Valerie J. 1996. 'Toxic Tragedy: Illegal Hazardous Waste Dumping in Mexico', in Sally M. Edwards, Terry D. Edwards and Charles B. Fields, eds., *Environmental Crime and Criminality: Theoretical and Practical Issues* (New York: Garland), pp. 99–120.

Castells, Manuel. 2010a. *The Rise of the Network Society* (Oxford: Blackwell), 2nd edition.

———. 2010b. *End of Millennium* (Oxford: Blackwell), 2nd edition.

CDF. 2012. 'Construcción de la rambla Sur y su incidencia en la ciudad', *Centro de Fotografía de Montevideo*, http://cdf.montevideo.gub.uy/system/files/descargas-exposiciones/rambla-prado.pdf. Accessed 8 November 2012.

Chiaravutthi, Yingyot. 2006. 'Firms' Strategies and Network Externalities: Empirical Evidence from the Browser War', *Journal of High Technology Management Research*, 17, 27–42.

Coleman, Sarah, and Nick Dyer-Witheford. 2007. 'Playing on the Digital Commons: Collectives, Capital and Contestation in Videogame Culture', *Media Culture Society*, 29:6, 934–953.

Colombia Journal. www.colombiajournal.org. Accessed 20 July 2012.

Comisión Nacional de Verdad y Reconciliación. 1991. *Informe de la Comisión Nacional de Verdad y Reconciliación* (Santiago de Chile: Secretaría de Comunicación y Cultura, Ministerio Secretaría General de Gobierno).

Comisión Nacional sobre la Desaparición de Personas. 1984. *Nunca más: informe de la comisión nacional sobre la desparición de personas* (Buenos Aires: Editorial Universitaria de Buenos Aires).

Comisión Nacional sobre Prisión Política y Tortura. 2005. *Informe de la Comisión Nacional sobre Prisión Política y Tortura, y respuestas institucionales.* (Santiago de Chile: Centro de Estudios Públicos).

Cooey, Paula M. 1994. *Religious Imagination and the Body: A Feminist Analysis* (Oxford: Oxford University Press).

Cooney, Paul. 2001. 'The Mexican Crisis and the Maquiladora Boom: A Paradox of Development or the Logic of Neoliberalism?', *Latin American Perspectives*, 28:3, 55–83.

Corby, Tom, ed. 2006. *Network Art: Practices and Positions* (London: Routledge).

Coremberg, Irene. 2003. *Túneles de la memoria - Memory Tunnels*, www.irenka.com.ar/memory_tunnels.htm. Accessed 6 December 2012.

Cornelius, Wayne A. 2001. 'Death at the Border: Efficacy and Unintended Consequences of US Immigration Control Policy', *Population and Development Review*, 27:4, 661–685.

Corporación Pro-Memorial Jaime Guzmán. n.d. 'Objetivos', www.memorialjaimeguzman.cl. Accessed 26 September 2012.

Cosic, Vuk. 1999. '3D ASCII: An Autobiography', *Circa*, 90, S20–21.

Council on Foreign Relations. 2000. 'Latin America: Sustaining Economic & Political Reform. A Working Conference on the Underlying Realities. Colombia—A New Vietnam?', *Council on Foreign Relations*, www.cfr.org/latinamerica/reports/colombia.html. Accessed 27 March 2012.

Crogan, Patrick. 2007, 'Playing Through: the Future of Alternative and Critical Game Projects', in Suzanne de Castell and Jennifer Jenson, eds., *Worlds in Play: International Perspectives on Computer Games Research* (New York: Peter Lang), pp. 87–100.

da Cunha, Nelly. 2002. 'Gestión municipal y tiempo libre en Montevideo (1900–1940)', in Elisa Pastoriza, ed. *Las puertas al mar: consumo, ocio y política en Mar del Plata, Montevideo y Viña del Mar* (Buenos Aires: Biblos), pp. 117–132.

———. 2010. *Montevideo, ciudad balnearia (1900–1950): el municipio y el fomento del turismo* (Montevideo: Universidad de la República).

Dahlberg, Lincoln. 2005. 'The Corporate Takeover of the Online Public Sphere: A Critical Examination, with Reference to "the New Zealand Case"', *Pacific Journalism Review*, 11:1, 90–112.

Da Silva Iddings, Ana Christina, Steven G. McCafferty and Maria Lucia Teixeira da Silva. 2011. '*Conscientização* Through Graffiti Literacies in the Streets of a São Paulo Neighborhood: An Ecosocial Semiotic Perspective', *Reading Research Quarterly*, 46:1, 5–21.

Davis, Mike. 2001. *Magical Urbanism: Latinos Reinvent the U.S. City* (London: Verso, 2001).

Davis, Mike and Justin Akers Chacón. 2006. *No One Is Illegal: Fighting Racism and State Violence on the U.S.-Mexico Border* (Chicago: Haymarket Books).

Debord, Guy. 1994. *The Society of the Spectacle*, trans. Donald Nicholson-Smith (New York: Zone Books).

———. 1995. 'Introduction to a Critique of Urban Geography' in Ken Knabb, ed., *Situationist International Anthology* (Berkeley: Bureau of Public Secrets), pp. 5–8. First published 1955.

De Brun, Julio and Gerardo Licandro. 2005. 'To Hell and Back. Crisis Management in a Dollarized Economy: The Case of Uruguay', *Documento de trabajo, 004–2005* (Banco de Uruguay).

Detwiler, Louise A. 2000. 'The Blindfolded (Eye)Witness in Alicia Partnoy's *The Little School*', *Journal of the Midwest Modern Language Association*, 33:3, 60–72.

Dion, Michelle L. and Catherine Russler. 2008. 'Eradication Efforts, the State, Displacement and Poverty: Explaining Coca Cultivation in Colombia During Plan Colombia', *Journal of Latin American Studies*, 40, 399–421.

Dittmar, Linda and Joseph Entin. 2010. 'Introduction: Jamming the Works. Art, Politics and Activism', *Radical Teacher*, 89, 3–9.

Dodge, Martin and Robbin Kitchin. 2001. *Mapping Cyberspace* (London: Routledge).

Domínguez, Ricardo. 2008. 'Electronic Civil Disobedience Post-9/11: Forget Cyber-Terrorism and Swarm the Future Now!', *Third Text*, 22:5, 661–670.

Donahue, Thomas J. 2010. 'Anthropocentrism and the Argument from Gaia Theory', *Ethics and the Environment*, 15:2, 51–78.

Douglas, Jane Yellowlees. 2001. *The End of Books – or Books without End? Reading Interactive Narratives* (Ann Arbor: University of Michigan Press).

Drainville, André C. 2008. 'Present in the World Economy: The Coalition of Immokalee Workers (1996–2007)', *Globalizations*, 5:3, 357–377.

Dyer-Witheford, Nick and Greig de Peuter. 2009. *Games of Empire: Global Capitalism and Video Games* (Minneapolis: University of Minnesota Press).

EAAF. 2005. *EAAF Annual Report 2005*, http://eaaf.typepad.com/cr_argentina/. Accessed 16 April 2013.

Egaña, Sofía, Silvana Turner, Merdedes Doretti, Patricia Bernardini and Anahí Ginarte. 2008. 'Conmingled Remains and Human Rights Investigations', in Bradley J. Adams and John E. Bird, *Recovery, Analysis and Identification of Conmingled Human Remains* (Totowa: Humana), pp. 57–80.

Elhawary, Samir. 2010. 'Security for Whom? Stabilisation and Civilian Protection in Colombia', *Disasters*, 34:3, 388–405.

Ensalaco, Mark. 1994. 'In with the New, Out with the Old? The Democratising Impact of Constitutional Reform', *Journal of Latin American Studies*, 26:2, 409–429.

———. 2000. *Chile under Pinochet: Recovering the Truth* (Philadelphia: University of Pennsylvania Press).

Erler, Carolyn. 2008. 'Targeting "Plan Colombia": A Critical Analysis of Ideological and Political Visual Narratives by the Beehive Collective and the Drug Enforcement Administration Museum', *Studies in Art Education*, 50:1, 83–97.

Escobar, Arturo. 1999. 'Gender, Place and Networks: A Political Ecology of Cyberculture', in Wendy Harcourt, ed., *Women@Internet: Creating New Cultures in Cyberspace* (London: Zed Books), pp. 31–54.

Estrades, Carmen and María Inés Terra. 2011. 'Fighting Informality in Segmented Labor Markets: A General Equilibrium Analysis Applied to Uruguay', *Latin American Journal of Economics*, 48:1, 1–37.

Fallon, Paul. 2007. 'Negotiating a (Border Literary) Community Online *en la línea*' in Claire Taylor and Thea Pitman, eds., *Latin American Cyberculture and Cyberliterature* (Liverpool: Liverpool University Press), pp. 161–175.

Fernández Retamar, Roberto. 1989. '*Caliban' and Other Essays*), trans. Edward Baker (Minneapolis: University of Minnesota Press).

Finn, Mark. 2000. 'Computer Games and Narrative Progression', *M/C: A Journal of Media and Culture* 3:5, www.api-network.com/mc/0010/narrative.php. Accessed 10 January 2011.

Foner, Nancy, ed. 2001. *New Immigrants in New York* (New York: Columbia University Press).

Frommherz, Gudrun. 2013. 'Memetics of Transhumanist Imagery', *Visual Anthropology*, 26:2, 147–164.

Fuchs, Christian. 2008. *Internet and Society: Social Theory in the Information Age* (New York: Routledge).

182 References

———. 2012. 'The Political Economy of Privacy on Facebook', *Television & New Media*, 13:2, 139–159.

Fundación Violeta Parra. 2008. 'Cancionero de Violeta Parra', www.violetaparra.cl/. Accessed 2 October 2012.

Fusco, Coco. 1995. *English is Broken Here: Notes on Cultural Fusions in the Americas* (New York: New Press)

———. 2002. *The Bodies That Were Not Ours, and Other Writings* (New York: Routledge).

———. 2003. 'On-Line Simulations/ Real-Life Politics: A Discussion with Ricardo Domínguez on Staging Virtual Theatre', *The Drama Review*, 47:2, 151–162.

Fusco, Coco and Ricardo Domínguez. 2005. *Turista Fronterizo*, www.thing. net/~cocofusco/StartPage.html. Accessed 21 November 2011.

———. 2006. '*Turista Fronterizo*: Proposal Text', https://wiki.brown.edu/conflu ence/display/MarkTribe/Turista+Fronterizo. Accessed 21 November 2011.

Gache, Belén. 2006. *Escrituras nómades* (Gijón: Trea).

Galeano, Eduardo. 2003. *Football in Sun and Shadow: An Emotional History of World Cup Football* (London: Harper Collins), trans. Mark Fried.

Garcé, Adolfo. 2011. 'Ideologías políticas y adaptación partidaria: el caso de MLN-Tupamaros (1985–2009)', *Revista de Ciencia Política*, 31:1, 117–137.

García, Mario T. 1985. 'La Frontera: The Border as Symbol and Reality in Mexican-American Thought', *Mexican Studies/Estudios Mexicanos*, 1:2, 195–225.

García-Canclini, Néstor. 1989. *Culturas híbridas: estrategias para entrar y salir de la modernidad* (Mexico City: Grijalbo).

Gaspar de Alba, Alicia, ed. 2003. *Velvet Barrios: Popular Culture and Chicana/o Sexualities* (New York: Palgrave Macmillan).

Gere, Charlie. 2006. 'The History of Network Art' in Corby, Tom, ed., *Network Art: Practices and Positions* (London: Routledge), pp. 11–23.

Geronimus, Arline T. et al. 2006. 'Urban-Rural Differences in Excess Mortality among High-Poverty Populations: Evidence from the Harlem Household Survey and the Pitt County, North Carolina Study of African American Health', *Journal of Health Care for the Poor and Underserved*, 17:3, 532–558.

Giddens, Anthony. 1990. *The Consequences of Modernity* (Cambridge: Polity)

Goldblatt, David. 2007. *The Ball Is Round: A Global History of Football* (London: Penguin).

Goldstein, Evan R. 2010. 'Digitally Incorrect', *Chronicle of Higher Education*, 57: 7, 6–9.

Gómez-Peña, Guillermo. 2002. 'The Border Is . . . A Manifesto', in Gilbert M. Joseph and Timothy J. Henderson, eds., *The Mexico Reader: Culture, History, Politics* (Durham: Duke UP), pp. 754–755.

Gordon, Eric and Adriana de Souza e Silva. 2011. *Net Locality: Why Location Matters in a Networked World* (Chichester: Wiley-Blackwell).

Gould, Stephen Jay. 1989. *Wonderful Life: The Burgess Shale and the Nature of History* (London: Hutchinson Radius).

Gray, Jonathan. 2010. *Show Sold Separately: Promos, Spoilers and other Media Paratexts* (New York: NYU Press).

Guzmán, Patricio. 1975. Dir. *La batalla de Chile: la insurrección de la burguesía.*

———. 1976. Dir. *La batalla de Chile: el golpe de estado*

———. 1978. Dir. *La batalla de Chile: el poder popular.*

———. 1996. Dir. *La memoria obstinada.*

Guzmán Bouvard, Marguerite. 1994. *Revolutionizing Motherhood: The Mothers of the Plaza de Mayo* (Wilmington: Scholarly Resources).

Hancox, Simone. 2012. 'Contemporary Walking Practices and the Situationist International: The Politics of Perambulating the Boundaries Between Art and Life', *Contemporary Theatre Review*, 22:2, 237–250.

Harvey, David. 1989. *The Condition of Postmodernity: An Enquiry into the Origins of Cultural Change* (Oxford: Blackwell)

Hauben, Michael and Ronda Hauben. 1997. *Netizens: On the History and Impact of Usenet and the Internet* (Los Alamitos, CF: IEEE Computer Society Press).

Herschberger, Andrew E. 2006. 'Bordering on Cultural Vision(s): Jay Dusard's Collaboration with the Border Art Workshop/Taller de Arte Fronterizo', *Art Journal*, 65:1, 83–93.

Hinkes, Madeleine. J. 2008. 'Migrant Deaths Along the California–Mexico Border: An Anthropological Perspective', *Journal of Forensic Sciences*, 53: 16–20.

Hite, Katherine and Cath Collins. 2009. 'Memorial Fragments, Monumental Silences and Reawakenings in 21st-Century Chile', *Millennium: Journal of International Studies*, 38:2, 379–400.

Holmes, Tiffany. 2003. 'Arcade Classics Spawn Art? Current Trends in the Art Game Genre', *Proceedings of the 5th International Digital Arts and Culture Conference* (Melbourne: RMIT University), pp. 46–52.

Holmes, Tori. 2012. 'The Travelling Texts of Local Content: Following Content Creation, Communication and Dissemination via Internet Platforms in a Brazilian favela', *Hispanic Issues Online*, 9, 263–288.

Huneeus, Carlos. 2007. *The Pinochet Regime* (Boulder: Lynne Rienner Publishers).

Ibañez, Ana María and Andrés Moya. 2009. 'Vulnerability of Victims of Civil Conflicts: Empirical Evidence from the Displaced Population in Colombia', *World Development*, 38:4, 647–63.

Jahn-Sudmann, Andreas. 2008. 'Innovation NOT Opposition the Logic of Distinction of Independent Games', *Eludamos: Journal for Computer Game Culture*, 2, 5–10.

JODI. 1997. *Digital Rain*, www.jodi.org/beta/rain/digi.html. Accessed 1 July 2011.

Kane, Stephanie. 2009. 'Stencil Graffiti in Urban Waterscapes of Buenos Aires and Rosario, Argentina', *Crime, Media, Culture*, 5:9, 9–28.

Keefe, Susan E., and Amado M. Padilla. 1987. *Chicano Ethnicity* (Albuquerque: University of New Mexico Press).

Klein, Jennie. 2007. 'Performance, Post-Border Art, and Urban Geography', *PAJ: A Journal of Performance and Art*, 29:2, 31–39.

Kline, Stephen, Nick Dyer-Witheford and Greig de Peuter. 2003. *Digital Play: The Interaction of Technology, Culture, and Marketing* (Montreal: McGill-Queen's University Press).

Kopinak, Kathryn. 2002. 'Environmental Implications of New Mexican Industrial Investment: The Rise of Asian Origin Maquiladoras as Generators of Hazardous Waste', *Asian Journal of Latin American Studies*, 15:1, 91–120.

Kornbluh, Peter. 2003. *The Pinochet File: A Declassified Dossier on Atrocity and Accountability* (New York: The New Press).

Kücklich, Julian. 2003. 'Perspectives of Computer Game Philology', *Game Studies: The International Journal of Computer Game Research*, 3–1, www.gamestudies. org/0301/kucklich/. Accessed 7 January 2011.

Lagos, Ricardo. 1999. 'Chile limita al centro de la injusticia', *Archivo Chile*. www.archi vochile.com/Gobiernos/gob_rlagos/de/GOBdelagos0001.pdf. Accessed 2 October 2012.

Landow, George P. 1997. *Hypertext 2.0: The Convergence of Contemporary Critical Theory and Technology* (Baltimore: Johns Hopkins University Press), 2nd ed.

Larrain, Jorge. 2006. 'Changes in Chilean Identity: Thirty Years after the Military Coup', *Nations and Nationalism*, 12:2, 321–338.

Lefebvre, Henri. 1991. *The Production of Space* (Blackwell: Oxford).

Lemebel, Pedro. 1998. *De perlas y cicatrices* (Santiago: LOM).

Li, He. 2000. 'Political Economy of Income Distribution: A Comparative Study of Taiwan and Mexico', *Policy Studies Journal*, 28:2, 275–291.

Liu, Alan. 2004. *The Laws of Cool: Knowledge Work and the Culture of Information* (Chicago: University of Chicago Press).

Livingston, Gretchen, and Joan R. Kahn. 2002. 'An American Dream Unfulfilled: The Limited Mobility of Mexican Americans', *Social Science Quarterly*, 83:4, 1002–1012.

Loader, Brian D. 1997. 'The Governance of Cyberspace: Politics, Technology and Global Restructuring' in Brian D. Loader, ed., *The Governance of Cyberspace: Politics, Technology and Global Restructuring* (London: Routledge), pp. 1–19.

Lovink, Geert. 2002. *Dark Fiber: Tracking Internet Culture* (Cambridge: MIT Press).

Lugo, Alejandro. 2008. *Fragmented Lives, Assembled Parts* (Austin: University of Texas Press).

Mackern, Brian. 2000. *JODI/web_o_matic [n]coder*, www.internet.com.uy/vibri/jwom/indexo.htm#. Accessed 7 November 2012.

———. 2005. *34s56w.org*, http://34s56w.org/. Accessed 7 November 2012.

———. 2006. 'Soundtoys/Interfaces sonorovisuales', http://34s56w.org/soundtoys2006/txt.htm. Accessed 7 November 2012.

———. n.d. *Cort_azar*, www.internet.com.uy/vibri/artefactos/cortazar/cortazar.htm. Accessed 7 November 2012.

Martín Barbero, Jesús. 1989. *De los medios a las mediaciones: comunicación, cultura y hegemonía* (Bogotá: Convenio Andrés Bello).

Mato, Daniel. 2002. 'Latin American Intellectual Practices in Culture and Power: Experiences and Debates', *Cultural Studies*, 17:6, 783–804.

McConnell, Eileen Diaz and Enrico A. Marcelli. 2007. 'Buying into the American Dream? Mexican Immigrants, Legal Status, and Homeownership in Los Angeles County', *Social Science Quarterly*, 88:1, 199–221.

McCord, C. and Freeman, H. P. 1990. 'Excess Mortality in Harlem', *New England Journal of Medicine*, 322:2, 173–177.

McLuhan, Marshall. 2001. *Understanding Media: The Extensions of Man* (London, Routledge). First published 1964.

McMahon, Robert J. 1985. 'A Question of Influence: the Council on Foreign Relations and American Foreign Policy. Review of *The Wise Men of Foreign Affairs: The History of the Council on Foreign Relations* by Robert D. Schulzinger', *Reviews in American History*, 13:3, 445–450.

Meade, Teresa. 2001. 'Holding the Junta Accountable: Chile's "Sitios de Memoria" and the History of Torture, Disappearance, and Death', *Radical History Review*, 79, 123–139.

Medina-Sancho, Gloria. 2013. 'Spaces Recovered by Memory: Film Language and Testimony in Parot's *Estadio Nacional*', *Latin American Perspectives*, 40:1, 161–169.

Memefest. n.d. *Memefest: Festival of Socially Responsive Communication and Art*, www.memefest.org. Accessed 10 July 2012.

Meneses, Guillermo Alonso. 2003. 'Human Rights and Undocumented Migration along the Mexican-U.S. Border', *UCLA Law Review*, 51:1, 267–283.

Milberry, Kate and Steve Anderson. 2009. 'Open Sourcing Our Way to an Online Commons: Contesting Corporate Impermeability in the New Media Ecology', *Journal of Communication Inquiry*, 33:4, 393–412.

Miranda Zúñiga, Ricardo. 2002. *Vagamundo: A Migrant's Tale*, www.ambriente.com/cart/about.html. Accessed 3 October 2011.

———. 2003. *NEXUM ATM*, www.ambriente.com/nexum/. Accessed: 3 October 2011.

———. 2005. *Dentimundo*, www.dentimundo.com. Accessed 3 October 2011.

———. 2007. *Carreta Nagua, siglo 21*. http://ambriente.com/carreta_nagua/. Accessed: 3 October 2011.

———. 2007–2008. *Votemos.us ¡México decide!*, http://votemos.us/. Accessed: 3 October 2011.

————. 2010. *Milagro de Chile*, http://miracleofchile.com/es/. Accessed: 3 October 2011.

————. n.d. 'Brief Artist Statement', www.ambriente.com/about.html. Accessed: 3 October 2011.

Mize, Ronald and Alicia Swords. 2011. *Consuming Mexican Labor: From the Bracero Programme to NAFTA* (Ontario: University of Toronto Press).

Moates, Shiloh A. 2010. 'Clasificadores: "Living Off the Trash" and Raising Hogs at the Urban Margin', *Culture and Agriculture*, 32:2, 50–60.

Montgomery, Anne. 2001. 'Globalization and "Free" Trade in Colombia', *Colombia Journal Online*. www.colombiajournal.org/globalization_colombia.htm. Accessed 10 December 2008.

Moreano Urigüen, Hernán. 2006. 'Las implicaciones del conflicto interno colombiano para las fronteras de Ecuador, Perú, Brasil y Venezuela, 2000–2005', *Iconos: Revista de Ciencias Sociales*, 24, 161–170.

Morrison, Aimée Hope. 2009. 'An Impossible Future: John Perry Barlow's "Declaration of the Independence of Cyberspace"', *New Media & Society*, 11:1–2, 53–71.

Muggah, H. C. R. 2000. 'Conflict-Induced Displacement and Involuntary Resettlement in Colombia: Putting Cernea's IRLR Model to the Test', *Disasters*, 24:3, 198–216.

Müller, Stefan. 2010. 'Equal Representation of Time and Space: Arno Peters' Universal History', *History Compass*, 8:7, 718–729.

Muñoz, José Esteban. 2008. 'Introduction. A Room of One's Own: Women and Power in the New America', *The Drama Review*, 52:1, 137–139.

Neruda, Pablo. 1924 [1980]. *Veinte poemas de amor un una canción desesperada* (Barcelona: Lumen).

Netzfunk. 2010. www.netzfunk.org. Accessed 20 January 2011.

Nevins, Joseph. 2003. 'Thinking Out of Bounds: A Critical Analysis of Academic and Human Rights Writings on Migrant Deaths in the U.S.-Mexico Border Region', *Migraciones Internacionales*, 2:2, 171–190.

Newman, Katherine S. 1996. 'Working Poor: Low-Wage Employment in the Lives of Harlem Youth', in Julia A. Graber, Jeanne Brooks-Gunn and Anne C. Peterson, eds., *Transitions through Adolescence: Interpersonal Domains and Context* (New York: Lawrence Erlbaum), pp. 323–344.

Niño, Martha Patricia. 2003. *Recorridos del Cartucho*, www.martha-patricia.net. Accessed 23 April 2012.

————. 2004. *Demo Scape v 05*, www.martha-patricia.net/ds/about-e/about.html. Accessed 4 July 2012.

————. 2007. *Relational Border Map*, www.martha-patricia.net/relational-border-map.html. Accessed 27 March 2012.

Nora, Pierre. 1989. 'Between Memory and History: *Les lieux de mémoire*', *Representations*, 26, 7–24.

O'Keeffe, Moira. 2009. 'Evidence and Absence: Documenting the *Desaparecidos* of Argentina', *Communication, Culture and Critique*, 2:4, 520–537.

Olson, Kathleen K. 2005. 'Cyberspace as Place and the Limits of Metaphor', *Convergence: The International Journal of Research into New Media Technologies*, 11:1, 10–18.

Orbanes, Philip E. 2006. *Monopoly: The World's Most Famous Game – and How it Got that Way* (Philadelphia: Perseus).

Palomino, Bárbara. 2007. 'Backpacking . . .', in Troyano, ed., *Instalando: Arte y Cultural Digital* (Santiago: Ediciones Lom), pp. 168–169.

Panizza, Francisco. 1997. 'Late Institutionalisation and Early Modernisation: The Emergence of Uruguay's Liberal Democratic Political Order', *Journal of Latin American Studies*, 29:3, 667–691.

Parot, Carmen Luz, Dir. 2001. *Estadio Nacional*.

Partnoy, Alicia, ed. 1986. *The Little School: Tales of Disappearance and Survival in Argentina*, trans. Alicia Partnoy with Lois Athey and Sandra Braunstein; illustrated by Raquel Partnoy (Pittsburgh: Cleis Press).

———. 1989. *You Can't Drown the Fire: Latin American Women Writing in Exile* (Virago: London).

———. 1992. *La venganza de la manzana/The Revenge of the Apple*, trans. Richard Schaaf, Regina Kreger and Alicia Partnoy (Pittsburgh: Cleis Press).

Partnoy, Raquel. 2005a. 'Surviving Genocide' in Kristin Ruggiero, ed., *The Jewish Diaspora in Latin America and the Caribbean: Fragments of Memory* (Brighton: Sussex Academic Press), pp. 209–233.

———. 2005b. 'The Silent Witness' in Jennifer Browdy de Hernández, ed., *Women Writing Resistance: Essays on Latin America and the Caribbean* (Cambridge, MA: South End Press), pp. 28–39.

Partnoy, Salomón. 2002. 'Disasters of Neoliberalism', *Covert Action Quarterly*, 72:1, 29–34.

Payne, Leigh A., 2008. *Unsettling Accounts: Neither Truth nor Reconciliation in Confessions of State Violence* (Durham: Duke UP).

Pellegrino, Adela, and Andrea Vigorito. 2005. 'Emigration and Economic Crisis: Recent Evidence from Uruguay', *Migraciones Internacionales*, 3:1, 57–81.

Pilcher, Jeffrey M., 2001. *Cantinflas and the Chaos of Mexican Modernity* (Wilmington: Scholarly Resources).

Pile, Steve. 1996. *The Body and the City: Psychoanalysis, Space and Subjectivity* (London: Routledge).

Plan espiritual de Aztlán, El. 1989. In Rudolfo A. Anaya and Francisco Lomeli, eds., *Aztlán: Essays on the Chicano Homeland* (Albuquerque: University of New Mexico Press), pp.1–5.

Plant, Sadie. 1992. *The Most Radical Gesture: The Situationist International in the Postmodern Age* (London: Routledge).

Presutto, Stefania. 2008. 'Los jueves en Londres 38', in Marco Coscione, ed., *Microhistorias: Santiago de Chile, una mirada particular*, pp. 113–114. Available at www.altramerica.info/libros.html.

Raley, Rita. 2009. *Tactical Media* (Minneapolis: University of Minnesota Press).

Read, Peter and Marivic Wyndham. 2008. 'Putting Site Back into Trauma Studies: a Study of Five Detention and Torture Centres in Santiago, Chile', *Life Writing*, 5:1, 79–96.

Remedi, Gustavo A. 2005. 'The Beach Front (la Rambla): Reality, Promise and Illusion of Democracy in Today's Montevideo', *Journal of Latin American Cultural Studies*, 14:2, 131–159.

Renfrew, Daniel. 2004. 'Punta del Este as Global City? Competing Visions of Uruguayan Nationhood in a Geography of Exclusion', *City and Society*, 16:2, 11–33.

Rheingold, Howard. 2000. *The Virtual Community: Homesteading on the Electronic Frontier* (Cambridge, Mass.: MIT Press), revised edition.

Riaño Alcalá, Pilar. 2008. 'Journeys and Landscapes of Forced Migration: Memorializing Fear Among Refugees and Internally Displaced Colombians', *Social Anthropology/Anthropologie Sociale*, 16:1, 11–18.

Richard, Nelly. 1993. 'The Latin American Problematic of Theoretical-Cultural Transference: Postmodern Appropriations and Counterappropriations', *The South Atlantic Quarterly*, 92:3, 453–459.

Rider, Shawn. 2002. 'Interview: Ricardo Miranda Zúñiga, Creator of *Vagamundo: A Migrant's Tale*', *Games First*, www.gamesfirst.com/articles/shawn/vagamundo/vagamundo_interview.htm. Accessed 12 January 2011.

Rivera-Sánchez, Liliana. 2004. 'Inmigrantes mexicanos en Nueva York: construyendo espacios de organización y pertenencia comunitaria', in Jonathan Fox and

Gaspar Rivera-Salgado, eds., *Indígenas mexicanos migrantes en los Estados Unidos* (Zacatecas: Universidad Autónoma de Zacatecas), pp. 451–480.

Robles, Víctor Hugo. 2008. *Bandera hueca: historia del movimiento homosexual de Chile* (Santiago: Editorial Arcis/Editorial Cuarto Propio).

Rocca, Pablo. 2000. 'El campo y la ciudad en la narrativa uruguaya (1920–1950)', *Fragmentos*, 19, 7–28.

Rogers, Scott. 2010. *Level Up! The Guide to Great Video Game Design* (Chichester: John Wiley and Sons).

Rovira, James. 2005. 'Subverting the Mechanisms of Control: Baudrillard, *The Matrix Trilogy*, and the Future of Religion', *International Journal of Baudrillard Studies*, 2:2, www.ubishops.ca/baudrillardstudies/vol2_2/rovirapf.htm. Accessed 19 July 2012.

Ruggiero, Kristin, ed. 2005. *The Jewish Diaspora in Latin America and the Caribbean: Fragments of Memory* (Brighton: Sussex Academic Press).

Russell, Adrienne. 2005. 'Myth and the Zapatista Movement: Exploring a Network Identity', *New Media & Society*, 7:4, 559–577.

Ryan, Marie-Laure, 2006. *Avatars of Story* (Minneapolis: University of Minnesota Press).

Sá, Lúcia. 2007. 'Cyberspace Neighbourhood: The Virtual Construction of Capão Redondo' in Claire Taylor and Thea Pitman, eds., *Latin American Cyberculture and Cyberliterature* (Liverpool: Liverpool UP), pp. 123–139.

Saldívar, José David. 2002. 'On the Bad Edge of *La Frontera*', in Arturo J. Aldama and Naomi H. Quiñónez, eds., *Decolonial Voices: Chicana and Chicano Cultural Studies in the 21st Century* (Bloomington: Indiana), pp. 262–296

Schulzinger, Robert. 1984. *The Wise Men of Foreign Affairs: The History of the Council on Foreign Relations* (New York: Columbia University Press).

Scollon, Ron, and Suzie Wong Scollon. 2003. *Discourses in Place: Language in the Material World* (New York: Routledge).

Shah, Nisha. 2008. 'From *Global Village* to *Global Marketplace*: Metaphorical Descriptions of the Global Internet', *International Journal of Media and Cultural Politics*, 4:1, 9–26.

Shelley, Cameron. 2001. 'Aspects of Visual Argument: A Study of the *March of Progress*', *Informal Logic*, 21:2, 85–96.

Shulgin, Alexei. 2007. 'net.art: The Origin', reproduced on www.net-art.org/netart. Accessed 2 December 2013.

Silva, Armando. 2006. 'Centros imaginados de América Latina', in *Lugares e imaginarios en la metrópolis*, eds Alicia Lindón, Miguel Ángel Aguilar and Daniel Hiernaux (Iztapalapa: Universidad Autónoma Mexicana), pp. 43–66.

Sletto, Bjørn Ingmunn. 2009. '"We Drew What We Imagined": Participatory Mapping, Performance, and the Arts of Landscape Making', *Current Anthropology*, 50:4, 443–476.

Snyder, Edward C. 1995. 'Dirty Legal War: Human Rights and the Rule of Law in Chile 1973–1995', *Tulsa Journal of Comparative and International Law*, 2:2, 253–288.

Sommer, Doris. 1991. *Foundational Fictions: The National Romances of Latin America* (Berkeley: University of California Press).

Sondrol, Paul C. 1993. 'Explaining and Reconceptualizing Underdevelopment: Paraguay and Uruguay', *Latin American Research Review*, 28:3, 235–250.

Sonvilla-Weiss, Stefan. 2010. 'Introduction: Mashups, Remix Practices and the Recombination of Existing Digital Content', in Stefan Sonvilla-Weiss, ed., *Mashup Cultures* (Vienna: Springer), pp. 8–23.

Spinello, Richard A. 2003. 'The Case Against Microsoft: An Ethical Perspective', *Business Ethics: A European Review*, 12:2, 116–132.

Stallabrass, Julian. 2003. *Internet Art: The Online Clash of Culture and Commerce* (London: Tate Publishing).

Steinberg, Philip E. and Stephen D. McDowell. 2007. *Managing the Infosphere: Governance, Technology, and Cultural Practice in Motion* (Philadelphia: Temple University Press).

Stern, Steve J. 2010. *Reckoning with Pinochet: The Memory Question in Democratic Chile, 1989–2006* (Durham: Duke UP).

Stone, Michael and Gabrielle Winkler. 1997. 'Translator's Foreword', in Norma Iglesias Prieto, *Beautiful Flowers of the Maquiladora: Life Histories of Women Workers in Tijuana* (Austin: University of Texas Press).

Sugden, John and Alan Tomlinson. 2007. 'Football, *Ressentiment* and Resistance in the Break-Up of the Former Soviet Union', *Culture, Sport, Society: Cultures, Commerce, Media, Politics*, 3:2, 89–108.

Swanger, Joanna. 2001. 'Laboring in a "Borderless" World: the Threat of Globalization', *International Journal of Qualitative Studies in Education*, 15:1, 11–32.

Tandeciarz, Silvia R. 2007. 'Citizens of Memory: Refiguring the Past in Postdictatorship Argentina', *PMLA*, 122:1, 151–169.

Tate, Winifred. 2009. 'U.S. Human Rights Activism and Plan Colombia', *Colombia Internacional*, 69, 50–69.

Taylor, Claire. 2013. 'Blogging from the Margins: Grassroots Activism and Mass Media Forms in the *Hiperbarrio* Project' in Geoffrey Kantaris and Rory O'Bryen, eds., *Latin American Popular Culture: Politics, Media, Affect* (London: Tamesis), pp. 207–224.

Taylor, Claire and Thea Pitman, 2012. *Latin American Identity in Online Cultural Production* (New York: Routledge).

Taylor, Diana. 1998. 'A Savage Performance: Guillermo Gómez-Peña and Coco Fusco's "Couple in the Cage", *The Drama Review*, 42:2, 160–175.

Téllez, Michelle. 2006. 'Generating Hope, Creating Change, Searching for Community: Stories of Resistance against Globalization at the U.S.-Mexico Border', in César Augusto Rossato, Ricky Lee Allen and Marc Pruyn, eds., *Reinventing Critical Pedagogy: Widening the Circle of Anti-Oppression Education* (Lanham: Rowman and Littlefield), pp. 225–234.

The Thing.net. n.d. 'History', *The Thing*, http://the.thing.net/about/about.html. Accessed 27 September 2011.

Tribe, Mark. 2008. '*Tijuana Calling*: Curatorial Statement', https://wiki.brown.edu/confluence/display/MarkTribe/Tijuana+Calling. Accessed 27 September 2011.

Trochon, Yvette. 2008. 'La quimera del oro: el tesoro de las Masilotti', in Yvette Trochon et al., *Escritores en capilla: el tesoro de las Masilotti* (Montevideo: Editorial Fin de Siglo), pp. 1–19.

Tufró, Manuel, and Luis Sanjurjo. 2010. 'Descentralizar la memoria: dos lógicas de intervención sobre el espacio urbano en la ciudad de Buenos Aires', *Universitas Humanística*, 70, 119–132.

Tuomi, Ilkka. 2002. *Networks of Innovation: Change and Meaning in the Age of the Internet* (Oxford: OUP).

Turner, Fred. 2006. *From Counterculture to Cyberculture: Steward Brand, the Whole Earth Network, and the Rise of Digital Utopianism* (Chicago: University of Chicago Press).

United States Government Accountability Office. 2006. *Illegal Immigration* (Washington: GAO).

Valdes, Dennis N. 1995. 'Legal Status and the Struggles of Farmworkers in West Texas and New Mexico, 1942–1993', *Latin American Perspectives*, 22:1, 117–137.

Valenzuela, Valeria. 2005. 'Yo te digo que el mundo es así: giro performativo en el documental chileno contemporáneo', *Revista Digital de Cine Documental*, 1, 6–22, http://bocc.ubi.pt/~doc/01/doc01.pdf#page=12. Accessed 28 September 2012.

Van Laer, Jeroen and Peter Van Aelst. 2010. 'Internet and Social Movement Action Repertoires: Opportunities and Limitations', *Information, Communication and Society*, 13:8, 1146–1171.

Villa, Raúl Homero. 2000. *Barrio-Logos: Space and Place in Urban Chicano Literature* (Austin: University of Texas Press).

Villaveces-Izquierdo, Santiago. 2004. 'Internal Diaspora and State Imagination: Colombia's Failure to Envision a Nation' in Simon Szreter, Hania Sholkamy and A. Dharmalingam, eds., *Categories and Contexts: Anthropological and Historical Studies in Critical Demography* (Oxford: OUP), pp. 173–184.

Villegas, Renato. 2008. Dir. *La batalla de Plaza Italia*.

Waldman Mitnick, Gilda. 2009. 'Chile: la persistencia de las memorias antagónicas', *Política y Cultura*, 31, 211–234.

Waldmann, Peter. 2011. 'How Terrorism Ceases: the Tupamaros in Uruguay', *Studies in Conflict and Terrorism*, 34:9, 717–731.

Why-War. 2004. 'Articles that Reference Colombia', http://why-war.com/encyclopedia/places/Colombia/. Accessed 23 June 2013.

Williams, Edward J. 1996.'The Maquiladora Industry and Environmental Degradation in the United States-Mexico Borderlands', *St Mary's Law Journal*, 27:4, 765–816.

Williams, Gareth. 1997 (2000). 'From Populism to Neoliberalism: Formalities of Identity, Citizenship, and Consumption in Contemporary Latinamericanism', *Dispositio/n*, 49, 13–41.

———. 2002. *The Other Side of the Popular: Neoliberalism and Subalternity in Latin America* (Durham: Duke UP).

Williams, Heather L. 2003. 'Of Labor Tragedy and Legal Farce: The Han Young Factory Struggle in Tijuana, Mexico', *Social Science History*, 27:4, 525–250.

Wilson, Laetitia J. 2006. 'Encountering the Unexpected: Play Perversion in the Political Art-game and Game-art', in *Proceedings of the 2006 International Conference on Game Research and Development* (Perth: ACM Digital Library), pp. 269–274.

Winn, Peter, ed. 2004. *Victims of the Chilean Miracle: Workers and Neoliberalism in the Pinochet Era, 1973–2002* (Durham: Duke UP).

Wood, Denis. 2011. 'Lynch Debord: About Two Psychogeographies', *Cartographica*, 45:3, 185–200.

Zembylas, Michalinos and Charalambos Vrasidas. 2005. 'Globalization, Information and Communication Technologies, and the Prospect of a "Global Village": Promises of Inclusion or Electronic Colonization?', *Journal of Curriculum Studies*, 71:1, 65–83.

Zimmerman, Eric. 2004. 'Narrative Interactivity, Play and Games: Four Naughty Concepts in Need of Discipline', in Noah Wardrip-Fruin and Pat Harrigan, eds., *First Person: New Media as Story, Performance and Game* (Cambridge MA: MIT Press), pp. 154–164.

Žižek, Slavoj. 2009. *Violence* (London: Profile Books).

Zlolniski, Christian. 1994. 'The Informal Economy in an Advanced Industrialized Society: Mexican Immigrant Labor in Silicon Valley', *The Yale Law Journal*, 103:8, 2305–2335.

———. 2006. *Janitors, Street Vendors, and Activists: the Lives of Mexican Immigrants in Silicon Valley* (Berkeley: University of California Press).

Images: Sources and Captions

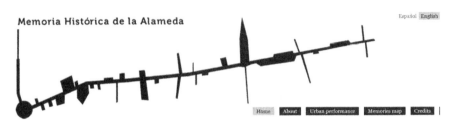

Figure 2.1 *Memoria histórica de la Alameda* (2005), opening screen

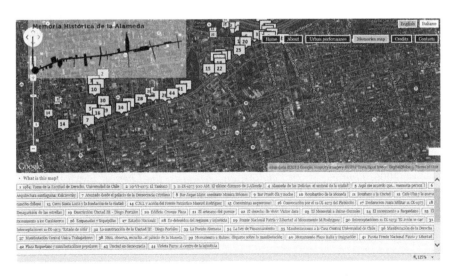

Figure 2.2 *Memoria histórica de la Alameda* (2005), map interface

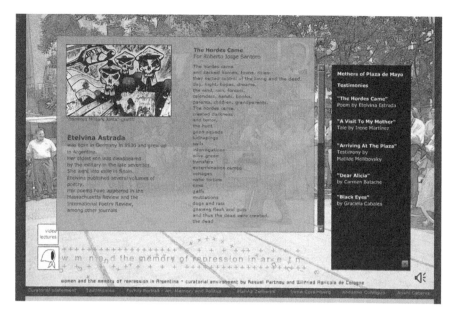

Figure 3.1 Agricola de Cologne and Raquel Partnoy, *Women: Memory of Repression in Argentina* (2003)

Figure 3.2 Marina Zerbarini, *Tejido de memoria* (2003)

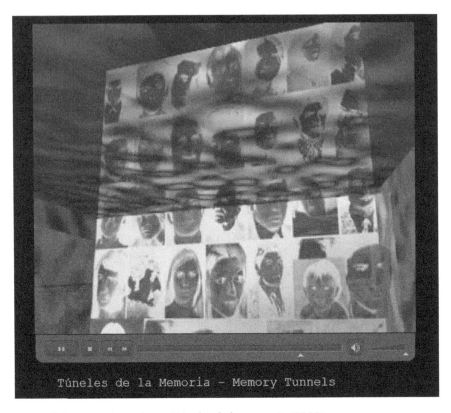

Figure 3.3 Irene Coremberg, *Túneles de la memoria* (2003)

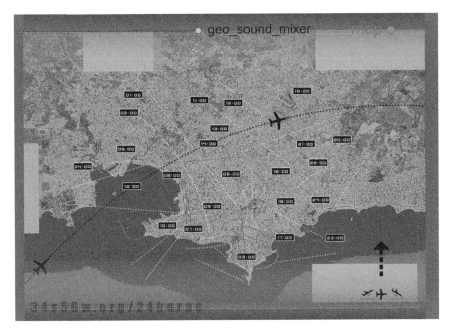

Figure 4.1 Brian Mackern, *24 horas* (2005)

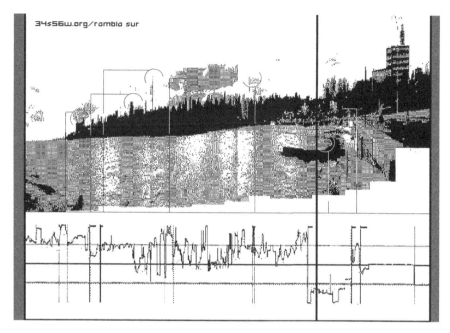

Figure 4.2 Brian Mackern, *Rambla Sur* (2005)

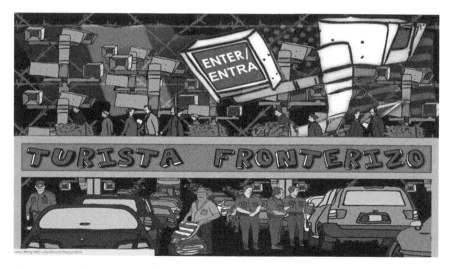

Figure 6.1 Coco Fusco and Ricardo Domínguez, *Turista Fronterizo* (2005), opening screen

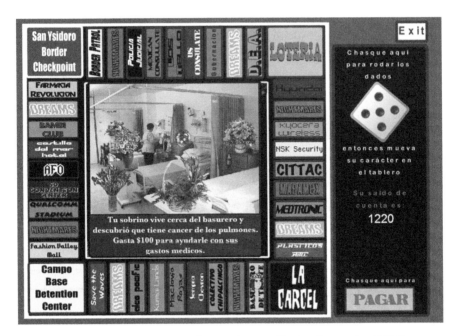

Figure 6.2 Coco Fusco and Ricardo Domínguez, *Turista Fronterizo* (2005), basurero

Figure 7.1 Ricardo Miranda Zúñiga, *Vagamundo* (2002), level 1

Figure 7.2 Ricardo Miranda Zúñiga, *Vagamundo* (2002), street game

Figure 7.3 Ricardo Miranda Zúñiga, *Vagamundo* (2002), level 3

Index

Printed and bound by CPI Group (UK) Ltd, Croydon, CR0 4YY

01/11/2024

01782632-0015